Art history

MANCHESTER
1824

Manchester University Press

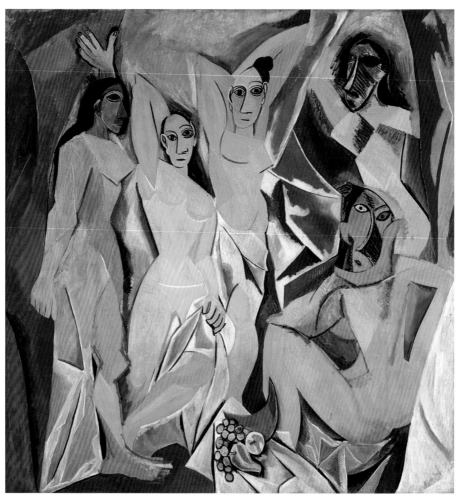

Pablo Picasso, *Les Demoiselles d'Avignon*, 1907, oil on canvas, 243.9 × 233.7 cm, Museum of Modern Art, New York.

Acquired through the Lillie P. Bliss Bequest. (Digital Image©2003 The Museum of Modern Art/Scala, Florence, and Succession Picasso/DACS 2006)

ART HISTORY

A critical introduction to its methods

MICHAEL HATT and CHARLOTTE KLONK

MANCHESTER UNIVERSITY PRESS
Manchester and New York

distributed exclusively in the USA by Palgrave

Copyright © Michael Hatt and Charlotte Klonk 2006

The right of Michael Hatt and Charlotte Klonk to be identified as the author of this work has been asserted by them in accordance with the Copyright, Designs and Patents Act 1988.

Published by Manchester University Press
Oxford Road, Manchester M13 9NR, UK
and Room 400, 175 Fifth Avenue, New York, NY 10010, USA
www.manchesteruniversitypress.co.uk

Distributed in the United States exclusively by
Palgrave Macmillan, 175 Fifth Avenue,
New York, NY 10010, USA

Distributed in Canada exclusively by
UBC Press, University of British Columbia, 2029 West Mall,
Vancouver, BC, Canada V6T 1Z2

British Library Cataloguing-in-Publication Data is available

Library of Congress Cataloging-in-Publication Data is available

ISBN 978 0 7190 6959 8 paperback

First published 2006

Seventh impression 2013

The publisher has no responsibility for the persistence or accuracy of URLs for any external or third-party internet websites referred to in this book, and does not guarantee that any content on such websites is, or will remain, accurate or appropriate.

Printed in Great Britain
by CPI Antony Rowe, Chippenham

Contents

Illustrations

Every effort has been made to obtain permission to reproduce the
illustrations in this book. If any proper acknowledgement has not
been made, copyright-holders are invited to contact the publisher.

Acknowledgements

It is a rare pleasure in one's academic life to be able to collaborate in the writing of a book. We have both found this an immensely stimulating process; indeed, although we originally anticipated writing this book quickly we found ourselves discussing it over many more years. On more than one occasion the book was merely the starting point for exploring unknown intellectual territory together and it is sad to think that this might come to an end now. Our debates emboldened us and gave the book a polemical aspect that we had not anticipated. On many occasions this project has benefited from discussions with other friends and colleagues. In particular we like to thank Michael Rosen for his intellectual rigour and encouragement. Thanks are due to Morna O'Neill and Rebecca Scragg for help with illustrations. We would also like to thank our students at the University of Warwick and the University of Nottingham who have impressed on us the need for this book, and without knowing shaped its argument.

IMAGINE AN ART GALLERY. A guard sits in the corner yawning while the visitors stroll around stopping in front of the paintings. Some of them discuss the works of art, some look at them on their own in silence. What is this painting about, what does it *mean*? A bell rings and the guard begins to usher people from the room. Once the visitors have gone he turns out the light. What do the paintings mean now? Are the meanings the visitors discussed somehow still there? Or do the paintings have no meaning in the dark with no one looking?

This is a difficult question. Some have claimed that artworks do not have a meaning unless someone is looking at them; others have argued that the meaning of a painting is intrinsic. But whether the meaning of a work is independent of the viewer is in fact moot, because, even if it is, this meaning is not objectively accessible to us. We simply do not have any way of knowing this meaning if we are not there. All we know is what happens when we are in front of a work of art and this suggests another possibility. Perhaps an artwork has as many meanings as there are viewers. People bring all kinds of past experience to the act of looking and understanding and they interpret artworks differently. However, this does not mean that all interpretations are equally valid. Some are better than others.

Why is this? What makes one interpretation better than another? Some ways of interpreting are more comprehensive than others. They have fewer contradictions and account for more detailed observations – both in terms of the visual appearance of the work and the historical evidence relating to it. If you have a framework within which to view an artwork your interpretation will be more plausible and more persuasive. The more systematic thought you bring to a work of art the more you get out of it. This book is concerned with these frameworks for viewing works of art which are usually called 'methods'. Every art historian relies on some method, although they do not always acknowledge it. They are committed to some underlying beliefs about art and its history which determine the meanings they find. In this book we offer an account of the most important methods that have been used in art history since the early nineteenth century. Our aim is to make explicit what commitments each one entails. The result is an account of how we go about things when we practise art

history and an invitation to think critically about what is sometimes taken for granted.

Before we go any further, a word about our terminology. Sometimes people use 'theory' and 'method' as interchangeable terms. However, in our view it is important to distinguish between the two. We use theory to mean a comprehensive explanation which deals with a set of phenomena. Method, on the other hand, is the particular way in which a theory is applied. Think of theory as a map and method as the way in which it is used to find one's way. Asking questions about art patronage or the art market is not a method, although it may be part of the way in which a method is practised. There is also a distinction between theoretical questions in art history and the philosophical discipline of aesthetics. While aesthetics is interested in the universal characteristics involved in the perception of beauty, art historians require theories that negotiate the relationship between the specific and the general. While aesthetics looks at the universal features of the perception of art, theoretical art history focuses on historically and culturally specific ways of seeing. Indeed, the assumption that art is fundamentally historical explains why theory is needed in art history. If we cannot appeal to universal conditions of seeing then how is it that the art produced at one place and time can be interpreted by a viewer in another? One purpose of theory in art history is to explain how a work can be understood by someone from a cultural standpoint outside its original context.

Each of the methods or frameworks discussed in this book provides a particular perspective on its chosen subject and entails certain commitments. Each gives an account of some things at the expense of others that lie outside its frame. The same thing applies to this book. We too are writing from a particular perspective which determines what we deal with and what we have left out. Others would do it differently and might quarrel with the methods we have chosen to discuss. Some people might think we have taken a rather narrow view of the discipline. It could be argued that we have ignored the most important development in art history in recent years, the rise of the study of 'visual culture'. The study of 'visual culture' can mean one of two things. On the one hand, the phrase is often used to describe the way that, in recent years, art historians have expanded the range of visual phenomena with which they deal; not just painting and sculpture, but television, computer games, hairstyles and so on. As it stands, this extension of art history's range does not raise any questions of method. The assumption is that the existing methods of art history are sufficiently powerful to be applied to this wider range of objects. But sometimes a stronger claim is made, namely that visual culture is a fundamentally new discipline with radically new methods. Perhaps that will prove to be true

in the future but as it stands, this claim is premature: what the methods of 'visual culture' might be has not yet been worked out.

We can imagine other objections to our selection of methods. For example, it might be said that we have opted for the most familiar names in art history and have ignored some of the most productive but less celebrated practitioners in the field. But the familiarity of the methods we have chosen is precisely why we discuss them. They have, in our experience, been the most widely influential and have done the most to shape the discipline of art history. Admittedly, we can think of a number of art historians and approaches we would like to have dealt with in more detail – we have no chapter on Ernst Gombrich, Michael Baxandall, or on deconstruction, for example – but clearly a book like this can never be exhaustive. Nevertheless, it is our hope and belief that what we have provided will be sufficient to allow the reader to develop a critical engagement with the discipline.

The main aim of the book is quite straightforward. We want to provide an introduction to these key approaches and to set them in context. We want to present these methods in relation to each other in order to explore how they are part of a continuous debate. This comparative approach will also help to make clearer the distinctiveness of each method. Extracts from the original texts that we discuss are now relatively easy to come by. In recent years many have appeared in a number of anthologies which we list in the annotated bibliography at the end of this introduction. Yet, valuable though these collections are, the fact that they consist of excerpts from much more extensive texts risks misunderstanding, particularly if the principles behind the author's work are not clearly grasped. There are also a number of books listed in the bibliography which deal with particular issues of theory and method. While these discussions offer very stimulating perspectives, one needs a certain breadth of knowledge of methods and its history in order to engage with them productively. Moreover, unless one is fluent in German (in which case there is more critical literature available), it is very difficult to get a sense of the continuing intellectual debates which spurred the development of different methods as responses to one another.

The book is organised chronologically. We begin with the very beginnings of art history as a discipline, which we find in the work of the German philosopher Hegel, and end with one of the most important contemporary developments – postcolonialism. It is a story which moves from mono-causal accounts of history – that is, explanations where historical change is referred back to a single, prime factor – to multi-causal accounts – explanations in which many factors interact. This is why the

book is divided into two parts and you will see that we identify an impor-
tant shift somewhere in the 1960s.

However, some warnings should be given now. First, this is not a story
of progress. We do not suggest that art-historical methods get steadily
better and better. The story we tell is one of gains and losses. The turn
away from mono-causal accounts limits our capacity to explain the develop-
ment of art through time, although it leads to a more socially specific
account of artworks. Second, one should not assume that the emergence
of a new method makes previous approaches redundant. On the contrary,
new approaches often depend on aspects of earlier ones. It is, for example,
hard to imagine how many of the points made by feminists could have
been presented without using the formalist technique of 'compare and
contrast' – that is, the juxtaposition of two revealing objects next to each
other. Similarly, every iconographical discussion of Renaissance art is
greatly dependent on the achievements of connoisseurial attribution. Indeed,
most art historians would not wish to align themselves with only one of
the methods we outline here. They would rather rely on different methods
for different purposes. This does not mean that one can simply mix
methods at will in an arbitrary manner. Different methods are not neces-
sarily compatible; as we shall see, the theoretical bases of feminism and
formalism, or of iconography and connoisseurship are in many ways anti-
thetical. Any historian has to decide what his or her fundamental commit-
ments are. We return to this issue in our conclusion.

For now, we simply want to make the point that different methods
can be, and are, combined by scholars, but that there are limits to how this
can be done. A further point to note in advance is that the chronological
organisation of this book is not rigid. For example, we treat psychoanalysis
as a contemporary approach, the reason being that it has been widely used
in art history only from the 1970s onwards. Yet its origins date back to the
turn of the twentieth century. Finally, we should guard against the idea that
the use of theory is somehow restricted to modern art history and that
earlier art historians were naive or unreflective in their approach. In this
book we set out to overturn this notion. In our view, the best art history
has always been underpinned by sophisticated reflections regarding the
determinants of art and its changing appearances. In this sense, theory has
been a permanent feature of art history.

Each of the chapters in this book has more or less the same structure.
With each approach we give a brief definition and a brief description of
its historical context; followed by an explanatory account which introduces
key terms and examines important examples of the method in practice.
Each chapter ends with a critical evaluation of the method drawing out the

questions it has enabled us to ask, and how it has responded to perceived deficiencies in other approaches. We also ask to what extent the approach fulfils its aims and offer some criticisms, either that have been made by others, or our own. Before we begin our historical accounts we provide a simple overview of what follows – a trailer before the main feature, if you like. In this trailer a single work is analysed, albeit very briefly, from the point of view of the various approaches we explore later. The purpose is partly to give the reader some idea of what to expect, but, more importantly, to emphasise a fundamental idea: that the approach a historian adopts depends upon the interests that he or she brings to the work of art and the questions he or she wishes to ask of it. Such questions are circumscribed by one's methodology. Thus, no approach can ever provide a comprehensive account of a work of art.

Here is a brief summary of the subsequent chapters. Part One, which is concerned with mono-causal explanations, begins with **Hegel** (Chapter 3). The argument is that two new notions which became widespread at the end of the eighteenth century led to art being seen as intrinsically historical and so made possible the emergence of art history as a discipline. The focus of the chapter is Hegel's postulation of an 'Absolute Spirit' which underpins his account of the differences between the artworks produced in different societies while at the same time postulating a developmental logic between them. This is followed by **Connoisseurship** (Chapter 4). This term is often used to refer to people who take an unhistorical approach to art, who think of the appreciation of art as a discriminating kind of visual enjoyment. Our point is that the connoisseurs represented a serious reaction against Hegel's speculative approach to art and it was this that led them to emphasise rigorous empirical and archival research. Connoisseurs like Giuseppe Morelli and Bernard Berenson shared an exalted notion of individual creativity. Then comes **Formalism** (Chapter 5) and the work of Alois Riegl and Heinrich Wölfflin. Formalism too is often misunderstood and presented as an unhistorical exercise in description. On the contrary, we argue, Riegl and Wölfflin are of fundamental importance to the extent that they raise the question of the historicity of vision. Following this we move on to a discussion of **Iconography–iconology** (Chapter 6), and Erwin Panofsky's contribution to the discipline. Panofsky's attempt to show 'how under different historical circumstances particular themes or ideas are articulated' will be shown to be dependent on his commitment to neo-Kantian philosophy. The final chapter in Part One, on **Marxism and the social history of art** (Chapter 7), marks a turning point in the book, since it embraces the shift from the search for a single causal explanation for historical change to the more

multi-factorial recent approaches discussed in Part Two. Both the work of orthodox Marxist art historians in the earlier part of the twentieth century, like Frederick Antal and Arnold Hauser, and the attenuated models of historical agency applied by later practitioners like T. J. Clark will be examined. What we argue is that social art history as it is now widely practised has left behind some of the fundamental principles of classical Marxist theory.

In Part Two we examine more recent approaches. All of these give up the idea of a single explanation for the changes in art through history. We start with **Feminism** (Chapter 8). In our view, feminist art history brings together a number of different ideas. Not only does the subject of investigation for feminists vary — for instance, the work of women artists, or images of masculinity — but feminism is also methodologically diverse, since feminist art history often draws on Marxism and psychoanalysis, as well as other theoretical traditions. We then move on to **Psychoanalysis** (Chapter 9). This chapter highlights the difference between those psychoanalytical interpretations influenced by Freud, which tend to concentrate on the way unconscious desires are expressed in works of art, and those approaches which, following Lacan, discuss how such desires are culturally determined. **Semiotics** (Chapter 10), which follows, is an approach based on the analysis of language developed by Ferdinand Saussure and Charles Peirce, among others. In art history it has been used to try to grasp more clearly the different functions of pictorial elements and forms of representation. Finally, we look at **Postcolonialism** (Chapter 11). We emphasise that postcolonialism in art history does not simply mean examining the art of non-Western cultures, but is concerned with interpreting the dominant Western culture from the point of view of the outsider. A distinction is made between two positions; one, following Edward Said, which polarises Western and non-Western culture, the other arguing that all cultures are created by cross-cultural exchanges. Our **Conclusion** sums up the basic theses of the book, although we end up asking more questions than offering final judgements. We ask which approaches are compatible with which, and why problems arise in trying to synthesise some theoretical models with others.

Bibliography

Belting, Hans, *The End of the History of Art?*, trans. Christopher S. Wood (Chicago: University of Chicago Press, 1987). This book is not an introduction to methods, although Belting discusses art-historical scholarship from Vasari to the present. It is a polemic in favour of a non-historical approach to the understanding of art, one that is decidedly contemporary in its focus.

Cheetham, Mark A., Holly, Michael Ann and Moxey, Keith (eds), *The Subjects of Art History* (Cambridge: Cambridge University Press, 1998). This collection of essays by contemporary cultural historians expands the themes and subjects of debate selected by Preziosi, although it does not provide a sense of their controversial relationship.

Edwards, Steve (ed.), *Art and Its Histories* (New Haven and London: Yale University Press in association with The Open University, 1999). This is only to a limited extent an introduction to approaches in art history. It is intended as a source book for six further volumes, each of which discusses the historical development of a subject under particular scrutiny in contemporary art history (the canon, the genius of the artist, gender, the avant-garde, postcolonialism, displays). As a consequence, the reader (which contains primary and secondary sources referred to in the series) only indirectly introduces the variety of methods employed in art historical discussions.

Fernie, Ernie (ed.), *Art History and Its Methods* (London: Phaidon, 1995). This was the first reader for art-historical methods to appear in English. It opens with a short introduction to the development of art history from antiquity to the present, followed by extracts from art historians whose significance is highlighted by brief commentaries. A glossary of critical terms concludes the book.

Hyde Minor, Vernon, *Art History's History* (New York: Harry N. Abrams, 1994). This is the only textbook in English (in contrast to Germany, which has a long tradition of historical and critical reflections on the discipline) that gives an account of art history's method from Vasari to the present and is written by one author. It is, however, not particularly useful in its presentation of methods developed in the second half of the twentieth century.

Mansfield, Elizabeth (ed.), *Art History and Its Institutions: Foundations of a Discipline* (London: Routledge, 2002). This book contains a number of articles on the history of art history, often addressing seminal but forgotten issues. Like all the other edited books in this list, it does not provide a critical or comparative account of art history's methods.

Nelson, Robert S. and Schiff, Richard (eds), *Critical Terms for Art History* (Chicago: University of Chicago Press, 1996). The aim of this book is not to introduce approaches to art history chronologically, but to provide clarification and commentary by specialists on twenty-three terms used in contemporary art history.

Preziosi, Donald (ed.), *The Art of Art History: A Critical Anthology* (Oxford: Oxford University Press, 1998). Rather than treating the authors and their texts in this collection as paradigmatic examples of particular approaches, Preziosi has organised his selection around particular debates and themes, which are introduced by him in a way that signals to the reader that the production of knowledge in art history is controversial and non-teleological.

Schneider Adams, Laurie, *The Methodologies of Art: An Introduction* (Boulder and Oxford: Westview, 1996). This book provides a useful although highly selective account of methods in art history. Nineteenth- and early-twentieth-century approaches are not the strengths of the book. Its merit lies in its accounts of semiotics and psychoanalysis.

Smith, Paul and Wilde, Carolyn (eds), *A Companion to Art Theory* (Oxford: Blackwell, 2002). This work provides a wide range of discussions by specialists on topics of importance in contemporary art history. It is not an introduction to art theories, nor does it provide a comparative account of them.

Williams, Robert, *Art Theory: An Historical Introduction* (Oxford: Blackwell, 2004). This book is not about art history's methods and theories, but introduces the theories used and developed by artists themselves.

PART ONE

Look at Exhibit A (frontispiece). As art historians we feel we should be able to say something significant about this image: to find a meaning in it, to explain why it looks the way it does. Most of us would assume that it is our specialised art historical knowledge and training that allows us to do this, and this is certainly true. But it is worth reminding ourselves that much of our understanding of art depends on our more general experience. This experience in turn is a product of our particular historical and social situation: our culture, our status, our gender and so forth. In other words, we should remember, in practising art history, that we are historical subjects too. An obvious example of this is the very fact that we see Exhibit A as a work of art. This is by no means a self-evident description. We take Exhibit A to be an artwork because we are part of a world which accepts Western aesthetic values. Yet, although we are part of that world, or have experience of its cultural products, and, therefore, immediately comprehend that Exhibit A is an artwork, there is still no certainty that we shall understand the image. After all, what do we see here? Five apparently unfriendly naked women with weird features and stylised body parts inhabit a shallow, fragmented and distorted space. Some viewers might turn away from the image, dismissing it as childish and not worth attention. Others of us might want to look at it more closely in order to see if we can make it meaningful, and it is at this point that a little art-historical knowledge comes in handy.

As it happens, Exhibit A is one of the icons of modern art. Surely every art historian, as well as very many interested non-art historians, knows that it is a painting by Pablo Picasso and that it is called *Les Demoiselles d'Avignon*. It was painted in 1907. Some may also know that it is to be found today in the Museum of Modern Art in New York. Let us pretend, however, that we do not know any of this. Assuming ignorance in this way is a reminder that, if we are to understand this work historically rather than passing an aesthetic judgement on it, our first move must be to identify and date it. Only when we have done this and put it in some kind of relationship to other works of art can we start to address what is particular to this image. So, the first thing that any art historian does is to give a picture a place in a historical sequence. We might do so by its formal characteristics or by its content, or, more likely, both. In this case, we might

compare Picasso's use of space, line and colour or his treatment of the female nude with that of other pictures. In order to come up with these comparisons we need to be familiar with a significant range of artists, yet the comparisons themselves need no more than close visual attention. Indeed, many art historians will perform this kind of operation seemingly instantaneously, given their mental archive of images and styles. So, let us make some comparisons.

There is, for example, a certain similarity to the all-over design of angular planes in paintings by El Greco, who worked in Spain in the late sixteenth and early seventeenth centuries. Yet the narrative in our image bears little relation to the biblical and religious subjects that concern El Greco and formally the differences are greater than the similarities; the colours are less hallucinatory and the angularity more intense. The figures' character and composition have more in common with a Turkish bath scene painted in the mid-nineteenth century by the French artist Ingres, but while it is thematically similar it lacks Ingres' suggestive eroticism. This lack of sensuality and its formal approach brings the picture closer to the turn-of-the-twentieth-century French artist Paul Cézanne. So could it have been painted by him?

In Cézanne's pictures figures and background are fused for the first time since the so-called discovery of the perspectival illusion in Renaissance art. Cézanne does this in a way that indicates his knowledge of the illusionistic rendering of space (so we are never in doubt that his works belong to the history of art since the Renaissance invention) yet he does not use it as the structuring device for his pictures. Instead Cézanne's figures are woven into the picture plane like patterns in a tapestry. In our picture, however, the painter has gone even further than Cézanne in abandoning the sculptural modelling of his figures. They are represented by straight lines and overlapping planes in a way that makes them flat and weightless. The high keynotes of the colours in the picture are reminiscent of Cézanne's French contemporaries, for example Paul Gauguin, and of his successors, such as Henri Matisse. The image's background changes from the browns, pinks and terracottas that dominate its left-hand side via grey in the centre to blue with accents of green and orange at the right. The image, however, has nothing of the harmoniousness of colour and form achieved in pictures by Gauguin and Matisse. The fierceness of the figures and the spatial dislocations suggest quite the reverse.

There can be no doubt: the image was created at the turn of the twentieth century, and is related to the fashion for paintings of groups of naked figures that we see in the paintings of Cézanne, Matisse and Gauguin. It also shares their abandonment of the illusionistic rendering of nature in

favour of abstract figure and form. We now have an approximate date but no artist. One particularly striking feature of the image may allow us to get closer to finding a name. While the painting resembles a classical figure composition, there is nothing classical about its appearance. Many artists around 1900 used non-classical means to convey classical themes, such as showing human beings naked and in a state of nature, but this image is different. The right half of the picture differs markedly from the left. Not only are its colours cooler, the planes are smaller and are more jagged and dynamic in appearance. Most striking, however, is the difference in the depiction of the women. While the three figures on the left and centre are shown in monumental, classical-type poses and their faces are depicted in simplified archaic forms, the two on the right seem to be wearing masks. Their faces are simplified – one might say, distorted – into the most basic sign languages. Small ovals are used for their mouths; they have massive, flat-ridged noses with dramatic shading and their eyes are out of line. The daemonic character of the figures and the sign language of the masks has been seen as an echo of sub-Saharan masks while the women's faces on the left resemble archaic Iberian stone sculptures. This incorporation of forms to be found in artefacts from primeval and non-Western cultures points to Picasso. Other artists of the period were fascinated by these artefacts (which were starting to appear in museum collections following France's colonial conquests) but it was Picasso who, more than anybody else, tried to use their conventions in his pictures. The subject matter suggests Picasso, then. Does a formal analysis bear this out?

Formally, it is the radicalism with which natural forms, be they figures or spaces, are broken up into semi-abstract, shallow, shifting and tilting planes and this confirms the artist as Picasso. In 1909 Picasso and his friend Braque launched a modern style of painting that they called 'Cubism', and this painting clearly anticipated it. The figures and spaces are not yet disassembled, nor are the colours as monochrome as they would later become. The noses of the two women in the centre of the picture are drawn in profile although the faces themselves are frontal – a device which was to become a hallmark of Cubist depictions. Picasso began to develop this way of representing figures in 1906 and 1907. We have now come pretty close to making an attribution for the painting and giving it a date. Once they have got as far as they can in placing a painting by its style and subject matter, art historians use whatever documentary evidence they can find to identify artist and the date. Naturally, this tends to be more difficult the older the work of art is. From the nineteenth century, most works are signed and dated. Bills, letters and account books also help. In the case of the *Demoiselles* we have many accounts by visitors to Picasso's studio (for

example, the writer Gertrude Stein) that confirm the origin of the painting in Picasso's studio, and that he worked on the painting between 1906 and 1907.

What we have accomplished at this stage is the work of the connoisseur. We have an artist's name and a date for the picture. The connoisseurial process was empirical, involving close visual analysis and comparison; although it also revealed certain assumptions evident in the kind of judgement made, such as whether an image was harmonious or sensual or erotic. The most important assumption, however, was that there would be something particular to an artist and to his work, and this in turn presupposes a conception of art as specific to its time and place. But simply to register this is insufficient. Changes from one historical moment to another are not random, and so have to be explained systematically. The fullest articulation of such a system is to be found in Hegel's aesthetics which we introduce in Chapter 3.

For now let us return to Exhibit A. We have an identification, but does this mean we have uncovered a meaning in the work? The answer to this question will vary from person to person. Quite often those who engage in the connoisseurial task of identifying and attributing works of art take a biographical approach to their meaning. In the Western world we often hold the deeply ingrained belief that whatever the fruits of our labour, they will bear the traces of our unique individuality and this belief implies that the way to gain understanding of the meaning of a work of art is to relate it to an artist's personality and experience.

Many have tried to explain Picasso's *Demoiselles* in this way. It has often been described as an act of personal exorcism. Biographers have pointed to Picasso's anxiety about women at that time as the source of the painting's power. Picasso's original title was 'The Brothel of Avignon'. Thus Picasso practised his formal techniques not on representations of classical Venuses but on hardbitten prostitutes looking for clients. Biographers have pointed out that at the time the painting was done Picasso was afraid that he had contracted a venereal disease while visiting brothels in Barcelona's red-light district. The distortions of the faces of the women were a response, it has been argued, to the artist's anxiety and echoed the horrific facial disfigurements that people suffering from syphilis develop in its advanced stages. Other biographers have pointed to Picasso's strained relationship with his mistress, Fernande Olivier. 'How could he wrestle the whole tradition of European art to the ground with his mistress sitting lazily by, fussing over her toilette, spraying herself with Chypre, doing precious little housework (visitors were horrified by the mess), distracting Picasso with her maddening "little ways"?' asked Picasso's most thorough English biographer, John

Richardson. Richardson concludes from diaries, statements and letters, as well as from his own later personal acquaintance with Picasso, that Fernande was trying to get Picasso's attention by making him jealous: 'All the more cause for the misogyny that fuelled this *chef d'oeuvre*' (John Richardson, *A Life of Picasso*, vol. 2, London, Jonathan Cape, 1996, pp. 19–20).

For a formalist, like Alfred Barr, for example – who as director of the Museum of Modern Art in New York did more than anybody to make the painting into a twentieth-century icon – this kind of explanation would not do. For the formalist, an artist's personal experience is no more relevant to the significance of a work of art than the trees from which our simian ancestors descended are to the evolution of human beings. What matters to the formalist is where the picture is to be placed in the progressive development of art. The formalist focuses on its technical radicalism. For Barr, who put the *Demoiselles* on display in New York in 1939, the picture (together with Matisse's very different *Joie de Vivre* of 1906) marked 'the beginning of a new period in the history of art' (Alfred Barr, *Picasso: Fifty Years of his Art*, New York, Museum of Modern Art, 1946, reprinted 1974, p. 56). According to Barr, the *Demoiselles* mattered because it was the start of a shift in interest from using painting for the imitation of natural appearances to realising the expressive potential of art's formal aspect.

If asked to agree with either the connoisseurial/biographical interpretation or the formalist one, you may feel that you would want to reply: neither. One the one hand, to say that the painting does no more than reflect Picasso's private experience with women seems rather banal. On the other hand, the formalist approach seems to tell us nothing of historical interest. Surely a work of art has a wider significance? What about the meaning of its subject matter? This is what art historians who take an iconographical approach are committed to. Although they do not doubt that the formal appearance of a work is significant, they argue that a change in style indicates a change in content. It is not so much that Picasso changes the form in which his subject – the nude female – is depicted, but that his conception of female nudity itself has changed and it is that which generates the technical radicalism of the painting, according to an iconographer. Look, for example, at the two figures at the centre of the picture with their arms raised. They are represented in the pose of a very old classical image of female beauty, the pose of Venus Anadyomene. If we were to trace the history of this image in texts and pictures it would bring us closer to the meaning that female nudity has in this picture, the iconographers believe. Again, it is a matter of establishing a background – in this case the theme of the Venus Anadyomene – in order to fix what is different and distinctive about its use in a particular case.

The image Venus Anadyomene is based on the myth of Venus's birth. In his anger for being thrown into the underworld, Uranus's son, Cronus, severed his father's genitals. The severed genitals were thrown into the sea, which caused the water to foam, and from that foam Venus emerged. Thus her birth is not from a mother's womb, but she emerges beautiful and fully formed. The depiction of Venus's birth became popular in nineteenth-century French painting as a symbol of ideal female beauty. But in the images by Ingres and others her horrific origins are forgotten and Uranus' mutilated body has disappeared. Venus appears as a universalised, unspecific, unblemished female figure emerging from sea foam, with her arms raised, ostensibly to wring water from her flowing hair but also displaying her perfect form all the better to the viewer. In Picasso's *Demoiselles* the two central figures are presented to the viewer by the woman on the left who draws a curtain back to reveal them. Francis Frascina has argued that they call up the idea of the female body as the embodiment of beauty and pure desire. Yet no woman appears unblemished in this picture; far from it. All have more or less horrific bodily distortions (Francis Frascina, 'Realism and Ideology', in C. Harrison, F. Frascina, and G. Perry, *Primitivism, Cubism, Abstraction: The Early Twentieth Century*, New Haven, Yale University Press, 1993, pp. 112–33). Knowing the traditional meaning of the pose of Venus Anadyomene allows us to become aware of Picasso's deviation from the tradition. His violation of the traditional ideal of feminine beauty seemed like a violent assault to his contemporaries. In contrast to the formalist interpretation of the picture as a point of origin for modern art, this iconographic reading interprets it as an act of fierce, daemonic destruction. The meaning you ascribe to the picture depends on the direction from which you approach it and that, in turn, depends on your interests.

You may still feel unsatisfied with our interpretation. While an iconographical approach explores the way that changing style is symptomatic of a changing conception of the female nude, it may seem a rather disengaged or impersonal conclusion. What, after all, is the point of all this intense study if works of art have nothing to say to us personally? To ask how works of art can help us find answers to contemporary questions is a dominant theme in art history today and approaches which start from such a position are the concern of the second part of this book.

Marxist and social art historians led the way in rejecting the idea that art requires disinterested contemplation, or that history can be practised from a neutral, objective stance. This was simply impossible, they argued – all interpretations are made from a standpoint and informed by particular experiences and interests. Instead, their own engagement with art gave priority to their concern with social inequality and exploitation. In relation to Picasso's *Desmoiselles*, for example, such critics have drawn attention to

the role of prostitution in capitalist societies. The proliferation of prosti-
tutes in the growing cities of the late nineteenth century were visible indi-
cators of the way in which commodification and alienation were entering
all areas of life, even the realm of love. The prostitutes in Picasso's image
were also the focus for considerable social anxiety. Rather than being high-
class courtesans of the kind represented as glamorous and tragic in Verdi's
opera *La Traviata*, Picasso's *Demoiselles* are at the bottom of society: 'Picasso's
subjects are humble brothel denizens, women who would have been on call,
if not always on their feet, from noon until three o'clock in the morning,
available to any passerby with a modicum of disposable income' (Anna C.
Chave, 'New Encounters with *Les Demoiselles d'Avignon*', in *Art Bulletin*, vol. 76,
no. 4, December 1994, p. 601). A generation before Picasso, Edouard Manet
had painted a courtesan, *Olympia*, but while she catered for bourgeois clients,
Les Demoiselles plainly serve a poorer class. Social historians emphasise that
part of what made the image so disturbing is its suggestion of social slip-
page: the prostitutes undermine the traditional boundaries between work
and sex, and their appearance in Picasso's work also mixes their lower-class
clientele with the bourgeois elite who constitute the public for such works
of art.

Marxist and social art historians' interpretations see injustices of past
and present societies inscribed in the artworks produced in those societies.
Feminists have taken this further to explore these injustices as they relate
to women. Anna Chave's discussion of Picasso's *Demoiselles* is a good example
of how feminists bring together a number of different approaches in order
to address this concern. Chave's starting point is the horrified reaction that
the picture received from male spectators. In her view, 'prostitutes and
femme fatales admittedly make less than perfect feminist heroines'. Although
'the demoiselles can never function successfully as models of empowerment,
they have, nonetheless, already functioned effectively as lightning rods for
fear of the empowerment of women and people of color' (Chave, 1994,
p. 610). Chave argues that the social slippages implicit in the picture trigger
anxiety in male viewers. She also uses an iconographic approach in
order to mount her feminist argument. According to Chave, the Venus
Anadyomene motif in the two central figures means that a buried subtext
of the image is 'the story of a woman coming to power at the expense of
a patriarch whose authority was unexpectedly and irretrievably revoked.
From a masculinist vantage point, this is certainly a horror story, but
from a feminist one it could be, to the contrary, a fable or even a good
omen of vengeance won against male tyranny' (Chave, 1994, p. 604).

The theme of castration then provokes a psychoanalytic development.
A central theme of psychoanalysis is male castration anxiety. According to
Freud, the female body appears in men's fantasies as a castrated version of

their own. Thus the female body inspires anxiety, provoking the uncon-
scious fear in the male viewer that he too could potentially be castrated. In
order to assuage this fear the female body can be fetishised, that is made
unblemished, ideal and separated from any particular woman or social
situation. Yet in Picasso's image recognition of this fear coexists with the
strategy of disavowal implicit in the image of Venus Anadyomene. While
the monumental posture of Picasso's prostitutes makes them phallic in
appearance, and thus disavowing castration anxiety, the picture's formal
characteristics cancel this fetishistic effect. 'The type of space', Chave
argues, 'that *Les Demoiselles d'Avignon* inaugurated or, rather, prognosticated is
a shallow space where voids seal over, becoming solid, while solids flatten
and fragment' (Chave, 1994, p. 602). The faceting of forms is a reminder
to the viewer of the cutting edge of the knife. It forbids the penetration
of the depth of the canvas's space on pain of castration. The significance
of Picasso's painting, read from this perspective, lies in the way that it
registers male anxiety about female power.

Postcolonial theorists also develop their interpretations from a con-
temporary concern. In their case it is not primarily the inequality of classes,
or sexes, but of nations and peoples, the legacy of European colonialism.
Postcolonialism in art history is not simply about non-Western artefacts;
nor is it the straightforward tracing of non-Western influences on Western
artists, but it is the telling of history from the perspective of the margin
rather than the centre. So a postcolonial account of the West's use of non-
Western art would discuss it as part of the colonial enterprise, since it is
about the appropriation of other cultures and their misinterpretation in
Western discourses, aesthetic or anthropological. Postcolonialists might
also use other approaches addressing their historical question, but for the
most part they turn to social history in order to explore the function of
images and artefacts from non-European cultures in European art.

Patricia Leighten, for example, is concerned to reconstruct the for-
gotten meaning of 'Africa' in turn-of-the-century France in relation to *Les
Desmoiselles*. She argues that the Iberian faces of the central figures in the
painting allude to Picasso's own self-image as a 'primitive' Spaniard coming
from outside the French classical tradition. The African masks worn by the
figures on the right, however, summon up 'an imagined ruthless barbarity
that the male modernist makes it his mission to confront' (Patricia Leighten,
'Colonialism, L'Art Nègre, and *Les Demoiselles d'Avignon*', in Christopher
Green (ed.), *Picasso's Les Desmoiselles d'Avignon*, Cambridge, Cambridge Uni-
versity Press, 2001, p. 93). According to Leighten, 'Picasso simultaneously
condemns the colonial policies that brought such masks to Europe, yet
embraces the very stereotypes that would see African culture as a

recuperative cure to degeneration "at home" rather than abroad' (Leighten, 2001, p. 96). This ambivalence is symptomatic, she claims, of Europeans' attitude towards non-European cultures. Picasso valued non-Western arte-facts as a primitive source for the regeneration of European forms and exploited it for his own ends; he shared the colonial discourse and attitudes of his day.

So, in Marxist, feminist, psychoanalytic and postcolonial approaches the painting is viewed in relation to specific psychic or political interests. A semiotic account of our image would allow all of these interpretations discussed so far, however much they might seem to contradict one another. Its starting point is that images have no objective significance in themselves but acquire their meaning in the context of the sign systems within which they circulate. In other words, meaning is not simply there in the image waiting to be excavated, but is produced in the act of viewing. It is not the artist who creates the significance of his or her work, but those who look at it. This argument was advanced by Rosalind Krauss in her seminal essay 'In the name of Picasso'. Picasso's collages, she argued, provided the first systematic investigation in art of 'the indeterminacy of the referent, and on absence', and thus one of the works' pleasures was what she called 'hospitableness to polysemy', to multiple readings (Rosalind Krauss, 'In the name of Picasso', in Rosalind Krauss, *The Originality of the Avant-Garde and Other Modernist Myths*, Cambridge MA, MIT Press, 1985, p. 39).

A strict semiotic reading, like Krauss', avoids interpreting art from a committed standpoint, such as a concern with class, or gender inequality. Instead it focuses on the conventional character of the individual elements that make up the image and the ways in which they acquire their meaning from the rules and conventions of representation. Christine Poggi has provided such a reading for *Les Demoiselles*. Picasso's Cubism was impelled, she argues, by an urge to highlight 'the conventional rather than the imita-tive nature of representation' (Christine Poggi, *In Defiance of Painting*, New Haven, Yale University Press, 1992, p. 45). *Les Demoiselles* quotes from dispa-rate sets of symbolic images, such as the Venus Anadyomene, African masks, Cézanne's bathers and Degas' squatting dancers without unifying them into a single, coherent new meaning. Like Krauss, Poggi concludes that what Picasso is seen to be doing is providing a meta-discourse on art's language and significance. This is art about art, an image that reveals the way in which meaning is derived not from references to the world, but from other representations and the possible readings these present to the viewer.

In different ways, all these contemporary approaches share certain convictions. First, they all believe that artworks do not develop in an

independent and neutral world of their own, but are determined by their contexts, whether that be political and social (as it is for Marxism and feminism) or linguistic (as it is for semiotics). Second, these different methods all begin from a personal perspective. There is no authoritative vantage point from which we can, like gods, survey history and find an immanent meaning. Our own interests will always play a part in our interpretations. This means that it is not only legitimate to interpret artworks in the light of contemporary concerns, but obligatory. As we have seen, many contemporary approaches to art history can be applied in conjunction with each other. Feminist, psychoanalytic or postcolonial enquiries are often combined with Marxist and social art history, for instance. However, they can also be associated with a radical semiotic approach. In that case, the link to social art history is attenuated and the focus turns to the relationship between the image and the contemporary viewer. Most of today's art historians acknowledge that connoisseurial, biographical, Hegelian, formalist, iconographic and orthodox Marxist approaches have useful, often indispensable, contributions to make. Yet they refuse to accept that any of these analyses are fully adequate and they dispute some of their most basic assumptions about art and its history. This comes, as we argue in Chapter 7, at a price. The gain, however, is that there is no closure to the range of interpretations that can be brought to Picasso's *Les Demoiselles d'Avignon* – or, indeed, to whatever other images art historians turn their attention to. The one requirement, we hasten to add, is that there should be committed viewers with some sense of what constitutes a rigorous enquiry similar to, if not the same as, those encountered in the following chapters.

A RT HISTORY in its modern form originated in Germany in the nine-teenth century. People had thought about the art of the past before, of course, but they did so in a way which we would now say was unhistorical: namely, they looked, not for what makes particular works significant in their own right, but how far these works realised what were thought to be universal aesthetic norms. Art theory was taught in the European academies which had been established in the seventeenth and eighteenth centuries for the training of artists, and included discussion of the art of the past; but individual artists and schools (that is, works of art grouped according to their country of origin) were judged according to whether they had achieved a representation of ideal beauty.

The Italian artist, **Giorgio Vasari (1511–74)** is often called the first art historian. His *The Lives of the Artists*, first published in 1550, provided an influential model for the understanding of past art. Vasari's art history was not historical in the modern sense, however. In his view, art's development over time was cyclical, and he discussed the achievement of individual artists with respect to their place in this cyclical process. According to Vasari, art achieved its first highpoint in the golden age of ancient Greek art, declined in the fourth and fifth centuries AD, was revived by Giotto in the thirteenth century, improved by Masaccio, Piero della Francesca and Mantegna in the fifteenth, and brought to new heights by Leonardo, Raphael and Michelangelo in Vasari's own time. But while Vasari saw art change during each cycle, approaching ever nearer to an aesthetic ideal, he did not understand these changes as a result of particular historical or social conditions at work at the time when each artist lived. A historical understanding of art in the modern sense did not start to develop until the end of the eighteenth century; until that time, history was thought to be extrinsic to art in the way that earthquakes are extrinsic to it. Art's value lay in striving to achieve timeless aesthetic norms, norms that were elaborated systematically by such French art theorists as **André Félibien (1619–95)** and **Roger de Piles (1635–1709)** in the late seventeenth and early eighteenth centuries. When the University of Göttingen in Germany founded the first chair in art history in 1813, this was not the dawn of art history as we now know it. The man appointed, Johann Dominicus Fiorillo, was a drawing master and his lectures followed the tradition of academic art theory.

Art history emerged as a recognisable academic discipline around 1850 in Germany. Two new ideas enabled this. First, art came to be seen as the embodiment of a distinctive expression of particular societies and civilisations. The pioneer of this idea was **Johann Joachim Winckelmann (1717–68)** in his *History of the Art of Antiquity* (1764). For Winckelmann, the art of antiquity represented an unsurpassable aesthetic achievement, which he explained as the result of the conjunction of the prevailing freedom at the time of its production along with the climate, form of government, ways of thinking and perceiving, and society's understanding of the role of the artist. The consequences of giving priority to the historical context of art over the qualities of individual artists were, however, not fully worked out by Winckelmann himself. Perhaps somewhat inconsistently, he understood classical art to be an embodiment of a moral idea, an aesthetic expression of the conception of goodness and freedom that human beings aspire to at their best. Moreover this moral idea remained a universal ideal applicable to all cultures at all times. The paradox here, of course, is that if particular aesthetic and moral values are, as Winckelmann had argued, dependent on the unique cultural context of their production, how could they be realised again under different circumstances at a different time and place?

It was Winckelmann's fellow countryman, the philosopher and theologian **Johann Gottfried Herder (1744–1803)**, who first recognised this problem in his essay on Winckelmann (1777). He agreed that artworks were the products of particular societies with distinct cultural values. The conclusion he drew from this was that no artwork produced in a certain period and culture should be judged by the standards of another. In mounting this argument, Herder laid the foundation for a modern understanding of art history. However, there is a second element which is characteristic of art history as we practise it today. The task of art history has been widely understood to be that of tracing the changes and developments that artworks have undergone over the centuries. Herder had provided a *synchronic* understanding of art – a conception of the relationship between art and the rest of a culture – and the ways in which the latter determines the former. This provided a sense of the differences and similarities between different cultures' works of art, and so enabled an account of art as part of a systematic social process extending through time: a *diachronic* view. Only with this in place did an understanding of art as developmental emerge, one which in the full sense constituted a history. The first person to present such a view of art was not an art historian but the philosopher, **Georg Wilhelm Friedrich Hegel (1770–1831)**, in his celebrated lectures on aesthetics, which were delivered in Berlin between 1820 and 1829 and published posthumously in 1835–38.

Hegel was born in Stuttgart and studied at the theological seminary in Tübingen. He moved to Jena in 1801 to become an unsalaried lecturer at the university and completed his first major work, *The Phenomenology of Spirit*, in 1806. The night after he finished the manuscript, Napoleon's victory at the Battle of Jena finally brought the Holy Roman Empire to an end, and Hegel had to leave Jena because Napoleon's government closed the university. For a time, he became the editor of a newspaper in Bamberg, before moving to Nuremberg in 1808 as the headmaster of a high school. It was only at the age of 46 that he obtained his first salaried academic post as professor of philosophy at Heidelberg University. During his time in Heidelberg, Hegel got to know the important private art collection of Melchior and Sulpice Boisserée. The Boisserées' collection was remarkable for two reasons. First, it concentrated on early German and Flemish works, a period which had hitherto not been widely esteemed. Second, the collection was based on its owners' conviction that national sentiment and religious belief could be given visual form in the presentation of Old Masters. Hegel's experience of the Boisserées' collection moved him to prepare lectures on aesthetics, which he gave between 1820 and 1829.

By then he had moved to Berlin where he was a keen visitor to the Royal art collection and took part in the discussions which led to the foundation of the first national art museum in 1830, housed in what is now the *Altes Museum* in Berlin. During the time that he was giving his lectures on aesthetics, Hegel made several journeys to see works of art on public display. In 1822 he went from Berlin to Cologne and from there on to Brussels, Ghent, Antwerp, Amsterdam and Hamburg. In 1824 he travelled to Prague and Vienna, and, finally, in 1827, to Paris. He also knew well the important collection of Old Masters in Dresden, but he never went south of the Alps. Most of the Italian artists whom he greatly esteemed, like Raphael and Correggio, he had encountered in the galleries of Dresden, Berlin, Vienna and Paris.

Hegel's philosophy of art

Hegel's philosophy is notoriously difficult but, fortunately for us, his lectures on aesthetics (or as he prefers to call it in his Introduction, the Philosophy of Fine Art) are among his more accessible works. This is partly because they were published after his death, based mainly on transcripts by members of his audience, and partly because Hegel uses a wealth of artworks, ranging from ancient India to contemporary German painting, to make concrete his otherwise rather abstract account. What Hegel found when he turned to art history was on the one hand Herder's claim that art

is always specific to the age and society which produced it, and on the other hand the desire of people like the Boisserées to find a meaning in past art that was relevant to the present. But how can one understand something if one does not share the conditions which gave meaning to it in the first place? This is called the **hermeneutic problem**. It was Hegel's philosophy which provided the first solution to this problem in art history.

Hegel's philosophical premise is that reality is the product of a **Universal Spirit** (*Geist*), or, '**Absolute Idea**', as he often calls it in the *Aesthetics*. We can think of this as being both a concept and its embodiment in reality. For Hegel, the Absolute Idea is, in a sense, both the blueprint of the world and its gradual realisation in particular expressions over the millennia. With each age the world gets closer and closer to understanding this ideal blueprint. Hegel pictures this in analogy to the human soul and body: the soul is the concept and the body is the physical form. Between the inner aspect of the soul and the outer aspect of the body there is a close relationship in which the one is expressed in the other. Similarly, the Absolute Idea articulates itself in the way that the human mind works within and upon the material world over the course of history. The Absolute Idea is continually acting in history, but its expressions are changeable and various depending on the particular stage of historical and social development.

Now, the question for us is, what is the role of art in this scheme? Art for Hegel is a portrait of the human mind. It expresses in a sensory form people's fundamental beliefs about the world and about themselves, that is, it shows mind as it attempts to understand the material realm and master it. In doing so the mind becomes increasingly aware of its own nature and art not only reveals the extent to which mind has achieved such self-consciousness, but provokes such awareness. Art for Hegel is, therefore, a necessity in the development of the Absolute Idea towards self-realisation. The Idea realises itself by working through and eventually overcoming the foreignness of the material world. Thus, art is both evidence of the progress of history, and, at various stages, crucial to the process by which progress takes place. At each stage of history, mind has related differently to the world of matter and has required a different kind of sensory articulation. In ancient Egypt, ancient Greece, and Renaissance Italy, for example, art was crucial, in Hegel's view, in revealing the Absolute Idea to individuals. At other times, however, other ways by which the human mind makes sense of the world and itself are more important. So, for example, religion, according to Hegel, was more fundamental during the Middle Ages. In modern times, philosophy plays this role, since the progress of history is towards an ever more rational and pure understanding of the Absolute Idea in the human mind and philosophy presents this in its

highest form. Because the mind has become aware of itself through philosophy in the modern age it no longer needs to struggle to know itself through the world of matter.

As we explained, art history required the idea that art is always an expression of the age and society in which it is produced. Hegel, following Herder and the German Romantic writers, argued that 'just as every man is a child of his time in every activity, whether political, religious, or scientific, and just as he has the task of bringing out the essential content and the therefore necessary form of that time, so it is the vocation of art to find for the spirit of a people the artistic expression corresponding to it' (Hegel, *Aesthetics*, 1975, vol. 1, p. 603). Beyond this, a mechanism had to be found by which it would be possible to identify a developmental logic linking these different expressions without violating the distinctive individuality of past art forms. Hegel's postulation of the Absolute Idea established this universal, inclusive viewpoint. The Idea, according to Hegel, made possible the distinctive articulation of art at each stage of history, provided the connection between all the diverse forms by which a society expressed itself and gave the impetus to progressive development through time. Moreover, it created a vantage point from which past and present could be seen as connected. This last aspect was crucial and would continue to haunt later writers who sought to do away with Hegel's metaphysical assumptions, for once art is recognised as being historically and socially specific, the question arises how it can be appreciated by someone from a cultural vantage point outside its original context.

If one accepts Hegel's underlying assumptions about the Absolute Idea and its progressive realisation in the products of the human mind, his art history has a certain force and logic – one which has proved difficult for later art historians entirely to escape. Although nineteenth-century art historians were uncomfortable with Hegel's claims for the existence of the Absolute Idea, a metaphysical entity that could neither be verified or falsified by experiment, it was from this premise that Hegel laid the foundation of art history as we now know it. We now turn to Hegel's specific account of art and its history, which will help us clarify these rather somewhat abstract postulations.

Hegel's art history

Hegel identified three fundamental steps in the historical development of art: **the Symbolic, the Classical, the Romantic**. Each phase first makes its appearance in a specific culture: the Symbolic stage emerged in ancient India and Persia and reached its peak in ancient Egypt *c.*3000 BC; the Classical

stage emerged in ancient Greece and reached its peak in the second half of the fourth century BC; and the Romantic stage coincided with the rise of Christianity and came to a peak in the art of Leonardo Da Vinci and Raphael around AD 1500 (Romantic here does not refer to Romanticism, the art movement which emerged in the early nineteenth century). Each phase, for Hegel, was best and most fully expressed in a particular art form: the Symbolic in architecture, the Classical in sculpture, and the Romantic in painting, music and poetry.

Logically enough, given his premises, Hegel starts his account of the Symbolic age and the art form that it produces with a description of the stage of human beings' mental development to which it gives expression. At this early stage people have come to realise that there is a power inherent in nature. Objects in the world are perceived as meaningful beyond their immediate usefulness, but what this meaning is remains, as yet, obscure to the human mind. The mind has an unclear sense of the Idea and its relation to the material world.

Hegel divides the Symbolic stage into three sub-stages. First, is Unconscious Symbolism, to be found in the very earliest Oriental religions like Zoroastrianism. Here objects are fashioned by human beings in mere imitation of existing entities, like the sun, stars, fire, animals, and so on. Symbolic meaning is found in objects but there is, as yet, no sense of the difference between a spiritual idea and a material body. Gradually, however, a sense of the distinctness between symbol and thing symbolised emerges. During this period, which Hegel calls the age of Fantastic Symbolism, people take arbitrarily-chosen existing objects and endow them with symbolic significance. A clear example, according to Hegel, is the Hindu art of ancient India. For Hindus, the most important abstract entity, the one which encapsulated their notion of divinity, was the god Brahma. But Brahma was conceived in such an abstract way in their religion that his realisation in the world was difficult to express. As a result, Hindu artists, lacking a symbolic form which would encapsulate the essence of Brahma, came up with highly fanciful creations (for example, creatures with many heads and arms), in an attempt to create an object that would serve as a vehicle for conveying something other than itself as its meaning.

Unconscious and Fantastic Symbolism are, however, in Hegel's view, preliminary stages in the progress towards a more highly developed Real or Genuine Symbolism. This stage is reached when human beings become capable of finding appropriate symbols for a now more clearly defined concept of divinity. At this stage divinity, which is for Hegel a form of the Absolute Idea, becomes characterised by qualities of permanence and power, and is seen as exercising complete control of the processes of living

and dying. The best articulation of this understanding of the absolute is in architecture, which evolved to represent the divine properties of permanence and power, going beyond its function of providing space for human beings to live and die in. Architecture reached a highpoint in ancient Egypt, where its religious symbolism was more important than its practical purpose.

The process is epitomised, according to Hegel, in the figure of the sphinx (Figure 1). The sphinx, with its lower animal parts out of which a human body struggles to emerge, represents the stage that the human mind had reached at this time: 'Out of the dull strength and power of the animal the human spirit tries to push itself forward, without coming to a perfect portrayal of its own freedom and animated shape, because it must still remain confused and associated with what is other than itself' (Hegel, 1975, vol. 1, p. 361). Likewise, the Egyptian pyramids' massive and impenetrable shells indicate that they contain an 'inner meaning separated from pure nature' (Hegel, 1975, vol. 1, p. 356). The human mind has found symbols to express its sense of the Idea as distinct from the natural world, yet it has not fully managed to understand the Idea or to express it in physical reality. The forbidding physical reality of the pyramids stands as a witness to their abstract spiritual dimension.

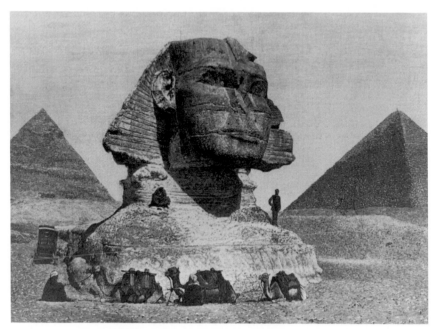

1 Anon., *Sphinx and the Pyramids of Giza near Kairo*, steel engraving after a photograph, from *Leipziger Illustrierte Zeitung*, January 1889, p. 35

Hegel was fortunate that, in the wake of Napoleon's campaign into Egypt in 1798–99, many archaeological discoveries were made available to him through such richly illustrated books as D. V. Baron Denon, *Voyage dans la basse et la haute Égypte* (1802) and the nine volumes of *Déscription de L'Égypte* (1809–22). He also consulted several of the travel accounts which had just appeared, and knew at first hand the Egyptian collection at the castle Montbijou near Berlin.

The pyramids were important to Hegel for a further reason: he thought they signified a point of transition from buildings whose character is determined by their religious significance to structures created on a mathematical plan. The exterior and interior construction of the pyramids show a conscious calculation designed to accommodate the tremendous pressure exerted by their massive structures and to permit the construction of the labyrinthine corridors and passages inside. Their technical achievement pointed the way forward to the construction of strong and useful buildings and the utilitarian aspect of architecture from here now outweighs architecture's symbolic meaning. At this point architecture starts to lose its central role in the expression of the Absolute Idea. But this does not mean that architecture has lost its power of expression altogether. Proportion, symmetry and aesthetic effect are still important in ancient Greek architecture, but the Absolute Idea has now found a higher expression in another art form: sculpture, a form of art that developed originally within the sphere of architecture. Although sculpture becomes the form that expresses the Absolute Idea, Hegel does not suggest that architecture stops developing. Indeed, for him architecture reached its highest level of symbolic expressiveness in such buildings as the Gothic cathedrals of Chartres and Amiens in the twelfth and thirteenth centuries. Here, says Hegel, mind has overcome matter, as can be seen in the great interior spaces whose vertical emphases and huge, thin sheets of glass create the impression of a spiritual dimension beyond the material world. The Gothic cathedrals, however, also show the limitations of architecture as an expression of the Idea, because the latter is still essentially articulated only in its material aspect, rather than depicted in its spiritual dimensions.

After Egyptian architecture, the next step in the development of art in its path towards an ever-increasing awareness of the spiritual was ancient Greek sculpture. For Hegel art has now entered the classical age, and in sculpture, the spirit begins to understand itself in a bodily form, that is, the mind is able to penetrate physical matter. Hegel's discussion of ancient Greek sculpture (which he got to know through the collection of plaster casts at Montbijou) is largely indebted to Winckelmann. Like Winckelmann, what Hegel valued above all in Greek sculpture was the balance and

harmony of its depictions of the human figure. He singled out for par-
ticular praise a work which was unknown to Winckelmann, and which he
himself could only have known from reproductions: the figure of *Illissus*, a
river god from the west pediment of the Parthenon frieze (Figure 2). This
was one of the sculptures taken and shipped to Britain by Lord Elgin; it
has been on show in the British museum as part of the 'Elgin Marbles'
since 1816. What Hegel saw in this fragmentary figure was an 'expression
of independence, of self-repose . . . and . . . free vivacity, by the way in
which the natural material is permeated and conquered by the spirit and
in which the artist has softened the marble, animated it, and given it a soul'
(Hegel, 1975, vol. 2, p. 724). *Illissus*, according to Hegel, was one of the most
beautiful objects to have come down to us from antiquity.

 In contrast to Winckelmann, however, Hegel did not believe that the
high quality of ancient Greek art was to be explained by its having attained
a timeless aesthetic ideal. Rather, it embodied a stage in the development
of the Idea in which spirituality could express itself through the finite
physical form of the human body. Greek culture saw the gods as having
human traits, so artists' subject matter was the way in which human exis-
tence could come to be imbued with divine spirit, or Idea. The human
form, for Hegel, is the only material body capable of capturing the expres-
sion of the spirit. In the human figure, poised yet mobile, spirit had found
a way to permeate matter completely and adequately. Hegel discusses a
number of the specific characteristics of Greek sculptures, such as their
facial features. He believed that the artists carefully studied such features
in real life but modified them in order to present a perfected and rational

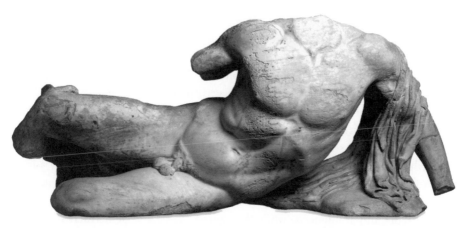

2 Image of the River-God (Illissus) from the west pediment of the Parthenon, The
Acropolis, Athens, Greece, *c*.438–432 BC, marble, British Museum, London

understanding of the human form in their works of art. Yet this idealisation did not come at the expense of the expression of individuality: all the Greek gods had their own characteristics, identified through subtle moulding of their features, specific hair styles and, in some cases, particular attributes.

Eventually, however, a tension appeared between the demands of individuality and the gods' unlimited, superhuman character. According to Hegel, the personality of the gods, as superhuman, exceeds the finite receptacle of the human body, however perfectly that might be rendered. The bodily form which expresses the divine becomes a limitation, and prevents the further development of the Absolute Idea. Hence, sculpture, being tied to the corporeal form, loses its privileged role as an expression of the Idea. Initially, this shows in the way that Greek sculpture starts to abandon the balance between universality and individuality in favour of the dynamic display of action, thus rendering its sculptures increasingly particular and human. Hegel already sees the beginning of this decline in the famous *Apollo Belvedere*, a work which for Winckelmann and others stood as the supreme achievement of the aesthetic ideal. It is, however, in the Laocoön group, made in about AD 50 (Figure 3), that artists' concern for humanity rather than divinity makes itself most clearly apparent in Hegel's view:

> the artificiality of the arrangement, the mathematical character of the pose, and the manner of its execution . . . aims at outstripping simple beauty and life by a deliberate display of its knowledge of the build and musculature of the human body, and tries to please by an all too subtle delicacy in its workmanship. The step from innocence and greatness of art to mannerism has here already been taken. (Hegel, 1975, vol. 2, p. 769).

There follows the realism of Roman sculpture with its particular skill in portraiture. Roman sculpture is no longer a privileged vehicle in the progress of the spirit or Idea, however. The new spiritual concepts of Christianity, the next step in the Idea's evolution, had to find other art forms, for sculpture – even Michelangelo's – was, in Hegel's view, concerned with external embodiment rather than those inner qualities of thought and feeling that are the central preoccupation of the Christian age.

At each stage in Hegel's account of art's development the artists whom he valued most highly were described as giving expression to a form of experience that was unique to their time. During the symbolic age this experience was not clearly perceived, so its artistic expression remained obscure and ambiguous, while during the classical stage it reached a height of physical clarity in the subject matter of the human form. It is important to realise that Hegel does not conceive of this as a failure on the part of

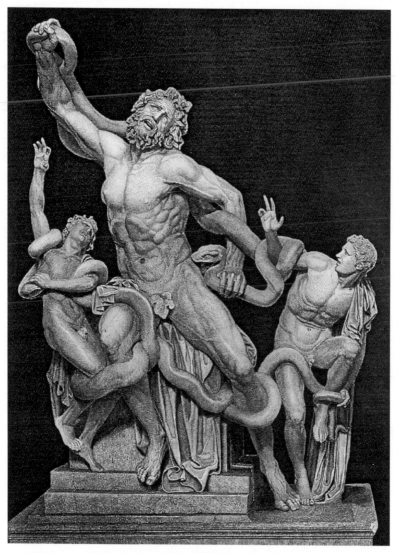

3 A. Krause, *Laokoon*, engraving, from Christian Oeser, *Briefe an eine Jungfrau über die Hauptgegenstände der Aesthetik: Ein Weihegeschenk für Frauen und Jungfrauen*, 19th edition, Leipzig: Friedrich Brandstetter, 1876, p. 161

Egyptian artists to realise more harmonious and adequate art forms. On the contrary, they were supremely able to express the highest beliefs of their age. It is the change in these beliefs themselves which requires new forms of expression. Experience of the world and intellectual enquiry into the nature of the Absolute Idea is gradual and progressive. The Greek ideal of self-containment, harmony and rational order had been adequate until the

moment that it came into conflict with the realisation that there were irrational and emotional elements in human nature. For Hegel, Christianity brings a new synthesis between these two opposing forces. Christian belief was based on the insight that the divine is to be found in the inner world of the human soul rather than located in external entities populating Mount Olympus. From now on, human self-examination becomes the most important source of information about the nature of God and the Absolute Idea. Thus artistic endeavour moves away from the task of finding the perfect external expression of the Idea in the human body towards the exploration of human beings' intellectual and emotional inner lives. Christianity prevents this new concern from becoming merely subjective because it maintains that God (and, thus, the universal) is present in every individual. With Christ, God has become human, and the events of His history incorporate profound human emotions, above all love and suffering.

The Romantic age epitomises this ideal of art as concerned with inwardness. According to Hegel, 'the Absolute is manifest as a living, actual, and therefore human subject, just as the human and finite subject in virtue of his being spiritual, makes the absolute substance and truth, the Spirit of God, living and actual in himself' (Hegel, 1975, vol. 2, p. 793).

In contrast to the Classical age, this new way of manifesting the Absolute can no longer be expressed as the indissoluble unity of spirit and physical body. It requires a form which can express the spirituality of a kind of experience which discovers the nature of God in the inner mental and emotional life of human beings. In Hegel's view, the art forms most capable of giving expression to this experience were painting, music and poetry (the latter two more so than the former, although it is painting that concerns us here). Painting is particularly significant for the way in which it reduces the three-dimensional world to a two-dimensional surface and thus, he argues, asserts inwardness by deliberately withdrawing from the external world. Moreover, while sculpture is largely 'unconcerned about the spectator who can place himself wherever he likes . . . in painting the content is subjectivity, more precisely the inner life inwardly particularised'. For this reason painting clearly marks itself out 'as existing not independently on its own account but for subjective apprehension, for the spectator' (Hegel, 1975, vol. 2, p. 806). As in his discussion of earlier artistic epochs, the particular techniques and materials used in the production of art are important to Hegel. In his view, painting's means of depiction – line, light and shadow, and colour – supports his contention that painting represents an abstraction from the material world that is important in the development of the Idea towards increasing awareness of its independence from sensuous material. Line in painting reduces three-dimensional bodies

to two, while light and shadow as they appear in painting do not 'exist as this abstraction in nature' (Hegel, 1975, vol. 2, p. 809). Most importantly, painting's use of colour makes it capable of arousing subjective emotions which evoke the spectator's inner life in a way that sculpture cannot. Hegel was heavily influenced on this point by Goethe's *Theory of Colours* (1810), a work which laid the foundation for the investigation of subjective and emotional responses to colour. Like Goethe, Hegel believed that a universal harmony of colour existed to place limits on the tendency for individual expression to become excessively particular.

Such aspects of the art of the Romantic age were, however, secondary to the subject matter it expressed. The formal characteristics of art merely furnish the vehicle for the most adequate physical embodiment of the concepts and belief systems of the age. Thus it is the religious concepts of Christianity that are the most important feature of Romantic painting. Hegel is aware of the fact that ancient cultures, from the Chinese to the Romans, had produced excellent paintings, but in his view neither their understanding of natural objects nor their vision of human or divine affairs 'was of such a kind as to make possible in painting the expression of such a depth of spirituality as was presented in Christian painting' (Hegel, 1975, vol. 2, p. 801). The artists of the Romantic age had the advantage over their predecessors that religion had progressed to a point at which it was capable of providing them with a source of inspiration that was at once both concrete and wide-ranging enough to produce great art. The highest Idea of the age is articulated in the stories of the Bible and the life of Christ, in particular: the reconciliation of individual human emotional and mental life with God. This development first made itself felt in Byzantine art which, although still displaying the stiffness and lifelessness of Greek painting, started to show a new awareness of emotions. But the real beginning of Romantic art came with Cimabue in Florence and Duccio in Siena at the end of the thirteenth century. It was Giotto, according to Hegel, who first went beyond the 'mainly mechanical type [of art] propagated by the Byzantines' (Hegel, 1975, vol. 2, p. 875) through a deeper understanding of the natural world and of human emotions in the depiction of religious scenes. The 'progressive incorporation of the religious material into the living forms of the human figure and the soulful expression of human traits' (Hegel, 1975, vol. 2, p. 878) continued in the fifteenth century with Masaccio and Fra Angelico.

For Hegel, painting reached a peak of expressiveness in the art of Leonardo da Vinci, Raphael, Correggio and Titian. While their predecessors only aimed at depicting religious subjects with humanity, these artists brought the religious spirit into contact with the full range of life in the

material world. Just as their contemporaries elsewhere in society were expe-
riencing a new self-reliance and extension of their realm of power 'with
their industriousness, their trade and commerce, their freedom, their manly
courage and patriotism, their well-being in enjoying life in the present'
(Hegel, 1975, vol. 2, p. 879), so the artists of the Renaissance extended their
subject matter to include landscape backgrounds, views of cities, the sur-
roundings of churches and palaces, contemporary portraits of people and
domestic and civil life. Yet, this expansion of subject matter was not at the
expense of religious feeling, Hegel argued. On the contrary, what made the
painters of the sixteenth century the apogee of Romantic art, was the fact
that they achieved a perfect fusion between the breadth of human beings'
lived experience and inner spirituality:

> For it was now a matter of harmonizing soulful depth of feeling, the seri-
> ousness and profundity of religion, with that sense of liveliness of the
> physical and spiritual presence of characters and forms, so that the physical
> figure in its posture, movement, and colouring should not remain merely an
> external scaffolding but become itself full of soul and life and, thanks to
> the perfect expression of all the parts, appear at the same time beautiful
> alike physically and spiritually. (Hegel, 1975, vol. 2, p. 880)

Hegel singles out Leonardo da Vinci and Raphael in this regard. In
the *Transfiguration* of 1517–20 (in the Vatican Museum in Rome) Raphael
depicts Christ as going beyond his immediate existence as an individual
being by creating a sharp separation between the earthly and the divine
realms to which Christ now returns. Yet, according to Hegel, it is more
favourable to the aims of religious art to concentrate on those religious
situations which show Christ at His most human, either at the moment of
His greatest suffering, in the story of the Passion, or in his childhood when
he does not yet appear as perfect. Raphael's *Sistine Madonna* (Figure 4), a
painting which Hegel knew well from his visits to the museum in Dresden,
is unequalled in this respect. It shows Christ in purely childlike innocence,
yet also 'gives us an inkling of the expansion of this Divinity into an infi-
nite revelation' (Hegel, 1975, vol. 2, p. 823). The picture shows the highest
form of the presence of divinity in humanity: love. Love is shown in perfect
form, as an emotion in which one finds oneself by totally sacrificing oneself
for another being, expressed here in the profound tenderness of the
Madonna towards her child. In love, maintains Hegel, we are filled with
compassion for and understanding of another. It is an emotion that leads
us to fulfil our own potentialities simply in order to satisfy the other, just
as the Madonna becomes saintly by virtue of fulfilling her role as the
mother of Christ. Raphael, he notes, repeats this subject in a variety of

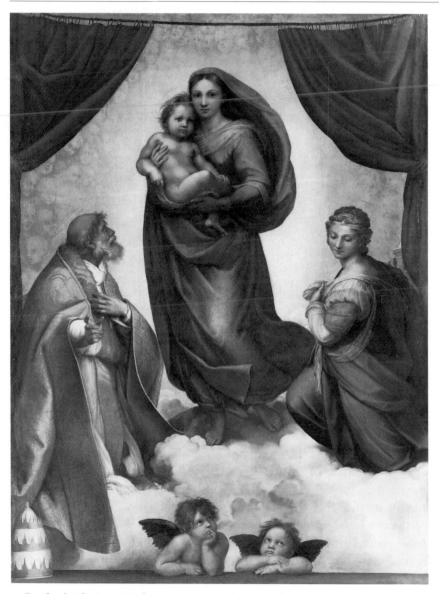

4 Raphael, *The Sistine Madonna*, *c*.1513–14, oil on panel, 269.5 × 201 cm, Staatliche Kunstsammlungen, Dresden

forms and contexts, thereby showing this most profound of human emotions across the full range of human life.

Hegel's admiration for Italian artists of the High Renaissance was relatively conventional for his time. Although he knew of the high esteem in which the brothers Boisserée held early German and Flemish art, and was acquainted with their collection, he did not share their enthusiasm. For

Hegel, German and Flemish painters simply did not attain the level of spirituality expressed by the Italian masters. While Jan van Eyck and Albrecht Dürer achieved a certain harmony between the soul and its external mode of expression, later German and Dutch artists increasingly concentrated on human beings' inner natures and external forms in a way that was without religious significance, he believed. Of course, painting during medieval times and the Renaissance was not exclusively concerned with religious subjects, but even when it took secular themes as its subject matter, it managed at its best – in Titian's portraits, for example – to 'give us a conception of spiritual vitality unlike what a face actually confronting us gives' (Hegel, 1975, vol. 2, p. 866).

Romantic painting declines when art begins to interest itself exclusively with secular matters, as in the German and Dutch schools. Profound ideas are abandoned for everyday concerns and artists lose their importance as articulators of the highest Idea. Hegel was scathing about the art of his own time. He felt it lacked true spiritual necessity and so appeared 'without any imagination of situations, motives, or expression' (Hegel, 1975, vol. 2, p. 857). Having lost the religious feeling of the High Renaissance, however, it is not open to the contemporary artist simply to attempt to revive the old religious subject matter and forms of expression. The artist is the child of his time and 'the past cannot be recalled to life' (Hegel, 1975, vol. 2, p. 815). Since art no longer has a serious subject, it has run its course and it is now the role of philosophy to articulate the Absolute Idea. Art was important at different historical stages for the way it allowed the Absolute Idea to realise itself in the material world. At the Symbolic stage, this awareness remained obscure since the material world was insufficiently mastered by the mind. In the Classical stage, mind found a perfect expression of itself in the physical form of the human body, but, with the arrival of the Romantic stage, painting pointed beyond the material world towards pure spirituality. Thus, art displays increasing inwardness as mind becomes more and more aware of itself. In modern times, the human mind does not need the articulation of the Idea in sensuous form any longer; the Idea has become fully aware of itself and is now best expressed in the purely mental constructs of philosophy. This was Hegel's answer to the hermeneutic problem. The different stages asserted that art was always specific to its historical context, but the universal process of the Absolute Idea tied them together and to the present. It provided both an explanation of why art changes, and how the art of the past can be interpreted from another historical vantage point.

Hegel's contention that art has come to an end has become famous. Yet, this does not mean that Hegel believes that no art should or could be

produced in modern times. In fact, all he says is that, although we 'may well hope that art will always rise higher and come to perfection,' art 'has ceased to be the supreme need of the spirit' (Hegel, 1975, vol. 1, p. 103). On one interpretation this might mean that at some unknown future point art might become important again. On another, art's liberation from the task of articulating the highest forms of consciousness allows it to address neglected aspects of life which might otherwise be forgotten. Either way, Hegel's *Aesthetics* is not the funeral oration for art that it has sometimes been thought to be.

Critical appraisal

Hegel's lectures on aesthetics are important for the two questions about art's history it raises: (1) What makes art historically and socially specific? (2) What motivates changes in art over time? These are fundamental questions art history still attempts to answer. Yet Hegel's own solutions were unacceptable to the majority of art historians during his own lifetime and have remained so ever since.

The first objection came from those more empirically-oriented scholars whom we encounter in Chapter 4. As we have seen, Hegel assumes that art's evolution through its various stages is ultimately caused by a meta-physical force, the Absolute Idea. For many art historians this is problem-atic on three counts. First, it is unverifiable. The Idea is supposed to necessitate the development of art in the way that Hegel describes, but we have no way of proving or disproving the Idea's own existence. Second, people have argued that Hegel's belief in a single metaphysical driving force leads him to give an excessively generalised account of art which does not do justice to the particularities of artworks, especially not to their unique formal characteristics.

This objection was raised during Hegel's time and formed the core of a competing approach that underlay much of art history as it developed in the nineteenth and twentieth centuries, as we see in Chapter 4. Hegel's contemporary, Karl Friedrich von Rumohr (on whose history of Italian Renaissance art Hegel relied heavily) argued that the significance of art lay in its unique ability to articulate visual knowledge as opposed to abstract conceptual understanding. This knowledge, far from having only one expression, was as manifold in any one period as there were manifold indi-viduals. What gives art its characteristic forms in each age is that such individuals worked within a precise set of technical and social constraints – for instance, the artistic materials at their disposal, contemporary commercial practices and the requirements of patrons. While this line of

objection to Hegel may lead to art-historical narratives which are more attuned to the particular characteristics, and historical contingencies which contribute to the production of individual works of art, it is less able to give a bird's-eye view of why art changes over time. As Chapter 4 makes clear, however, those who followed this approach did provide an answer to this question – one which differed significantly from Hegel's conception.

The privilege that Hegel gives to thought and subject matter over form in his account of the development of art was to become the focus of criticism of his art history. Hegel's main nineteenth-century disciple, Karl Schnaase, tried to modify this aspect of Hegel's theory. He describes the transformation of ancient architecture into medieval Christian church building, for example, as part of a developing argument between earlier and later forms. At some historical moments, Schnaase suggests, it is art's autonomous development that contributes to human beings' spiritual progress; at others, it is religion. While Schnaase retained Hegel's assumption of spirit as the driving force behind historical development, later authors interested in charting the history of art as a series of changes in formal expressions found a way of doing without recourse to a metaphysical cause. As we see in Chapter 5, on formalism, such authors followed one of Hegel's rivals, Johann Friedrich Herbart. Herbart rejected Hegel's view that the importance of art lies in the way it articulates religious or philosophical ideas. Instead, he argued that the search for the meaning of a work of art is superfluous. Each work consists, in essence, of a unique set of formal relations: lines, tones, planes, colours and so on. In Alois Riegl's and Heinrich Wölfflin's art histories, transformations in the formal characteristics of art replaced Hegel's emphasis on changing intellectual content. Changes in art are explained as a result of changes in people's perception.

A third fundamental criticism which applies not only to Hegel but to other nineteenth-century art historians as well arose in the twentieth century: such theories did not adequately link artistic expression with social conditions prevailing at the time. For art historians influenced by Karl Marx's critique of ideology and the capitalist economy (see Chapter 7), art plays an active part in maintaining the unequal distribution of power and wealth in societies and it is these that need to be considered when discussing art. What changed art was not innovations by individuals, different modes of perception, or the power of Hegel's metaphysical spirit, but the concrete redistribution of wealth and power in the economic sphere. For Marx there was a clear historical pattern in which changes in the economic base of societies unfolded and hence Marxist art historians were able to retain Hegel's ambition of giving a developmental account of art without accepting his metaphysical presuppositions.

Others have become sceptical whether such a developmental account was either possible or desirable (see Chapters 7 and 11) in the first place. Hegel's attempt to answer the two fundamental questions of what makes art historically specific and what motivates changes in art, has come to be criticised as misguided altogether. According to this position, Hegel's account set the agenda for an art history that claimed to have privileged insight into history, leading to a narrative which in some magical way is supposed to reflect the immanent logic of art's development. The consequence of abandoning such claims to objectivity is that 'historians can make no claim as to whether or not their narratives intersect with anything beyond themselves' (Moxey, 1998, p. 27). Hence Hegel's fundamental questions for art history are best abandoned, the argument goes, in favour of an honest acknowledgement of the fact that the writer's own account plays a contemporary, not timeless, role.

Bibliography

Gombrich, Ernst H., *In Search of Cultural History* (Oxford: Clarendon Press, 1969). A succinct and lucid account of Hegel's influence on subsequent art historians, although Gombrich's tendency to see every subsequent art historian as a Hegelian is rather sweeping.

Hegel, Georg Wilhelm Friedrich, *Aesthetics: Lectures on Fine Art*, trans. T. M. Knox, 2 vols (Oxford: Clarendon Press, 1975). The most recent English translation of Hegel's philosophy of art. It was first published posthumously in Germany in 1835–38 on the basis of lecture notes made by students.

Moxey, Keith, 'Art History's Hegelian Unconscious', in Mark A. Cheetham, Michael Ann Holly, Keith Moxey (eds), *The Subjects of Art History* (Cambridge: Cambridge University Press, 1998) pp. 25–51. A contemporary critique of Hegel's art history.

Podro, Michael, *The Critical Historians of Art* (New Haven and London: Yale University Press, 1982) pp. 17–30. The most intelligent discussion of Hegel's and his disciples' contribution to art history in English.

Potts, Alex, *Flesh and the Ideal: Winckelmann and the Origins of Art History* (New Haven and London: Yale University Press, 1994). The best discussion of Winckelmann, Herder and their time in English.

Vasari, Giorgio, *The Lives of the Artists*, trans. George Bull, 2 vols (Harmondsworth: Penguin Books, 1987). Often called the first art historian. Proposes a cyclical account of art's rise and decline towards and from an ideal height.

Winckelmann, Johann Joachim, *The History of Ancient Art*, trans. G. Henry Lodge (Boston: J. R. Osgood, 1880). Discusses ancient art as the result of the particular society which gave rise of it.

Nowadays 'connoisseurship' is taken to refer to an approach
that is diametrically opposed to Hegelianism. When people think of
connoisseurs they think of men and women of independent means pursu-
ing the minute empirical study of artworks in order to pronounce on
authorship and distinguish original work from fakes. Untroubled by the
fundamental theoretical problems of art history, connoisseurs do not ask,
the preconception goes, how art is linked to the cultures in which it is
produced or how one can best explain art's transformations through time.
Instead they carry out their detective work for its own sake – or, less
benignly, for the returns firm attributions can bring in the marketplace.
This image is largely due to connoisseurship's most famous practitioner of
the twentieth century, the American Bernard Berenson, and to the rhetoric
of his nineteenth-century Italian predecessor, Giovanni Morelli. In an
article published in 1927, Berenson writes: 'I, for one, love the sport. Only
one must enjoy it for no utilitarian or pretentious reason, but for its own
sake and because it exercises eyes, mind, and judgement' (Berenson, 'Nine
Pictures', 1927 p. 1).

Berenson was being disingenuous here; working for art dealers such
as Joseph Duveen, he earned vast sums of money from his attributions.
What is more, Colin Simpson has shown that Berenson often operated less
than completely honestly, making attributions for his dealers that went
against his better judgement. All the connoisseurs to be discussed in this
chapter were heavily involved in the growing art market of the nineteenth
century, although not all gained personally in the way that Berenson did.
More often than not, nineteenth-century connoisseurs were employed by
art galleries and their skilful negotiation of the marketplace benefited the
public collections over which they presided.

Passing judgement on authenticity and authorship is the core activity
of a connoisseur but, as Berenson's article makes clear, what precedes this
judgement is work of varied kinds: the close observation of size, condition,
medium and technique, as well as substantial knowledge of contemporary
customs, fashions and literary sources, which might influence the depiction
of the subject matter. Most importantly, however, it is the close and
repeated observation of the formal traits of works that will, in the practice
of a connoisseur, lead to the capacity to distinguish the hand of an author

and to tell originals from copies. Visual appearance rather than the work of art's meaning was the primary concern of most of the early connoisseurs.

Although the authors discussed in this chapter worked in the nineteenth and early twentieth centuries, connoisseurship was not a nineteenth-century invention. The practice of picking out the formal characteristics of works of art can be traced back to Vasari, and the Sienese physician Giulio Mancini, in the sixteenth century. The term 'connoisseurship' came into wide use in the seventeenth. During the eighteenth century many caricatures were published, which derided connoisseurs, and their claim to refined and elevated judgement was satirised by showing them in lecherous and sensually indulgent poses in front of pictures. This image of the connoisseur still lingers today, but this bears little relation to those who developed connoisseurship as an art-historical method. We must make it clear at the outset that connoisseurship is not to be confused with a notion of art as a realm of uninflected visual pleasure. Connoisseurship constituted an attempt to conduct art history empirically, emulating procedures from disciplines such as history and science. Certain historical data, such as names, dates, the details of who studied under whom, who lived where and so on, were used in making attributions prior to the nineteenth century, but they were subordinated to judgements of aesthetic quality. For the nineteenth-century connoisseurs, however, objectively verifiable facts became paramount. Attribution based on stylistic analysis became the basis for the writing of art's history. In their endeavour to capture the specific and particular in art and their sometimes vicious arguments over which are the best empirically verifiable ways to establish this, connoisseurs contributed greatly to the development of methods in art history. In fact, it was the connoisseurs' endeavour to base their method on empirically verifiable procedures that established art history as an academically recognised discipline in the second half of the nineteenth century. In this chapter we look at Karl Friedrich von Rumohr and his attempt to apply the historical method of source criticism to works of art; Giovanni Morelli who pioneered an inductive procedure modelled on scientific methods; and Bernard Berenson who incorporated iconographical research into the practice of the connoisseur.

This empirical turn given to art history by the connoisseurs was symptomatic of the broader intellectual culture of the late nineteenth century. The idealist and speculative dimension of Hegel's philosophy was to become highly suspect to German academics both in the sciences and the arts after the failed bourgeois revolution of 1848. What is now called the positivistic method dominated the academy in the second half of the

nineteenth century. With its reliance on the description of verifiable obser-
vations, the rise of positivism was, among other things, a reaction to a loss
of political power on the part of the bourgeoisie. Given the limited pos-
sibility for direct political participation, the bourgeoisie staked a claim to
influence in domains with pragmatic value, such as science, education,
learning and culture. The German-speaking countries remained the place
where art history developed most vigorously and was most fiercely debated
until the early twentieth century.

Nevertheless, as this chapter shows, a set of beliefs lay behind the
conceptions of art history promoted by the connoisseurs, which were just
as speculative, if less obviously so, than the progression of Hegel's univer-
sal spirit. They, no less than Hegel, had a metaphysics of value, in their
case one centred around the concepts of individuality and particularity. It
is only when individual artists are at their most particular that they achieve
their highest worth and at the same time give fullest expression to what is
most distinctive in the culture of the time. In other words, the greater the
individuality the more exemplary of its culture it becomes. In the end, the
connoisseurs discussed here held that it is the emergence of such great
artists that causes cultures to progress. While such underlying beliefs were
made more explicit in early nineteenth-century writings than later, they
remain, even if not fully acknowledged, important assumptions behind
connoisseurship, as well as its close relative, artistic biography.

Style, manner and artistic character: Karl Friedrich von Rumohr

Karl Friedrich von Rumohr (1785–1843) is a significant figure for our
account because he is both the initiator of a new way of thinking about
art as well as a representative of an old tradition. When he was nineteen
years old, Rumohr, the son of an aristocrat, inherited his family's substan-
tial landholdings outside Lübeck and this allowed him to lead the life of
an independent scholar, rather than being forced to gain his income through
writing or teaching. It allowed him to spend a substantial amount of time
in Italy and to write books on subjects as diverse as the art of cookery, law
and etiquette, as well as to edit a series of Italian Renaissance novellas. He
was, in short, the perfect man of leisure, later to be identified as the ideal
connoisseur in the writings of Morelli and Berenson. Yet he undertook his
attributional work not as an end in itself but as part of a search for a
systematic art-historical programme – one which started from particular
works of art, in contrast to Hegel's interest in the universal spiritual char-
acteristics of art in any period.

The three volumes of Rumohr's research into the Italian Renaissance,
Italian Studies (*Italienische Forschungen*) (1827–31), marked a new beginning in

art history. As a pioneer, he raised the question of his own methods and their relation to those of his predecessors. The first volume opens with two lengthy chapters on such issues. Here Rumohr describes his differences with Hegelian aesthetics and sets out to clarify the terminology used by connoisseurs. His discussion hinges around three important notions which are central to connoisseurship: manner/style, artistic character, and the metaphysics of individuality.

Let us take first his discussion of the key words **manner** and **style**. Rumohr notes that these have been used interchangeably by previous connoisseurs to denote an artist's characteristic handling of forms and colours as well as mere technical dexterity. In this sense both terms continued (and still continue) to be used in connoisseurship. Rumohr, however, wishes them to be clearly distinguished, and although his own definitions would not be accepted by later writers, the act of doing so introduced a way of thinking about art and its historical character which would have lasting consequences. For Rumohr, only the word 'manner' should be used in referring to the individual way in which an artist handles form. The word 'style' means something different: Rumohr's definition does not signify the characteristic formal expressions of a society, age or period. This use of the term, now widespread, as when we identify an age by its style (for example, the Baroque), was only introduced in the late nineteenth century by those art historians who are discussed in Chapter 5. Nor is Rumohr's definition the same as Winckelmann's, for whom style connotes moral values. For Rumohr style is the realisation of an artist's unique visual intuition. According to Rumohr artists realise their particular insights within the constraints of historically given material, such as painting on panel or canvas, or the demands of different patrons such as the Church or wealthy bankers. It is in this spirit that he defines style as 'a submission, grown into habit, to the intrinsic demands of the material' (Rumohr, 1827–31, vol. 1, p. 87). So artists are able to express their individuality precisely because they work within constraints imposed by techniques and purpose. As he remarks in a footnote, his use of 'style' corresponds to the term's most ancient use in the art of rhetoric, wherein a speaker chooses, for example, a high or low style of speech according to the demands of the occasion. Manner, then, is purely subjective. It refers only to the idiosyncrasies of a particular artist. Style, in contrast, unites the subjective and the objective, in that individual artists with a style express not only themselves, but also the historical age in which they work. Artists who can submit to the requirements of the material, therefore, have a greater universal significance.

Rumohr sets out to establish distinct **artistic characters**, as a kind of formal portfolio for the artists he discusses. In trying to capture in words the formal particularities of an individual, his or her character, and to cor-

roborate this with archival documentation on the individual concerned, Rumohr introduced another important strategy in connoisseurship, what Berenson would later call the building up of an **artistic personality**. There is a century of difference, however, between Rumohr's and Berenson's employment of such artistic profiles. For Berenson, artistic personality was conceived in distinctly twentieth-century psychological terms: artistic forms were an expression of the psychology of an individual. Rumohr, on the other hand, valued artistic individuality in as much as geniuses, in his view, had the capacity to give a unique expression to the manifold ways in which the universal laws of unity and harmony could be realised. This becomes clear in his discussion of Rembrandt, who for Rumohr does not have a style. He is merely an idiosyncratic painter with his own way of handling paint, a manner which does not rise to express these universal laws. Here we can see Rumohr for the transitional figure that he is. On the one hand, he goes a long way towards introducing the appreciation of particularity into art history, on the other, he still holds on to classical notions of unity and harmony, which place the work of Raphael at the pinnacle of achievement and exclude Rembrandt entirely.

Although this might sound like Winckelmann's celebration of ideal form, an examination of Rumohr's work shows the characteristic way in which nineteenth-century art history parted company with both Winckelmann's classicism and Hegel's intellectual approach. Rumohr spends much time in the first volume of the *Italienische Forschungen* making his opposition to both these approaches clear on the grounds of a third notion that underpins his version of the method of connoisseurship, the **metaphysics of individuality**. What Rumohr – like many of his Romantic contemporaries – values in art is the expression of individual unity that comes from the unique conjunction of subjective and objective forces. This means that Rumohr values artists like Raphael because they produce distinctive works which, nonetheless, are characteristic of their age.

For Rumohr style is always about harmony and unity of artistic form no matter what historical figure one is looking at. This puts him in opposition to Hegel's more historical aesthetic in which artistic forms express different values at different times. Although Hegel's *Aesthetics* had not been published when Rumohr's *Italian Studies* appeared, Rumohr was clearly acquainted with Hegel's ideas. During the period when Hegel was giving the lectures on which the *Aesthetics* was based, Rumohr was an adviser to the new Berlin Art Gallery, and his protégé, Gustav Friedrich Waagen, who was the gallery's first director, had attended Hegel's lectures on aesthetics in Heidelberg. For Rumohr, Hegel's history of art was far too unspecific to be of help in displaying the Italian paintings in the Berlin collection in a

historically appropriate manner. Against Hegel's picture of an essentially uniform spirit, the Absolute Idea, finding progressive expression in specific material forms, Rumohr sets the characteristics of individual artists' expression within the material and social constraints prevailing at the time. Moreover, he states: 'the visual arts are a specifically visual form of comprehension and representation which is in opposition to understanding based on concepts' (Rumohr, 1827–31, vol. 1, p. 8). Rumohr here picks up a distinction, introduced by the eighteenth-century philosopher Immanuel Kant, which has come to play a central role in the way many art historians understand their practice. Kant claims that there is a difference in principle between conceptual or logical understanding and the material that is derived directly from sense perception, or, as Rumohr has it, the opposition of visual and conceptual comprehension.

For Hegel, of course, the visual arts are always expressive of conceptual understanding. There is an interesting contrast too between the ways in which Hegel and Rumohr treat the material forms through which artists articulate their vision of the world. For Hegel, artistic materials are obstacles which the mind has to overcome in the process of reaching conceptual clarity about itself. For Rumohr, in contrast, rather than a hindrance to universal expression, artistic materials are what enable that expression. They set the universal conditions which restrain the idiosyncrasies of individuals, thus producing a 'submission under general and unchangeable laws of beauty' (Rumohr, 1827–31, vol. 3, p. 18). If Hegel's art history is founded on the metaphysics of a Universal Spirit, Rumohr's art history is ultimately predicated on his belief in the metaphysical value of the individual. Visual forms are not valued for the fixed ideals they embody, but as distinctive and particular expressions of the unity and harmony achieved between individuals and the world at specific times.

Rumohr's art history

Let us now see what kind of art history this set of underlying beliefs about manner/style, artistic character and the metaphysics of individuality engendered. Given that Rumohr was concerned with the individual as expressed in stylistic forms, he had to identify a reliable corpus of texts and images from which to establish the artistic character he was after. This led to a two-pronged approach. On the one hand, he based his art history on close visual analyses of works of art; on the other, he searched archives throughout Italy for reliable documentary information on Renaissance artists. A careful discrimination between documents he judged to be either reliable or unreliable, led Rumohr to discount much of what Vasari had written in

his *Life of the Artists* as merely anecdotal. His verdict on the writings of
Ghiberti, Lanzi and Cicognara was similarly critical. Dismissing anecdote,
Rumohr used only evidence for which he found corroborating evidence in
the archive. Once he had established a core of works by an artist, either on
the basis of a signature or because it was thoroughly and reliably docu-
mented, Rumohr started to draw a stylistic profile of the artist. This
artistic character could then provide the basis for the identification for
further authentic work.

In his discussion of Giotto (Rumohr, 1827–31, vol. 2, pp. 39–75), for
example, he opposed the traditional image of this artist as pious and other-
worldly. On the basis of what Rumohr argued to be reliable documentary
evidence, he describes Giotto as shrewd, practical and worldly. He then
turns to the visual evidence; starting with signed works, he identifies the
Coronation of the Virgin in the Baroncelli Chapel in Santa Croce in Florence
as the only certain work by Giotto. From this he establishes Giotto's char-
acteristic forms, such as his depiction of eyes, noses and drapery, and then
attributes other work to Giotto to the extent that they depict these features
in the same manner. His overall verdict on Giotto, however, is characteris-
tic of his aesthetic commitments. He objects to the traditional view of
Giotto's greatness, because in his view the artist was neither the great inno-
vator he is usually made out to be, nor was he driven by spiritual devotion.
Rumohr attributes an artistic character to Giotto which centres on his
ability to introduce action and emotion in keeping with his own outgoing
approach to life. For Rumohr, however, this amounts to no more than a
characteristic peculiarity which was to dominate subsequent Florentine and
Sienese art and is best described by the word 'manner'. Italian art had to
await Raphael in order to gain a truly objective style in Rumohr's sense.

> Art works necessarily carry within them the imprint of the spirit which has
> created them; Raphael certainly could never deny the mildness of his
> outlook, the calmness and considerateness of his spirit. Yet, it is in these
> main character traits that his objectivity is grounded and this, despite the
> many dissimilarities in the appearance of his work, makes Raphael's works
> comparable to that of the ancients. (Rumohr, 1827–31, vol. 3, p. 15)

What Rumohr values in Raphael is his capacity to submit himself to the
artistic requirements of his material: the demands made by the subject
matter, and the circumstances under which it was commissioned. This
produces a diversity of forms of expression, which nonetheless show the
characteristic individuality of the artist. Raphael, in contrast to Giotto,
does not manifest 'manner' in the sense of a recognisable habit of the hand.
Instead his treatment is always dictated by the requirements of the com-

mission and the subject to be depicted. In fact, Raphael's artistic character is primarily identified by its reluctance to assert personal traits: the edges of the canvases are clean, the ground usually monochrome, the tonality light, there is a love of order and diligence, all of which are signs of the artist's endeavour to meet the requirements of his patron. Each time that Rumohr discusses a work he considers authentic he makes clear how Raphael realised his own particular form of expression at the same time as submitting to such external demands. In the *Sistine Madonna* (Figure 4, p. 35) from the picture gallery in Dresden, he is not struck by the theme of love in the way that Hegel was, but more by the unusual way in which the composition floats in the air. He rejects Vasari's account of the picture as having been commissioned for an altar in the Convent of St Sixtus in Piacenza. Instead, Rumohr uses documentary evidence to argue that it was commissioned in order to be carried in procession through the streets (Rumohr, 1827–31, vol. 3, p. 129) (However this argument is rejected by the majority of scholars today.) For him, the formal composition of the picture is best explained by the picture's function (as an object to be carried in procession) rather than its role in expressing theoretical ideas as would have been the case for Hegel. This would explain the picture's unusual composition and its being painted on canvas rather than wood, Rumohr argues: it was meant to be perceived as if floating.

Rumohr's art history is composed of individual artists finding their own particular character in ever more general forms. They are strong individuals with unified characters who propel art history forward. Their vision, however, only finds adequate realisation by working within the material and social constraints peculiar to their own time. For Rumohr, the individuality of the greatest artists becomes objectified, that is, the artist becomes representative of the social and cultural conditions of his or her own times. The individuality of the great artist does not just express his or her own character, as with Giotto, but the character of the age, as is the case with Raphael. Thus, an artist's individual expression can acquire universal validity. The decline in Renaissance art set in shortly after Raphael's death, according to Rumohr; after the second half of the fifteenth century, the perfect balance of individuality achieved in Raphael's work was disturbed. Patrons no longer restrained artists' individuality in the way that Julius II had done in the cases of Raphael and Michelangelo, and artists asserted themselves unrestrainedly in a competition for recognition.

We can see how closely related the work of the connoisseurs is to another genre of art history: biography. Those who take the biographical approach also believe that the emergence of great artists leads to artistic progress. At the end of the nineteenth century two art historians, **Carl Justi**

(1832–1912) and **Hermann Grimm** (1828–1901), established artistic biography as a distinctive genre within art history. Justi's and Grimm's conception of what makes art forms historically specific and what makes for progress in art history was very much in line with that of Rumohr and other connoisseurs. Where they differ, however, is that they represent their subjects – Velasquez in Justi's case or Raphael in Grimm's – as being in opposition to their own culture, rather than in harmony with it. We can see them as the founders of the still popular image of artists as alienated geniuses realising their greatness despite, and not because of, prevailing social constraints.

Giovanni Morelli

In the Italian **Giovanni Morelli** (1816–91) we encounter a connoisseur who saw himself in opposition not only to Hegelian art history but also to the German connoisseurs. Against the Hegelian approach, he shared the German connoisseurs' conviction that the Hegelians unduly disregarded the particular givenness of an artwork in order to construct a general account of how art forms change over time. However, for Morelli, the German connoisseurs also started from a mistaken premise; in their case an empirically unsound a priori assumption regarding the power of individuality. In attempting to show how this individuality articulated itself in specific periods, the Germans depended, so Morelli claimed, on material that was either unreliable or insignificant – for instance on external accounts of the political and social conditions under which the artist worked.

Morelli asserted that the only evidence from which a connoisseur should work was the visual forms given in the artwork itself. On this basis he proposed a method which, he claimed, was truly scientific, in as much as it operated by forming hypotheses inductively. In Morelli's view art historians had worked by making a hypothesis and then gathering evidence to support it. In order to avoid the obvious dangers of this procedure, Morelli advocated the painstaking gathering of detailed observations before any conclusion was drawn. This meant attending to even the smallest and apparently trivial details of a work. During his lifetime Morelli was derided for his focus on such details as the depiction of hands, ears and fingernails. In 1914, however, Sigmund Freud (see Chapter 9) claimed that Morelli's attention to apparently insignificant details was methodologically closely related to psychoanalysis, and Morelli's attributional procedure became famous for being based upon involuntary, or even unconscious, traces. According to this understanding of Morelli's method, artists follow convention in the more important features of a work, such as composition and

facial details, while reverting to an instinctive and individually characteristic manner in marginal elements, such as the treatment of ears and hands. Such a psychological understanding, however, represents something of a misreading of Morelli. Rather than drawing on a notion of the unconscious (a term which was already current in psychological writing in the second half of the nineteenth century before Freud popularised it), Morelli's aspiration to scientific art history led him to see what he was doing much more on the model of the palaeontologist identifying a fossil. The art historian is a taxonomist who identifies specimens by genera and species, each of which is understood as being given form by particular features of the natural environment surrounding it.

Morelli was born in Bergamo, attended school in Switzerland, and went on to study medicine at the University of Munich. He continued with his studies of physiology and comparative anatomy in Switzerland and Paris and accompanied the great palaeontologist Louis Agassiz on an expedition to a Swiss glacier. In his student days, Morelli already had a lively interest in art. He befriended the art dealer Otto Mündler, who later became the National Gallery of London's travelling agent responsible for negotiating the purchase of pictures on the continent. Morelli returned to Italy from Paris in 1840 and got to know the art collections in Rome and Florence. He also became politically engaged and participated in the revolution of 1848, which led to the unification of Italy and the expulsion of Austria from those parts of northern Italy that had previously belonged to the Austro-Hungarian Empire. Morelli entered Parliament in 1861 as a deputy for Bergamo and in 1873 was elevated to the Upper House as Senator.

During these years of political activity he, nonetheless, found time to pursue his interest in the art of his native country. As an ardent nationalist he opposed the export of artworks and helped to draw up the first Italian law to prevent this. He was friendly, however, with Charles Eastlake, the Director of the National Gallery as well as with Mündler, and played a part in making possible several purchases of Italian paintings for London. Morelli was also active in the art market as a collector in his own right. During the years following unification, concern arose over the sale of works of art from public Italian galleries and Morelli was made president of a government commission in 1861, whose task it was to make a record of all works of art in such institutions in Umbria and the Marches. His assistant was another great connoisseur, **Giovanni Battista Cavalcaselle (1819–97)**.

Cavalcaselle (with the English writer Joseph Crowe) was to publish the first comprehensive connoisseurial study of Italian paintings from the second to the sixteenth century. Morelli's and Cavalcaselle's collaboration

did not go well, however, although their work for the National Inventory was to be of crucial value to both men. There were political differences – Cavalcaselle was a Liberal while Morelli was a Royalist nationalist – and there were also significant differences in their conceptions of art history. While Cavalcaselle's connoisseurship was largely in the tradition of Rumohr and Waagen, Morelli espoused a more environmentally-oriented organic history of art. Instead of placing prime emphasis on distinguishing between individual artists, Morelli saw his first task as that of delineating the regional differences that separated the schools of the Italian Renaissance.

Morelli's natural history of art

Morelli's first publication only appeared in 1874–76 in a German art journal. It was a critical review of the ascriptions of authorship for the pictures in the Borghese collection in Rome. He followed this in 1880 with a similar critique of the attributions contained in the official catalogues of the German museum collections in Munich, Dresden and Berlin. Morelli concentrated on Italian Renaissance artists and divided his discussion of the pictures in each collection according to the regional schools of painting. For these articles he used the pseudonym Ivan Lermolieff, a near anagram of his name, and added a fictitious German translator with the name 'Johannes Schwarz', also derived from his own name ('Johannes' is the German equivalent of the Italian 'Giovanni' while 'schwarz' means black, as does the Italian word 'moro'). He continued to publish articles on Raphael under his own name. Although Morelli's identity was well known at the end of the 1880s, his criticism of the attributions in the Borghese collection and in the German museums was republished in the 1890s under the name of Ivan Lermolieff along with discussion of the Doria Pamfili galleries in Rome and a long methodological introduction. An English translation, *Italian Painters: Critical Studies of their Works*, was published under Morelli's real name in two volumes in 1892–93. Morelli was very conscious of the controversial nature of his critical discussion of attributions and his own reattributions. Many of the attributions he contested had been made by highly respected figures from the tradition of Rumohr and Waagen. Wilhelm von Bode, the head of the department of paintings at the Berlin museum, reacted predictably fiercely. Although Morelli might initially have chosen to use a pseudonym in order to protect himself, he clearly came to enjoy his fame as the *enfant terrible* of the art connoisseurial world. Morelli had many victories to celebrate in his attributions, such as his identification of one of the most famous pictures in the Dresden Gallery, Correggio's *Magdalen*, as a seventeenth-century copy, while in the other direction, he

demonstrated that what had until then been taken to be a copy after Titian in the same gallery was in fact a rare work by Giorgione. It must be said, however, that Morelli often presented as his own work attributions that had already been accepted by others.

Morelli's distinctive method and underlying convictions are not particularly evident in his discussion of individual pictures. He acknowledges as much in the methodological chapter which preceded the republication, in book form, of his journal essays. Here he writes that for many years he, too, simply trusted his intuition in making attributions. This was the strategy adopted by other connoisseurs who, he claimed, rested their attribution on the total impression of a work, rather than the evaluation of its individual details. Morelli was to some extent right about this. Although Rumohr, Waagen and others tried to identify the specific characteristics of an artist, they ultimately judged a work authentic when it seemed coherent, both in conception and in handling. Many have questioned whether Morelli worked any differently in practice. In his chapter on method, however, he claims that the only certain and scientific method for a connoisseur would be to take the opposite course: only from the painstaking collection of individual traits and their systematic comparison with those of other artists can we come to an objective view of an artist's authentic output. In this chapter he also makes it clear that he regards correct attributions as merely a means to an end, namely the writing of a more systematic history of Italian art. The relationship between attribution and an account of art's transformation in art history was like the relationship between anatomy and physiology, Morelli claimed. The one merely identified, while the other asked questions about causation and function.

Morelli never wrote such a history of Italian art, but he gave enough hints both in this chapter and in his letters, that it was to be an organic history of art. According to Morelli art, like a biological organism, develops in accordance with its environment, the prevailing climate and geography. Hence he placed great emphasis on the regional schools in Italy and – in contrast to Rumohr for example – held social and political factors to be relatively unimportant for the development of art. When Morelli says that in order to place a work of art in the context of its particular region and age a general impression is sufficient, he is clearly thinking in terms of something like the identification of types to be found in the work of palaeontologists such as Cuvier and Agassiz. The notion of types had been widespread amongst scientists in the nineteenth century, the idea being that the type shows what is characteristic of a larger group – it is 'typical'. Thus, just as for Cuvier and Agassiz the perch was the type of the larger group 'fish', so for Morelli the Florentine School was the type of the larger group

'Renaissance Italian painting'. However, when artists make works of art, they do not only reveal the typical characteristics of their regional school. Each artist also has distinct individual characteristics. In order to find these distinguishing features, Morelli suggested, one had to turn one's attention from general type-impressions to small, apparently unimportant, treatment of hands, ears and fingernails. On the basis of independently authenticated works, Morelli drew up a series of diagrams, showing the characteristic ways in which hand, ear, foot and drapery were depicted by individual artists (Figure 5). Thus, there are characteristics in the artwork such as line and composition which enable one to identify the type or regional school, and characteristics that identify the individual artist.

For his chapter on 'Principles and Methods', Morelli adopts the literary form of a dialogue. It purports to be a narrative by Ivan Lermolieff, who, on a trip from Russia to Italy, is initiated into the 'experimental method' of connoisseurship by an elderly Italian gentleman. After having persuaded his young student of the inadequacy of art connoisseurship and art history as currently practised in Germany, the Italian goes on to recall many examples in which documentation has proved misleading in the attribution of artworks. Finally, both end up in front of paintings by Raphael

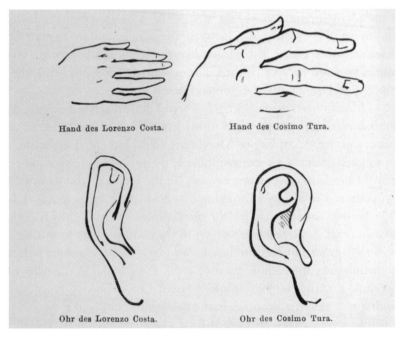

5 Illustration from Giovanni Morelli, *Kunstkritische Studien über italienische Malerei*, vol. 3, Gustav Frizzoni (ed.), Leipzig: Brockhaus, 1893, p. 58

in the Uffizi and Pitti galleries in Florence. There they concentrate on Raphael's Madonnas and his female portraits. Morelli does not make any attributions or disattributions which had not already been made by Rumohr, Passavant, Mündler or Cavalcaselle, although the text does not make this very clear since its starting point is the overenthusiastic attributions of some pictures to Raphael made by the then curator of the Uffizi. As a showpiece for his method, Morelli's discussion of the paintings in this chapter is most revealing, however. The Italian gentleman, Morelli's alter ego, and his student start by looking at Raphael's *Madonna della Cartolina* (Figure 6). Here the Italian draws attention solely to the depictions of hand and ear:

> Look at this Raphaelesque type of ear in the children. See how round and fleshy it is; how it unites naturally with the cheek and does not appear to be merely stuck on, as in the works of so many other masters; observe the hand of the Madonna with the broad metacarpus and somewhat stiff fingers, the nails extending to the tips only. You will find this type of hand in other authentic contemporary works of Raphael, for instance, in the 'Marriage of the Madonna,' in the Brera; the 'Madonna de' Tempi' at Munich; the small Madonna belonging to Lord Cowper, and in others. (Morelli, 1892–93, vol. 1, p. 37)

Having established these characteristic forms, the pair go on to discuss three other female portraits ascribed to Raphael in the gallery and discount them on the basis that they do not show such features. In ascribing one of them to Sebastiano del Piombo, the Italian gentleman exasperates his student with his insistence on the detailed comparison of small features of works of art. He finally admits that such eclectic pictures, although very apposite for demonstrating his method of minute detection, are not suited to beginners. Morelli's argument is based on the tacit assumption that great artists such as Raphael are able to produce more uniformly characteristic forms than can second-rate ones. While the work of first-rate artists follows a coherent internal development in accordance with its environment, the latter pick from and jump between styles from different environments without establishing a necessary connection.

How close Morelli's appreciation of what he considers to be a typically authentic work comes to what Rumohr, Waagen and other connoisseurs also believed becomes clear in his discussion of Raphael's *Donna Velata* in the Gallery of the Pitti Palace. Since Rumohr's days no connoisseur had doubted that this was an authentic work by Raphael. Yet Morelli takes the Gallery's own attribution of it to an unknown master as the occasion for introducing an artist from the local academy into the dialogue. The latter doubts the Italian gentleman's conviction that this is an authentic work by Raphael. Outraged at the assertion that this painting is only a copy by a

later Bolognese artist, the Italian gentleman cites the documentary evidence from Vasari, the technical evidence of a later restorer's work on the face of the woman and the background (this despite his earlier disparagement of the usefulness of such testimony) and finally declares: 'A copyist, indeed! to have painted those eyes, with their wonderful expression, that proud mouth, that noble brow – never!' (Morelli, 1892–93, vol. 1, p. 54).

So, just like other connoisseurs, Morelli ultimately based his attributions not just on the treatment of insignificant details, but on the idea that an authentic work by a great master will reveal a coherent overall vision. The difference from other connoisseurs lies in how Morelli explains the changes in individual forms within an artist's wider vision. Rumohr had accounted for changes in Raphael's style as a response to the different social contexts in which he worked, such as his move from Florence to the patronage of the dynamic Pope Julius II in Rome. Morelli, instead, presents such shifts as analogous to the way that natural organisms alter their appearance as they mature. This becomes apparent in his discussion of the *Madonna della Sedia*, also in the Pitti Palace in Florence. The Italian gentleman starts by drawing his student's attention to the ears, which he notices as being very similar to those in works by the young Raphael, such as the *Madonna della Cartolina*, from his Umbrian and Florentine period. The hand, however, he says,

> is no longer of the *bourgeois* type, faithfully reproduced from nature, but is of that elegant and refined form, which Raphael adhered to throughout his Roman period. Even here the metacarpus is still broad and rather flat, after the manner of his first master, Timoteo Viti; but the fingers are tapering, and it is a well-shaped, you may say an ideal, female hand. This 'Tondo' was probably painted about 1513 or 1514. In all Raphael's works from this period to his death you will find the same conventional form of hand, both in the few paintings which proceeded from his own brush, and in those which his pupils executed from his cartoons. (Morelli, 1892–93, vol. 1, p. 51)

In Morelli's view, prevailing culture is significant to the extent that it affects what is depicted in paintings, not as an influence on style itself. Raphael's portraits show, for example, that ideal comportment had died out among the aristocracy at his time. For Morelli the fact that noble demeanour appears in Raphael's portraits of his supposed love, the legendary Fornarina, in his *Donna Velata*, is a sign that it had migrated to the lower orders. 'Among the people a healthy vitality and moral vigour still prevailed', he lets his Italian gentleman assert (Morelli, 1892–93, vol. 1, p. 56). Perhaps Morelli never went beyond the discussions of attribution to more systematic art history, because art and artists do not behave like natural organisms. In discounting the influence of social factors on artists' work, Morelli

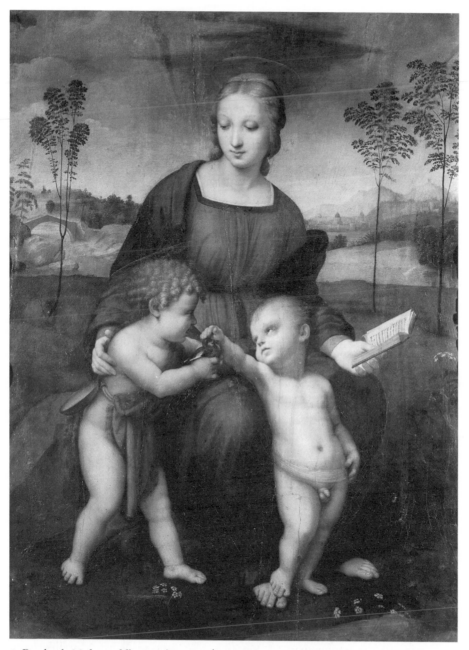

6 Raphael, *Madonna della Cartolina*, 1505/6, tempera on wood, 107 × 77 cm, Uffizi, Florence

would have had to face the fact that changes in natural forms occur at a very much slower rate than they do in art. Art is capable of responding quickly to a range of influences in a way that natural organisms are not. In the end, his project of a natural history of art was impossible.

As his more comprehensive theory of art was never fully articulated in Morelli's work, critics from the outset have focused on his endeavour to establish a set of stable individual features in the work of particular artists. Richard Wollheim has argued that this cannot be demonstrated consistently in the work of the artists discussed by Morelli; nor is it perceptually plausible. Our judgement of individual forms is always dependent, according to Wollheim, on the other forms in whose context they appear and so cannot be separately identified. Morelli's commitment to a natural history of art led him to suppose the contrary. Although Morelli hoped to give a scientific inductive method for making attributions, he himself never worked by its rules alone and did not claim to have done so. His most famous disciple, Bernard Berenson, continued to advocate Morelli's inductive method, but greatly expanded the range of features to be taken into consideration. But, as another great connoisseur, Max Friedländer observed, neither Morelli nor Berenson worked that way in practice. Rather than forming hypotheses from observations, their observations were always made in the light of some already framed hypothesis.

Bernard Berenson

Bernard Berenson (1865–1950) was born in Lithuania and went to the USA when he was 9 years old. His is a true story of progress from rags to riches. He gained a scholarship to Harvard where he studied art history. His energetic, witty and charming personality gained him the support of wealthy American patrons, in particular Isabella Stewart Gardner, who funded his first trip to Europe in 1887. He spent time in Paris and then in Oxford where he was soon drawn into Oscar Wilde's circle. During his stay in England he came into contact with Morelli's method of connoisseurship through reading Jean Paul Richter's critical discussion of the Italian pictures in the National Gallery. Jean Paul Richter was one of Morelli's most faithful acolytes and, when Berenson congratulated him on his work, Richter referred the young man to Morelli's own writing. With Morelli's *Italian Painters* in hand, Berenson travelled through Germany's galleries before reaching Italy and meeting Morelli himself. When money from his wealthy supporters in the USA ran out, Berenson started to become actively involved in the art market. Using his contacts with rich Americans, Berenson became something of a secret agent for Richter and his friend, the art dealer Otto

Gutekunst. It was only after meeting Mary Smith, his future wife, in England in 1890, that he began writing, and in collaboration with her, produced the many books on Italian art which made him famous in the twentieth century. First there came a small book on *Venetian Painters in the Renaissance* (1892), then a monograph, *Lorenzo Lotto* (1895), then volumes on *Florentine Painters of the Renaissance* (1896) and on *North Italian Painters of the Renaissance* (1907). In 1903 his most famous work appeared: the critical catalogue of *The Drawings of the Florentine Painters*. He also published several articles on his methods, collected in *The Study and Criticism of Italian Art* (1901) and *Three Essays in Method* (1927), as well as a book on aesthetics (1948) and an autobiography (1949).

He first came to the art world's attention at the age of 30 when he wrote a review of an exhibition of Venetian paintings in London assembled from private collections to parade his, by now, highly developed skills as a connoisseur. What most enraged the owners and dealers of the time was that Berenson argued in his review that of the 33 paintings ascribed in the catalogue to Titian, only one was an original. The influential art dealer Joseph Duveen realised the usefulness of this young man for his own purposes. From then on there was hardly a single important Italian painting that crossed the Atlantic into a public or private collection in the USA, which did not pass through Berenson's hands. Berenson and his wife Mary could afford to live very well in Italy, and they bought a villa near Florence, the Villa I Tatti, which later became an important research institution on Renaissance art.

Berenson's claim to fame as a connoisseur lay in his extension of Morelli's idea of a set of traits into a more elaborate set of criteria. In his essay 'The Rudiments of Connoisseurship' he presented a schema by which aspects of a painting are ordered into three groups, ranked according to their usefulness for the attribution of authorship. Into the first and most useful group, Berenson placed ears, hands and folds, as well as landscapes. In the second, he located hair, eyes, nose and mouth, and in the third, skull, chin, the structure and movement of the human figure, architecture, colour and light and shade. These aspects needed to be checked one by one in order to arrive at an attribution, Berenson claimed. Together they constituted what he came to call the Morellian tests.

There is, however, an important difference from Morelli, for whom certain features such as colour, line and composition indicated the type – that is, to which regional school a painting belonged – while such features as ears and hands indicated to which artist a painting belonged. Berenson departed from his teacher in his belief that all the features of a painting and the ways in which they come together pointed towards an individual

author. In fact, Berenson's distinctive approach was the result of his marrying the language of Morelli's inductive method with the beliefs of Rumohr, Waagen and others in the indivisibility of the total impression. Like them, his art history was underwritten by a metaphysics of individuality. A great artist presented an original vision of the world which transcended its time, he believed. Like Morelli, however, he thought that connoisseurship had not progressed sufficiently to write a systematic art history from this perspective. He hoped that connoisseurship would be able to order works of art on the basis of their visual characteristics alone, just as natural history orders flora and fauna. Then and only then would one be able to account systematically for the way art is transformed by great artists.

Berenson repeatedly declared that a great work of art surpasses words in its power of expression. In his aesthetic appreciation of the total impression of artworks he was influenced by the style criticism of Riegl and Wölfflin, the subjects of Chapter 5. While Berenson's approach, like Morelli's, was to pass from the analysis of parts of a work to a judgement, theirs was the reverse: for Riegl and Wölfflin style lies not in individual aspects of a painting, but in the synthetic way they form a whole. Nevertheless, Berenson attempted to include more aspects of works of art in his judgement than Morelli had done, so it is not surprising that he found the information derived from students of iconography (see Chapter 6) valuable. Their research into the traditions and customs that determine the subject matter depicted was useful for his practice as a connoisseur. Berenson never, however, valued Erwin Panofsky's work. The latter's conviction that artworks are to be understood in terms of the relationship between thought and image was antithetical to Berenson's understanding of art as operating in opposition to conceptual thinking.

Berenson's method

For Berenson, Morelli's most important insight was the significance of the apparently insignificant details in attribution. Like Morelli, Berenson took such details to be something that artists executed routinely and unthinkingly like a signature, and these were, therefore, most characteristic of their way of handling material. Berenson's classification of these traits in three groups according to their importance was meant to provide a verifiable alternative to unprovable guesswork. That he considered the process of going through such a checklist as no more than mechanical becomes clear from an article he wrote to illustrate his method. In 'Nine Pictures in Search of an Attribution' (1927) Berenson starts off with a careful description of

nine pictures by the same unidentified artist. After considering their subject matter (where he adopts an iconographic method, considering, for example, historical and geographical variations in the celebration of saints), Berenson establishes them as having been executed in Verona at the end of the fifteenth century, largely on the basis of the type of architecture, fashions and landscape depicted in them. The learning Berenson brings to bear here is truly impressive, particularly as he disputes the existence of regional schools in Italy, emphasising instead the migration of artists, and the way that changes in fashion and political allegiance led to rapid changes of taste. It is only when he starts to ascribe the works to a specific artist that he turns to his Morellian tests. Since the figures in the panels are small, Berenson does not in this case consider the depiction of ears, but he does focus on the relation of the metacarpus to the wrist and fingers and the arabesque with which that is rendered, as well as the deep, long furrows of the folds of material, close and crisp at first and then more spaced with brittle edges. On the basis of these features he attributes the panels to Domenico Morone and concludes: 'Such a resemblance in a case like this, where none of the other factors oppose it, is really as good as a signature' (Berenson, 1927, p. 68). His very last sentences, however, are: 'But a problem such as this essay has attempted to deal with cannot be treated dialectically and forensically alone. It has to be experienced and lived, it has to be tasted and felt. Just that vital substratum cannot be communicated. The most authentic evidence, nevertheless, is there, but beyond the realm of discourse' (Berenson, 1927, p. 71).

Rather than following the inductive procedure presented in this article, Berenson had, of course, already attributed the panels to Domenico Morone prior to its writing. The account he gives of the procedure of attribution is, in reality, more a strategy of justification in support of a judgement based on intuition. The grounds for this intuition lie in an impression of the whole that is beyond the analysis of the works' individual elements. While his mechanical rules of attribution work well for second-rate masters, according to Berenson, they are less appropriate when it comes to dealing with the original vision found in a masterpiece. For Berenson the appearance of great masterpieces is beyond discursive comprehension. Given his commitment to original artistic intuition it comes as no surprise that he expands on Rumohr's notion of artistic character and gives his own definition of artistic personality. In his book on Lorenzo Lotto, Berenson, with the help of Mary, reconstructs Lotto's personality on the basis of his paintings. Lotto is described as the pre-eminent psychologist of his age, sensitive to feelings and emotions. While Berenson made connoisseurship respectable by offering what he claimed to be a set of reliable criteria by which

judgements about authorship could be made, he also brought it into disrepute by his own shady involvement in the marketplace. In his underlying assumptions about art and its history, however, he extended into the twentieth century the metaphysics of individuality which had come into being in the writing of connoisseurs in the early nineteenth century.

Critical appraisal

Connoisseurship posed a question for art history at the beginning of the nineteenth century that still remains a troubling issue for art historians, whatever their underlying beliefs. This approach focused attention on the most specific features of the appearance of a work of art. But this forces us to ask how we can account for changes in appearances. There is no doubt that almost all art historians of all shades rely heavily on attributions of works to particular artists. A general prejudice, however, is that what distinguishes art historians from mere connoisseurs is that for the latter attribution is an end in itself. As we have seen, this is clearly unjustified; the most famous connoisseurs developed their methods on the basis of a strong set of underlying beliefs about art and its history. It turns out, however, that their method is, in its own way, no less problematic than Hegel's.

Let us first address the procedure of attribution. However much one widens the circle of evidence, to include documentary evidence, iconographic sources and (predominantly today) the technical reports of picture restorers, in order to help one to arrive at firm attributions people ultimately work through identifying a set of visual features which are taken to be the trademarks of a particular artist. Although connoisseurs have always allowed for variations as artists develop, they, nonetheless, hold to the belief that those traits remain essentially distinctive. This assumption is however deeply problematic. Since the turn of the nineteenth century, but particularly since the 1930s, psychologists have pointed out that the same configuration of features in one's field of vision can look very different in different contexts. In identifying a set of core features, it is assumed that artists do not adjust such features according to the different configuration of their compositions or according to the contexts in which the works are intended to appear. Moreover, it is thought that we as viewers can distinguish individuating features irrespective of the way in which our own perceptions are context-bound. It is worth noticing here that despite the rhetoric of connoisseurship with its claims to base itself on the close study of the original work of art, both Morelli and Berenson actually developed their connoisseurship largely working from photographs. But this is a

medium which tends to highlight a different set of perceptual phenomena from the work of art of which it is a representation. It dramatically alters size and colour and dislocates the work even further from the original site of its experience than by hanging it in a gallery. There at least the composition of the picture and its dimensions indicate to some extent the intended viewing position (seen from below, from above, straight on, far or near). Since perceptual phenomena of the kind on which connoisseurs base their method are highly unstable, the art historian Ernst Gombrich has argued that skilful stylistic analysis of a work can support the most unlikely attribution.

A contemporary example that illustrates the uncertainties associated with attributions is the Rembrandt Research Project, established in 1968 in order to find scientific ways of proving which works by Rembrandt are authentic and which not. Over time, the accepted corpus of Rembrandt's work shrank more and more under the Project's influence, until a curator, Bernhard Schnackenburg in Kassel, Germany, insisted that the Project reconsider its exclusion of a particular picture in the collection there. The Project was led to revise its previous judgement and now believes that early in his career Rembrandt switched consciously between different styles, much as an ancient rhetorician would chose a low or high style depending on the occasion of his speech. The exhibition *The Young Rembrandt* which was mounted in Kassel and Amsterdam in 2001/2002 on the basis of this reconsideration had a knock-on effect, and has led the Project to reconsider several works that it had previously believed not to be by Rembrandt.

A second point of difficulty concerns the underlying belief shared by most connoisseurs in what we have been calling the metaphysics of individuality. As the early twentieth-century connoisseur Max Friedländer wrote:

> Our courage to proceed to the determination of authorship – whether we go by intuition or by analysis and 'objective' criteria – we derive from a belief that creative individuality has an unchangeable core. We start on the assumption that the artist – whatever he experiences, whatever impulses he receives, however he may change his abode – at bottom remains the same, and that something which cannot be lost reveals itself in his every expression. This belief is often shaken by practical experience, but remains indispensable as a compass on the journey of the critique of style. (Friedländer, 1942, p. 200)

The idea that individuality expresses itself in a unique way and that its creativeness is the motor for the development of art is, of course, no less mysterious than Hegel's supposition of a universal spirit. Moreover, the cult of genius which it closely supports has come under attack from Marxist

art historians, for masking the social contradictions underlying art's production (Chapter 7), as well as from feminists (Chapter 8), who have criticised it as an approach which more often than not militates against meaningful discussion of women's contribution to the art world. In the endeavour to study cultures, the concept of 'great masters' often excludes a spectrum of other visual productions that are, in fact, equally significant. The conviction that only high art is expressive of a culture was already being abandoned by the art historians who will concern us in Chapter 5: the formalists Alois Riegl and Heinrich Wölfflin.

While the celebration of creative individuality in art remains a recurrent theme in the popular understanding of art and continues to flourish in some forms of artists' biographies, both on film and in books, connoisseurship saw its greatest triumph in 1871. In that year an exhibition was organised in Dresden showing 46 paintings ascribed to the artist Hans Holbein the Younger. Most spectacular was the hanging of two almost identical works next to each other. Each had been identified as an authentic work by Holbein, entitled *Madonna of the Burgomeister Meyer*, for which documentary evidence proved that it had been painted in 1526. One of the paintings had long been celebrated as Holbein's masterpiece in the collection in Dresden, the other only appeared on the art market in Paris in 1822 and had ended up in a picture collection in Darmstadt. The confrontation divided the art world. The Dresden picture appeared smoother and sweeter than the Darmstadt work and hence many followed the Romantics' celebration of it, declaring it to be authentic because of its superior beauty. Several connoisseurs, however, starting with Kugler and Waagen pointed to the fact that this conception of beauty was anachronistic. Waagen noted that the work in Darmstadt showed the broad and edgy brushwork typical of Holbein in a way that was absent in Dresden. Finally Cavalcaselle's collaborator, Joseph Crowe, demonstrated that the binding agent present in the paint in Dresden made Holbein's authorship impossible. A symposium was organised to coincide with the exhibition and to decide the question of which was the original and which the copy. A communiqué was finally issued and signed by some of the most famous German connoisseurs, including Wilhelm von Bode, which declared the Darmstadt picture to be the original. To many, the visual sophistication shown by connoisseurs in this case demonstrated that art history had come of age. Given the inconclusive nature of the documentary evidence, the connoisseurs had worked mainly on the basis of visual analysis, thus giving the relatively young discipline the authority of an independent method.

The next generation of art historians saw their role as developing the primacy of stylistic visual analysis in art history. As we will see in Chapter

5, their main aim, however, was to go beyond the discussion of style as significant of individual artists and extend it to capture a culture's aesthetic self-understanding more broadly. Their starting point was the work of the cultural historian **Jakob Burckhardt (1818–97)**. Burckhardt had described the culture of the Italian Renaissance on the basis of a highly refined and nuanced analysis of works of art in the period. In his most famous book, *The Civilisation of the Renaissance in Italy* (1860), insights gleaned from his encounters with art provided him with the analytical and conceptual apparatus with which to describe the mentality of the epoch. Art itself, however, is never used as evidence in the book's historical arguments. In Burckhardt's book on art of the Italian Renaissance, a guide called *The Cicerone* (1855), on the other hand, historical circumstances are rarely mentioned in his analysis of the works. Burckhardt, too, believed in the great transformative power of individual artists. Yet his methodological caution prevented him from making sweeping generalisations with regard to what explained what. As far as he was concerned, it had to be decided case by case if it was the social context which explained the appearance of a work of art, or if it was the artist's powerful vision which influenced the outlook of the age. Riegl and Wölfflin were more ambitious than this. Their aim was to provide an account of style which went beyond the individual work of art and captured the general visual tradition of a period.

Bibliography

Berenson, Bernard, 'The Rudiments of Connoisseurship', in *The Study of Criticism of Italian Art* (London: George Bell, 1902) pp. 111–48. Here Berenson discusses systematically Morelli's sets of criteria, expands them and orders them according to their usefulness in the attribution of authorship.

Berenson, Bernard, 'Nine Pictures in Search of an Attribution', in *Three Essays in Method* (Oxford: Clarendon Press, 1927) pp. 1–71. Berenson's set-piece example of attribution following an inductive method.

Friedländer, Max, *On Art and Connoisseurship*, trans. Tancred Borenius (London: B. Cassirer, 1942). A self-conscious and critical account of connoisseurship by one of its foremost early twentieth-century practitioners.

Gibson-Wood, Carol, *Studies in the Theory of Connoisseurship from Vasari to Morelli* (New York and London: Garland Publishing, 1988). The most comprehensive secondary account of connoisseurship.

Morelli, Giovanni, *Italian Painters: Critical Studies of their Works*, intro. A. H. Layard, trans. Constance Jocelyn Ffoulkes, 2 vols (London: John Murray, 1892–93). This contains Morelli's critical discussion of attributions in Italian and German collections and his important methodological introduction.

Rumohr, Carl Friedrich von, *Italienische Forschungen*, 3 vols (Berlin und Stettin: Nicolaische Buchhandlung, 1827–31). Unfortunately this ground-breaking work for the history of art does not exist in an English translation. It demonstrates Rumohr's effort to establish firm attributions with the aid of archival evidence and visual sophistication. It is also demonstrates that from the beginning connoisseurship was underpinned by a metaphysics of individuality.

Simpson, Colin, *The Partnership: The Secret Association of Bernard Berenson and Joseph Duveen* (London: Bodley Head, 1987). A critical biography of Berenson drawing attention to the way that he benefited materially from his connoisseurship.

Waagen, Gustav Friedrich, *Peter Paul Rubens: His Life and Genius*, ed. Anna Jameson, trans. Robert R. Noel (London: Saunders and Otley, 1840). Waagen extends Rumohr's method to Rubens and Northern countries. This work was translated into English during Waagen's lifetime.

Wollheim, Richard, 'Giovanni Morelli and the Origins of Scientific Connoisseurship', in *On Art and the Mind: Essays and Lectures* (London: Allen Lane, 1973) pp. 177–201. This essay, by a twentieth-century philosopher, contains the most penetrating criticism of Morelli's claims for the scientific status of his method.

A S WE HAVE SEEN in the dispute over Holbein, the connoisseurs developed a range of sophisticated techniques for establishing the authenticity (or otherwise) of particular works of art. The late nineteenth-century art historians, **Heinrich Wölfflin (1864–1945)**, **Alois Riegl (1858–1905)** and their disciples radically broadened the enterprise of art history, however. For these scholars who are known as formalists, the key issue now was to find the style characteristic of an epoch or a culture in works of art. In their writings, **style** became more than just a term for the characteristic features discernible in the work of an individual artist. Moreover, instead of Rumohr's use of style as a designation for an artist's individuality that transcends itself and becomes universal, Wölfflin and Riegl used it to capture the specific expressions of an age. What is it, they asked, that makes us recognise immediately a family resemblance between the architecture, painting, sculpture and ornament of a single period and to distinguish them from those of another? What is it, for example, that makes us see a Gothic church, a medieval picture, its frame or even a medieval shoe as belonging to one age and a Renaissance church, painting, ornament or costume to another? What makes it so natural to speak of 'Gothic', 'Renaissance', 'Baroque' forms and what is the motor behind the changes in period styles? In answering this Wölfflin and Riegl recast Hegel's conception of the fundamental questions of art history in the light of the achievement of the connoisseurs.

As we have seen, Hegel conceived of art as historical, and this not only required him to account for the differences between artworks of different historical cultures, but also to explain why these changes took place. Yet, with its emphasis on the pre-eminence of thought, Hegel's aesthetic was deficient in the eyes of the subsequent generation of connoisseurs. It was unable to account for what seemed to them to be the most characteristic feature of works of art, such as line, colour, and the distribution of light and shade. While the connoisseurs, in attending to these features, developed a sophisticated set of tools for visual analysis, their belief in creative individuals meant that they could not provide a satisfactory account of general changes in period styles. Wölfflin and Riegl set out to go beyond this limitation and yet retain the emphasis on the sensuous characteristics of art (as opposed to its relation to the conceptual thought embedded in

it). Both men were adamant that art history had to look beyond exemplary individual cases and search for more fundamental laws in the development of artistic forms.

In the preface to the first German edition of *Principles of Art History* (1932 [1915]) Wölfflin famously envisioned an art history 'without names' (although he removed this somewhat provocative statement in subsequent editions). The notion of individuality was (and still is) a deeply entrenched value among many historians and critics, and Wölfflin was mocked for his neglect of it by connoisseurs such as Bode and Friedländer. Yet, for reasons which will become clear, Wölfflin and Riegl initiated a counternarrative which was to transform art history around the turn of the twentieth century into one of the most highly regarded academic disciplines in Germany and Austria. Going beyond connoisseurship, Riegl and Wölfflin argued that art offered unmediated sensory access to past world-views. They placed art history at the centre of all other historical disciplines. Previously, art history had been an adjunct to general history; their suggestion was the opposite:

> As every history of vision must lead beyond mere art, it goes without saying that such national differences of the eye are more than a mere question of taste: conditioned and conditioning, they contain the bases of the whole world picture of people. That is why the history of art as the doctrine of the modes of vision can claim to be, not only a mere super in the company of historical disciplines, but as necessary as sight itself. (Wölfflin, 1932 [1915], p. 237)

As we see in Chapter 5, up until the Second World War European art historians developed, reformulated and reconceptualised this history of vision. The reputation that the discipline achieved through the methodological ambitiousness of its academic practitioners in Germany and Austria was unmatched in England or America, where methods of connoisseurship largely dominated. In England many art historians worked in museums or auction houses. In universities, art history was taught, if at all, as an adjunct to general history and very few independent art history departments existed. This changed, however, with the influx of a large number of distinguished art historians who fled from Nazi Germany and Austria during the 1930s.

Formalism

What is formalism? We can speak of a formalist approach in art history whenever a writer on art concentrates solely on the formal properties of works of art and presupposes that such forms follow their own developmental logic – that is, one form leads to another in a way that can be

understood by an observer as something more than just a haphazard change. Riegl and Wölfflin proposed a scheme for this. They were, however, not the first to separate the development of visual forms from their contingent contexts. To some extent Hegel's closest follower Karl Schnaase had already done this. As we saw in the Chapter 3, Schnaase argued that the formal aspects of art could develop autonomously, and should not always be viewed as necessarily tied to their intellectual context. Nevertheless, he retained the notion that art was an expression of people's spiritual progress. Wölfflin, in particular, was very critical of Hegelian conceptions of this kind: 'What, first of all, determines the artist's creative attitude to form? It has been said to be the character of the age he lives in; for the gothic period, for instance, feudalism, scholasticism, the life of the spirit. But, we still have to find the path that leads from the cell of the scholar to the mason's yard' (Wölfflin, *Renaissance and Baroque*, 1964, pp. 76–7).

Although we might assert that art is determined by social practices, this does not explain exactly how the two are connected. For Wölfflin and Riegl the answer lay in discovering those underlying visual laws that govern both art and society generally (although it is in art that they find their expression). This led them to emphasise art's forms rather than its content and set them in opposition to both Hegelian accounts and to connoisseurship. We would be mistaken, therefore, if we understood Wölfflin's and Riegl's emphasis on the autonomy of art forms, their formalism, as implying that they thought of art as isolated from its wider cultural context: far from it. The history of vision to which art gave access was supposed to provide the key to unlock different cultures' wider 'mentalities'.

If one rejects the Hegelian notion of spirit, the connoisseurial belief in individuality, and an explanation of artistic change as the product of changes in functional, material and technical requirements, as Wölfflin and Riegl did, how can one give an answer to the fundamental questions for art history: (1) What makes art historically and socially specific? and (2) What motivates changes in art over time? Riegl's and Wölfflin's answers to these questions came from contemporary views in the psychology of perception which they recast in historical terms. We need, therefore, to introduce a few key figures whose work in this field provided the theoretical underpinnings of Formalism.

Throughout the nineteenth century the psychology of perception had been a vigorously debated subject in the sciences. By the end of the century, experimental psychology had emerged as a powerful academic discipline on the borderline between physiology and philosophy in the academic curriculum. Physiologists set out to research how our bodies produced perception. In doing so they followed the philosopher Immanuel Kant's idea that

we do not have knowledge of the objects in the world as they are in themselves, but only as they appear, mediated by our sense organs. The most famous German physicist and physiologist of the nineteenth century, Hermann von Helmholtz, gave several public lectures in which he repeatedly impressed on his listeners and readers that our sensations are no more than symbols for the objects of the external world. We have no direct access to the world; our perceptions are only a representation of the world. But for Helmholtz this did not mean that each person has their own disconnected subjective view of the world. We are all able to make rational (but unconscious) mental judgements and these generate a coherent image of the world on which we can all agree. It was the task of psychology to explain how these unconscious mental judgements operated to produce a mental image of the world and the self. The role of art as well as science was to communicate this image in an active manner.

Three types of psychological explanation were available to Riegl and Wölfflin, and they drew on all of them to some extent, even though they were in conflict with each other in places. Each of the three offered them an important insight at a particular stage in their careers, although this sometimes entailed major revisions to their own earlier accounts. The first influence came from the neo-Kantian philosopher, Johann Friedrich Herbart. Herbart fiercely rejected Hegel's aesthetic of content and proposed instead an account of mental activity which concentrated on the formal characteristics of sense data, such as line and colour. According to Hebart, our senses perceive these elements in isolation and it is the mind that brings sensory data into a systematic whole either by suppressing or by enhancing the interrelationship between them. This emphasis on the formal elements in perception was picked up by both Wölfflin and Riegl. Indeed, Riegl studied with a disciple of Herbart, Robert Zimmermann, who wrote an Aesthetics based on Herbart's philosophy of the mind. Zimmermann argued that the way the mind constructed the relationship between forms was wholly internal and not influenced by events in the social world. Not only did this account of artistic form greatly impress the young Riegl, but he also adopted Zimmermann's distinction between the tactile and the optical in his art history.

A second psychological explanation of aesthetic experience became popular towards the end of the nineteenth century. This was the so-called 'empathy theory' whose most influential advocate was Theodor Lipps, under whose supervision Wölfflin wrote his doctoral dissertation on the psychology of architecture. The fundamental doctrine of empathy theory is that aesthetic experience is dependent on the experiencing subject's projection of bodily sensations and emotional remembrances. Like the

Herbartians, empathy theory focused on fundamental formal elements of experience, such as lines and colour, and shared the belief that diverse formal elements only produce their effect when seen together as a whole. Unlike the Hebartians, however, empathy theorists produced an analysis rich in expressive content. Projecting a sense of our own body onto aesthetic forms, for example, might result in our interpreting lines that taper and are drawn from bottom to top as elating, or colours that are dark as brooding. While Wölfflin's early work relies very heavily on empathy theory, he moved away from it later in his career. For Riegl the opposite was true; he began as an opponent of empathy theory, but came closer to it in his later work.

In contrast to these largely hypothetical psychologies of perception, a third group of scientists set out to investigate such issues experimentally, focusing on the most basic formal elements given to perception. Most prominent at the end of the nineteenth century was Wilhelm Wundt's experimental psychology laboratory in Leipzig. Although Wundt accepted empathy theory's basic tenet that our perceptions are shaped by our psycho-physiological constitutions, he made a clear separation between basic emotional sensations, which were amenable to experimental investigation, and intellectual processes which were not; for Lipps both were parts of the same psychological process. Riegl adopted Wundt's terminology for the faculties of the mind and both he and Wölfflin studied closely the third volume of Wundt's *Ethnopsychology*, dedicated to art, which appeared just after the turn of the century. Here they found an account of art that referred historical and cultural differences back to differences in basic perceptual principles. Implicit in this argument is the idea that art changes because people actually come to perceive the world differently. Although Wundt himself did not propose an account of the history of art as a history of vision, his work contained strong indications that could be developed in this way.

All three of these psychological theories were important for Wölfflin and Riegl. However, they were not the first thinkers to use such theories as a means of explaining art. A further influence on Riegl's and Wölfflin's writing that strengthened their interest in the psychology of perception came from an artist who tried to draw conclusions for his own practice from these discussions. In 1893 the then much celebrated sculptor Adolf Hildebrand published his book, *The Problem of Form in the Visual Arts.* Both Wölfflin and Riegl were heavily influenced by this book.

Hildebrand's discussion owes much to his friend, the philosopher Konrad Fiedler, and they took as their starting point Helmholtz's position that stable perception is not something given to the eye, but that it is our mental activities which select and order the contingent, shifting phenomena

that our eyes perceive. Furthermore, Hildebrand and Fiedler followed in the tradition of Rumohr in privileging artistic visual intuition over conceptual knowledge. They claimed that the task of the artists was not merely to produce an image that represents our ordinary perceptions, but to convey knowledge of the world in a peculiarly artistic form. Hildebrand and Fiedler rejected the idea that image making is mimetic, copying the way the world appears, because this would lack the interpretative visual intuition required from artists. When Hildebrand came to set out his idea of creative artistic vision, he greatly simplified some recent results in the psychology of vision, largely drawn from his reading of Helmholtz. He started from the assumption that our eyes have no grasp of the three dimensions of space; this was a reasonable conclusion from Helmholtz's writing. But Hildebrand went on to make the further claim that such three-dimensional awareness depended upon the sense of touch and movement. He began by declaring that the first task of the artist was to understand that only objects presented in the plane in front of the eyes are grasped visually; yet because we have all acquired a sense of space through movement and touch we continually make unconscious inferences about objects' relationships in space. The artist, confined to the two-dimensional plane, has to give enough visual clues for the viewer to reconstitute the intended spatial relationships in his mind. The peculiar skill of the artist is to provide a clear image in which no clue remains ambiguous, but which, nonetheless, generates an impression of continuous form across the plane.

The physiology of Helmholtz, the psychology of Hebart, Lipps and Wundt, and the aesthetic theory of Hildebrand and Fiedler were all crucial to the development of Formalism. On the face of it, this may seem strange, since none of these, nor any of the other works on psychological aesthetics of the time were congenial to a historical view of art. All insisted that the production and reception of art were marked by detachment from the world of ordinary experience. Art's special appeal was its self-containment and formal coherence. For the empathy theorists the autonomy of art was the precondition for aesthetic appreciation (which involved a selfless projection of our own inward states onto the objects of perception). Hildebrand, and Fiedler even more strongly than Hildebrand, took a more radical position. They rejected empathy theory's expressive interpretation of vision, and argued that the creative artistic act defied translation into something other than itself; it was utterly self-reflexive. Wundt took a position in the middle. While he gave empathetic projections a place in reception, he denied their role in processes of artistic creation.

How could one move from such aesthetic psychologies to an understanding of art objects as historically contingent and changeable? Independently, both Riegl and Wölfflin historicised the psychologists' accounts of

vision. Influenced by recent investigations into the differences between the visual perception of children and adults, they projected the basic assumptions of developmental psychology into history. Drawing particularly on Wundt's suggestion that different aspects of vision played a different role at different stages of the development of civilisations, they offered an account of the history of art as a history of vision. For example, children at first disregard the relationship of objects in space and concentrate on grasping the contours of individual features in isolation from each other. As they grow up they learn to perceive objects in relation to each other in space. This relationship between earlier and later stages of children's development was exactly, Wölfflin and Riegl thought, like earlier and later stages of art. Vision itself developed with a kind of logic through different ages and periods, and by analysing the art objects produced at different stages art historians could discover something important about different cultures' ways of seeing the world.

Wölfflin's and Riegl's formalism is not an account of art for its own sake, and it would be a mistake to think of their method as one that separates art history from other disciplines. By studying vision and the history of perception they focused on the fundamental relationship people have had to their environment and so it is not surprising that their work became important for other historical disciplines. The prestige of art history as a subject in German-speaking countries after the turn of the nineteenth century was largely due to its practitioners' willingness to develop ideas from other disciplines and their success in getting their own ideas accepted by non-art historians.

Heinrich Wölfflin

Heinrich Wölfflin was born in Switzerland, but grew up in Germany. After finishing school he went back to Basel and studied with Jakob Burckhardt, before moving to Theodor Lipps's Department of Philosophy in Munich where he wrote his dissertation on the perception of form in architecture. In German universities a further post-doctoral qualification was needed before one could gain a full teaching position at universities, and Wölfflin's first well-known book, *Renaissance and Baroque*, was written to meet this qualification. It appeared in 1889 and gained him his first posts at Bern and Heidelberg. In 1893 he became Burckhardt's successor at Basel. In 1901 he moved to the History of Art Department in Berlin and from there in 1914 to Munich. Although his best-known books, *Renaissance and Baroque, Classic Art* (1899) and *Principles of Art History* (1915), were published during his career as an academic, he continued to publish after he retired to Zurich in 1924.

It has often been remarked that each of Wölfflin's publications to some extent revises his earlier work. What is clear, however, is that two elements remained constant: first, Wölfflin's conviction that a systematic art history had to be built on the foundation of the psychology of perception; second, his conception of art's formal language as a set of oppositions which structure the art of all ages. Thus although the appearance of art changes dramatically through time, certain categories persist such as whether compositions are closed or open, unified or multiple in conception, relatively clear in their presentation or evoking obscurity. In his best-known book, *Principles of Art History*, often described as the most influential and widely read book ever written by an art historian, Wölfflin presented his most refined account of these categories. Few art historians to this day manage to describe a picture without evoking these in one way or another. Moreover, Wölfflin's method of comparing and contrasting pictures has come to be seen as a natural and commonsensical way to conduct art history; think, for example, of how most art history lectures involve dual projection, with contrasting images side by side.

Wölfflin's immediate predecessor at the University of Berlin was the, then famous, art historian Hermann Grimm. Grimm's biographical approach to art history valued above all those great personalities who had the capacity to transcend their age and time. He describes Raphael's tapestry cartoon, *The Miraculous Draught of Fishes*, in the Victoria and Albert Museum in London: 'It is astonishing what Raphael has done here only with the aid of drawing; he lets the lake expand under clouds that lose themselves in the distance and awakes a feeling of loneliness and being abandoned in us. (Hermann Grimm, *Das Leben Raphaels von Urbino*, Berlin: Dummler, 1872, p. 295)

Wölfflin once noted he appeared as a cold rational formalist among art historians in contrast to this. Here is a fragment of Wölfflin's own description of the same image:

> every part, down to the last detail, is related to the whole; each line is calculated to fit in with its counterparts elsewhere . . . The shapes of the landscape are also created with a pictorial purpose: the line of the river bank exactly follows the ascending contour of the figure group, then there is a gap on the horizon, and only above Christ does a hilly bank recur, so that the landscape gives emphasis to the important caesura in the figure composition. (Wölfflin, *Classic Art*, 1952 [1899], p. 110)

What is immediately striking is how much Wölfflin's conception of style in a picture has shifted away from individual aspects to an understanding of the whole. Each element partakes in and contributes to the stylistic

character of the total image. This emphasis on the relationship of formal elements was what Wölfflin had learnt from his time with Lipps, and his interest in psychology. It was common to all three psychological approaches outlined at the beginning of this chapter.

Wölfflin's set of fundamental formal characteristics and his account of the psychology of perception were distinctively his own and they were refined with every new publication. In each, however, his explanation of what causes changes in art differed radically. In his doctoral dissertation, *Prolegomena towards an Aesthetic of Architecture*, Wölfflin gave an ahistorical account of how we perceive forms in architecture. In line with Lipps's empathy theory he started from the assumption that forms in architecture are without expression in themselves, but that we read their proportions and relations according to our own physiological and psychological constitution and thus endow them with something of our own body's posture and mood. Like empathy theory, this reading based itself on the perceptions of a viewer who was assumed to be universal, rather than historically situated. The problem this left for Wölfflin, as an art historian, was that it provided no way of explaining why one age should choose certain stylistic principles over others.

In *Renaissance and Baroque* (1964) Wölfflin gave his first answer to this question: it was the bodily feeling itself which changed from one period to another, he claimed. Instead of the firmly contoured and articulated feeling for form of the Renaissance, a more solid, heavy and restless sense prevails in the Baroque age. Calm fulfilment is now replaced by violent animation in tension with large immobile masses. This change of feeling is not only responsible for the change in style as it appears in art, but is also detectable in the way that clothes change. It is also the cause, according to Wölfflin, of changes in other spheres of life, such as the new religious consciousness which separates the worldly from the ecclesiastical and inhibits what previously expressed itself as enjoyment of life in the Renaissance.

Such an account raised a further problem, however. Changes in style are attributed to changes in bodily feeling, but what, one needs to ask, caused that change? Wölfflin was aware of this problem, and his next publication explained stylistic changes differently. *Classic Art* was written after Wölfflin had encountered Hildebrand's *The Problem of Form*. Following Hildebrand, he now postulated that purely artistic forms of vision change independently from feelings and states of mind and that both factors together condition a new style. This was Hildebrand's (and his friend Konrad Fiedler's) distinct contribution to the discussion of vision and artistic creation. The transformation from Italian Quattrocento to Cinquecento art, which is Wölfflin's subject in *Classic Art*, is explained by

these two causes. There is a new temperament and ideal of beauty in society which expresses itself in a newly dignified and reserved deportment.

From the visual evidence presented in pictures, he concludes, for example, that the actual gait of women changed from a stiff mincing walk to a tempo more akin to an *andante maestoso*. But this change of feeling and altered mindset is not the only cause of the new style. The new pictorial forms are also due to an independently occurring development in vision. According to Wölfflin, artistic vision, whose task it was to order the chaotic mass of sensory perception, was capable of integrating a greater variety of perceptual phenomena in the sixteenth century than had been the case in the fifteenth. At the same time it grasped this variety more effectively as a unified whole and presented its visual analysis with greater clarity to the viewer. Here again Wölfflin was appropriating common beliefs about perception and applying them to a historic period.

In his most famous book, *Principles of Art History*, (1932 [1915]) Wölfflin addressed the problem of giving causal explanations for changes in style most explicitly: 'it remains no mean problem to discover the conditions which, as material elements – call it temperament, *Zeitgeist*, or racial character – determine the style of individuals, periods, or peoples'. But, he continues emphatically, there is another factor – the mode of representation itself: 'Every artist finds certain visual possibilities before him to which he is bound. Not everything is possible at all times. Vision itself has its history, and the revelation of these visual strata must be regarded as the primary task of art history' (Wölfflin, 1932 [1915], p. 11). This is what he set out to do in this book. He wished to provide a general set of descriptive terms that could capture the artistic visual forms of an age without presupposing any further explanation. In a sense, he sidestepped his own problem, although he did, to some extent, address it in the introduction and the conclusion. In the introduction he criticised the empathy theory that he had once accepted. He argues that in reading forms as expressions of states of mind, we make the false assumption that the same expressive methods are always available. In the conclusion he states that both external and internal modes of explanation are justified. 'Doubtless,' he says, 'certain forms of beholding pre-exist as possibilities; whether and how they come to development depends on outward circumstances' (Wölfflin, 1932 [1915], p. 230).

Wölfflin sees the forms of visuality he identifies as universally applicable, capable of describing the development of pictorial forms in the most different ages, countries and periods. However, although they are universally applicable, different forms dominate at different historical moments.

Indeed, they operate in a cyclical fashion moving from classical simplicity to baroque complexity. This pattern is repeated again and again throughout Western art history. Once a cycle is started it runs its course, but having reached a state of complexity what makes art return to the beginning and adopt simplicity once again? Wölfflin's answer is that this is something that cannot be explained just by looking at the internal development of art; it is here that wider, external factors come into play. The example he gives is the return to a new 'linear' mode of vision that developed around 1800. This, says Wölfflin, was part of the whole reappraisal of human values that we now think of as the Romantic movement: art responded to wider social change and thus set itself on the path to a new cycle of internal development. In *Italy and the German Feeling for Form* (1931), published after his retirement, Wölfflin shifted focus once again to investigate not only the cyclical nature of ways of seeing, but also their dependence on what he thought were racial differences between northern Europeans and the Mediterranean people. The one is given to ambiguity, he writes, the other to clarity.

Wölfflin's struggle to identify the ultimate causes of historical change is a problem shared by anyone who wishes to explain transformations in the past. Take our own account here as an example: as we have presented the shifts of focus in Wölfflin's writings, they appear as a relatively continuous internal argument that Wölfflin has with himself. One could, however, account for these shifts differently, placing more emphasis on the implicit value judgements contained in his account of the Renaissance and the Baroque. When Wölfflin speaks of the aristocratic ease, the order and the dignity of the ideal of beauty in cinquecento Italy, he clearly does so with the longing of someone who sees himself as living in a very different age. The modern age, he thought, had lost all sense of style and lacked the cultivated forms of social life he saw in the Renaissance. Fiedler, Hildebrand and their artist friend Hans von Marées shared Wölfflin's attitude of elitist aestheticism.

Wölfflin encountered this circle of friends at a moment when empathy theory had become popular as an aesthetic which offered to make the experience of art accessible to the lower middle classes. In journals targeted at this constituency, art criticism was framed in the language of empathy theory. This theory offered a conception of aesthetic experience that was not dependent on classical learning, nor did it involve Fiedler's rarified formalism. Instead it championed an understanding of aesthetic experience based on sensual projection, something that would be, in theory, accessible to every 'body'. We might then see Wölfflin's advocacy of an autonomous history of artistic vision in *Classic Art* as motivated not so much by the logic of internal argument as by a response to external social developments.

Similarly we might see Wölfflin's reticence with regard to underlying social causes in *Principles* as a negative response to the national euphoria which gripped Germany before the outbreak of the First World War. At this stage, Wölfflin's formal analysis knew no national boundaries. Wölfflin's own problem remains: while we may be able to give some account of immediate influences and causes for a transformation in aesthetic and historic phenomena, the trouble starts when we want to point to ultimate causes.

Wölfflin's art history

Wölfflin's art history is essentially comparative in method. It begins with pairs of images each embodying a different set of visual principles, and thus demonstrating stylistic and historical shifts. Such an approach, as has often been remarked, was greatly encouraged by the rapid growth of photography, which allowed the juxtaposition of images of works of art that were otherwise widely dispersed. When he became a professor in Berlin, Wölfflin enthusiastically embraced the practice of his predecessor, Hermann Grimm, of showing slides side by side for comparison. His lectures, much like art-history lectures today, centred upon the careful elucidation of images according to the set of characteristics he wanted to draw out. This is also how Wölfflin's books are constructed. But neither the slides nor the photographs that he used were in colour. It is noticeable that the discussion of colour is a fairly neglected aspect of his stylistic analysis, as are features related to texture. Nor was Wölfflin interested in questions of originality. In fact, his concentration on the need to develop principled categories for stylistic description, opened him to the ridicule of his connoisseurial colleagues in the museum in Berlin. Both Bode and Friedländer delighted in circulating anecdotes about Wölfflin's inability to give accurate attributions.

This comparative approach is clearly illustrated in *Renaissance and Baroque* (1964). Part 2 of the book closed with a quotation from the art historian Carl Justi characterising another art historian, Johann Joachim Winckelmann who, like Wölfflin, had been in love with classic art: 'moderation and form, simplicity and noble line, stillness of soul and gentleness of sensibility.' Wölfflin concluded, 'If one were to take the opposite of each of these concepts, we should have the substance of the new style [the baroque]' (Wölfflin, 1964, p. 88). This is essentially how he proceeded in his description of the change in style. Concerned as he was in *Renaissance and Baroque* with the stylistic change in the architecture of Rome between 1520 and 1630, he began to define the opposites to 'moderation and form,

simplicity and noble line, stillness and gentleness' as 'painterliness, grand scale, and massiveness in tension with movement'.

The third part of Wölfflin's book deals with different building types – churches, palaces, villas, gardens – but, unlike his teacher Burckhardt, Wölfflin does not think that style results from the demands made by the functional requirements of the buildings in question. In *Classic Art* Wölfflin's interest is in showing the emergence of the first set of principles in the High Renaissance in central Italy. He focuses mainly on paintings by four artists: Leonardo, Michelangelo, Raphael and Andrea del Sarto. In contrast to Quattrocento art, their work is marked by a clarity of presentation which is, nonetheless, capable of unifying a variety of visual elements. It is interesting to note that Michelangelo's work after 1520 marks the beginning of what Wölfflin sees as an artistic decline in central Italy. Much like Rumohr, he talks of the subsequent generation of artists as being vainly in competition with one another, striving for mere effect rather than style. Like Morelli, he speaks of a generation of eclectics. A revival of the principles of classic art, according to Wölfflin in this book at least, only came with the new attention to nature that took place in the 'Germanic North of Italy' (he has Venice and Titian in mind) (Wölfflin, 1952 [1899], p. 203).

In *Principles of Art History* Wölfflin presented the formal properties he had identified in his earlier writings most systematically and comprehensively. These were meant to provide general descriptive terms, which would capture the development of artistic vision across countries and ages. They embodied a cycle which Wölfflin in theory saw being repeated over and over again, restarting whenever the external conditions for its realisation arose. In the book, however, his categories are explained by comparison of sixteenth- and seventeenth-century art in several countries, ranging from Italy, to Flanders and Holland, Spain and Germany. Here Wölfflin proposed his famous set of five oppositions:

1 **Linear** versus **Painterly**
2 **Plane** versus **Recession**
3 **Closed** versus **Open**
4 **Multiplicity** versus **Unity**
5 **Absolute** versus **Relative Clarity**

Let us turn to a concrete comparison from Wölfflin's book in order to see how the principles were supposed to work. Wölfflin discusses Titian's *Venus of Urbino* from 1538 (Figure 7) together with Diego Velazquez's *The Toilet of Venus* ('Rokeby Venus') of c.1648 (Figure 8) in order to elucidate the contrast between 'multiplicity versus unity'. He is, however, adamant that

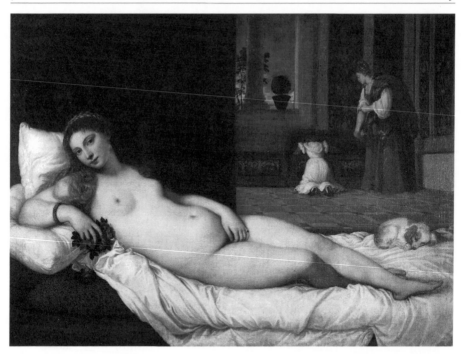

7 Titian, *Venus of Urbino*, 1538, oil on canvas, 119 × 165 cm, Uffizi, Florence

his categories are such that all pictures which show one of the terms must of necessity also display the other characteristics belonging to its side of the table. So all artworks that are described as being linear in conception, will also display to a greater or lesser extent the features 'plane', 'closed', 'multiplicity' and 'absolute'; never, however, 'painterly', 'recession', 'open', 'unity' and 'relative clarity'.

The first contrast of linear versus painterly lies in the attention given on the one hand to the delineation of firm outlines and the apprehension of individual material objects, on the other in the emphasis placed on the shifting, atmospheric appearances of the world. In Wölfflin's estimation this can be seen clearly in the contrast between the Renaissance artist Titian, and Velasquez as an example from the Baroque age. It is typical of classic art (and hence of Titian), he says, that we could cut the figures out of such a painting:

> The very existence of the baroque figure, on the other hand, is bound to the other motives [*sic*] in the picture This is still truer of a composition such as Velasquez' *Venus*. While Titian's beautiful figure possesses a rhythm in itself alone, in Velasquez the figure is only completed by what is added to it in the picture. (Wölfflin, 1932 [1915], p. 169)

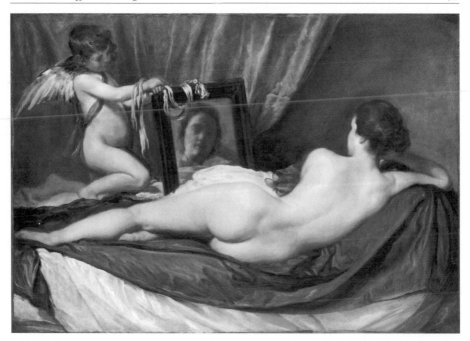

8 Diego Velazquez, *The Toilet of Venus* (*Rokeby Venus*), 1647–51, oil on canvas, 122.5 ×
177 cm, National Gallery, London

The difference between a planar and a recessional composition can
be seen in the way that the two paintings present the three-dimensional
space behind the figures. The main order of Titian's painting is constructed
parallel to the picture space. In Velasquez's *Venus*, however, the pull is into
the background. Having her back turned to the viewer, we are forced to
follow the woman's glance into the mirror just to the left of the centre and
from there beyond into the void in the background on the right. Our gaze
zigzags through the picture space into the back, rather than grasping the
composition in a side-to-side reading as in the case of the Titian.

Wölfflin's next pair is closed versus open form. This relates to the
way a work of art is framed and how it places us in relation to itself. In
the Titian picture, the viewer is clearly positioned at eye level with the
woman looking down somewhat onto the bed. The spatial setting is more
or less like a clearly defined box which the viewer confronts. There are no
clear spatial indicators in the Velasquez, however. As Wölfflin points out
in a different context, there is no longer an affinity between the lines of
the figure and the rectangle of the depiction. The bed and the woman seem
to be placed somewhat diagonally, with her head and shoulders towards the
picture foreground and the feet further backwards. In order to see the

frontal reflection of the woman's face in the mirror, as one does, the viewer may be assumed to be standing somewhat to the right of the picture. In its ambiguity the composition is not internally fixed but opens itself out to different viewer positions. Unlike Titian's painting we do not have the impression that we encounter a discrete world.

In the contrast between multiplicity and unity, Wölfflin emphasises the fact that Titian's figure appears as a self-sufficient form made up of clearly articulated parts. Similarly there is a variety of details in the picture, such as the dog, or the maids in the background. Yet, each in itself is complete and together they form a unified whole. In contrast, in Velasquez' nude 'the effect is not based on the juxtaposition of separate forms, but rather on the whole as a whole . . . For the beauty of the classic style, the uniformly clear visibility of all the parts is the *sine qua non*: the baroque can dispense with it, as Velasquez' example shows' (Wölfflin, 1932 [1915], p. 169).

Wölfflin's last contrast, absolute versus relative clarity of the subject is closely related to his first opposition: the linear versus the painterly. For Wölfflin it adds, however, the qualitative difference between a painting that uses optical effects in order to render the subject with the utmost precision, and one which delights in painterly techniques for their own atmospheric effect. We might see the difference in the contrast between Titian's and Velasquez's images if we turn to the precise quality of their brushstrokes. Titian uses them to evoke the textural difference between the silky sheets of the bed and the smooth skin of the woman, thrown further into relief by the material richness evoked in the background. Velasquez, on the other hand, is much less concerned with material illusions and instead employs subtle changes in tone and colour which register the almost imperceptible changes in the angles of the surfaces and which consequently capture the reflection of light and bathe the nude in a peculiar atmosphere.

The application of Wölfflin's pairs of descriptive terms to two paintings yields a remarkable range of observations and therein lies their fame. From Berenson to contemporary art historians like Rosalind Krauss, his terminology has proved difficult to resist.

Alois Riegl

After studying law, then history and philosophy, the Austrian Alois Riegl started his career as an art historian as a curator of textiles at the Austrian Museum for Art and Industry. His first book, *Problems of Style* (1893), directly grew out of his endeavour to understand the development of ornament in his dealings with decorative artefacts in the museum. His next major pub-

lication, *Late Roman Art Industry* (1901), also grew out of practical work, a report he wrote on some recent excavations of early medieval artefacts in the Austro-Hungarian Empire. His research interests were much wider than Wölfflin's. They ranged over antiquity and the Middle Ages, the Baroque era and modern times. His last major work, *The Group Portraiture of Holland*, appeared as a very long article in 1902 and was posthumously published as a monograph in 1931.

In many ways, although related by their common concern to base art history on a history of vision, Riegl and Wölfflin present mirror images of each other. In the German-speaking countries, Riegl's reputation and influence was greater than Wölfflin's in the early decades of the twentieth century. A whole school of later Viennese art historians claimed Riegl as their founding father. Abroad, however, the picture is different. All three of Wölfflin's major books were translated into English in 1932, 1952 and 1964. Riegl's three main works only appeared in English in 1985, 1992 and 1999. There seem to be two main reasons for the Anglo-American preference for Wölfflin. Firstly, Wölfflin's assumptions about the motor of stylistic change, his history of vision, was revised in each of his books, so that his position appeared much less monolithic and dogmatic than in Riegl's work. Riegl, as we will see, proposed a notion of **Kunstwollen** (variously translated as artistic volition, will to form, or artistic intent) which seemed too uncomfortably close to Hegel's *deus ex machina*, the Absolute Idea. In 1960, the Viennese emigré, Ernst Gombrich, influentially included Riegl in his dictum that the invocation of ultimate causes in art history 'weakens resistance to totalitarian habits of mind' (Gombrich, *Art and Illusion*, 1977 [1960], p. 17). Gombrich always excepted Wölfflin somewhat from this charge. A second reason for Wölfflin's greater acceptance may be that his system of formal properties appears to offer a useful tool for description independent of any commitment to his underlying theory, while Riegl used more general categories and contrasts (such as **haptic** versus **optic** and **subjective** versus **objective**) which seem more closely dependent upon his theoretical assumptions.

In recent decades, however, the tables have been turned. Several books have been published assessing Riegl's work, but no comparable effort has been given to Wölfflin. The three main reasons that have attracted the attention of contemporary art historians to Riegl's work are features which he does not share with Wölfflin. Firstly, he worked on a period of art history, late antiquity, which had been conventionally regarded as a period of decline. Riegl insisted that the art of late antiquity embodied a significant new development, without which subsequent European art would have been unthinkable. In contrast to Wölfflin, for whom the classical remained

the epitome of beauty, Riegl refuses to see any period as setting a norma-
tive ideal against which others are to be measured. Secondly, Riegl does not
differentiate between high and low art. For Riegl ornament or neglected
genres such as group portraiture in Dutch art were just as revealing of the
period style as the most highly valued canonical work. In *Renaissance and
Baroque* (1964) Wölfflin actually asserted that the formal sensibilities of an
age find their most immediate and freest expression in the decorative arts
and that new styles were always born there (Wölfflin, 1964, p. 79). But he
never followed this up and in *Principles of Art History* (1932 [1915]) he asserts
that the general principles of style are to be seen most clearly in the most
outstanding artworks (Wölfflin, 1932 [1915], p. 227). A third point of inter-
est which recent art historians have found in Riegl's work is his explicit
consideration of the viewing subject implied by a work of art. His discus-
sion in *The Group Portraiture of Holland* (1999 [1902]) traces a development
from works that are internally self-sufficient to those that require the mental
activity of the viewer for their completion.

Apart from the different reception of Wölfflin's and Riegl's work,
there are two fundamental contrasts in their approach to art history. The
first concerns the importance of external circumstances for the develop-
ment of artistic creations. As we have seen, Wölfflin at first took such
circumstances to be of prime importance but later came to posit a process
of autonomous artistic development. Riegl took the opposite route. In
Problems of Style, (1992 [1893]), he argued against the view that ornamental
motifs were conditioned by material and technical requirements. Instead,
he traced style changes internally to show the development of motifs as
being due to a drive for more interconnectedness, variety and symmetry.
This is essentially Riegl's notion of *Kunstwollen* which expressed his assump-
tion that the process of artistic form development was autonomous.

In *Late Roman Art Industry* (1985 [1901]) he developed this notion further.
In this work Riegl elaborates *Kunstwollen* as a dynamic drive which, in dis-
tinction to the forms of the will expressed in religion, law or politics, was
solely directed at the artistic ordering of the perceptual world. Its concern
was with the way that subjects apprehended the objective world and pre-
sented this vision to themselves in art. This makes clear that the impetus
for Riegl's art history was his interest in the changes of the psychology of
vision. The specific ways in which this shaping took place, however, were
bound up with the world-views of the age. In *Late Roman Art Industry* the
Kunstwollen was largely presented without reference to the spheres of poli-
tics, religion and government – only in the conclusion did Riegl draw some
parallels to natural history and religion. This changed in *The Group Portraiture
of Holland*. He suggests, in the preface, that the peculiarities of group por-

traiture and the guilds whose members such paintings usually depict were due to the fundamentally democratic nature of Dutch society between 1529 and 1662. These changes in Riegl's emphasis on what determines artistic forms, show that his use of the term *Kunstwollen* also shifted: while it at first denoted the internal development of form or art's autonomy it later came to capture the specifically artistic modes of representing the perceptual and, finally, the social world.

Riegl's and Wölfflin's attitudes towards contemporary psychologies of perception also developed in diametrically different ways. Wölfflin started off by using empathy theory as an explanation for changes in style, but increasingly abandoned it in favour of an account based on the development of vision. Riegl, on the other hand, explicitly rejected the application of empathy theory to art history and in *Problems of Style* started with a Herbartian model; although, as we shall see, certain tenets of empathy theory later became implicit in his work. The development of the formal characteristics of ornamental motifs was held to correspond to the mind's tendency to synthesise an increasing range of elements. In *Late Roman Art Industry*, he adopts a distinction between tactile and optical perceptions from his teacher, the Herbartian Zimmermann, although the influence of Hildebrand and even empathy theory is also noticeable here.

Riegl describes in this book the development of art from ancient Egypt to late Roman antiquity as a development from the tactile (his term is **haptic**) comprehension of the outlines of individual objects to an optical, three-dimensional perception of figures in space. He suggests that in the early haptic stage individual objects are apprehended as bodies in analogy to the sense we have of our own bodies. In making this analogy Riegl adopts the assumptions of empathy theory. Furthermore, as the **optic** mode of vision made its appearance in late Roman art, space was not yet seen to be infinite but taking the form of shallow intervals between figures. When Riegl wrote that such intervals appeared rhythmically organised as forms through the patterned alternation of light and dark, he invokes a similar psycho-physiological response to form as that analysed by the empathy theorists Lipps and Wilhelm Wundt.

While Riegl always stayed clear of the cruder emotional projections supposed by some popular forms of empathy theory, his last major work, *The Group Portraiture of Holland*, centres upon the paintings' implicit viewing subject, which was likewise empathy theory's main focus. Riegl accepted Wundt's division of the processes of perception in the mind but set it to work for his own purposes. According to Wundt there was always an immediate emotional response to sense data, but only when this became the focus of attention was it raised to consciousness and conceptually processed. The

central term for Riegl's argument in *The Group Portraiture of Holland* (1999 [1902]) was **attentiveness**, which transcended the subjectivism of the emotions and the self-interest of the will. He writes:

> Then, on the psychological level . . . this meant depicting attentiveness, which is essentially a state of the human mind devoid of will and emotion. This explains, on the one hand, the old and enduring aversion that the Hollanders had to depicting self-contained, historical events: history requires that figures interact, therefore making it very difficult for them to be depicted in a pure state of attentiveness. On the other hand, it also explains the preference in Holland for both individual and group portraiture, because it is a type of painting that exists solely in terms of the mental representations of the viewing subject. (Riegl, 1999 [1902], p. 366)

Before we look at Riegl's art history in practice, it is important to summarise his theoretical assumptions. We have already encountered his notion of *Kunstwollen*. This is the term that Riegl initially introduced to denote the autonomous development of art forms, but eventually used to describe the specifically artistic mode of representing the perceptual world. It was in the latter sense that Riegl used *Kunstwollen* when he described the way that people in antiquity attempted to represent the world as **objective**. They did this, according to Riegl, by isolating individual elements and presenting them in a self-contained manner, as one does in getting to know items via the sense of touch. In late antiquity, however, attempts to relate these individual elements to each other gave a new importance to the surrounding space, something which can only be apprehended (and represented) by visual means that are decidedly subjective, principally light and colour. This marks the beginning of the **subjective** mode of artistic apprehension which has since dominated Western European art. Within this generally subjective approach, there are greater and lesser degrees of objectivity. As one traces a trajectory from the Renaissance and the Baroque age through to Modern art, the emphasis shifts from giving a subjective apprehension of the objective world towards art that is merely subjective projection. Riegl saw Impressionism as the embodiment of the excessive subjectivism that was, he feared, characteristic of his own age. While Riegl may have abandoned the elevation of certain periods into ideals typical of other art historians (including Wölfflin) his art history also embodied a normative evaluation. In the Dutch art of the sixteenth and early seventeenth century, Riegl saw a model of human communication in which attentiveness to the other had not yet been abandoned in favour of unbridled subjectivism.

Riegl's historical account of artistic vision developing away from concern with the apprehension of the objective world towards the expres-

sion of subjective projections did not need to appeal to external causes. Social contexts played a role, however, in determining the form which the development took. The particular form of attentiveness towards others that is embodied in Dutch art is determined by the democratic nature of Dutch society, for example.

The dependence of Riegl's ideas on Hegel and Schnaase has often been noted. Hegel, as we have seen, also saw art's history as moving towards increasingly subjective modes of expression. Likewise, Hegel saw the characteristic painterly means of light, shade and colour as fundamentally subjective. But Riegl jettisons the notion of a self-realising universal spirit in favour of the idea that art is the product of a drive for a particular kind of perceptual apprehension. Thus he represents the development of art as independent of human beings' spiritual progress. In contrast to Hegel and Schnaase, Riegl sees the rise of subjective forms of vision as a product of late antiquity rather than of Christianity. Nor is Riegl's model teleological in the way that Hegel's is. For Hegel art was required in order for the mind to gain self-knowledge, but it lost this role once the balance of the subjective expressing itself in the objective was lost. At the moment art became merely subjective it was superseded by philosophy, which was better able to represent the mind's nature to itself. For Riegl, however, there is no such end point for art:

> Life is a constant struggle between the individual ego and the surrounding world, between subject and object. Civilised human beings are not content with a passive role in relation to the objective world, with its power to influence every aspect of life. Art (in its broadest sense) allows them to replace the objective world that is beyond their control with an alternative realm that they can freely define on their own terms. (Riegl, 1999 [1902], p. 366)

Riegl's art history

When Riegl wrote his *Problems of Style* (1992 [1893]) he was not the first to trace stylistic changes in ornament, but he was the first to understand that while the earliest ornaments were representations of nature, subsequent developments were generated by the forms themselves. He patiently attempted to identify each link in a historical chain that would show the continuous development of ornamental forms in antiquity and the Middle Ages. He went back as far as the Ancient Egyptian lotus motif to demonstrate its development into the palmette and later into the acanthus, to be found on Corinthian capitals in ancient Greece. Riegl thus set out to refute the traditional belief that the acanthus ornament was derived from natural observation. In this book Riegl chose to follow the transformation of forms

over a long period of time (a diachronic historical account), but he chose
a different focus for his next book. In *Late Roman Art Industry* (1985 [1901])
Riegl concentrates on one place and one period only, late Roman Italy in
the five and a half centuries between Constantine the Great and Char-
lemagne. Although the time and place are circumscribed, the range of
objects Riegl considers is much broader. His aim is to build up a synchronic
historical account, to show the stylistic similarities between the decorative
arts of the time, architecture and reliefs. Brooches and glass vessels get as
much attention as buildings like the Pantheon.

A key object of analysis for Riegl, is the Arch of Constantine in
Rome, erected between 312 and 315. From Raphael onwards the Arch of
Constantine had been taken as prime evidence for the decline of ancient
art. The juxtaposition of late-antique and second-century reliefs enabled a
comparison which demonstrated unmistakably, it was supposed, the infe-
riority of art from the time of Constantine onwards. Riegl focused on the
much-derided fourth-century reliefs on the arch's north face to argue that
its artistic endeavour was neither a success nor a failure but the expression
of a new phase in the development of artistic vision (Figure 9). He claims
that the reliefs illustrate perfectly the *Kunstwollen* of the period and in their
analysis he identifies all the characteristics he found in the other art produc-
tions of the period. What was notable for Riegl was the effort to organise

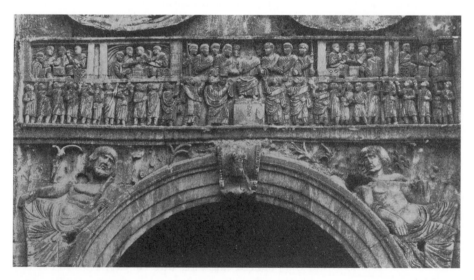

9 Photograph of a relief from the Arch of Constantine, *c.*AD 310, Rome, from Alois
Riegl, *Die Spätrömische Kunstindustrie*, (1901), 2nd edition, Vienna: Staatsdruckerei, 1927,
p. 87

the composition symmetrically and to conceive it as a self-contained unit, while at the same time maintaining the individual figures and their body parts as distinct elements. How is this done? Riegl compares the reliefs with those of Egyptian art and early antiquity, describing the figures in Egyptian art as presented in firm contours. All important features are given in one plane (hence the contortions of body and face) as if felt with our hands. Thus the viewer's apprehension of the work is principally tactile rather than optical. In ancient Greek art the figures are still self-contained but start to be presented with more movement. While still essentially conceived as tactile entities now put in relation with each other, the primacy of the plane of the relief is not challenged. Figure and ground are part of the same tactile continuum. This is different, according to Riegl in the late Roman reliefs:

> While the entity appears to be projected on one plane with painstaking precision, the individual figures strive towards spatial isolation from the common plane. The outlines of the figures are all deeply undercut so that they appear nowhere visibly connected with the ground. . . . This is a decisive point wherein the Constantinian differ from ancient Oriental and Classical reliefs; during the earlier Empire it was still an invariable law for any relief to maintain an obvious tactile connection, whether directly or through intermediate figures. The common plane consequently now loses its formal tactile connection and falls apart into a series of light figures and dark spatial shadows in between them, which all together evoke a colouristic impression through their irregular change. Yet the impression continues to be one of a symmetrically designed plane; but now it is no longer a tactile plane, which is either entirely interrupted or just slightly obscured through half shadows, but rather an optical plane like the one where all objects appear to our eye from the long view. (Riegl, 1985 [1901], p. 53)

In his conclusion Riegl argues that the way figures were conceived in ancient art was consonant with the religious and scientific views of the age. In classical antiquity, he says, a mechanistic conception prevailed, which saw individual bodies as self-contained entities exerting pressure or thrust upon each other much like the relationships expressed between the individual figures in the reliefs. In late antiquity, however, individual forms were again put into mutual external isolation. Yet a magical belief common to late paganism, Neoplatonism, and early Christianity, arose which made the connection between individual entities a matter of the agency of mysterious forces. The play with appearances such as light and shade in the intervals between figures on the relief gave pictorial expression to this force. This was the crucial step towards the conception of deep space that would prevail from now on in European societies.

Attending to the optical values of spatial relationships was the beginning of the subjectivisation of artistic creation for Riegl. The apprehension of the objective world in subjective vision was nonetheless of primary importance. A further step in this development is described in *The Group Portraiture of Holland*. Figures and space, Riegl writes, are now understood not in their objective relationship but in terms of their psychological interaction. Whereas previous art had aimed at defining material relationships within the world, Dutch art was concerned with something immaterial and beyond perception, the psychological relationship of the figures at a particular moment in a particular place. In contrast to Italian Renaissance and Baroque painting, however, it was not the depiction of action which motivated the psychological narrative. Rather it was the figures' inner life towards which the viewer's attention was drawn. The pictures achieve coherence once the viewer involves himself or herself with the psychic sphere represented. Far from merely presenting the artist's subjective point of view (as Riegl understood Impressionism to do), the objectivity of Dutch group portraits resides in the way that they present the existence of people as independent from each other and from us as the viewer.

Riegl identifies three stages in the development of the Dutch group portrait. In the first period, from 1529 to 1566, the members of a group are depicted individually and connected merely by objects or gestures. As the depiction of the individuals was often organised in rows, the coherence of the picture was created externally, by the viewer. In the second period, from 1580 to 1624, this external coherence is complemented by an internal coherence. The figures depicted are shown as being at a particular place and time and this provides a narrative motivation within the picture for their being together. In the third period from 1624 to 1662 the development reaches its culmination. Group portraits from this time are characterised by the figures' attentiveness to something which is not depicted in the picture. Thus viewers are forced to complete the image for themselves. In Rembrandt's *The Night Watch* of 1642 (Figure 10) the company of Captain Banning Cocq is shown at a particular moment, just as they are about to get their marching orders. Riegl notes that there is more action than is usual in a Dutch group portrait for the troops are busy getting themselves ready behind the captain and lieutenant. What is attended to in this picture – even anticipated in its actions – is the imminent word of command from the captain, after which the company will start to march towards the viewer. Riegl insists, however, that it is not in the picture itself that movement creates this fusion between the inner coherence of the image and the completion of its action by the spectator: 'Rembrandt's contour lines are much too

vigorously suppressed to give the viewer that kind of information. Rather, what fascinates us is the way the color unmistakably informs us of the figures' inner intention to move in our direction in the very next instant' (Riegl, 1999 [1902], p. 271).

Riegl goes on to say that modern subjectivity can see here a satisfying solution to a problem that is closely related to its own situation. The concentrated attentiveness cultivated in Dutch art (Riegl sees the group portraits as representative of all art of the period), and the idea of a collectivity which does not submerge individuality were for Riegl what the High Renaissance was for Wölfflin: testimony to a superior way of life that had been lost in their own world.

Riegl's understanding of the history of vision, like Wölfflin's, led him to treat individual features as part of a diachronic series. What motivated stylistic change was changes in perception. This approach led to a level of

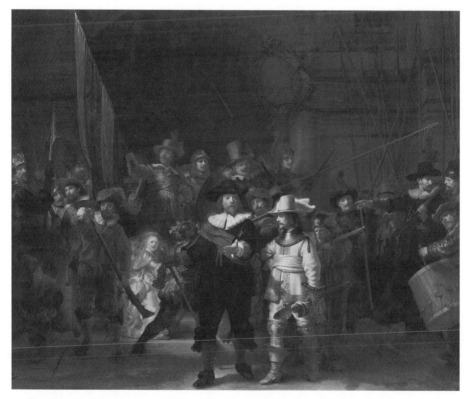

10 Rembrandt Harmensz van Rijn, *The Company of Captain Frans Banning Cocq and Lieutenant Willem van Ruytenburch (The Night Watch)*, 1642, oil on canvas, 363 × 437 cm, Rijksmuseum, Amsterdam

historical investigation beyond what the connoisseurs had been able to achieve and a richness of observation regarding individual works of art beyond the general statements of Hegelian art history.

Critical appraisal

Riegl and Wölfflin developed versions of the history of art which showed artworks embedded in their particular cultures at the same time as being attentive to their specific artistic character. Both were aware that the current situation of art historians shapes their accounts of the past. How can the art historian escape what Wölfflin once said of artists: 'we only see what we look for, but we only look for what we can see' (Wölfflin, 1932 [1915], p. 230)? Like the connoisseurs and like Hegel, Riegl and Wölfflin needed to identify an underlying principle that would both explain a work's historical specificity yet provide sufficient continuity with the past to allow the art historian to explain historical transformations. This is the hermeneutic problem. Wölfflin and Riegl thought they had avoided the necessity of positing a mysterious force such as universal spirit or the notion of individuality, believing that they were basing their theories on scientific research, instead of evoking unverifiable forces. Their model projected contemporary research on the progression of individual's visual capacity onto the past. At the base of this lay the conviction that the development of the species mirrors the development of the individual; just as individual perception becomes more complex as we develop from children into adults, so human perception becomes more complex and more sophisticated from the beginnings of man to the present. Thus, there is a parallel between the way children perceive the world and earlier art. In this they were not alone. The eminent experimental psychologist, Wilhelm Wundt, had suggested as much in the third volume of his *Ethnopsychology* which both Riegl and Wölfflin consulted. This model gave Wölfflin and Riegl a basis for the conviction that their formal description of works was empirically valid.

By the 1930s, however, this conception of the development of vision was already being called into question both by historians and psychologists. The latter increasingly came to challenge a conception of vision as a piecemeal process by which we attend first to individual figures before turning to spatial clues. Instead, they advanced a conception of vision in which all the different elements of the visual field are processed and related to each other simultaneously. Historians and anthropologists challenged the image of art in earlier or in non-Western cultures as the first step towards a mature artistic vision. It was, they argued, no more than the projection backwards of modern Western art onto the past. To give such an account of Egyptian

artefacts, for example, was to miss the point. Their purpose was not a coherent vision of the objective world but to develop a symbolic pictorial system which was intended to be read rather than seen. It might seem that this criticism only affected Riegl, but a similar criticism could be applied to Wölfflin's account of Renaissance art. Since the 1920s a competing school of art history (the subject of Chapter 6) had been gathering force. For these writers what was at stake in the changing style of Renaissance art was not so much alterations in the mode of vision but changing intentions in art's symbolic function.

Such early criticisms of Wölfflin and Riegl identify a serious problem. Far from pointing the royal road to a form of art history which both accounts for transformations in art and yet can claim to be historically and empirically specific, their histories of vision merely extend their own interests and perceptions to other times and cultures. From a postcolonial perspective (see Chapter 11) such accounts could be characterised as a form of colonisation. From this point of view Wölfflin's attempt to identify the different artistic vision between Germans and Italians is extremely problematic, as is Riegl's conviction that cultural progress was due to the Indo-Germanic people and that influences from the Near East had always proved to be retarding.

No one was better placed than the art historian **Ernst Gombrich (1909–2001)** to assess the shortcomings of Riegl and Wölfflin. When Gombrich studied in Vienna in the 1920s, Riegl's legacy was very much alive and being reshaped in line with the insights of Gestalt psychology. Some members of the Vienna School wanted to identify racial characteristics in art, and for someone who had had to flee from Fascism this was unsettling. Furthermore, for Gombrich, the Vienna School's ambition to develop comprehensive accounts of culture – where every element is subsumed under one overarching feature – came too close to the totalitarian vision of the Nazis and Communists for comfort. When Gombrich arrived in England, he joined the Warburg Institute, which had recently been set up by another emigré from Nazi Germany, Aby Warburg. Warburg's roots were in a tradition that was more focused on the symbolic meaning of art than were Riegl and Wölfflin (see Chapter 6). After the war, however, Gombrich set out to familiarise himself with recent developments in the psychology of perception. By this time psychology had moved from investigating the stimuli of vision towards the mental operations of the perceiver. Seen from the vantage point of this later research, Riegl and Wölfflin's history of vision in art seemed quite mistaken.

Gombrich's most famous book, *Art and Illusion* (1960), opened with a cartoon from the *New Yorker Magazine* of 1955, supposedly showing a group

of Egyptian art students in a life-drawing class. In front of them appears a life model who looks just like one of the half-frontal half sideways-facing figures on Egyptian reliefs. The caricaturist's point picked up by Gombrich was to ridicule the idea that artists of other times and cultures really saw the world in any way differently from us. As soon as one stops believing in this aspect of Riegl and Wölfflin's art history, it is easy to see how much their underlying beliefs shaped what they themselves saw.

Although he respected both Wölfflin and Riegl, it was not difficult for Gombrich to find counter-examples to their image of cultures as stylistically homogeneous. He notes that Riegl sometimes disregarded the evidence of coins when their appearance or date did not suit his narrative and that many tribal artefacts and ancient Greek patterns show an interest in just the kind of phenomena that Riegl claimed only developed in late antiquity. Likewise Wölfflin, he argued, was often too sweeping in his account of Renaissance art. Why, for example, Gombrich asks, does Wölfflin consider Raphael and Leonardo to be jointly representative of the classic style, when there is just as much a contrast between Raphael's Florentine Madonnas or the *Battle of Ostia* and Leonardo's *Last Supper* and *Battle of Anghiari* as there is between Titian and Velasquez? Gombrich's charge was that Riegl and Wölfflin's division of art into period styles was largely a product of their own artificial systems.

Riegl and Wölfflin have sometimes been defended for basing their speculative accounts of the development of vision on empirically verifiable visual data. Nothing could be further from the truth. Gombrich's point was that they only saw what they were looking for, and only looked for what they could see. Gombrich's own art history conceived of style and artistic vision as much more dependent on the pictorial traditions available to artists. The media available to the artist, the technological requirements, the patrons' wishes and the public's expectation were as important determining factors as the artist's own perceptual apprehension of the world. Famously, Gombrich described his own approach as based on the assumption that art history itself comes about because artists proceed by a method of trial and error.

Social art historians have been uncomfortable with the circularity of Riegl's and Wölfflin's analyses. Riegl, for example, explains the peculiar quality of attentiveness in Dutch art by recourse to the democratic society in which the works were produced. Yet his understanding of the nature of that society was itself inferred from the artworks he examined. Similarly, Wölfflin identifies a change in temperament in Italian High Renaissance society as one cause of the transformation of its style (the change in artis-

tic vision being another). Yet his evidence for this is drawn from the art-works themselves. Women's gait, for example, is said to have changed, simply because women are depicted differently in Ghirlandaio and Raphael. Already in the 1930s, Marxist critics, such as the German social critic and philosopher, Walter Benjamin, and the American art historian Meyer Schapiro, deplored the lack of any analysis by Riegl and Wölfflin of the specific historical and social conditions giving rise to the changes.

From this point of view, it seemed staggeringly negligent to discuss, for example, Titian's *Venus of Urbino* (Figure 7) in the way that Wölfflin did and note only that 'the whole naturalistic, material content of the picture sinks into insignificance beside the realisation of a definite notion of beauty which presided over the conception' (Wölfflin, 1932 [1915], p. 169). He does not once mention the suggestive position of the hand which, rather than hiding the genitals, draws attention to them. Does this gesture seem insignificant in relation to the grander aim of composing a picture in accordance with the classic norm of beauty? If not, then the question of what social function the picture had seems paramount. Social art historians have pointed out that the contemporary setting and the absence of attributes make it unlikely that this is a purely mythological picture of Venus. They point to the tradition of pictures commissioned to mark the occasion of a marriage by a patron of high standing. Vasari himself, in fact, had already read the painting in this way. Venus would then be seen as the personification of love within marriage, the dog would symbolise fidelity and the two wooden wedding boxes and the myrtle plant on the window sill further corroborate that intention. Yet social historians have also been puzzled by the fact that when this picture was painted the patron, Guidobaldo della Rovere, had already been married for four years, and so they place it in another tradition: that of images which have been commissioned for the private consumption and arousal of largely male patrons. Thus what Wölfflin assumes to be a matter of classic beauty turns out to be high-class pornography.

Similarly, Riegl's understanding of the Dutch group portraits as expressing the egalitarian democratic nature of Holland has also been called into question. As social historians have pointed out, the militias depicted in the group portraits Riegl discusses had the task of maintaining public order. They enforced the political policies of regents (themselves not subject to democratic control). The members of the militias were drawn largely from the wealthy strata of society: those who had a stake in the defence of law and property. The men shown in Rembrandt's *Night Watch*, for example, are known to have paid Rembrandt on average 100 guilders each to have their portraits painted. Appearing in the portrait demonstrated their asso-

ciation with their captain, a man who rose to the top of the rigidly oligar-chic governing elite when he became mayor of Amsterdam. On this account, Rembrandt's *Night Watch* would seem to be more a way of marking social stratification than expressing equality as Riegl would have it.

In the light of all this criticism it is important to remember that both Riegl and Wölfflin consciously set out to write art histories which would go beyond what they considered to be the cult of individual facts. Although the history of vision that they promoted may seem with hindsight to be reductive, their ambition of combining an account of artefacts which is highly specific with a larger historical view of changes over time still remains a challenge for art history, as the next chapters show.

One criticism made of Riegl or Wölfflin is clearly wrong – the charge that formalism considers art without paying attention to the cultural context that gives rise to it. As we have seen, their starting point was pre-cisely the attempt to make the stylistic changes they traced intelligible as part of wider cultural change. It was Riegl's and Wölfflin's successors later in the twentieth century, particularly in America, who married formalism to the beliefs of connoisseurship and, in so doing, developed a kind of art history that provided highly nuanced formal descriptions of the develop-ment of art and artistic movements, while detaching art history from wider claims about the culture at large.

Most famously, the first director of the Museum of Modern Art in New York, **Alfred H. Barr, Jr** (1902–81), took this kind of approach in the 1920s in his campaign to persuade a largely hostile American public to accept modern art (although he himself did belief that in the broader cultural significance of style). Two decades later the critic American critic **Clement Greenberg** (1909–94) adopted it to promote American contem-porary art as the true inheritor of the Parisian avant-garde. Barr celebrated great individuals and argued that their work would trickle down to fertilise art and taste in society more broadly. Greenberg, on the other hand, and especially in his later works, presented modern art as something specialised and autonomous, whose practice was determined by recognition of the demands of the media used. Such an understanding of 'art for art's sake' dominated Greenberg's writing in the 1950s and 1960s and represented a U-turn from Riegl's and Wölfflin's desire to make art history the key dis-cipline that would unlock other cultures' wider world-views. How to do justice to the particular appearance of works of art in the context of spe-cific cultures and how to give an account of the causes of change remained as unresolved in their art histories as it had been in Hegel's and the con-noisseurs. It remained and still remains a problem for subsequent approaches as we will see in the next chapters.

Bibliography

Gombrich, Ernst H., *Art and Illusion: A Study in the Psychology of Pictorial Representation* (London: Phaidon, 1960) [fifth edn 1977 and reprints]. Written in an accessible manner, this book contains a pithy criticism of Riegl and implicitly of Wölfflin.

Iversen, Margaret, *Alois Riegl: Art History and Theory* (Cambridge: Mass., MIT Press, 1993). A lucid investigation of Riegl's theoretical convictions and relevance today.

Olin, Margaret R., *Forms of Representation in Alois Riegl's Theory of Art* (University Park: Pennsylvania State University Press, 1992). A comprehensive account of the historical roots of Riegl's art history.

Podro, Michael, *The Critical Art Historians of Art* (New Haven and London: Yale University Press, 1982). Brief, apt and to the point critical assessment of Riegl's and Wölfflin's art histories.

Riegl, Alois, *Late Roman Art Industry*, trans. Rolf Winkes (Rome: Giorgio Bretschneider, 1985 [1901]). This is a not particularly good English translation of one of Riegl's most seminal works in which he develops most thoroughly his famous notion of the *Kunstwollen*.

Riegl, Alois, *Problems of Style: Foundations for a History of Ornament*, trans. Evelyn M. Kain (Princeton: Princeton University Press, 1992 [1893]). Riegl's account of the transformation of ornaments through the ages.

Riegl, Alois, *The Group Portraiture of Holland*, trans. Evelyn M. Kain and David Britt (Los Angeles: Getty Research Institute, 1999 [1902]). Initially published as an essay, this is the recent English translation of Riegl's fascinating study of the viewing subject as positioned by Dutch group portraits. The publication contains a helpful introduction by Wolfgang Kemp.

Wölfflin, Heinrich, *Principles of Art History: The Problem of the Development of Style in Later Art*, trans. M. D. Hottinger (London: George Bell, 1932 [1915]) [and later editions and reprints]. Wölfflin's most influential book in which his formal categories are developed.

Wölfflin, Heinrich, *Classic Art: An Introduction to the Italian Renaissance*, trans. Peter and Linda Murray (London: Phaidon, 1952 [1899]) [and later editions and reprints]. This book contains Wölfflin's famous postulate of the two roots of stylistic change, artistic vision and cultural temperament.

Wölfflin, Heinrich, *Renaissance and Baroque*, trans. Kathrin Simon (London: Collins, 1964) [reprinted 1984]. Here Wölfflin uses empathy theory to explain changes in architectural style.

Wood, Christopher S. (ed.), *The Vienna School Reader: Politics and Art Historical Method in the 1930s* (New York: Zone Books, 2000). This book contains a good critical assessment of Riegl and the Vienna School which followed him.

Woodfield, Richard (ed.), *Framing Formalism: Riegl's Work* (Amsterdam: G+B Arts International, 2001). A collection of essays that interrogate aspects of Riegl's art history.

THE ICONOGRAPHICAL–ICONOLOGICAL METHOD as practised by Erwin Panofsky (1892–1968) between c.1920 and 1968 was, with formalism, one of the two most famous and influential approaches taken in twentieth-century art history. Iconography has often been seen as the antithesis of formalism; while the latter focuses on the morphology of forms, iconography focuses on themes and ideas. Yet concern with the subject matter or meaning of works of art is only one aspect of Panofsky's approach. He also sought to ground his interpretations in a sound account of artistic form. Most ambitiously, he hoped to give interpretations of works of art that would show them to be symbolic expressions of the cultures within which they were created. Panofsky described his method as having three stages: first, a concern for the formal elements of art; second, the iconographical analysis of its subject matter; and third, an iconological analysis to show how the works under consideration formed part of the culture in which they had been produced. This may seem straightforward, but Panofsky's method is informed by a crucial theoretical notion. While every artwork is specific to its culture he also sees every cultural expression as a characteristic articulation of certain essential tendencies of the human mind. The mind, for Panofsky, is both universal (it lies behind every cultural expression) and particular (that is, it is articulated in a particular way in a particular historical context). He was thus giving his own answer to the hermeneutic problem: because the mind is both universal and particular, we can understand art objects as historically and culturally specific, and yet interpret them from another historical vantage point.

Panofsky belonged to that generation of German-speaking art historians who were students during the years that Riegl and Wölfflin published their seminal works. His great contribution to art history was to restore a conception of art which had been abandoned with the rejection of Hegel's theory: the idea that art is a particular kind of knowledge and, as such, can be related to other intellectual activities. Like Hegel, Panofsky's guiding question was to ask what kind of relationship between the mind and the world was being expressed in the art of different times and different periods. Unlike Hegel, Panofsky did not think that this was determined by the power of some kind of universal spirit. Rather, art embodied different answers to an essentially irresolvable human problem, which found par-

ticular articulation at different moments in history: namely, how the mind conceptualised the world. Unlike either Hegel or Riegl, Panofsky did not think of the progress of art as a process by which subjectivity increases and objectivity diminishes. Art was always there in order that what was subjective – the dimension that is human, conscious, and personal – could be objectified, and made independent and publicly available.

This conviction became particularly forceful for Panofsky after the Nazis came to power in Germany in 1933. Panofsky taught art history at the University of Hamburg from 1921 but by the early 1930s he also held a concurrent visiting professorship at New York University. This made it easier for him to emigrate to the USA than for many other Jews who were dismissed from their posts by the Nazis. He was appointed as a professor at the Institute for Advanced Studies in Princeton in 1935, and remained there until his death in 1968.

Panofsky's method is bound up with his personal history in that, having witnessed the authoritarian aestheticisation of politics under the Nazis, he was adamant that art-historical work must withstand this tendency. It must resist, on the one hand, the danger of a subjectivistic psychological interpretation – which leads to a privatised and emotionalised conception of art – but also, on the other hand, that of a technocratic, stimulus–response picture according to which the artistic process is merely an effective way for certain politically desirable attitudes to be called forth. This political concern emerges clearly in an article published in 1940, defending history of art as a humanistic discipline: one that embodies values such as rationality and freedom while at the same time accepting human limitations, such as fallibility and frailty. 'From this,' he concludes, 'two postulates result – responsibility and tolerance' (Panofsky, *Meaning in the Visual Arts*, 1970[1955], p. 24).

In the Anglo-American world of art history such a philosophical understanding of the discipline was, as Panofsky himself wrote in 1953, a novelty. In England, Panofsky noted, two radio speeches by art historians defending art history had been broadcast in 1952 under the title 'An Un-English Activity?' To an English gentleman, Panofsky suggested, 'the art historian is apt to look like a fellow who compares and analyses the charms of his feminine acquaintances in public instead of making love to them in private or writing up their family trees' (Panofsky, 1970[1955], p. 371).

In the USA in the 1930s, however, Panofsky experienced the discipline as full of youthful adventurousness, uninhibited by the nationalistic passions and narrow horizons of European art historians. The success of Panofsky's method is no doubt to no small extent due to the fact that his intellectual ambitiousness fell on such fertile ground. During his time in

the USA Panofsky limited discussion of the philosophical basis of his work and for the first time turned his attention seriously to matters of technique. Yet his theoretical framework remained unchanged from that which he had developed during his early years in Germany.

In bringing his own experiences and attitudes to the interpretation of art Panofsky is not exceptional. All critics and historians do this. But what is notable, though, is that he was prepared to acknowledge this. Indeed he considered it a virtue. Without a personal viewpoint, he argued, one would have no system of reference against which observations could make sense. Panofsky's method developed in response to three key intellectual encounters which shaped the three stages of his iconographical–iconological approach. The first of these is the work of the formalists. At the age of 23, just a year after submitting his PhD thesis at the University of Freiburg, Panofsky challenged Wölfflin in print. Five years later he set out to adapt Riegl's ideas to his own views regarding art and knowledge. In particular, Panofsky's concern was to make clear that formal values are never content free. In the early 1920s, after his appointment at the University of Hamburg, he came into contact with the second and third of the important influences. There he met the scholar Fritz Saxl and the philosopher Ernst Cassirer, who were associated with Aby Warburg and his famous library.

Aby Warburg (1866–1929) is also often identified as the founding father of the iconographic–iconological approach. His family's fortune allowed him to pursue his art-historical research from his own private means, developing his library according to his own interests, and employing several research assistants. Warburg called his method 'critical iconology', central to which was the discovery and tracing of motifs through different cultures and visual forms (not restricted to so-called high art). Both the words 'iconography' and 'iconology' had already had a long history. *Iconologia* was the name of a famous collection of emblems, published by Cesare Ripa in 1613. The word referred to the way that allegorical images were presented with explanatory texts elaborating their meanings. Later, iconography was used to refer to the way art historians would link motifs from a work of art to other art objects and to the textual sources available at the time. This is what the German art historian Anton Springer did in his *Iconographical Studies* published in 1860.

Warburg and Panofsky followed Springer in his conviction that the elaboration of analogies between visual and literary motifs was fundamental to connecting artworks with their culture. In contrast to Springer, however, they also believed that it is impossible to understand the significance of a picture's subject matter without knowing how it had been used before and after: rather than simply a comparison of sources at one his-

torical moment, what was needed was a history of types, which might trace themes and concepts through time. But both Warburg and Panofsky wanted to go further still, beyond the history of types to a deeper level of interpretation, which they called iconology. The aim of this was to get beyond the consciously articulated meaning of a work to its deeper significance. There were differences between the two as to what iconological interpretation amounted to, however. Warburg was particularly interested in the way that art expresses psychological tensions between irrational and rational impulses. He wanted to demonstrate how conflicting and contradictory forces in human nature manifest themselves in art and other forms of social behaviour. Panofsky was less interested in works of art as articulations of social behaviour. For him art was not the place where tensions are manifested but where they are resolved. Critical iconology for Warburg meant understanding historical material as prefiguring contemporary anxieties. For Panofsky it meant uncovering the way that particular works achieve reconciliation between subjective drives and an objective understanding of the world.

In Hamburg, Panofsky also met the third great influence on his work, the philosopher **Ernst Cassirer (1874–1945)**. They shared historical interests – in particular a concern for the thought system of Renaissance Neoplatonism – and a philosophical interest – the late eighteenth-century philosopher, Immanuel Kant. Kant's claim that we do not have knowledge of the objects of the world as they are in themselves, but only of appearances, is crucial to both Cassirer and Panofsky. Both start from the premise that forms of perception and cognition – space, time and causality – are part of the human mind. What inspired Panofsky about Cassirer's work was the way it moved from Kant's own critique of reason to a critique of culture. Kant asserted that human beings impose order on the world by organising their experience within the framework created by certain fundamental concepts such as unity, causality, or necessity – concepts that Kant called the 'categories'. Likewise, Cassirer argues that human beings create meaning and impose order on the chaos of experience through what he calls 'symbolic forms', a concept he developed in his Hamburg lectures of 1921–22.

By a symbolic form Cassirer understands those mental activities which give meanings to concrete, sensual signs. Different symbolic forms belong to different realms – for example, to myth, religion, language, science or art – but all have their origin in specific cultures and are subject to historical change. For Cassirer the objective world is not something given independently from and in opposition to the subject, but rather objectivity is constituted by the sum of the symbolic forms that result from the creative

ordering activity of the human mind. Cassirer claimed that although symbolical forms were subject to historical change, they were themselves determined by a set of a priori functions, or unchanging mental characteristics. This was very influential on Panofsky. As we see in the next section, Panofsky tried to identify such functions within the realm of art. Although Cassirer hoped that all the different symbolic forms could eventually be shown to be manifestations of the same basic functions of the human mind, he himself never provided such an account. This was also Panofsky's final ambition: to connect the symbolic content of a work of art with the kind of mind–world relation being articulated in other spheres of the culture and to set the whole process in relation to the fundamental structures of the human mind.

As will have become clear, Panofsky was one of those writers who develops his own theory by confronting and synthesising the thinking of others. We can see these three intellectual influences clearly reflected in the three stages of his method. While his critical engagement with Riegl and Wölfflin helped him articulate the first, pre-iconographical step in his method, his collaboration with the Warburg Library scholars shaped his formulation of the second step – iconographical analysis – and provided the impetus for the third stage: iconological interpretation. The latter, however, he developed in a different way from Warburg himself, under the influence of Cassirer's philosophy. Given such a range of sources it is remarkable that Panofsky's method is among the most coherent of all the approaches discussed in this book. His achievement was very similar to the one that he himself attributed to the German artist Albrecht Dürer: in taking up a series of diverse strands and sources, Dürer arrived at a new synthesis, one that involved a fundamental reassessment of the concepts at stake.

Panofsky's theoretical framework

Having surveyed Panofsky's intellectual development, we are now in a position to understand his theoretical ideas. Panofsky published on a wide range of art historical topics, but few of his works deal directly with theory and method. Nonetheless, his theoretical commitments always structure his account and he demonstrates a significantly higher level of reflection on method than most art historians. Although his theoretical commitments are sometimes obscured by the wealth of art-historical material he presents to his readers, they are fundamental to how he sets about interpreting specific works of art.

Even in his doctoral thesis on Albrecht Dürer's theory of art Panofsky was interested in issues concerning the relationship between thought and

visualisation. As such it is unsurprising that he engaged with the work of Wölfflin, whom he criticised in an article in 1915. He is particularly unsympathetic to Wölfflin's suggestion that artistic forms of vision change independently from feelings and states of mind. Wölfflin, as we have seen, took these ideas from Hildebrand and Fiedler, who in turn drew on the Kantian-influenced psychological theory that our sense organs give an order of their own to the chaotic world of phenomena. For Fiedler and Hildebrand the task of art was to reveal this specifically visual form of knowledge in a manner independent of the expressive or content-giving tendencies of the mind. This, for Panofsky, was impossible.

Starting from a very different understanding of Kant, he argues that the ordering of sense data was an activity of the higher faculties of mind and hence endowed with expression and content from the outset. Panofsky could not accept Wölfflin's separation of form and content. Wölfflin believed that although styles and forms change, the same content can be expressed in different times. So, the content that Dürer and Raphael had depicted in a linear style was the same content depicted a century later by Salvator Rosa and Rubens in a painterly style. On the contrary, Panofsky asserts, the fact that the styles are different means that the content itself has changed. Hence the same content cannot be expressed in different ages. While Panofsky did not doubt the descriptive aptness of Wölfflin's categories, he argued that no critically valid formal principles could be derived from empirical observation.

This was an argument developed in more detail in an article on Riegl's *Kunstwollen* published in 1920. Little in the article is actually about Riegl's work. What Panofsky appreciates in Riegl is the attempt to grasp art as a specific form of visual expression. Panofsky favoured Riegl's terminology rather than Wölfflin's because of its closeness to his own Kantian understanding. Panofsky saw in Riegl's *Kunstwollen* a more comprehensive kind of Kantianism than Wölfflin's: something that animates both concepts and feelings. The work of Riegl's he valued most highly was *The Group Portraiture of Holland*, in which Riegl interprets the contrast between objectivism and subjectivism as a question of content rather than, as in his earlier work, as a question of form. Yet, Riegl was guilty of a double mistake, according to Panofsky: he had interpreted these terms psychologically, and he had derived them from the observation of images rather than as a priori categories. This latter point was crucial for Panofsky. He argues for the necessity of categories which govern the varying forms of art but are themselves beyond history.

In Panofsky's view, there is a circularity in the way that Riegl moves between art and the wider characteristics of society. On the one hand, a society's visual culture is characterised on the basis of observations made

from works of art produced in that society (for example, that the Renaissance spirit of clarity and order can be seen in Raphael's painting); on the other hand, those experientially-derived categories are then used to identify the intentions behind the works of art themselves (for example, it is said that Raphael's intention was to convey the Renaissance spirit of clarity and order). In fact, Panofsky considers all attempts to determine artists' intentions to be a blind alley for art history. Even if artists have stated their intentions explicitly, these are often misleading or need some further act of interpretation in the same way that their images do. In general, Panofsky thinks that both empathy theory and the historicised psychological explanations of Riegl and Wölfflin depend too heavily on what the observer brings to the understanding of works of art to be able to offer an objective framework for art historical analysis. Only a system of categories would take art history from mere subjectivism.

What Panofsky was after was not the kind of descriptive categories that Wölfflin had prescribed, but a set of a priori principles of the kind that Kant had developed for other cognitive processes. These must be established by rational reflection quite independently of experience, derived from the mind rather than from works of art themselves. So what concepts does the mind use when contemplating art? Panofsky formulated his answer in 1924 in an, as yet, untranslated German article 'On the relationship between art history and art theory'. Panofsky's a priori principles for art embodied five pairs of oppositions. The first opposition was between 'plenitude' and 'form' (terms he adopted from Edgar Wind, a student of Ernst Cassirer's who was later professor of art history at Oxford). While the term 'form' referred to circumscribed shapes, the term 'plenitude' signalled the opposite, undifferentiated appearances. Neither absolute form nor absolute plenitude could ever be realised in a work of art. Absolute form would be no more than a purely abstract geometric figure, and absolute plenitude an appearance of light without any form at all. Yet, the two could be seen as setting the polar axis, as it were, along which any work of art must be situated.

Against this pair, Panofsky set the terms 'time' and 'space'. While 'plenitude' and 'form' expressed the fundamental artistic problem, the concepts 'time' and 'space' were the a priori categories for their solution. They were the cognitive functions within which the antithesis between 'plenitude' and 'form' was resolved. An emphasis on plenitude, for example, presupposes the preponderance of the concept of time, which rejects the division of elements imposed by space. Between those two fundamental pairs come three further pairs of concepts that underpin the appearance of all art: (1) *optical values* denoting free space are contrasted with the *haptic values* that

denote bodies – this is close to the basic problem of art, how to decide between 'plenitude' and 'form' (and Panofsky is taking his cue from Riegl here); (2) *depth* and *surface* constitute the figurative appearance of works of art; (3) and overall composition is determined by decisions made either in favour of *merging forms* or in favour of *division*. This last contrast is closely related to the concepts of space and time.

Together these categories establish the universal possibilities of art, not its actual instantiation, Panofsky emphasises. They are connected to the extent that a tendency in a work of art towards plenitude shifts the emphasis in all other spheres towards optical values, depth, merging forms and time. On the other hand, a stronger emphasis on form entails a tendency towards haptic values, surface, division and space. Any actual artwork will always be somewhere between the extremes, since his antitheses are only the categories with which the mind comprehends art. Panofsky wants to develop a viewpoint from which the distinctiveness of artworks can be appreciated, something he believes is only possible within this overall system of reference. It is only such a system that enables us to detect differences and similarities between works and establish their meaning. This system is supposed to take interpretation beyond subjective projection and into the objective realm. Panofsky's categories are not arbitrary, or merely personal; they correspond to fundamental structures that, he believes, are involved in any attempt by human beings to know the world. While Wölfflin based his categories on his observation of works of art, Panofsky's most challenging point for art historians is his claim that formal analysis already assumes the existence of such categories. Terms such as 'painterly' and 'linear' cannot be justified on the basis of empirical observation alone: counter-examples are always easily found, as we have seen in Gombrich's critique of Wölfflin. For Panofsky, empirical observations can show the solutions artists give to artistic problems but cannot reveal the underlying problems themselves. These can only be identified from a knowledge of the a priori principles which provide the framework for the work.

All this is extremely abstract philosophical stuff and yet it underpins one of Panofsky's most famous pieces of art history, his essay 'Perspective as Symbolic Form', which appeared in 1927. Although it was only translated into English in 1991, it might well be the single piece of writing by an art historian that has had the most influence on other disciplines in the humanities. Panofsky's main claim is that perspectival construction is not an objective way of seeing the world, which was achieved by progressive experimentation in the Renaissance, but a conventional cultural symbol. He contrasts antique and Renaissance forms of perspective and states that antique perspective is the expression of 'a specific and fundamentally

unmodern view of space' (Panofsky, *Perspective as Symbolic Form*, 1991, p. 43). According to Panofsky, perspective in antiquity was constructed in relation to subjective optical impressions. We do not see with a single, fixed eye, but with two constantly moving eyes. The result is an aggregate space rather than a modern systematic space and this is what antique art attempts to render. If we follow Panofsky's own a priori criteria, which are implied but not explicitly articulated in this essay, form and plenitude coexist next to each other without being resolved into a unified view of space and time. On the one hand, bodies are clearly rendered in an almost tangible manner; on the other, when antiquity attempted to articulate the surrounding space, it became an intervening medium with an independent vibrancy:

> Antiquity . . . lacking a domineering unity, must, so to speak, purchase every spatial gain with a loss of corporality, so that space really seems to consume objects. This explains the almost paradoxical phenomenon that so long as antique art makes no attempt to represent the space between bodies, its world seems more solid and harmonious than the world represented by modern art; but as soon as space is included in the representation, above all in landscape painting, that world becomes curiously unreal and inconsistent, like a dream or a mirage. (Panofsky, 1991, pp. 42–3)

The Renaissance, by contrast, articulates an understanding of space as homogenous and infinite which is constructed according to the vanishing axis principle. In this way, according to Panofsky, Renaissance perspective abstracts from the immediate psycho-physical nature of visual space as it is experienced by the ordinary person perceiving the world. It places all objects in relation to a single static eye and establishes a flat plane of projection.

In moving away from immediate experience the Renaissance established a breakthrough of permanent importance for Western art. Its system of spatial representation provided a context within which the fundamental artistic problem of plenitude and form could be resolved. Figures could be clearly defined yet related to one another in the depth of space. Instead of being mutually exclusive, the oppositions that Panofsky had seen running through the history of Western art could be articulated as a unity. From now on, modern art might give greater weight to one or other half of the set of oppositions, but these would be linked rather than being competing demands. So, for example, Panofsky writes that Impressionism tends towards plenitude and time and all of their values, yet it always presupposes that higher unity of homogenous space: 'This is how Impressionism can so persistently devalue and dissolve solid forms without ever jeopardizing the stability of the space and the solidity of the individual

objects; on the contrary, it conceals that stability and solidity' (Panofsky, 1991, p. 42).

Perspective, for Panofsky, was one of the 'symbolic forms' in which, in Cassirer's words, 'spiritual meaning is attached to a concrete, material sign and intrinsically given to this sign' (Panofsky, 1991, p. 41). The representational space introduced by Renaissance perspective made possible the objective coexistence of competing forms in a way that was impossible in ancient art and thought. Yet it also anchored vision to a specific viewpoint which allowed a relation between the subject and the object perceived that was unthinkable in Antiquity.

Describing and analysing the symbolic form in which art presented itself was only one step in Panofsky's interpretative procedure. His ambition was to reach a deeper level at which art would be identifiable with the world-view of the age. Panofsky took the mind–world relation expressed in perspectival art to reveal the general attitude of the age and he accompanied his discussion with accounts of the forms of thought that were expressed in contemporary geometry, philosophy and cosmology. In doing so, Panofsky departed considerably from Cassirer. Cassirer never thought that different systems of symbolic forms could be aligned in one world-view. Furthermore, it would be impossible for Cassirer to describe one perspectival form as being closer to the actual retinal image than another, as Panofsky does when he compares ancient and modern systems of perspective. According to Cassirer, there can be no natural point of reference for modes of representation. It is impossible to talk about Renaissance perspective as a symbolic form created by abstraction since there is no natural substratum from which to abstract.

An even more fundamental difference between Panofsky and Cassirer was that Cassirer understood the mind's activities to be principally objective. Instead of looking for the universal elements in the subjective reactions to the world of particular individuals, ages, and cultures, the problem, as he saw it, was rather the opposite: how a shared set of mental structures could nevertheless take on so many different forms. Panofsky, on the other hand, was far more traditional in his understanding of the relationship between the mind and the world – far more Hegelian, in fact. Experience is first and foremost subjective; if and only if it is reflected upon in the mind can it become objective. The weakness of *Perspective as Symbolic Form* is that, although Panofsky sets out to show that the modern system of vanishing-point perspective is a cultural construct, as the essay progresses, he comes to present it as the visual symbol of his own Kantian convictions. According to Panofsky, perspective holds subjectivity and objectivity in balance, just as Kant's epistemology links the world given to the senses and

the understanding as the twin conditions of experience. Just as with Riegl and Wölfflin, what starts out as cultural relativism turns into the advocacy of an ideal inspired by Panofsky's own ethical convictions. In all his later art-historical writing, whether on Dürer, Gothic architecture, Jan Van Eyck or Michelangelo, Panofsky assessed art according to the degree to which the mind and the world, the spiritual and material, subject and object were resolved into a harmonious unity.

One further element is also present in this early essay, which would recur in Panofsky's writing: the principle of disjunction. For Panofsky one culture can understand the products of another only when there is enough difference and distance between the two, and then only by assimilating, incorporating and appropriating it according to its own interests. This idea was to influence the Marxist cultural critic Walter Benjamin. Benjamin was greatly impressed with Panofsky's *Perspective as Symbolic Form*. In one passage in particular, Panofsky reveals himself to be a dialectical thinker in a way that would appeal to Benjamin. Panofsky argues that, in order for the Renaissance system of perspective to come about, a vision entirely anti-thetical to the ancient perspective system had to have been developed during the Middle Ages. Only against this could the Renaissance appreciate anew the achievements of ancient geometry and synthesise them with the con-ceptualisation of infinite space in medieval art:

> When work on certain artistic problems has advanced so far that further work in the same direction, proceeding from the same premises, appears unlikely to bear fruit, the result is often a great recoil, or perhaps better, a reversal of direction. Such reversals, which are often associated with the transfer of artistic 'leadership' to a new country or a new genre, create the possibility of erecting a new edifice out of the rubble of the old; they do this precisely by abandoning what has already been achieved, that is, by turning back to apparently more 'primitive' modes of representation. These reversals lay the groundwork for a creative reengagement with older prob-lems. (Panofsky, 1991, p. 47)

Panofsky addressed this problem of how art changes over time and how distances and differences are bridged many times. The late collection of much earlier essays that first appeared in 1955 under the title *Meaning in the Visual Arts*, is largely concerned with this question, as is his *Renaissance and Renascences in Western Art* of 1960.

Panofsky's method in action

Panofsky confronted the difficult task of presenting his method theoreti-cally four times, twice while he was still in Germany (in the introduction

to a collection of essays, *Hercules am Scheideweg* that appeared 1930, and in an article in the journal *Logos* of 1932) and twice in the USA (in the introduction to *Studies in Iconology* of 1939, and, finally in a chapter in *Meaning in the Visual Arts*). The different contexts for which he was writing demanded slight changes but his argument remained essentially the same. While in 1930 Panofsky described his method only as iconography, in 1932 he used entirely different terms adopted from the Austrian sociologist Karl Mannheim. In his first publication in the USA he spoke of 'pre-iconographical description', 'iconographical analysis' and 'iconographical interpretation in the deeper sense' in order to give his three steps a name. Only in 1955 did he introduce the term 'iconological interpretation' to describe the last and most penetrating stage of his interpretative procedure. The following discussion takes this last version as its basis.

Famously, Panofsky started his discussion with an everyday scene: what happens when an acquaintance greets us on the street by raising his hat? His point is that our apprehension of the scene must be more than a mere perception from the start. If it were purely perception we can only say that we discern a general pattern of colour and light from which particular forms emerge. In fact, we perceive a man raising his hat and in identifying this, Panofsky says, we have already gone beyond the limits of purely formal perception and identified subject-matter or meaning. This, we might remember, was his objection to formalist art history as proposed by Wölfflin: content cannot be separated from form. So far, our understanding of the scene is limited to its factual meaning. Interpreting the scene in this factual and expressive manner constitutes what Panofsky describes as **pre-iconographical description**. The action, however, elicits a second response, one which interprets the gesture as either friendly, indifferent or hostile. When we read the lifting of the hat as a form of greeting, we are in the realm of **iconographical analysis**. This presupposes that we are familiar or have the means to make ourselves familiar with the habits and customs of the civilisation to which the man belongs. This step in our understanding goes beyond what is presented to the senses and relates the action to cultural conventions.

Finally, Panofsky writes, we read the action of the man on the street in a manner beyond what is visible or intelligible from a familiarity with conventions. This he calls **iconological interpretation**. We understand the man as a personality conditioned by his age, social and educational background, previous life and present surroundings. This mental image of him is not arrived at by seeing the action alone, but by coordinating in our mind a large number of relevant pieces of information regarding his nationality, class, and so forth. All these coordinates are only implicit in the action, but

they allow us to make sense of it. Such an interpretation is, of course, what Panofsky hopes he can provide when he interprets art objects. It proceeds on the organicist assumption common in art history since Hegel: the view that every individual articulation determines and is determined by the whole of the cultural and social context.

Starting with an everyday scene in order to outline his practice might suggest a method that consists of easy-to-come-by, commonsensical interpretations. As any reader of Panofsky's art history knows, nothing could be further from the truth. The wealth of learning and range of comparative material that goes into Panofsky's work is impressive. Yet Panofsky is serious when he says that a layperson might be better equipped than a specialist to perform the pre-iconographical description and the iconological interpretation of art. The pre-iconographical needs practical experience in the world, while the iconological, since it is about capturing the world-view that forms the framework for a society's engagement with reality, requires a special 'synthetic' intuition of a sort that does not come from mere factual research. Only the relation of the work of art to specific themes or concepts that are transmitted through literary sources requires extended learning. Yet Panofsky also insists that it is the scholar who must ensure that the interpretation does not become subjective or irrational.

He outlines a control mechanism for each step and it is clear that these all require scholarly training. In order to arrive at a correct pre-iconographical description of artistic forms, we need to be familiar with the history of style. We will not be able to understand the forms of, for example, an Impressionist painting, if we do not place it in a sequence of styles. In order to identify the painting's special character we need to relate its appearance to realist or expressionistic styles. This, Panofsky says, is done almost intuitively by anyone familiar with the history of Western art. In his 1932 article, Panofsky asserted that the history of style had to be informed by an understanding of the possible modes of representation available to art. He clearly had his own a priori categories in mind. In order to arrive at a correct iconographical analysis we need to check our correlation of literary sources and image with a history of types, that is, of the way in which specific themes and concepts were expressed under different historical conditions. The last step, the iconological, also needs a control mechanism because it is so dependent on the personal psychology of the interpreter. For Panofsky, the danger of an overly subjective account is averted by a general knowledge of the history of culture and a familiarity with what he regards to be the essential tendencies of the human mind throughout history. Panofsky summarises his scheme in a table, although he also emphasises that the three steps are never simply followed one by one. Rather, all three levels of interpretation are active at the same time.

Object of interpretation	Act of interpretation	Equipment for interpretation	Corrective principle of interpretation
I *Primary or natural subject matter* (A) factual, (B) expressional, constituting the world of artistic motifs	*Pre-iconographical description* (and pseudo-formal analysis)	*Practical experience* (familiarity with *objects* and *events*)	History of *style* (insight into the manner in which, under varying historical conditions, *objects* and *events* were expressed by *forms*)
II *Secondary or conventional subject matter, constituting the world of images, stories* and *allegories*	*Iconographical analysis*	*Knowledge of literary sources* (familiarity with specific *themes* and *concepts*)	History of *types* (insight into the manner in which, under varying historical conditions, specific *themes* or *concepts* were expressed by *objects* and *events*)
III *Intrinsic meaning* or *events, constituting the world of 'symbolical'* values	*Iconological interpretation*	*Synthetic intuition* (familiarity with the *essential tendencies of the human mind*), conditioned by personal psychology and '*Weltanschauung*'	History of *cultural symptoms* or '*symbols*' in general (insight into the manner in which, under varying historical conditions, *essential tendencies of the human mind* were expressed by specific *themes* and *concepts*)

Melancholia I

Let us turn now from a general account of Panofsky's method to his inter-
pretation of Albrecht Dürer's engraving *Melancholia I* of 1514 (Figure 11). Few
images in the history of Western art have been so widely and richly dis-
cussed by artists and scholars. The print's interpretation has changed
according to the times, cultures and minds which have engaged with it.
Shortly before Panofsky embarked on his interpretation, art historians of

the stature of Wölfflin and Warburg had added their voices to this stream. The Viennese art historian, Karl Giehlow, had begun a comprehensive study aimed at deciphering the various items scattered around the figures in the engraving. When Giehlow was unable to complete his work, his editors asked Warburg to continue with it. When Warburg fell ill, his assistant, Fritz Saxl, took over. Saxl contacted Panofsky, then a new lecturer at the

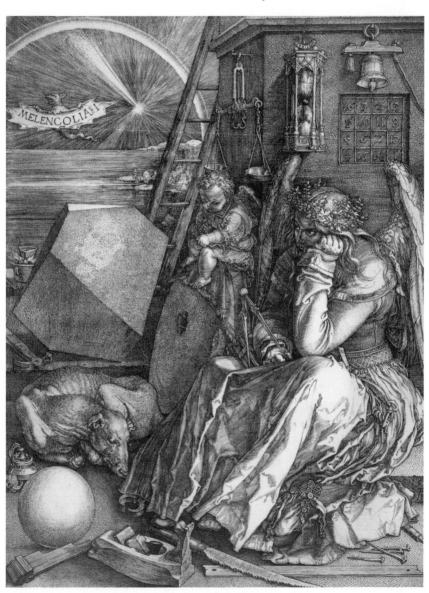

11 Albrecht Dürer, *Melancholia I*, 1514, engraving, 24.1 × 19.2 cm, British Museum, London

University of Hamburg, whose dissertation had been on Dürer. What made the engraving a challenge to the scholars of Warburg's circle was the way it referred in the title to a well-known pictorial and literary figure, melancholia, yet showed many elements which did not fit this tradition. When Saxl and Panofsky published the results of their research in 1923 what distinguished their interpretation from earlier ones was their attention to the various strands and traditions of images that were transformed in Dürer's engraving. The research appeared summarised in English in Panofsky's monograph on Dürer of 1943 and again in 1964 in the much wider context of a study on the themes of Saturn and melancholy in natural philosophy, religion and art which Panofsky published in collaboration with Saxl and Raymond Kilbansky.

A pre-iconographic analysis of Panofsky's kind does not start by just noting the dramatic distribution of light and shade and the compositional arrangement. Instead, it starts with an identification of the figures as they are given to us in our practical experience in the world. Thus, we may begin by recognising a grumpy, dishevelled woman sitting among a disorderly collection of stuff. She sits in front of a building, not far from the sea, resting her head in one hand and holding a compass in the other. The scene is dimly illuminated by the light of the moon, something that we can infer from the shadow cast by the hourglass on the wall. She seems not to notice the comet and the rainbow in the evening sky behind her. She is not alone. A morose little child scribbling on a slate sits next to her on an old grindstone while a half-starved dog sleeps at her feet.

This description is not neutral but mixes factual and expressive identifications. Panofsky suggests that this is how we respond to any scene. For many of us our own experience of the world will not take us very much further. Christmas traditions might enable us not to be baffled by the wings on the shoulders of the woman and so recognise her as an angel and the small child as a putto. We might also be able to recognise the ladder attached to the building, the pair of scales, the hourglass and the bell. Many of the tools clearly belong to the crafts of building and carpentry: a plane, a saw, a ruler, nails, a hammer, etc. There is a melting pot in the background and an inkpot in the foreground. The truncated rhombohedron of stone and the turned sphere of wood seem to belong to a different realm – geometry and applied mathematics. That we are so confident in identifying the figures and objects in this image is to no small extent due to the fact that we have tacitly given the print a place in the history of styles. We can talk about the woman crouching in front of a building and assume that the tools are hers because we have already recognised that this image does not embody the aggregate space of pre-Renaissance art but assumes a homog-

enous infinite space in which all objects are functionally related. We might also recognise the engraving line as characteristic of Northern European Renaissance prints and we might note a particularly Dürer-like preoccupation with cubes and volumes, although in a way that is quite dissimilar to early twentieth-century cubism.

But some elements will elude us. The square with numbers on the wall may look like a weird version of 'Noughts and Crosses' but is a magic square, an astrological talisman which has the power to counteract melancholy. Here, we clearly need learning requisite for the second level of iconographic analysis. It must be admitted that we have not got very far by means of what is already quite an extensive piece of analysis. What is required next, if we follow Panofsky, is not simply an interpretation of our description, but the gathering of the material that will permit this. Literary sources, for example, will tell us that our understanding of melancholy as a passing mood or *Weltschmerz* is inappropriate to Dürer's engraving. Rather the title 'Melancholia I' that is inscribed on the wings of the bat in the sky refers to the ancient theory of the four humours. This supposed that the body and mind of man were governed by four basic fluids, related to the four elements, the four winds, the four seasons, the four times of day, the four phases of life and so on. If one element were to dominate a person's constitution, then they would become choleric (governed by yellow gall and fire, related to summer and maturity), phlegmatic (governed by phlegm and water, related to winter and old age), sanguine (governed by blood and air, related to spring and youth), or melancholic (governed by black gall and earth, related to autumn and middle age).

In the Middle Ages the four humours were commonly represented either as single figures, often with characteristic occupations (such as the Choleric as a warlike man, and the Melancholic as an elderly, cheerless miser) or as dramatic figures acting out their characteristics. Panofsky remarks that what is noticeable about this latter tradition is the way the temperaments derive from the theological characterisation of the vices. In this context melancholia becomes 'acedia', laziness.

In Dürer's image, however, much of the traditional iconography is altered. While in earlier depictions, two equally slothful figures were to be seen, here a contrast is emphasised between the inaction of the figure of Melancholia and the absorbed hyperactivity of the putto. Furthermore, the paraphernalia scattered around the figures points to a different type of representation, the '*Typus Geometriae*':

> Thus Dürer's engraving represents a fusion of two iconographical formulae hitherto distinct: the 'Melancholici' of popular Calendars and 'Complex-büchlein,' and the 'Typus Geometriae' of philosophical treatises and ency-clopaedic decorations. The result was an intellectualization of melancholy

on the one hand, and a humanization of geometry on the other. The former Melancholics had been unfortunate misers and sluggards, despised for their unsociability and general incompetence. The former Geometries had been abstract personifications of a noble science, devoid of human emotions and quite incapable of suffering. Dürer imagined a being endowed with the intellectual power of technical accomplishments of an 'Art,' yet despairing under the cloud of 'black humour'. He depicted Geometry gone melancholy or, to put it the other way, a Melancholy gifted with all that is implied in the word geometry – in short, a 'Melancholia artificialis' or Artist's Melancholy. (Panofsky, *The Life and Art of Albrecht Dürer*, 1995[1943], p. 162)

For Panofsky, Dürer synthesised these strands into an entirely new meaning – an active striving artistic imagination which despairs at its own limits – and this makes his print into a true symbolic form. He interpreted every detail of the picture in the light of this meaning, right down to the significance of the plants in the wreath (said to be a palliative against the dangers of the melancholic humour). Dürer himself had given an explanation for the key and the purse that dangle down from Melancholia's belt: the key denoting power and the purse, wealth. Not that this is particularly revealing. Panofsky shows that both items were traditional attributes of the melancholic and the related planetary ruler Saturn. Yet from other writings we can tell that for Dürer wealth was a well-deserved reward for an artist's labours and power bestowed by God on ingenious people. The disordered and neglected condition of the key and the purse in *Melancholia I* indicates the dejected state of affairs, the temporary absence of both.

At this point in his analysis Panofsky goes on to relate the specific symbolic form of *Melancholia I* to the world-view of Dürer and his time. We have now reached the level of iconological analysis where we begin to understand the image as an expression of a personality conditioned by their age and by their social and educational background. According to Panofsky, the particular fusion of elements in the engraving corresponds to the way that contemporary Neoplatonic philosophy associated melancholy with genius. The Florentine Neoplatonist, Marsilio Ficino, restricted the idea of genius to those who led a contemplative life – philosophers, theologians and poets – and so were able to search for the highest and most secret principles. Artists, since their imagination exercises itself in the world of perceptions, are bound more to base *materia* than *spiritus*. Panofsky identified an early version of an occult text by the German Cornelius Agrippa of Nettesheim which was known, he claimed, in Dürer's circle. Along with much occult lore, the text expounds and expands Ficino's Neoplatonism. It explains the number in Dürer's title. According to Agrippa, *Melancholia I* was the first stage of creative melancholy, operating on the sensory world. While stage 2 was governed by reason and controls the sphere of judicial

and political action, and stage 3 by the intuitive mind, the prerogative of theologians, stage 1 was ruled by imagination and thus fell under the aegis of artists and craftsmen. From this, Panofsky concludes:

> Thus Dürer's most perplexing engraving is, at the same time, the objective statement of a general philosophy and the subjective confession of an individual man. It fuses, and transforms, two great representational and literary traditions, that of Melancholy as one of the four humors and that of Geometry as one of the Seven Liberal Arts. It typifies the artist of the Renaissance who respects practical skill, but longs all the more fervently for mathematical theory – who feels 'inspired' by celestial influences and eternal ideas, but suffers all the more deeply from his human frailty and intellectual finiteness. It epitomizes the Neo-Platonic theory of Saturnian genius as revised by Agrippa of Nettesheim. But in doing all this it is in a sense a spiritual self-portrait of Albrecht Dürer. (Panofsky, 1995[1943], p. 171).

Whether he was trying to prove the direct influence of Neoplatonism on Renaissance artists, as he did with Dürer, Michelangelo and Titian, or not, all of Panofsky's interpretations treated the works discussed as expressions of the artist's struggle to objectify subjective impulses and turn private feelings into general statements. In Dürer's case he saw the artist as engaged in an effort to bring into balance creativeness and imitation, originality and rule following. In Michelangelo there was an attempt to spiritualise bodily desires, in Van Eyck the search for a way to infuse every fragment of 'reality' with spirituality. Thus Panofsky's own Neo-Kantian *Weltanschauung*, in which subjectivity and objectivity are jointly the conditions for experience, is at work everywhere in his interpretations. The correspondence that Panofsky saw between Neo-Kantian epistemology, the Renaissance theory of perspective and Neoplatonism, led him to assume that his own position was more than a projection on his part. It was his insight into what he took to be the essential tendencies of the human mind. Panofsky's Neo-Kantianism played the same role for him as the assumption of a universal spirit did for Hegel and the historicised psychology of perception for Riegl and Wölfflin. It provided him with a framework which made it possible to appreciate the cultural productions of the past as distinct from us yet accessible to interpretation from the perspective of the present.

Critical appraisal

There is no doubting Panofsky's phenomenal contribution to art history. He dramatically broadened what would be considered legitimate material for consideration by art historians. He also clearly identified the problems

in contemporary approaches: on the one hand, a kind of archaeological art history had emerged which tried to give a cause-and-effect account of works of art by relating them to non-artistic phenomena; on the other, formalist interpretation threatened to sever works of art from the cultures which gave rise to them. A cause-and-effect explanation, Panofsky pointed out, tends to be circular — while one person, for example, might explain the emergence of the Baroque as a result of the Counter-Reformation, another might turn this round and explain the Counter-Reformation as conditioned by the Baroque style. On the other hand, to treat art without relating it to the cultures that give rise to it is unacceptable. Panofsky's theory and method represented a systematic effort to avoid these problems. Yet, like all systematic viewpoints, it proceeded from assumptions that are open to serious challenge. The first charge is that Panofsky over-intellectualises art. The second is that history, as a matter of changing social relations, is noticeably absent from his accounts. The third is that Panofsky subjects all objects and historical epochs in his purview to what he assumes to be the universal natural and rational tendencies of the human mind. In doing so, it might seem as if Panofsky homogenises cultures and effaces conflict and differences. Although these objections interrelate we want to address them one at a time.

(1) *Does Panofsky over-intellectualise art?*

If we take the alternative to be that art is a non-rational and purely emotional activity, the allegation is so obviously absurd that it would not warrant discussion. In fact, it is a real strength of Panofsky's view of art that he proceeds from the assumption that in an expressive form like art the rational and emotional aspects will always inform each other. If we take the objection, however, to say that in Panofsky's iconography—iconology the visual image is too greatly absorbed by linguistic forms of thinking, there is a serious point.

Panofsky starts by insisting that art must be explained in its own terms and not by reference to other non-visual phenomena. Yet it is also clear that he believed that art was a cognitive activity amenable to analysis by the rational mind and, therefore, its relationship to textual expression seemed less problematic than its relationship to other forms of social behaviour. It is for this reason, according to critics, that Panofsky concentrates his art history on periods in which art was linked through a patronage system to theological and philosophical programmes. Clearly, he also thought that the art of his own time had abandoned the concern to articulate the subject—object relationship that interested him. Dürer's cubistic mode of vision, he writes, is different from modern Cubism because

it was, unlike its modern counterpart, intended, 'not as a justification for breaking away from what is commonly understood by "reality" but, on the contrary, as an aid to clarifying and mastering it' (Panofsky, 1995[1943], p. 202). In his essay, 'Style and Medium in the Motion Picture', first published in 1937, Panofsky did concern himself positively with a very contemporary art form. Yet what Panofsky praises is the conventional popular form of film which, in contrast to modern literature or avant-garde art, preserves the synthesis of form and content, technique and narrative, and a clear correspondence between inner and outer 'reality'. One might say, as W. J. T. Mitchell has done, that 'modernism becomes intelligible, for instance, precisely as a resistance to Panofsky's iconology' – that modernism is the very opposite of Panofsky's emphasis on organic wholes, his literary orientation and his bias towards figurative rather than abstract art (Mitchell, *Picture Theory*, 1994, p. 28).

Yet many other art historians have shown that modernist art is by no means resistant to an iconographical reading. Some have explicitly set out to argue that, despite Panofsky's own prejudices, his method can yield remarkable insights when applied to modern and contemporary art – that, for example, Cubism is precisely the kind of construction of 'reality' Panofsky had in mind when he rejected naive assumptions about mimesis. In general, however, the relationship between 'icon' and 'logos', between image and word, remains one of the hot issues of contemporary art theory, much discussed by philosophers and theorists such as W. J. T. Mitchell. The question is how to conceptualise a purely visual form of understanding independent of discursive thought without returning to the naive psychologistic assumptions of Riegl and Wölfflin. Here let us just note that Panofsky does indeed work on the understanding that art is a particular visual expression governed by the higher faculties of the mind, the 'logos'.

(2) *What kind of history is at stake in Panofsky's work?*

History of the kind that interested Warburg, constituted by individuals involved in social situations of choice and conflict, does not appear. History, from Panofsky's perspective, is principally the story of changing mind–world relationships. His book on Dürer does include a fair amount of biographical information, yet there is little sense of the social tensions of the Reformation in the book. Dürer's conversion to Lutheranism is treated solely as an expression of his mental struggle to conceptualise the world.

In his book on Gothic architecture, Panofsky perceptively writes that the postulation of a certain parallelism between art and other cultural

manifestations will not be enough to show the affinity between scholastic thought and Gothic art. Nor could a narrow cause-and-effect account of the influences on individuals and their works do this. Yet, beyond stating in general that scholasticism reached the architects of the cathedrals through their education, we get very little sense of why it should be that Gothic churches appear as the perfect embodiment of the scholastic habit of mind. Wölfflin's demand that we should find the path that leads from the cell of the scholar to the mason's yard, remains unanswered by Panofsky.

Possibly the most common criticism of Panofsky's method is that it leads interpreters to identify a deeper meaning behind every aspect of a work of art and to link it to other cultural manifestations by no more than apparent analogy. Panofsky himself was not unaware of this danger. 'There is,' he wrote, 'admittedly some danger that iconology will behave, not like ethnology as opposed to ethnography, but like astrology as opposed to astrography' (Panofsky, *Meaning in the Visual Arts*, 1970[1955], p. 58). Yet, not wanting to limit himself to narrow cause-and-effect accounts nor happy with a mere parallelism, Panofsky had no better mechanism to offer as a guarantee for the reasonableness of his accounts than his synthetic intuition, conditioned by his own *Weltanschauung* and the personal psychology of an émigré Jew optimistically holding on to humanist values in the face of personal and historical tragedy. Separated in time and circumstance from Panofsky's particular social experience, many scholars have rejected the set of values that underpins his enterprise.

(3) *Is Panofsky's homogenised view of the past defensible?*

In principle, Panofsky's scheme allows for other sets of values or *Weltanschauungen* to condition the interpreter's synthetic intuition. This will inevitably mean that the scholar will look for different objects and sources relevant to his or her interpretation. In 1978 the German art historian Konrad Hoffmann, for example, advanced an entirely different, equally comprehensive, interpretation of *Melancholia I*. Instead of Panofsky's humanist, Dürer appeared in this reading as a pious man of the Medieval Age. Similarly, from a feminist perspective which sees the struggle of the sexes as a fundamental feature of human history, attention shifts away from Panofsky's Neoplatonist interpretation of Titian's *Sacred and Profane Love* towards historic understandings of sexuality and the interests of Titian's patrons, as it has in a reading by the American art historian Rona Goffen (1944–2000). Yet such readings, although they do not share Panofsky's specific underlying set of values, at least share his conviction that artworks are amenable to a coherent interpretation which can situate them meaningfully within the larger set of beliefs of their age.

Even this view has come under attack in the last twenty years or so. Christopher Wood, for example, in his introduction to his translation of Panofsky's *Perspective as Symbolic Form*, states that iconology 'has not proved an especially useful hermeneutic of culture' because Panofsky was unwilling to perceive that cultures are not homogenous but arbitrary, irrational and faulty (Panofsky, *Perspective as Symbolic Form*, 1991, pp. 23–4). In the 1920s the German Marxist Walter Benjamin had already proposed a reading of *Melancholia I* which denied that the image's elements cohered in a single meaning. In his hands the engraving became a field of fragments which contradicted each other and played off each other ambiguously. In this way the print pointed, for Benjamin, to tensions and faults. Moreover, it also testified to a ruined world of meaning inaccessible to the historian of the present.

What mattered ultimately to Benjamin was not an objective image of the past but a motivated engagement from the present with its fragments. In contrast to today's postmodernist writers, who have seen in Benjamin a kindred spirit, Benjamin himself believed that engagement with the past must be motivated by a conviction of the progress of history leading to the overthrow of capitalism. (This view of history is the subject of Chapter 7.) In an article on the collector Edward Fuchs, Benjamin states that any collection assembled from a specific viewpoint, even if its validity has passed, is preferable to mere hoarding or fact-gathering. If we extend this dictum to art history, we might say of Panofsky's art history that, although we can recognise its basis in a particular point of view that we might not share, it makes certain aspects salient and in so doing gives us a perspective we might not have otherwise had. Its coherence forces us to test our own viewpoints against it, and so it brings out ambiguities in our assumptions and leads us to reconstruct our position. It is in this sense that Panofsky has been for twentieth-century art history what Hegel was for the art historians of the nineteenth.

Bibliography

Camille, Michael, 'Walter Benjamin and Dürer's Melancholia I: The Dialectics of Allegory and the Limits of Iconology', *Ideas and Production*, 5 (1986), pp. 58–79. Contrasts critically Panofsky's interpretation with Benjamin's.

Holly, Michael Ann, *Panofsky and the Foundations of Art History* (Ithaca: Cornell University Press, 1984). This was the first comprehensive study of Panofsky's early theoretical work in English. The conclusion, in which the author argues that Panofsky provided for art history what the French critic Michel Foucault did subsequently for cultural studies, is problematic.

Kilbansky, Raymond, Panofsky, Erwin and Saxl, Fritz, *Saturn and Melancholy* [1964] (Nendeln: Kraus-Thomson, 1979) pp. 284–373. The authors trace and discuss one theme in

its transformations from ancient medicine to modern art. Dürer's *Melancholia I* is discussed at great length.

Mitchell, W. J. T., *Picture Theory* (Chicago: Chicago University Press, 1994). Interrogates Panofsky's art history briefly at the beginning from the point of view of a critic of ideology. Also provides stimulating reflection on the relationship between texts and images.

Panofsky, Erwin, *Studies in Iconology: Humanistic Themes in the Art of the Renaissance* (Oxford: Westview Press, 1972[1939]). Contains Panofsky's first English outline of his method and articles tracing themes in Renaissance art, including his discussion of the influence of Neoplatonism on Titian and Michelangelo.

Panofsky, Erwin, *The Life and Art of Albrecht Dürer* (Princeton: Princeton University Press, 1995[1943]). An extremely accessible monograph which was intended for the general public.

Panofsky, Erwin, *Meaning in the Visual Arts* (Harmondsworth: Penguin, 1970[1955]). This is Panofsky's most famous collection of essays and contains his second English outline on method, as well as a well-known article on Poussin. It also contains his defence of Humanism and several articles (on the history and theory of human proportions, on Vasari, Dürer and Titian) which had previously appeared in German.

Panofsky, Erwin, *Renaissance and Renascences in Western Art* (Stockholm: Almqvist and Wiksell, 1960) [and later editions]. Concerns the reformulation and assimilation of classical art.

Panofsky, Erwin, *Gothic Architecture and Scholasticism* (New York: Meridian, 1976[1957]). Here Panofsky analyses Gothic architecture as an embodiment of scholastic thought.

Panofsky, Erwin, *Perspective as Symbolic Form*, intro. and trans. Christopher S. Wood (New York: Zone Books, 1991). Wood provides a critical introduction which argues that Panofsky's iconology has not been a particularly fruitful method of interpretation.

Podro, Michael, *The Critical Historians of Art* (New Haven and London: Yale University Press, 1982) pp. 178–208. Still one of the most penetrating critical accounts of Panofsky's art history.

WITH THIS CHAPTER we reach a turning point in this book. So far we have examined a number of systematic histories of art, each of which gives a single explanation for artistic change. They try to identify one principle that can explain every aspect of art. For Hegel this explanation was provided by the metaphysical assumption of the developing mind. For the connoisseurs the history of art was propelled by the self-realisation of individual geniuses. The systematic formalists, Riegl and Wölfflin, located the driving force in the development of human psychology, and the iconographer Erwin Panofsky saw it in changing conceptualisations of the world. Early Marxist art historians too tried to give a straightforward cause-and-effect account of art's changing appearances. Following the economic analyses of the nineteenth-century socialist revolutionary, **Karl Marx (1818–83)**, they saw the cause for artistic change in the changing economic organisation of society – the different technologies used and the different organisation of labour which results from this. For the Marxists, art and other forms of cultural expression (for example, philosophy, religion, law, and the like) were part of a superstructure which is determined by the nature of the economic base. As part of that superstructure, art reflects economic reality, in the Marxist view. So, when economic changes occur these cause parallel shifts in the cultural sphere.

This so-called 'orthodox Marxist' view was criticised in the second half of the twentieth century by writers who shared Marx's concern with the inequalities and injustices that lie at the heart of existing societies, but who doubted that the base-superstructure model was sufficient to explain the complex relationship that art has with its social environment. In the accounts of these authors changes in the way that art presents itself cannot be accounted for simply by reference to transformations in the economic base. In proposing far more diffuse and pluralistic models of historical agency these art historians were at the forefront of a general shift in art history which will take up the second part of this book. Since the 1970s, art historians, like their colleagues in other disciplines, have become suspicious of the kind of generalisations about the human condition and identification of transcendental ideals that ran through earlier systematic accounts. They have also become suspicious of explanations of art that refer to global changes in the economy and society. Instead they concentrate

on the analysis of the specific historical circumstances in which a work of art was produced. The social roots of works of art are much more concretely identified in these accounts. They include religion, politics and gender, as well as economics, without privileging any one of them. Although differing in many ways, such approaches to art history share the fact that they reject any unifying notion of historical agency or mono-causal explanation, as we see in the following chapters.

At this point an important qualification is needed. It is sometimes said that what is characteristic of Marxist art history and social art history, is that their practitioners accept the influence of social and political circumstances on art. Yet, put like this, this is something so obvious that it is hard to think of any art historian who would reject it. Finding a way of showing the connection between art and society was of prime concern to every art historian discussed in this book so far. What is at stake for Marxism and social art history is not the embeddedness of art in society but the nature of this relationship and its consequences. Marxists and social art historians have often objected to earlier approaches for glossing over the way that concrete social processes and conflicts determine the production of artworks. From the 1920s, Marxist art historians set themselves the task of showing the operation of social-economic forces not simply as setting the background against which a work of art develops, but as conditioning the way it appears. The difference between traditional Marxist art historians and later social art historians, both Marxist and non-Marxist, is in the way that they conceptualise this influence. While orthodox Marxists adopt a 'determinist' position and present art as the passive product of socio-economic forces, social art historians object to this model, attributing historical agency not only to social and economic developments but to cultural and intellectual concerns too.

There is a second aspect of Marxist and social art histories that is important to note. Writers in the Marxist tradition write from a decidedly partisan point of view and their view of the public for art is also a political one. Writers on art have, of course, always recognised that spectators come in many different forms. But traditionally it was standard practice to differentiate only between those (well-educated and leisured, it went without saying) who were well able to appreciate artistic quality and the supposedly 'philistine' masses. Marxists with their radically anti-elitist political stance will have nothing to do with this, of course. They have urged consistently that spectators should be understood not by their supposed greater or lesser degree of awareness of a timeless canon of values but as interested agents within a social whole that is radically divided along class lines.

What this entails has been beautifully expressed in fictional form by
the writer Peter Weiss in his remarkable novel *The Aesthetic of Resistance*, which
was published in three volumes between 1975 and 1981. This tells the story
of a group of German communists who, in the years between 1937 and
1945, find themselves persecuted on all sides. The novel opens with a group
of three young communists standing in front of the most famous late-
antique work of art in Germany, the monumental Pergamon altar in Berlin
(Figure 12). Two of them are working class while one has a bourgeois
background and education. For page after page the reader witnesses how
these three young men begin to develop an interpretation of this famous
artwork which differs significantly from traditional venerations of classical
antiquity. Where other authors emphasise the timeless idealised beauty of
the bodies presented, these young men engage with the content. The scenes
of fight and struggle on the frieze are read as an embodiment of subjuga-
tion of the many by the few. The men's encounter with the Pergamon altar
is thus not presented as being motivated by the search for beauty, but as
an engaged encounter which provides them with an opportunity to clarify
their own project, to make them aware of the long history of class struggle
and of the trials ahead. Marxist writers were the first to understand their
own intellectual work as an interested and politically motivated intervention
in the discourse of their time in the way that later feminists and people
from non-Western countries would do (see Chapters 8 and 11).

Marxism

Many of the difficulties and controversies between orthodox Marxists and
neo-Marxist art historians are the result of ambiguities in Karl Marx's own
writing and it is to him that we, therefore, turn first. Karl Marx came to
England from Germany as a political exile after the failed revolution of
1848. He and his lifelong collaborator, **Friedrich Engels (1820–95)**,
announced the advent of communism in their jointly-written *Communist
Manifesto* (1848). They called on the workers of all countries to unite in the
struggle to overthrow the capitalist system of production that saw the
ownership of the means of production in the hands of a few. Marxists
hold that society progresses through a series of stages from slavery and
feudalism through capitalism to communism. Under communism, the
private ownership of the means of production is superseded by collective
ownership. Each stage, as Marx makes clear in *Capital* (1867), his most
famous work, is the result of the development of new production tech-
niques and the class conflict that that generates. Feudalism comes to an end

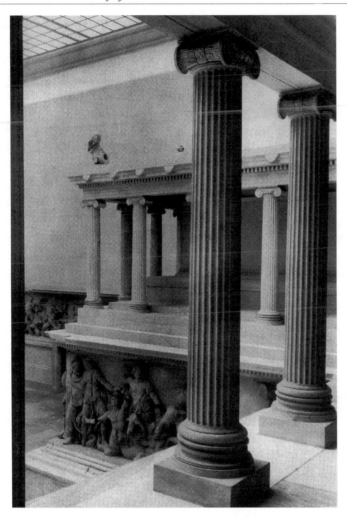

12 Pergamon Altar, Pergamos, Turkey, *c.*165–56 BC, marble,
Pergamon Museum, Berlin

with the revolt of the newly emergent bourgeoisie against the aristocracy.
The exploitation of the working class lies at the heart of modern industrial
capitalism, which is the result of the victory of the bourgeoisie. The devel-
opment of new technologies in industry means that the worker under
capitalism has become deskilled and made to perform fragmented, repeti-
tive tasks whose significance he or she cannot comprehend. The working
class is at the mercy of the capitalist labour market and alienated from the
fruits of their labour and from their own selves.

Marx and Engels held out the promise of a working-class uprising, which would lead to a socialist revolution. Many observers believed that the Soviet Revolution of 1917 was just such a revolution. But when it failed to develop into the equal and non-coercive society that Marx had predicted, some began to describe it as premature. In their analysis, capitalism has to run its full course, reaching a far higher level of industrial production than had been the case in Tsarist Russia, before it could be superseded. The collapse of the Soviet model of communism after 1989 has forced Marxists into a reassessment of the Marxist legacy, and powerfully reinforced those who, since the late 1960s, had questioned whether Marx had indeed been an economic determinist, prophesying an inevitable historical path to communism. As a result neo-Marxist art-historical interpretations have emerged which, although they base themselves on Marx's analysis of class structures and ideologies, emphasise the need for multi-causal explanations of historical phenomena and the indeterminacy of developmental processes (Craven, 'Marxism and Critical Art History', 2002, p. 281).

Two keywords are significant for all forms of Marxist art history. The first is **class**. Marx and Engels saw their own society as characterised by the struggle between two classes, the bourgeoisie and the proletariat. What separated the two was their different relationship to the means of production: while the bourgeoisie owned it, the proletariat owned nothing but their own labour. Marx's critics have pointed out that the class structure of modern industrial society is not so simply polarised and this is something that more recent Marxists have come to accept. As perhaps the most celebrated contemporary art historian who identifies himself with the Marxist tradition, T. J. Clark put it:

> Class will in any case necessarily be a complex matter: to make the simplest point, there is never only one 'means of production' in society for individuals to possess or be denied: any social formation is always a palimpsest of old and new modes of production, hence old and new classes, and hybrids born of their mating. (Clark, *The Painting of Modern Life*, 1985, p. 7)

Although modern Marxists work with a looser, more permeable and varied conception of class, it still remains of central importance in Marxism and social art history more generally.

This is also the case with the second keyword, **ideology**. The term in its modern sense originates with Marx and, although it is widely used by non-Marxists and even anti-Marxists, the best way to understand it is to start with Marx himself. There are, however, considerable difficulties for, as many commentators have pointed out, Marx himself uses the term in a variety of ways and contexts. Although it is conventional to talk about 'the

theory of ideology', Marx does not have a single theory so much as a series of models by which he aims to articulate some basic convictions regarding the place of ideas in society (Rosen, 'Marx', 1996, pp. 179–207).

What are those convictions? In essence, Marx sees all societies prior to the coming of communism (or socialism – he makes no distinction between the two words) as class societies based on the dominance (as he puts it, 'dictatorship') of one or more ruling classes. This 'dictatorship' is not maintained by means of violence alone but takes place with the, in some sense, willing complicity of those who are subject to its rule. It is here that the notion of ideology comes in. The central meaning of ideology for Marxists is that it is a kind of 'false consciousness' by means of which the inequalities of power characteristic of class societies are preserved. It is this false consciousness that makes people believe that their interests are the same as those that oppress them.

Many of the key ideas about ideology were introduced by Marx in the *German Ideology* (written with some collaboration by Engels in 1845–46). It must be said, however, that Marx's statements there are somewhat compressed and indeed, at times, contradictory. Marx identifies the emergence of ideology with a certain stage in the development of the division of labour, namely that at which a fundamental division between mental and manual labour has been established. It is at this stage that the first ideologists (the priests) come on the scene and human beings start to believe in ideas as if they had independent existence. But this is an illusion: ideas are always connected to the interests of those who produce them.

It is apparent how this may lead people to submit to a social order that goes against their own interests. People adopt ideas that are really in the interests of a particular class under the illusion that those ideas are not interested but neutral. And in this way the ideas promote interests all the more effectively (just as it would be were a judge in a court of law to be bribed, but none of the participants to know that). This picture, of course, raises many problems. If ideas are produced by a separate group of idea-producers (ideologists) why should those ideas, nevertheless, still be in the interests of the ruling class? And if Marx is right that people produce ideas in pursuit of their own interests, why do the members of the subordinate classes accept ideas from the ideologists that go against their interests? A further issue that has been much disputed concerns the dividing line between ideology and science. Marxism represents itself as a science of society; yet what is it that separates the Marxist world-view from the 'ideological' social conceptions that it rejects? Who is able to decide what is false consciousness and what is true? These are deep difficulties for

Marxist theory and have been vigorously debated. For our purposes here, however, the difficulty in drawing another dividing line is more pressing: are all cultural phenomena to be considered ideological? In particular, is art ideology?

On the one hand, art certainly seems to play a major role within that complex of attitudes, values and beliefs that structure the ways in which the members of societies see the world and their own place within it. On the other hand, it is not clear that art can easily be analysed as 'false consciousness'. It is not that artistic representations of the world (or most of them at least) are literally accurate depictions of reality so much as the fact that they do not pretend to be true. A classic piece of ideology would be something false that was believed to be true, but it is not clear that the spectator of Titian's *Venus* or Bosch's *Garden of Earthly Delights* ever believed that these pictures showed the way that reality is. So, if art is false consciousness it must be false in some less obvious way. Marxists have responded to this challenge in many different ways. Here, for example, is an extremely interesting presentation of the term 'ideology', again by T. J. Clark. It is worth quoting it at length:

> I use the word [ideology] to indicate the existence in society of distinct and singular bodies of knowledge: *orders* of knowing, most often imposed on quite disparate bits and pieces of representation. The sign of an ideology is a kind of inertness in discourse: a fixed pattern of imagery and belief, a syntax which seems obligatory, a set of permitted modes of seeing and saying; each with its own structure of closure and disclosure, its own horizons, its way of providing certain perceptions and rendering others unthinkable, aberrant, or extreme. And these things are done – I suppose this is the other suggestion carried in the word – as it were *surreptitiously*. Which is to say that ideologies, like any forms of knowledge, are constructs; they are most often tied to the attitudes and experiences of a particular class, and therefore at odds, at least to some extent, with the attitudes and experience of those who do not belong to it. (This is a cautious statement of the case: in fact there is often a positive antagonism between the ideological frames of reference belonging to different and conflicting classes; it is hard to avoid the sense of bourgeois ideology actively struggling in the nineteenth century to include, invert, or displace the meanings of those classes the bourgeoisie sought to dominate. . . .) But in any case, the function of ideology is as far as possible to dispose of the very ground for such conflicts. Ideologies tend to deny in their very structure and procedures that they have any such thing: knowledge, in ideology, is not a procedure but a simple array; and insofar as pictures or statements possess a structure at all, it is one provided for them by the Real. Ideologies naturalize representation, one might say: they present constructed and disputable meanings as if they were hardly

meanings at all, but, rather, forms inherent in the world-out-there which the observer is privileged to intuit directly.

Therefore one ought to beware of a notion of ideology which conceives it merely as a set of images, ideas, and 'mistakes', for its action on and in the process of representation is different from this: it is more internal, more interminable. Rather, an ideology is a set of limits to discourse, a set of resistances, repetitions, kinds of circularity. It is that which closes speech against consciousness of itself as production, as process, as practice, as subsistence and contingency. And of necessity this work of deletion is never done: it would hardly make sense to think of it finished, (Clark, 1985, p. 8)

Let us note two important points from this extremely complex passage. First, Clark defines ideology in a way that allows it to include art: it is a quality, he writes, of 'discourse . . . of imagery and belief'. Thus he leaves it open where the boundaries between the ideological and the non-ideological come. Second, the 'false consciousness' aspect of ideology for Clark is not the falsehood that we are familiar with when a representation or belief fails to match reality. What makes ideology false consciousness for Clark is a kind of spurious naturalisation, the way in which ideologies present 'constructed and disputable meanings as if they were hardly meanings at all, but, rather, forms inherent in the world-out-there'.

This is an excellent example of the more attenuated version of Marxist art history which appeared in the 1970s. Clark himself calls this 'social art history', but it is important to note that not all of those who would accept this label would see themselves as even neo-Marxists. In Clark's writing, art is seen as both ideological and utopian, pointing beyond its historical conditions. Marx himself, in fact, appears to allow that art can play both roles. In one famous passage he refers to classical Greek art as still representing an aesthetic ideal, despite the passing of the social conditions which gave rise to it. This would be an example of the power of art to have a significance that transcended the limitations of the societies in which it was produced. It was in this sense that many Marxist writers on art, both in the Eastern Bloc and the West, developed a conception of art as a mode of expression that goes beyond historical determination. Instead of being merely a piece of ideology, art retains a utopian capacity. This version of Marxism was pursued most notably by **Theodor Adorno** **(1903–69)** and the other writers of the Frankfurt School, a group that was formed in the 1930s and operated in exile in the USA during the Nazi years. In his *Aesthetic Theory* (published posthumously in 1970) Adorno postulates art as a critical counterweight to alienated social labour.

Although for Adorno art is an expression of the society in which it is produced it also transcends this and carries a vision of human freedom. This it does not by virtue of its subject matter (in the way that the Socialist Realism of the communist world was supposed to indicate the emancipating reality of socialism), but because of the unalienated way in which its formal characteristics are determined. Art thus becomes a form of fulfilled labour of a kind which is absent in capitalist society. But this utopian dimension is socially unspecific; it does not have the strength of other Marxist accounts of art which have related art to specific social circumstances. It is only when art is seen as ideological that its social character can be analysed. Furthermore, orthodox Marxism, which takes art to be determined by the economic conditions of society, gives a solution to the fundamental question that occupied art history from Hegel to Panofsky. The changing means of production form the link between stages of society and the art which is produced in them in the way that the Absolute Idea did for Hegel. Moreover, Marx's understanding of labour as the vehicle for human self-realisation resolves what we have called the hermeneutic problem: labour runs through history and connects the present with the past. It is the abandonment (or, at least, the drastic complication) of these two suppositions that marks a radical break in art history between the systematic art history of the nineteenth and early twentieth centuries and the approaches discussed in Part Two of this book. In this chapter we first introduce the orthodox Marxist approach to art history before turning to the more complex and multilateral strategies of social art history.

Marxist art history

Many important art historians in the twentieth century were Marxists, for example, Max Raphael, Francis Klingender and Meyer Shapiro. Like Panofsky, the fact that they were forced into exile brought their work to a larger audience. In this section we examine the work of two of the best-known orthodox Marxist art historians, **Frederick Antal (1887–1954)** and **Arnold Hauser (1892–1978)**. Both were members of a group of Marxist intellectuals who supported the Hungarian Revolution of 1919. When the uprising was suppressed they went into exile in Germany (Hauser moved to Vienna in 1924) only to be moved on again after the Nazis came to power. They lived and worked in Britain after 1933 and 1938, respectively.

During his exile years in Britain, Antal became interested in another, earlier European who had lived and worked in London when the first great revolution, the French Revolution, shook the continent – the Swiss painter Henry Fuseli. In 1956 he published his *Fuseli Studies* and six years later his

investigation of the socially engaged art of the English eighteenth-century artist, William Hogarth, followed (Antal, *Hogarth and His Place in European Art*, 1962). It was, however, Antal's first book, *Florentine Painting and Its Social Background* (1948), written in exile in England, that became a classic example of Marxist art history. It appeared in the aftermath of the Second World War and its production was not without difficulties. In the preface, Antal explains that he wrote the book between 1932 and 1938. These were years of great disillusion for many communists, as Peter Weiss's *The Aesthetic of Resistance* illustrates. As Stalin's purges and Hitler's repression devastated the communist movement, Antal set to work to study a seemingly remote subject: the stylistic changes in Florentine painting in the fourteenth and early fifteenth centuries. But far from escaping into the realm of beauty and the safety of the past, Antal's book was an attempt to come to terms with the culture of an earlier failed class struggle, the struggle of the bourgeoisie against the aristocracy.

Antal declares that his starting point is the firmly established facts of the economic, social and political conditions of fourteenth- and fifteenth-century Florence (Antal, 1948, p. 5). His book is built up according to the model of base and superstructure. The first chapter deals with the economic causes of the rise of the bourgeoisie in Florence, followed by chapters on the superstructure of religion, philosophy and literature and finally art that reflects this base. Perhaps because of his own experience with the warring communist and socialist factions of the 1930s, Antal emphasises not only the class struggle of the bourgeoisie with the aristocracy but also the role of divisions among the bourgeoisie in leading to the point when 'in 1434, Cosimo de' Medici put an end to the regime of several warring bourgeois factions and made himself, in fact if not in name, ruler of the city, which was now rapidly declining in prosperity' (Antal, 1948, p. 4).

Antal begins his book programmatically with a comparison of two pictures painted almost at the same time and in the same place: Gentile da Fabriano's *Madonna and Child with Angels* (Figure 13) painted around 1425 and Masaccio's painting of the same subject from around 1426 (Figure 14). He notes that

> Gentile's picture has none of [Masaccio's] clarity and objectivity, none of Masaccio's austerity. His Mary's bearing and pose are those of a lovely and gracious queen, enthroned in a pomp-loving Court of heaven. Her mantle, open in front, reveals richly ornamented robes. Compared with Masaccio's figures, her body has little plasticity. . . . Gentile does not build up his figure robustly from within, but defines it by means of rhythmic, undulating outlines. (Antal, 1948, p. 1)

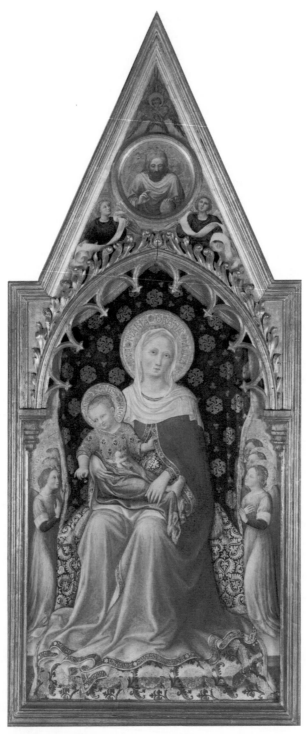

13 Gentile da Fabriano, *The Madonna and Child with Angels*,
1425, egg tempera on wood, 139 × 83 cm, National
Gallery, London

14 Masaccio, *The Virgin and Child*, 1426, egg tempera on wood, 134.8–136
× 73 cm, National Gallery, London

In contrast to Gentile's emphasis on decoration, rich materiality and ritualistic behaviour, Masaccio, according to Antal, treats space and figures rationally, following the rules of foreshortening in a textbook-like manner. This matter-of-fact conception presents the Madonna and infant Jesus like any mother and child. Jesus sucks his thumb in a way that babies do.

'How could two such widely differing pictures have been painted in the same town and at the same time?' Antal asks (Antal, 1948, p. 2). It helps little, he says, to give a stylistic explanation, describing one as late Gothic the other as classical Renaissance. It is exactly this difference which needs to be explained. Drawing on the age difference between the artists or seeing them as subject to different regional influences as connoisseurs have done will not give the explanation, he declares. 'These confusingly numerous and frequent influences require explanation as urgently as the styles themselves' (Antal, 1948, p. 3). When Antal writes that 'influences do not explain essentials' (*ibid.*) he is looking for some fundamental cause for historical appearances and change as spirit was for Hegel, individual genius for the connoisseurs, perceptual psychology for formalists like Riegl and Wölfflin, and the rational mind for Panofsky.

For the Marxist Antal, however, this fundamental cause is the economic structure at the base of society. The ideology of the class that benefits from the ruling relations of production governs the art of the time. What Gentile and Masaccio's entirely different stylistic approaches to the same theme show, is that societies (until the advent of communism) are antagonistic. Gentile's ritualistic and courtly style is an expression of the endurance of the outlook of the aristocracy. Masaccio's more rational, natural and realistic style, on the other hand, is a reflection of the values of the newly prosperous and briefly powerful bourgeoisie. When the middle-class elite becomes a money aristocracy and asserts its dominance in the second half of the fifteenth century, no painter, Antal writes, 'really carried on the Masaccio tradition; all the painting of this period can be classed, more or less, as "late-Gothic" ' (Antal is here thinking of Botticelli and Filippino: 1948, p. 3).

Three years after *Florentine Painting and Its Social Background* appeared, Antal's colleague Arnold Hauser, then teaching art history at Leeds University, published his magisterial *The Social History of Art* (1962 [1951]). In two volumes he ambitiously aims to provide an account of the development of art from prehistoric times to the beginning of the twentieth century from a historical-materialist, i.e. Marxist, perspective. It is in the nature of such a survey that it can hardly analyse individual works in depth. Instead, like Antal but on a much broader canvas, Hauser is concerned to give an account of the economic and social structures underlying the appearance of styles

such as the late Gothic, Mannerist and Impressionist. In his chapter on the early Renaissance in Italy, for example, Hauser basically repeats Antal's analysis. Courtly artistic taste as found in the work of Gentile da Fabriano and Domenico Veneziano, exists alongside the naturalism of Masaccio, the master of a simple, sober straightforward middle-class art. The history of the fourteenth century, according to Hauser, is the history of class struggle not only between the bourgeoisie and the aristocracy, but also between the bourgeoisie and the working classes. The period proves that the interests of the latter 'were incompatible with those of the bourgeoisie' (Hauser, vol. 2, 1962 [1951], p. 17). Yet, as the century progresses, the newly powerful middle-class elite 'begins to adopt the manners of court society and to see in the themes of romantic chivalry not merely something exotic but also something worth emulating' (Hauser, vol. 2, 1962, pp. 26–7). As a class of rentiers who lived a life of courtly leisure developed out of the 'once so plain and industrious middle class' (Hauser, 1962 [1951], vol. 2, p. 30), so art changed correspondingly:

> The monumental naturalism of Masaccio, with its anti-Gothic simplicity and its emphasis on the clarification of spatial relationships and proportions, the richness of genre traits in the art of Gozzoli and the psychological sensibility of Botticelli represent three different stages in the historical development of the middle class as it rises from frugal circumstances to the level of a real money aristocracy. (Hauser, 1962 [1951], vol. 2, p. 29)

On occasion Hauser acknowledges art's capacity to develop independently of social and economic circumstances. In his later methodological publication, *The Philosophy of Art* (1958), he declared that it was important to reconcile historical-materialist analysis with the independent dynamism of art postulated by formalists and an appreciation of the role of artistic individuality. Such independent development, however, never departs very far from the line determined by the underlying economic reality. While styles may linger on after the class which they served has ceased to exist, artistic forms cannot be independently revolutionary. In the last instance, for Hauser as for Antal and other orthodox Marxist art historians, they always change in response to fundamental economic and social changes. This becomes clear in Hauser's discussion of the French nineteenth-century artist, Gustave Courbet. Courbet, for Hauser, is the prime exponent of an anti-bourgeois form of naturalism that coexists in the aftermath of the failed revolution of 1848 with the elitist naturalism of the *rentiers*, practised by Flaubert and the Goncourts. Yet, however novel Courbet's proletarian outlook is, its political force must not be exaggerated. To do so is to give

art a significance that it does not possess 'and makes a prophet out of a confusedly chattering painter and a historical event out of the exhibition of an unsaleable picture' (Hauser is referring to the exhibition in 1850 of Courbet's *The Burial of Ornans*: 1962 [1951], vol. 4, p. 62). Hauser's successor at Leeds, T. J. Clark could not disagree more. The differences between Clark and Hauser are symptomatic of the difference between orthodox Marxist art history and neo-Marxist art history.

Social art history

A large number of contemporary art historians could be considered in this section. Having loosened its ties to the determinist versions of Marxism dominant in the first half of the twentieth century, social art history has become a broad church indeed, with both neo-Marxist and non-Marxist streams. It might well be the most widely practised approach to art history today. In a highly influential chapter 'On the Social History of Art' of his book *Image of the People: Gustave Courbet and the Revolution of 1848* (1973), T. J. Clark sets out how the new generation dissents from the old. In the place of generalised accounts identifying styles of art like naturalism with middle-class values, the new social art history aims to be far more historically specific. Instead of using unhistorical analytical categories to explain historical phenomena, art history must, Clark says, attend to a range of relevant social relations between artists, artworks and institutions, as well as to political arguments and economic conflicts without giving explanatory priority to any one of them. The economic base and ideological superstructure model was now seen as simplistic and reductive.

In the 1960s the Marxist theory of ideology was reformulated by Louis Althusser in France so that ideology was understood as part of a complex power struggle rather than simply mirroring the economic base of society. Ideologies were the product of what Althusser termed 'ideological state apparatuses' (legal and political institutions and educational systems, for example) which were themselves often the battlefields on which different interests in society came into conflict. Following this, a range of social histories of art appeared, which concentrated on specific conjunctures of image and society or on short and circumscribed moments in the history of art. At the same time as Clark was focusing on artists and politics in France in the period from 1848 to 1851, German art historians were beginning to provide critiques of art's ideology which were diverse, historically specific and decidedly anti-reductive. Berthold Hinz, for example, examined paintings produced in Nazi Germany while paying attention, but not reducing them, to the economic conditions of the time.

Martin Warnke gave an account of medieval architecture as the nexus where
ideologically diverse outlooks came together and were brought into harmony
with one another. Horst Bredekamp, on the other hand, focused on art as
a medium of social conflict within a broad time span, tracing iconoclasm
from late antiquity to the sixteenth century. Scholars in France were par-
ticularly influenced by Althusser's picture of ideology as the product of a
conflict between contending social forces rather than a simple reflection of
basic underlying structures.

In 1973 Nicos Hadjinicolaou published a critique of mainstream art
history and a methodological guide to social art history, which was trans-
lated into English five years later as *Art History and Class Struggle*. In the USA
scholars such as O. K. Werckmeister in the art history department at the
University of California, Los Angeles (where T. J. Clark was soon to move)
provided the impetus for a reassessment of Marxist art history. Today many
more scholars could be added to the list. A closer look at T. J. Clark's study
of Courbet, however, will raise all the important issues. Furthermore,
Patricia Leighten's study of Picasso's collages and her criticism of Clark
and other art historians in the Marxist tradition makes clear that some
social art historians nowadays find it possible to write social art history
without a general theory of the structure of a capitalist economy, a pos-
sibility that Clark rejected (Clark, 1973, p. 11).

In 1973 Clark published two books, both focusing on three years of
art in France: his study of Courbet, *Image of the People*, and *The Absolute
Bourgeois: Artists and Politics in France, 1848–1851*. According to Clark, the period
was at once an important and 'unfamiliar' moment in the history of art,
'when art and politics could not escape each other' (Clark, *Image of the People*,
1973, p. 9). In paying close attention to a very narrow place and time on
the map of history, Clark avoids having to make the general assumptions
about class ideologies and art that Hauser and Antal do. It also enables
him to widen the circle under consideration from the artist's studio and
group of friends to the range of historical and social phenomena relevant
to the production of works of art. Lastly, it enables Clark to avoid relying
on intuitive analogies between form and ideological content of the kind to
be found in Adorno's work, for example (Clark, 1973, pp. 10–11).

Instead – and in deliberate contrast to Hauser – Clark aims to show
the work that an image like Courbet's *The Stonebreakers* of 1848 (Figure 15)
has done 'in and on history' (Clark, 1973, p. 13). Famously, Clark declared
that he wanted

To discover what concrete transactions are hidden behind the mechanical
image of 'reflection' [invoked in orthodox Marxist accounts], to know *how*

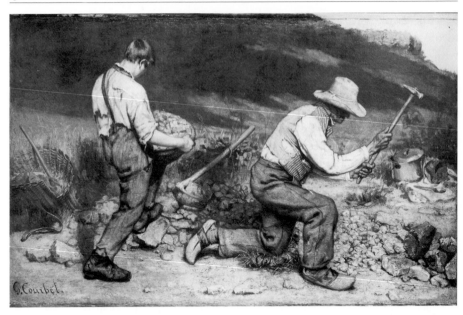

15 Gustave Courbet, *The Stonebreakers*, 1849–50, oil on canvas, 159 × 259 cm, Staatliche
Kunstsammlungen, Dresden

'background' [invoked, for example, in formalist studies] becomes 'fore-
ground'; instead of analogy between form and content [as in iconography],
to discover the network of real, complex relations between the two. These
mediations are themselves historically formed and historically altered; in the
case of each artist, each work of art, they are historically specific. (Clark,
1973, p. 12)

In his study of Courbet, Clark gives a careful reconstruction of the
artist's intentions and his milieu as well as making extensive use of the
documented reactions to Courbet's work by contemporary critics. When
discussing *The Stonebreakers*, Clark emphasises the material labour that has
gone into it in order to evoke the material weight of things the picture is
about. The image of a young man and an old man shown in a 'frozen
movement' and 'turned away from the spectator' was about 'labour gone to
waste, and men turned stiff and wooden by routine' (Clark, 1973, pp. 80–1).
Neither reassuring peasants nor proletarians, such images of the people,
Clark argues, were deeply unsettling to Courbet's audience in Paris, which
was riddled with class anxieties in the aftermath of the 1848 revolution.
Bourgeois identity, threatened both from below and from above, was unset-
tled by Courbet's pictures because 'there was more than one middle class,
and more than one class struggle' (Clark, 1973, p. 142). The *Burial of Ornans*
and the *Stonebreakers* evoked all sorts of middle-class types and class struggles

in an attempt to define its own ideal democratic public. 'But [Courbet] failed, of course, and his friends were inaccurate prophets' (Clark, 1973, p. 161).

Courbet failed for Clark because the class that he imagined as existing beyond the conditions of capitalism did not – and still does not – exist. Hence, his communist friends were misguided. Art, as Clark continued to maintain in his subsequent books, can be utopian but no more. He is Marxist enough to believe that no art can bring about the only social change that really matters: a revolution in the ownership of the means of production. In his most recent publication, *Farewell to an Idea: Episodes of a History of Modernism*, Clark argues that Picasso's cubist works fail to present a coherent representation and so do not generate a resolved representation or meaning. Great as they are in their pictorial inventiveness and in their critique of art's inherited pictorial language, for Clark they represent the heroic failure of avant-garde art in its aspiration to change the world. The critique of art's illusionistic strategies itself leads to a form of disillusion (Clark, *Farewell to an Idea*, 1999, p. 220).

It is this assertion, that Picasso's work in the end is politically disillusioned, that is contested by **Patricia Leighten** in *Re-Ordering the Universe: Picasso and Anarchism, 1897–1914* (1989). Unburdened by the Marxist doctrine that to be politically effective can only mean contributing to a revolution in the organisation of the means of production, Leighten traces Picasso's political activism both in his art and his life from his time in Barcelona, and emphasises his active commitment to anarchist politics. For example, she analyses the newspaper clippings in Picasso's collages during the time before the First World War, and finds that a half were used to give an anti-war message: 'Another quarter introduces macabre accounts of suicide, murder, and vandalism, which accumulate to depict, with the blackest humor, a pathological bourgeois world gone mad' (Leighten, *Re-Ordering the Universe*, 1989, p. 121). The fragmentation, abruptness and anti-illusionism of the collages is read by Leighten as a deliberate attempt by Picasso to show the topsy-turvyness of the world in the run-up to the First World War.

Marxists are criticised for denying the political force of this work: 'Some art historians and critics, usually Marxists, have offered political interpretations of Picasso's role and work, though none have suggested the conscious political component of Picasso's relations to culture in his Cubist period' (Leighten, 1989, p. 150 – in an earlier article Leighten names Clark directly). Leighten, in contrast to Clark, gives up the Marxist notion of art as ideological in the sense of being an embodiment of false consciousness. Although Clark does not believe that art is *just* false consciousness, he is nevertheless concerned with 'what prevents representations as much as what

allows it; one studies blindness as much as vision' (Clark, 1973, p. 15). In Leighten's approach it is not a matter of revealing Picasso's blind spots. What she knows about the work is just what the artist has intentionally conveyed. This is an important difference between non-Marxist and neo-Marxist art historians, like Clark.

Nevertheless, Leighten and Clark have much in common. Both aim to capture the historical specificity of works of art by weaving a dense image of artists in their specific milieux without the generalisations about bourgeois ideology and economic structures of the kind we find in Antal and Hauser. Both believe that art can oppose the dominant ideology. According to Clark, Courbet developed a new form capable of subverting contemporary ideology (Clark, 1973, p. 13). Leighten maintains that Picasso's pacifist works were produced in opposition to the warmongering prevalent in France at the time. Yet, a comparison between Clark and Leighten also shows three important differences:

1 Neo-Marxist art historians are social art historians and committed to showing the deep embeddedness of art in social processes, but not all social art historians are Marxists.
2 Neo-Marxist social art historians acknowledge as social progress only what leads to a revolution in the means of production; non-Marxist social art historians do not believe in social progress of that kind.
3 Neo-Marxist social art historians contend that some, even if not all, art is ideological in the sense of embodying false consciousness; non-Marxist social art historians focus on the more or less consciously held political and social beliefs behind works of art.

Neither group, however, is committed to an orthodox Marxist determinist account by which art is part of the superstructure which in turn is a reflection of the economic base.

Critical appraisal

Marxist art history cannot avoid one of the most difficult and controversial issues in Marxist theory: that of the relationship between the economic 'base' and the 'ideological superstructure'. In early and mid-twentieth century debate, the problem was understood to be that this model was crude and reductive: superstructural phenomena, such as art, were supposed to be read off as a 'reflection' of economic circumstances. In the face of this some Marxists (most notably the Italian Communist leader, Antonio Gramsci) produced versions of the theory of ideology which loosened in certain ways the ties between base and superstructure. Thus for Gramsci

ideology was a matter of 'hegemony' – the way in which a particular group and its ideas might come to be dominant in a complex and shifting field of class conflict – rather than being merely a simple reflection of the economic base. While this had the advantage of making the Marxist theory less crude, the disadvantage (or so it may seem) is that the theory becomes much less precise. Indeed, if there is a kind of autonomous struggle taking place in the ideological realm then it is no longer very clear what the Marxists' insistence on the primacy of economics amounts to – perhaps not very much more than a commitment to a certain political position and set of social values.

More recently, G. A. Cohen, one of a group of theorists who go under the label of 'analytical Marxists', has attempted to defend an account of base and superstructure as an example of what is called 'functional explanation'. Functional explanations are not reductive in the sense of seeing the phenomenon to be explained (in this case the ideological realm) as a directly caused reflection of the economic base. Rather they assert (1) that ideological superstructures *are good for* (serve or promote) the economic base, and (2) that they come about *because* they are good for the economic base. Cohen's reconstruction of Marxism has been very widely discussed. A central criticism seems to be that – even granting that ideological phenomena do in some way promote the economic base – it is very unclear that there is any evidence to support the claim that that is the very reason why those phenomena take the form that they do. What miraculous power does the economic base have to ensure that just those ideological phenomena which will suit it come about?

Cohen and his supporters are for the most part philosophers and it is notable that their discussions have dealt with the theory of ideology at a very abstract conceptual level – their concern has been whether the theory is coherent in principle. Art historians (and other investigators of specific empirical phenomena) face different problems. In particular, while it may be true that the cultural realm in some sense supports the existing ruling order, it is absurd to think that this is true of every individual work of art, a point that T. J. Clark has gone out of his way to emphasise. While some artists may be conservative, others, like Courbet, are (in intention and perhaps also in effect) consciously revolutionary, while still others, it seems, have no obvious political position one way or the other. Can the Marxist theory accommodate all three possibilities? And, if the answer is yes, does not an even more profound problem present itself: if Marxism can find a place for every phenomenon, does that not make it unfalsifiable and (as Sir Karl Popper famously alleged) something that has more of the character of religion than of science?

Not being scientific in one's theory has, however, been turned into a virtue by some art historians in the second half of the twentieth century. It was, in fact, the Marxists who led the way. They claimed that the understanding of social phenomena is never politically neutral in the way that the sciences claim to be. It is, they argued, ideological from the start. Thus the Marxists themselves placed a heavy emphasis on their own engagement and political standpoint. We have seen how Peter Weiss tries to present a consciously working-class interpretation of classical works of art in the *Aesthetic of Resistance*. Such an interpretation provokes self-conscious reflection in the novel's protagonists about their own social purpose. In a similar vein, although less obviously, both Antal and Hauser wrote about the stops and starts, disintegrations and reformations of the bourgeois class struggle until its victory in the nineteenth century under the influence of the fragmentation and disintegration of the Communist movement in the 1930s. T. J. Clark's two books on the failure of the 1848 revolution in France and its aftermath were a way of addressing his own experience of the failure of a radical movement for social and political change in May 1968. Clark was involved with an international group of activists called the Situationists who, unlike some other Marxist groups, believed in the power of art to intervene effectively in the historical process. As those hopes disappeared following the collapse of the movement, Clark turned to the past, as he wrote in the preface to the 1982 edition of *Image of the People*, in order to recuperate a similar historical moment.

Writing from an entrenched and explicit political point of view has become quite common in art history and has produced, as seen in the next chapters, some of the most interesting recent interpretations. In Chapter 3, however, we claimed that art history is founded on two basic beliefs: (1) the notion that art is historically specific; and (2) that it changes over time in a manner for which art historians can account. Chapters 3 to 7 showed various mechanisms by which different theories sustained both conditions. Now, although there are good reasons why social art historians should give up the orthodox Marxist account of the determination of the superstructure by the economic base, in doing so they also give up the Marxist version of the mechanism which fulfils art history's twin conditions. For orthodox Marxism the economic base not only determines the art of any period (in as much as art is part of the superstructure) it also links the past with the present in order to understand them. Without such a mechanism social art history must pay a price. Changes in the way art appears can no longer be referred back to a single cause, but may have many diverse reasons.

This seems to be the common predicament for the approaches to contemporary art history that will be discussed in Part Two. Historical

changes can only be explained in specific ways at specific times without broader generalisations. The benefit that we stand to gain is more detailed, complex, diverse and politically engaged accounts of particular historical, social and cultural constellations. But we have lost a sense of the patterns of change across times. Of the two beliefs that were basic to the discipline of art history only the first (art's historical specificity) has remained. For some this may be a liberation; others will count it a loss.

Bibliography

Adorno, Theodor W., *Aesthetic Theory* (1970), Gretel Adorno and Rolf Tiedemann (eds), trans. Robert Hullot-Kentor (London: Athlone Press, 1997). Adorno is a major figure in the Frankfurt School who advocates a utopian and anti-ideological understanding of art.

Antal, Frederick, *Florentine Painting and Its Social Background* (London: Kegan Paul, 1948). A classic of orthodox Marxist art history. Changes in style in the late fourteenth and early fifteenth century are explained as the result of shifting economic structures and class struggles.

Clark, T. J., *Image of the People: Gustave Courbet and the 1848 Revolution* (London: Thames and Hudson, 1973). This close study of the historical moment which made Courbet's paintings possible contains a seminal introduction, 'On the Social History of Art', a kind of manifesto for the attenuation of ties to orthodox Marxism.

Clark, T. J., *The Painting of Modern Life: Paris in the Art of Manet and his Followers* (London: Thames and Hudson, 1985). In this book Clark gives an exemplary social art history of Impressionism. The introduction contains a clear account of a non-orthodox Marxist use of the terms class and ideology.

Cohen, G. A., *Karl Marx's Theory of History: A Defence* (Oxford: Oxford University Press, 1978). This is what the title says, a defence of Marxism, including a functional analysis of Marx's base/superstructure relationship claim.

Craven, David, 'Marxism and Critical Art History', in Paul Smith, Carolyn Wilde (eds), *A Companion to Art Theory* (Oxford: Blackwell, 2002) pp. 267–85. Craven discusses Marx's writings and argues for a non-dogmatic interpretation of the kind that supports social art history.

Hadjinicolaou, Nicos, *Art History and Class Struggle* (London: Pluto Press, 1978). This is a clearly written attenuated Marxist critique of formalism, connoisseurship, etc. with a methodological guide to the practice of social art history at the end.

Harris, Jonathan, *The New Art History: A Critical Introduction* (London: Routledge, 2001). A recent account of the history of social art history which is less concerned with methodological questions than with the strengths of partisan perspectives.

Hauser, Arnold, *The Social History of Art*, new edn, 4 vols. in 1 (London: Routledge, 1962 [1951]). This is the only survey of art's history from prehistoric times to the age of film written by a Marxist from a materialist perspective.

Leighten, Patricia, *Re-Ordering the Universe: Picasso and Anarchism, 1897–1914* (Princeton: Princeton University Press, 1989). A social art history account of Picasso's political engagements in life and art.

Rosen, Michael, 'Marx', in *On Voluntary Servitude: False Consciousness and the Theory of Ideology* (Cambridge: Polity Press, 1996) pp. 168–222. A challenging but very clear and accessible critique of Marx's theory of ideology.

Werckmeister, O. K., 'Marx on Ideology and Art', *New Literary History*, 4 (1972) pp. 501–19. A good discussion of the utopian versus the ideological role of art in Marxist writing.

PART TWO

THE FIRST PART OF THIS BOOK has traced a series of methods, each of which assumed that it is possible both to give an account of any artwork at one historical moment and to identify the single element that explains why and how art changes through time. With Marxism, and in particular those versions that do not accept the economic determinism of orthodox Marxism, we have reached a point where such mono-causal histories give way to multi-causal ones; a point at which only the specific historical moment with its diverse determinants and forces can be addressed and claims to explain why art changes have to be given up. Indeed, to account fully for the specific necessitates this, since no single generalisation, no universal rule, and no metaphysical precept can comprehend the many different aspects of the artwork that require explanation. Feminism is perhaps the clearest and most powerful example of this shift to a multi-causal model. It shares many characteristics with Marxism, however, not least that it is an *interested* method where the historian's own political views motivate historical inquiry. Like Marxism, feminism claims that history is never neutral; thus, to acknowledge one's own viewpoint is not a failing, but a virtue. For Marxists, this means speaking of social class and the inequalities that arise from it; for feminists, the central concern is sexual inequality, the oppression of women, and the ways in which this has structured culture and its history. This automatically rules out any mono-causal generalisation, since to talk of a universal human history is to ignore the inequalities that have existed between men and women; and these inequalities cannot provide the mechanism for historical change, since they are always bound up with other issues such as class, race, age and so on.

Feminist scholarship may well be the clearest example of the way in which a political and social movement can change academic life. The discussion of sex and gender, and the use of feminist approaches, is now central to the work of many scholars and students, and is present in many university courses, not only in art history but in such diverse fields as literary studies, classics, history, law, sociology, music and linguistics. The effect that feminism has had on the academy is nothing short of remarkable, and it is sometimes difficult for students today to grasp how different the situation was in the 1970s. Feminism did not, of course, emerge in the academy. While there is a long history of women campaigning for equality, it is so-

called 'second wave feminism' – the Women's Movement of the 1960s and 1970s – which was the immediate impetus for the development of feminist art history. What the Women's Movement identified was a general prejudice against women throughout society and its institutions, both public and private. The aim was to give women a voice and thus enable their full participation in public life and full control of their private lives. Some feminists argued for equality. They wanted a society where women would be treated equally with men, granted the same rights, with access to the same opportunities.

However, at its most forceful, the Women's Movement wanted to go beyond this and sought a more fundamental shift in social values. According to this view, it was not enough simply to treat women as honorary men; the same social hierarchies would remain in place, and the same values would shape social and political life. Instead, a fundamental reorganisation of society was needed – one which would value women in their own terms. Both these tendencies had an analogue in art history, the former arguing that art should be viewed as neutral, that a work is simply good or bad, interesting or not, regardless of the sex of its maker; the latter arguing that sex is always a concern and that the idea of neutrality is in fact a male position masquerading as objectivity.

Two key terms emerged in feminist theory. The first of these is **patriarchy**. This literally means the rule of fathers, the ways in which power in society is handed down from father to son, nearly always bypassing women. 'Patriarchy' has also been used in a less literal way, though, to refer to the fact that power in politics, business, the home, religion, culture and so on has traditionally been in the hands of men. The question the Women's Movement asked was: Why is this the case? Why are women denied access to social and political institutions? Why are men always the arbiters and those with power? The second key term is **sexism**. Sexism is discrimination against women; and, specifically, discrimination against women purely because they are women. In some instances, sexism is obvious; for example, a woman receiving a lower salary than a man for doing the same job, or the belief in many countries that women should not be allowed to vote. But sexism can also be covert. Think, for instance, of the claim that women are instinctively maternal and nurturing and therefore unsuited for highly competitive environments such as business or law. Many might see this claim as a statement of fact and thus be blind to the prejudices that underpin it. It is not purely aesthetic issues but these political terms that lie at the root of feminist art history.

Nonetheless, the more immediate context for the emergence of feminist art history was the growth of women's art from around 1970. Art and

its institutions are by no means free of patriarchy and sexism, and many early feminist artists, critics and historians exposed the ways in which women had been denied opportunities in making art, or had suffered a sexist evaluation of their art. Feminist debates had provoked women artists, critics, and curators to ask: Why are women so underrepresented in museums and galleries? Why do women artists not have the same careers as their male counterparts?

The Women's Art Movement did not seek simply to promote female practitioners and place them alongside their male colleagues. In keeping with the radical aims of the women's movement, they challenged the very structures in which art was made and displayed. Hence they opted out of the commercial gallery structure, and found alternative ways of exhibiting, alternative audiences beyond collectors and galleries. They also promoted different kinds of work, including what has traditionally been denigrated as mere craft rather than art, 'women's work' like textiles and embroidery. The work of the artists in this movement often dealt explicitly with women's own experiences, matters such as childbirth, menstruation and oppression, which were not represented in canonical art. In this way, feminist work both celebrated and rued female experience while pointing to absences in traditions of artistic subject matter.

There are very direct parallels between this project and the earliest feminist art histories. The question of why women artists were so invisible was given a historical slant; we look at **Linda Nochlin**'s famous article provocatively titled 'Why Have There Been No Great Women Artists?' Other scholars addressed the hierarchy of art and craft, and the roles sex and gender played in this. **Anthea Callen** examined the Arts and Crafts movement, unmasking the sexual division of labour between male leaders of the movement, often anti-feminist socialists, and the feminist women who were the major producers, and who found possibilities for creativity even as they were subject to patriarchal limitations. Many feminist historians have examined the iconography of sex and gender both in historical research and in analyses of contemporary women's art production, in order to uncover the ways in which art reproduces or challenges sexist ideas.

The question of women's art and female experience brings us to another crucial theoretical intervention, which had a considerable impact on the development of feminist art history. Early feminist work, including work in the arts, often presented what it assumed was a woman's way of seeing the world, or represented experience with which all women could identify. The assumption was that women all shared something, that the fact they all had similar bodies indicated a female core common to all women. Thus, many artworks celebrated universal sisterhood, or the female

body, or feminine qualities like nurturing. Other feminists, however, were troubled by this. It was as if women were not challenging patriarchal ideas, but accepting stereotypes and merely giving them a new value. For example, the celebration of mothering often came close to a familiar sexist belief that since women have wombs they are naturally maternal and thus not equipped to perform public roles.

The word that has been used to describe this belief in qualities shared by all women (or all men) is **essentialism**. Essentialism is a philosophical notion that all objects have some qualities that are essential and some that are accidental. Essential qualities are those without which the object would fail to be what it is; accidental qualities are those which are purely contingent and which may vary between different members of the same type. For example, one could say that it is an essential quality of an oak tree that it grew from an acorn, but not that it was once struck by lightning. It is impossible for an oak tree to exist that did not grow from an acorn – hence, this is essential – but whether or not an oak tree has been struck by lightning does not change the fact that it is an oak. Feminist theorists have often argued that the difference between the essential and the accidental is the same as the difference between **sex** and **gender**. Sex – the question of one's bodily make-up, primary and secondary sexual characteristics, and so on – is essential. This is biological fact. Gender is the socially constructed protocol for how certain bodies should behave; that male bodies should be in the public sphere, while the female should be in the private; or that male bodies should be active and aggressive while female bodies should be passive and subservient. These gender notions may be understood as essential, but are in fact social conventions. There is a qualification to be made here. While the term essentialism is widely used, what is at stake here is not essentialism in a philosophical sense but rather biological determinism. This is the idea that one's biology, one's body, determines one's destiny; for instance, that because a woman has a womb she is destined by nature to raise children in private rather than pursue a public career as, say, an artist or an art historian. In denying that there is a necessary connection between sex and gender, feminism combats this notion. This anti-essentialist tendency also explains why culture is so central to feminist politics. It is culture that naturalises these ideas, that makes socially prescribed gender distinctions appear to be natural qualities. Art, for instance, often presents the ideal of passive femininity as if it were a biological fact rather than a social prescription.

Before looking more closely at a few key examples of feminist method, we want to make three more general points about feminist art history. First, feminist scholarship should not be thought of a homogenous category.

Indeed, many writers use the plural form and talk of *feminisms*. Although feminists do share certain values and beliefs, their commitments are very varied. This is why we discuss feminism as an approach rather than a method. Feminist scholarship may always begin from an anti-sexist point of view, but there are many forms this can take, and diverse ways of explaining the sexism to be challenged. A psychoanalytic feminism might conceive sexism as the result of psychic developments. A Marxist feminism might understand sexism as the result of the economic organisation of society, where women are identified with home and family and men with work and the public realm. Liberal feminism might see sexism as a question of women being denied certain civil rights. We shall see that within art history, feminism has often drawn on other theories, such as psychoanalysis or discourse theory, and we shall see too how the use of these reveals opposing philosophical commitments.

Second, the range of questions and objects addressed by feminist art historians is extremely broad and one should not think that feminism refers only to a specific interest in, say, women artists or representations of the female nude. Of course, these are extremely important issues and valuable work continues to be done here. But feminist art historians have also examined the cultural construction of masculinity and of different sexual identities. They have examined many kinds of art from those which have a very clear sexual content, such as the female nude, to those which may appear gender neutral, like minimalist sculpture. As well as images and objects, they have explored the ways in which gender or sexual prejudice informs art criticism and art historical writing. And feminism has been particularly important for raising questions about spectatorship – how our looking at art is inflected by sex and gender. While certain historical subjects may seem to lend themselves more readily to a feminist analysis, feminist art historians claim that their approach is equipped to address all art. Indeed, the notion that sex and gender are only pertinent to certain kinds of object is something that feminists have consistently challenged.

The third general point is that feminism, while always rooted in anti-sexism, is a developing approach. In this chapter, we trace a particularly influential debate within feminist art history. One of the central issues in feminism, as we have seen, has been essentialism. The first feminist interventions made a distinction between sex and gender, elaborating the ways in which the latter was socially constructed; that masculinity and femininity were not natural categories shared by all men or all women, but were ways of behaving and appearing prescribed by social convention. By the latter part of the 1980s, feminist art historians were applying this anti-essentialist position to sexuality as well as gender. The argument here was that sexual

orientations like homosexuality and heterosexuality, or of normal and perverse sexualities, were also socially constructed. Although we may think these are natural and fundamental facts about ourselves, some arguments have claimed that labels like 'gay' and 'straight' are not straightforward descriptions but are also prescribed identities. More recently still, what is often called **queer theory** has claimed that sex itself – that is, being male or female – is also socially constructed. This position sees all categories as fictions, tools of power that pigeonhole us.

This narrative of increasing anti-essentialism is by no means the only one we could trace in this chapter, but it is perhaps the most theoretically explicit, and demonstrates some of the ways in which feminism has inter-acted with other methods. However, these recent arguments are highly contentious and one should not view these changes as symptomatic of all feminist art history. While some feminists have extended the anti-essentialist position in this way, this is not true of all. Indeed, some adhere to essentialism (the influential French feminist philosopher Luce Irigaray, for example, describes herself as an essentialist). Others stick to the distinction between sex and gender. The more important point is that feminist art history is not a rigidly demarcated field of theory, but a continual debate about the relationship between gender, ideology and culture.

Setting the agenda: Nochlin, Parker and Pollock

The first crucial feminist intervention in art history was Linda Nochlin's article 'Why Have There Been No Great Women Artists?' (1972). It is worth following the argument of this brief polemical piece step by step, since it begins to map out both the problems with art history as a discipline and some of the ways in which a feminist rethinking can challenge these. Indeed, Nochlin begins by stating that although the question of the woman artist is the focus of her article, a feminist critique needs to address the discipline as a whole and to challenge 'every accepted assumption of the field' (Nochlin, 1972, p. 2). While she does not really elaborate on this, it does make clear the ambitions of feminism: not merely to reformulate the content of art history – which artists are viewed and discussed – but to transform the discipline in its entirety.

Nochlin's argument begins with the question in her title: Why have there been no great women artists? This question is carefully and cleverly chosen. The first response might be to find women artists in history and to place them in the canon of great painters and sculptors. Indeed, many feminist scholars in the 1970s did exactly this, and artists like Angelica Kauffmann and Artemisia Gentileschi were rediscovered and celebrated. But Nochlin points out that this is an inadequate response to the question, and

'merely reinforces its negative implications' (Nochlin, 1972, p. 3). It supports the notion that the great woman artist is rare and an exception to a general rule of genius as a male preserve. A second response would be to claim that women's work cannot be judged by male standards; that there is for women a different kind of greatness. This has a parallel in the broader politics of feminism. Many feminists argued that women should not try simply to conform to patriarchal notions of success, but should recognise the fundamental difference of women. Rather than, say, trying to become the CEO of a large multinational, and thus assenting to male values of competition, aggression, and so on, women should find alternative ways of living their lives. In the same way, some art critics and historians claimed that women's cultural work was fundamentally different from men's, exposing a female sensibility, female experience, a feminine aesthetic. But this too, says Nochlin, is an inadequate response. There is 'no subtle essence of femininity' (Nochlin, 1972, p. 4), nothing that connects female artworks. Indeed, the painting of a woman like Artemisia Gentileschi has far more in common with the work of her male contemporaries than of other women artists. To claim that a woman's work has an affinity with that of another woman in another historical period and culture is to claim that there is some feminine essence that transcends history.

So, Nochlin boldly avers, there are no female equivalents to Michelangelo or Delacroix. But this is not to suggest that women are incapable of producing great art. Nochlin by no means assents to the commonplace notion that genius is a male quality, a category from which women are excluded by virtue of some inherent deficiency. The reason history reveals no female Michelangelo is that women have been denied access to art institutions and so have been unable to participate fully in the art world. Moreover, art history has been complicit in this exclusion, since the domination of art by men and the unequal access to art have gone unrecorded in scholarship. Instead, the assumption that women simply are not great artists is repeated in historical accounts.

What kind of opportunities does Nochlin refer to in order to substantiate her thesis? First and foremost, she cites art education. In art academies, women were long excluded from the life class. They were not allowed to work from the nude model since it was believed to be inappropriate or indecent for women to come face to face with the naked body; in this way, prejudices about women's sensibility or supposed delicacy functioned as a means of validating inequality. This is no trivial matter. Through the eighteenth and nineteenth centuries the most elevated art, history painting, relied on a knowledge of and ability to represent the nude. Unable to do this, women were forced to concentrate on lesser genres such as flower painting. This in turn consolidated patriarchal prejudice by means

of circular reasoning: women paint flowers rather than history painting, therefore, they are lesser artists than men, and as lesser artists than men they need to be channelled towards lesser genres like flower painting.

Nochlin points out that women's art also depended on what was considered appropriate for women. While it was accepted that it was desirable for a woman to be accomplished in the arts, there were limits on the forms this should take. Above all, painting – or any other cultural pursuit – should not interfere with woman's ostensibly natural role as wife and mother. Thus, institutional and practical arrangements were often symptoms of a more abstract prejudice. There have been women artists who have had successful careers, of course, and Nochlin acknowledges this. She emphasises, however, that these women often had artist fathers, like Artemisia Gentileschi, or other male support which afforded them access to materials and knowledge, exemplified by Berthe Morisot's connection with Manet.

The keystone of Nochlin's argument, then, is that women's apparent failure in the field of art is not a question of individual characteristics, of women's lives and abilities, but rather one of institutional prejudice and practical obstacles that have hindered women. The answer to the rhetorical question of the title lies not in an analysis of the private sphere – that is, what is it about women that stops them being great artists? – but in the public – what is it about patriarchal society that prevents women realising their creative potential? And one could add: What is it about art history that blinds it to the question of sex and gender?

Ten years later, **Griselda Pollock** and **Roszika Parker** published their book *Old Mistresses: Women, Art and Ideology* (1981). While this book is a continuation of the pioneering work of Nochlin (and others), it also represents a rigorous critique of this position. Drawing on Marxism, semiotics and psychoanalysis, Parker and Pollock provide a much more systematic account of how a feminist approach to art history might proceed. Three key differences emerge when juxtaposed with Nochlin. First, they occupy a different political position. Rather than what they identify as Nochlin's equal-rights feminism, they favour a more radical stance heavily influenced by Marxism. Second, rather than thinking about patriarchy in terms of institutional exclusions, they emphasise ideology. Third, in place of Nochlin's general account of patriarchal prejudice in the art world, Parker and Pollock insist on a historical specificity and a refusal of generalised categories like 'woman artist' or, indeed, 'woman'. We shall look at each of these in turn.

Parker and Pollock's political critique of Nochlin represents a wider debate in feminism. They suggest that Nochlin adheres to an equal-rights

feminism, a position that seeks to grant women the same opportunities to participate in public life, the same rights in respect to employment, education, health and so on. Thus, Nochlin argues that women can become great artists if they are afforded the same opportunities as their male peers, and this is the means by which sexism can be eliminated. For Parker and Pollock this is quite mistaken. Their claim is a more radical one: that even if women are given the same rights as men, sexism will persist and patriarchy will continue. It is not simply that patriarchy erects certain obstacles to hinder women, but that society is founded on a structure that is sexist. If women had had access to the nude or other education, their work would still have been viewed as inferior, since men control meaning. Whatever institutional changes, this difference will pertain.

An example they give is the Abstract Expressionist painter Helen Frankenthaler (Figure 16). Here is a woman who had a privileged art education and became part of the most important avant-garde circle of the 1950s. She was keenly aware of theoretical debates in contemporary painting, and her work was produced within an intellectual and aesthetically sophisticated context. Nevertheless, critics – both male and female – always associated her work with nature, described it as intuitive, or in terms of natural metaphors of flowing and flowering. In other words, her painting is seen as stereotypically feminine. This is quite different from the kind of language and judgement made about a painter like Jackson Pollock who is characterised in terms of action and struggle (Figure 24, p. 193). In effect, Frankenthaler is the female Abstract Expressionist exception that proves the rule of male genius. One might elaborate this example by speculating what would be the case if Frankenthaler's and Jackson Pollock's styles were reversed. The drip painting would no doubt be characterised as delicate, woven, lace-like, and the stained canvases as strongly composed, on a heroic scale, with heavy blocks of colour. What needs to be addressed then, is not simply whether women have access to the life class or not, but the fundamental question of who controls meaning.

Second, Parker and Pollock seek the deep structure of sexism, and the systematic means by which patriarchy continually reproduces itself. Here they turn to the theory of ideology. It is summed up in their phrase 'Art is not a mirror'. We have already come across this idea, of course, that art is not mimetic. It does not simply copy what the world is like in a straightforward and unproblematic manner. But for the feminist critique of Parker and Pollock this has a particular interest and force. Art does not reflect women's lives but constructs a stereotype. It is prescriptive, not descriptive. Moreover, art and culture reproduce patriarchy, playing an active role, rather than simply reflecting social relations. The key term here

16 Helen Frankenthaler, *Low Tide*, 1963, oil on canvas, 213.4 × 207.6 cm, Yale University Art Gallery

is **difference**. Parker and Pollock assert that woman is always defined as man's other, his opposite or negative. She is represented and understood as the nature to his culture, the weakness to his strength, the object to his subject. It is not enough to explore how woman herself is positioned; one must do this within the broader system of sexual differentiation. In representation one might think of the nude. The female nude is conventionally passive, objectified, and sexually available while the male nude tends to be active, self-aware and desiring. The example of Frankenthaler and Jackson Pollock also reveals this sense of difference; she is the feminine and intuitive artist whose difference only confirms his masculine endeavour.

An important insight here is that rather than being an absence in the discipline, women artists have always been central to art history. Rather than being excluded they have been stereotyped or misrepresented, used to

define what male creativity is. Moreover, what makes this stereotype particularly pernicious is that it is ideological. When a man sits down to paint a female nude, he does not necessarily participate consciously in a patriarchal plot. Sexual difference is the mental structure in which he operates. It is taken to be the natural order of things. The same might be said of art history. For Parker and Pollock, art history is 'not the exercise of neutral "objective" scholarship, but an ideological practice' (Parker and Pollock, 1981, p. xvii). Here is the point that Marxist scholars had made: that histories are always written from a particular political perspective. Again, this is not to make a bald accusation of bias against historians, but to point out that they too work within a structure of knowledge and ideas, an ideology that determines what can be said. None of us can step outside our own culture and history and adopt an Olympian, value-free viewpoint (although we can identify and acknowledge our position).

The third divergence from Nochlin concerns history. Parker and Pollock insist that feminism must be very precise in writing the history of women or of sexism. Categories such as 'women' or 'women artists' are to be avoided. To talk of 'women artists' as a group is to suggest an unchanging history, as if women who paint or sculpt are always subject to the same pressures, the same prejudices, the same rewards. As *Old Mistresses* demonstrates, the lives and struggles of women artists have changed greatly over history. In discussing women artists, they dispel any idea of similarity, that somehow women in different ages and cultures are directly comparable. They also challenge the notion that there is a straightforward historical narrative of progress as the woman artist becomes increasingly empowered.

Looking at Renaissance painter Sofonisba Anguissola, they identify her class status as what enables her artistic career. At the time Anguissola was working, a shift was taking place in the definition of the artist, from that of a craftsman characterised chiefly by manual skills, to that of an intellectual, characterised by education. As a noblewoman, Anguissola had many of the accomplishments that conformed to the newer definition of the artist; thus her class privilege enabled a career where painting was merely an extension of an already permissible role. The late eighteenth-century painter Angelica Kauffmann, however, was in a quite different position. When she was working, the category of the 'woman artist' had taken hold, a kind of artist admired less for her rational and scholarly strengths and more for her own beauty and charm. This created a tension for Kauffmann between being both an object, and a creator, of beauty, the former taking precedence over the latter. Thus while she was able to have a career, it was circumscribed in significant ways.

The theoretical point here is that these are two quite distinct worlds and sets of problems. Women, art and ideology exist in different relations at different times; to talk about 'women artists' is to homogenise, and to claim that exclusion lies at the heart of women's art is to misunderstand the ways in which their work was made possible within the confines of patriarchy. Indeed, this critical point extends beyond artists. To talk of 'women' as a category outside history is to suggest that there is some essential quality that all women share regardless of their culture, age, social position, ethnicity, or historical location. For Parker and Pollock, to assert such a female essence would be to play into the enemy's hands, since this is one of the tools patriarchy has used to subjugate women.

Although they focus on women artists, and to a lesser extent images of women, Parker and Pollock lay out some general principles that might structure any other kind of feminist inquiry: gender as ideology; the way this is structured through sexual difference; and the need for historically-specific definitions of woman. Central to this is an explicit and self-conscious stance in relation to the hermeneutic problem. Pollock herself says of *Old Mistresses*, 'In place of the traditional survey, [Rozsika Parker and I] studied women's history in its discontinuities and specificities' (Pollock, *Vision and Difference*, 1988, p. 41). Broad generalisations and continuous narratives are rejected, along with the possibility of identifying a single mechanism for historical change, in order to provide ever more detailed and specific case studies. On the one hand, sex or gender itself cannot provide such a mechanism since, as Pollock and Parker eloquently point out, economic and other concerns must also be fully accounted for. On the other hand, sex and gender cannot be reduced to a second order effect, something that merely follows shifts in the psychology of perception or the mode of production, since feminism is committed to the notion that gender is fundamental to history. What is required is a 'complex and non-unitary history' (Parker and Pollock, 1981, p. 84), a necessarily messy imbrication of gender with other social categories, of women's history with other historical narratives.

This is wholly consonant with Parker and Pollock's critique of art history, the claim that it is not a neutral uncovering of truth but an ideological practice that is shaped, consciously and unconsciously, by the historian's own position. As we have seen, this is a general point that Marxists have made, and feminism adds an additional nuance. Imagine that a feminist has wandered in to Weiss's *The Aesthetics of Resistance* which we mentioned in Chapter 7. As the young men in the story view the Pergamon altar and find in it the history of subjugation and resistance in the class struggle, the feminist might add that one could also engage with the altar to see the

dominance of masculine values and the invisibility of women in the public sphere. Sex inequality and gender struggle can also be read in historical objects by an engaged viewer.

There is an important rider to be added here. This refutation of a neutral position should not be mistaken for relativism. It is sometimes suggested that if there is no pure objective account of the world, then all versions must be equally valid or invalid; that there can be no truth and we cannot adjudicate between different arguments. Now, in some instances this may seem to be the case. Take statements of personal taste, for instance. If Charlotte says 'I like Raphael more than Michelangelo' and Michael says 'I like Michelangelo more than Raphael', both statements may well be true. But imagine if we were arguing about chemistry. Charlotte, who has studied chemistry, says 'Water is made of hydrogen and oxygen', but Michael, who has joined a cult that believes everything in the world is made of metal, says 'Water is made of silver and lead.' Clearly only one of us is right. There is no sense in which relativism can be legitimate here. Although we are both speaking from a particular position or commitment, Charlotte's statement is true, Michael's is false.

Political questions may seem more problematic that chemistry, but the point remains that one can acknowledge that one has an *interested* approach without acceding to relativism. Indeed, the idea of a relativist feminism is problematic. A true relativist would have to claim that the statements: 'Women are inferior to men' and 'Women are equal to men' were both equally valid for those who believed them, that they simply represented two different perspectives. But this would clearly be self-undermining. It would require a feminist to accept as true something that contradicted her belief, or accept as false something that confirmed that belief. However, some feminists have adopted or adapted theories that are relativist in origin, and in the next section we turn to the most important of these.

Michel Foucault: discourse and power

An important alternative to liberal and Marxist-based approaches, and to the psychoanalytic methods discussed in Chapter 9, has emerged in feminist scholarship that deploys the ideas of the French philosopher Michel Foucault (1926–84). In particular, this influence has been felt in work concerned with sexuality, which has always been central to feminist debates. Foucault makes the claim that sexuality is a social construct. Although we may feel that categories like heterosexual and homosexual are descriptive of our fundamental natures, something absolutely central to who we are,

he argues that there is nothing natural about these categories at all. Our sexuality is discursively produced. In order to understand what this means, we shall first have to outline some Foucauldian principles.

Central to feminist uses of Foucault is his notion of **discourse**. Foucault asserts that all concepts are historically formed and contingent, and so are never universally true. Indeed, there is no sense in which a statement can be said to be true or false. What one has to look for is what counts as true at a given historical moment; who is, to use Foucault's phrase, 'in the true' and thus has the authority to declare truth. So our concepts and descriptions of the world are discursively produced. There is no objective way one can speak of, say, sexuality. We can only trace changing descriptions made at different historical moments which tell us not what sexuality is, but what *counted* as a true account at that time. It is important to emphasise exactly how radical Foucault's claims are. Foucault does not simply argue that people fail to find the true account. He argues that there is *no* true account since sexuality does not exist in the world but is created in discourse. We do not just argue about different *conceptions*; such an argument would assume that there is something real that the term sexuality describes, but that we have different notions of what it is. Instead, the very *concept* is discursively constructed, produced in particular powerful institutions with an authoritative language. It is a fiction we live as if it were real.

This position entails two other important claims. First, any knowledge is inextricable from the question of power. Since there can never be an objective description of the world, any description, any truth claim, must be understood in terms of its purpose and function in the regulation of power. Second, the historian must eschew continuity and look for discontinuity. Unlike a model of history where ideas develop and progress towards a truer picture of the world, the Foucauldian examines shifts in thinking, moments when one account gives way to another; and unlike historical practices which assume that some things are a continuous presence or force (such as our mono-causal accounts in Part One of this book), Foucault insists that all values and ideas and concepts change fundamentally, and it is these shifts that need to be identified.

It should be clear how different this is from some of the other approaches examined in this book. In Chapter 9 we discuss the psychoanalytic argument that sexuality is fundamental to human development on both individual and collective levels – the truth that is so often hidden or repressed. For Foucault, psychoanalysis is exactly the kind of institution that fosters the illusion that our sexuality is natural and inherent by generating discourse that counts as true. There is also a marked difference between Marxism and Foucault. In Chapter 7 we examined the notion of

ideology, the sense of false consciousness by which people misidentify the interests of the ruling class as their own interests. Orthodox Marxism (and certain variants) believes that this falseness can be stripped away to make people see the truth of their lives and social conditions. Foucault stands in opposition to a philosophy which rests on notions of truth and falsity. He also challenges Marxism (and Hegelianism) in regard to the notion of social progress. Marxism is premised on the possibility of people becoming freer, of society moving to a more equitable and rational state; for Foucauldians, such a notion is mistaken. There are only changes in the ways in which we are regulated.

This latter point is made very clear in Foucault's *The History of Sexuality: An Introduction*, published in 1976 (English translation, 1978). Here, he outlines a common notion about sexuality in the nineteenth century. People tend to believe that the Victorians were repressed; that sex was not spoken of, that sexuality was kept hidden, covered up like piano legs. In contrast, the twentieth century is seen as an era of sexual liberation, when people faced up to their desires and appetites and became more honest about the sexual nature of humanity in, for instance, psychoanalysis or the so-called sexual revolution of the 1960s. This, Foucault says, is a complete fiction. First, rather than remaining silent about sexuality, the nineteenth century generated a 'discursive explosion' with endless books, advice manuals, speeches, and articles about all aspects of sexuality. Indeed, this discourse was a means of inventing categories like the homosexual man or the masturbating child, and thus provided a means of categorising and controlling. Second, sexual liberation in the twentieth century is similarly misleading. If, for example, men and women came out and declared themselves to be homosexual, this was not an unveiling of their true nature, but complicity with the power regime that sought to categorise them in this way, an acceptance of an identity prescribed elsewhere. What looks like liberation is in fact just a different form of regulation. Foucault, then, not only questions historical orthodoxies but also the politics on which the women's movement was based.

A pioneering use of Foucault in art history was **Lynda Nead**'s book *Myths of Sexuality* (1988), which uses a Foucauldian framework to address images of women in Victorian Britain. Nead begins with the question: why did female sexuality become such an important issue in the middle decades of the nineteenth century? In a close examination of a series of images, she argues that categories were established which produced a notion of normal healthy sexuality, such as the bourgeois mother, and deviation from that norm, such as the adulteress. These categories were produced by powerful discourses that were 'in the true' such as law, medicine and religion, and to

these Nead adds art. Let us take a brief look at two of Nead's case studies
to see how she deploys two Foucauldian principles: the idea of discourse,
and the notion of power.

Augustus Egg's *Past and Present* (1858) is a series of three paintings that
tell the story of a woman's adultery and its effect on her family. The central
panel shows the scene of the discovery of her affair, and the two flanking
pictures events five years later. In these later scenes, the father/husband has
died (this information was included in the original caption to the images),
and we see the orphaned daughters living in poverty on one side, and the
woman herself, abandoned by her lover, destitute and with her bastard child
beneath a bridge by the Thames. The implication here is that there will
soon be suicide and infanticide. The date of the paintings coincides with
what Nead calls 'a moral panic'. In 1857 new divorce legislation, the
Matrimonial Causes Act, declared that women should excuse a husband's
adultery, while men should never condone a woman's. It was also the year
of the Indian Mutiny, a traumatic event for the British Empire, when
Indians rose up and challenged British rule in the sub-continent.

Connecting these two things, Nead points out that concerns about
social collapse, at home and abroad, were often projected onto sexual
behaviour. Hopes and fears about the stability of Britain and its Empire
were expressed in terms of sexual morality. One might, therefore, see *Past
and Present* as a 'coherent reflection of Victorian moral values' (Nead, 1988,
p. 79). In such a reading, the narrative of the trilogy would be seen to
illustrate the moral position of the Matrimonial Causes Act, and to warn
of the social dangers when women dare to cross the line of respectability.
But Nead very firmly asserts that this is an inadequate interpretation. The
paintings do not reflect ready-made ideas produced in other fields. They
actively produce the category of the fallen woman: 'this visual representa-
tion took part in the obsessive and insistent definition and categorization
of respectable and non-respectable sexual behaviour' (Nead, 1988, p. 86).
These are not effects of the moral panic, but causes; they do not illustrate,
but define.

Let us be quite clear about what this Foucauldian approach entails.
In looking at these images of the fallen woman, Nead is certainly not sug-
gesting that they are somehow documents that tell us something about
women's lives (the idea of art as a reflection of life that Parker and Pollock
so roundly refuted). Nor is she taking a more familiar feminist line, iden-
tifying these as sexist images providing an illustration of patriarchal atti-
tudes, offering a moral judgement on women while surreptitiously, perhaps,
providing titillation for a male viewer. Instead, these paintings are part of
the very process of inventing the category of the fallen woman. In her

introductory chapter, Nead invokes the helpful model of cause and effect. Social historical approaches might place these paintings next to contextual material such as legal documents or medical reports of female sexuality and use this contextual material to explain the imagery. Ideas emerging in the law or in science could be seen as the source of the image, an intellectual cause producing a visual and aesthetic effect. Nead, in contrast, wants to identify art as a discourse, as part of the cause whose effect is the creation of a category like the fallen woman. The images do not report something that has already happened – whether in reality, or in discourse – but bring the category of the fallen woman into being.

Nead also draws on Foucault's particular notion of power. The Women's Liberation Movement had argued that women were oppressed by patriarchy, but could fight to free themselves from the constraints and limits imposed upon them by a sexist society, thus realising their true selves. A Foucauldian account argues the opposite of this. First, as we have seen, such an account would say that there is no true self to be liberated, only another self to be produced and regulated. Second, Foucault takes issue with the notion that power is something that is imposed from the top of a hierarchy by removing freedoms, limiting actions, and oppressing. He argues that power is not repressive but productive. It does not forbid, operating by saying 'Thou Shalt Not', but instead provokes and enables, saying 'Thou Shalt'. When Nead turns to another trilogy, George Elgar Hicks's *Woman's Mission* (1863) this notion emerges very clearly. *Woman's Mission* comprises three paintings of a woman: as a mother guiding her small son along a path as he learns to walk; as a wife supporting her husband (Figure 17); and as a daughter tending her ageing father. While three different men are depicted, the same woman occupies each of these roles. Feminist historians have often discussed the ways in which patriarchy has confined woman, circumscribing her life by imposing particular roles on her and incarcerating her in the private sphere. In the second panel, *Companion to Manhood*, her domain is defined as the home and her duty to attend to her husband, so legible in the poses of the figures. So why does Nead not interpret the images as proof of this oppressive regime?

The answer lies in the Foucauldian conception of power. Nead contends that these are not images of women repressed by power but images which produce 'pleasures and incentives' for the respectable bourgeoise. It is historically implausible, she suggests, to read these roles of mother, wife and daughter as purgatory or torment for women; rather, this healthy, female sexuality provides pleasures, an elevated moral status, and a rewarding sense of embodiment. The wife in *Companion to Manhood* is not being forbidden, but is permitted to enjoy moral strength. The images do not

17 George Elgar Hicks, *Woman's Mission: Companion to Manhood*, 1863, oil on canvas, 76.2 × 64.1 cm, Tate Gallery, London

detail a gender prison, but the delight of engaging with children, the affective rewards of marital support, and the emotional and sentimental satisfactions of caring and duty. The structuring of the woman's life around a husband and a son cannot help but invoke sexuality: the images make it clear that this is a healthy sexuality in contrast to, say, the fallen woman that Egg defined. Discourses like art, then, regulate sexuality not by denying it but rather by enabling it.

This Foucauldian approach has sidestepped some of the problems inherent in other feminist approaches, such as Marxist interpretations with

their attendant difficulties in the theory of ideology (see Chapter 7), or in psychoanalytic readings (see Chapter 9), but has inevitably raised others. Nead herself cautions against too fixed an application of Foucault's principles, first on the grounds that his concept of discourse is rather inconsistent, and second – and more importantly for a feminist – because his work on sexuality ignores the question of gender. But beyond this one might ask other difficult questions of this approach. While one can identify changes, how does one explain why and how that change comes about? A new discourse creating, say, the fallen woman or the homosexual might emerge, but what causes this? Here, again, we come across the hermeneutic problem, in effect. We can identify discontinuities and shifts, but cannot account for why they occur in the manner they do. Moreover, if one needs to attend to the connections between discourses, how does one do this? If art, law and medicine are involved in the constitution of a sexual type, does this happen simultaneously in each? If not, which discourse has priority, and what does this mean for an approach which refuses art as an illustration of other discourses?

Above all, there is the thorny problem of relativism. It seems that one can only accept all that Foucault says if one is prepared to surrender the political tenets of feminism. This is why, in the end, Nead, like many others, offers only a weak Foucauldianism; that is, she uses his ideas without subscribing to his fundamental philosophical commitments. ('Weak' is not a qualitative term here.) Rather than asserting that there is no truth, no progress, and only productive power, she makes less radical and more plausible claims: namely, some apparently natural categories are socially constituted, there is no straightforward process of liberation or teleological progress, and that power is not only repressive. In this way, she is able to challenge certain orthodoxies, and sidestep the problems of other theoretical models, but resist the radical relativism which is incompatible with feminism.

Gay, lesbian, queer

Foucault has also been hugely important in the development of gay and lesbian scholarship in art history (and, indeed, in many other disciplines). Just as the movement for gay liberation followed in the wake of second-wave feminism, so art histories concerned with and written from the perspective of homosexuality followed feminist accounts. Again, this is work that has to be understood in a context of political and social struggles from the late 1960s seeking to overturn prejudice. While gay and lesbian politics has always had a specific set of issues to deal with, many of the underlying debates were similar to those in feminism: whether one should seek equal

rights within the status quo or attempt to remould society; how to think about sexuality in relation to other categories such as sex, gender, race, class, age; whether to assume and celebrate essential gay and lesbian qualities or to challenge them as stereotypes, and so on. In art history, there is also a parallel with feminism. Gay and lesbian scholarship in its earliest days attempted to recover homosexual artists, and to find traces of their sexual desire in their work. Thus, artists like Caravaggio or Michelangelo were discussed as homosexual and their attitudes to male nudes were taken to be erotically charged and thus symptomatic of their own desires, and those of their patrons. Against this wish to insert gay men and lesbians into art history, many argued that this merely creates a kind of aesthetic or sexual ghetto, a separate enclave of homosexual images which made no substantive difference to the discipline and its values. Furthermore, such work seems to rely on a trans-historical category of homosexuality; as if there is a particular kind of man or woman whose identity is fundamentally unaffected by their historical and cultural location. Thus, Michelangelo and Simeon Solomon and Robert Mapplethorpe all seem to be the same: homosexual men depicting male nudes in order to satisfy an erotic longing, unaffected by the specific historical circumstances in which they live and work.

A Foucauldian approach seemed to provide a solution to this essentialism. In place of a trans-historical homosexuality, scholars have tried to find historically specific concepts of certain desires. One needs to be very clear about this. Foucault is often invoked, but not always in a wholly accurate way. While scholars may argue that there are historically specific *conceptions* of homosexuality – for instance, that it is seen as the pinnacle of male friendship in one era and a psychological pathology in another – this is not the same as Foucault's claim that the very *concept* is a historical construction. Even to use the category in an analysis of, say, Greek art or the Renaissance male nude would be, for a strict Foucauldian, utterly mistaken. Instead, one would need to find the sexual categories that were in operation and which were taken to be true at that moment – such as the pedagogical categories of *erastes* and *eronomos* in ancient Greece, or the molly in eighteenth-century London.

In this way, **Michael Camille** has discussed the medieval French art patron, the Duc de Berry (Camille, 'For Our Devotion and Pleasure', 2001, vol. 26, no. 2, pp. 7–32). While the Duc clearly found pleasure in younger men, Camille describes this pleasure and its relationship to images, such as the illuminated manuscript *Les Très Riches Heures*, in terms of late-fourteenth and early-fifteenth-century concepts. This has by no means been the only approach in gay and lesbian work. Psychoanalytic approaches have also been

much in evidence, as have social historical methods. The film historian **Richard Dyer** has produced many studies of the representation of homosexuality in still and moving images, and has concentrated on iconographical concerns, albeit within the terms of feminist debates. In an article entitled 'Don't Look Now', first published in the journal *Screen* in 1982, Dyer examines male pin-ups. His topic is actually images of men aimed at women, but the article exemplifies the goal of much gay and lesbian scholarship in its critique of visual constructions of heterosexuality. Thus, Dyer explains how the use of natural settings for male nudes present muscle as something not created in the gymnasium but as 'a biological given' (Dyer, 1992 [1982], p. 114); or how the ways in which the model's gaze, either staring directly out of the image or fixed intently on some object outside the frame, establishes the male as self-possessed and in control, in spite of being an object of scrutiny.

Broadly speaking, it is Foucauldian developments in gay and lesbian scholarship that have led to the most recent model for gender-based theory: what has come to be known as queer theory (although some queer theorists have relied more on psychoanalysis). Whether or not queer theory will have the kind of impact on art history that earlier versions of feminism have had remains to be seen. Certainly, there is no figure comparable to, say, Griselda Pollock, but this may change in the coming years. At the root of queer theory is a profound distrust of any kind of fixed identity, of any categorisation of people and the binary divisions that structured much feminist work – male and female, masculine and feminine, homosexual and heterosexual – are decisively rejected. Gay and lesbian scholars often work with the idea that people are divided into two categories: heterosexual and homosexual, or gay and straight. Of course, they do not suggest that nobody can move from one to another, or that someone might not experience both kinds of desire, but these arguments still assume that there are two distinct modes of desire. Queer theory argues that these are not stable, but very unstable categories. To invoke one is always to reveal the other. An image of a heterosexual man must, by its very nature, exclude the idea of homosexuality; and in excluding it, brings it to mind. In other words, heterosexuality is simply the exclusion of homosexuality, bisexuality, lesbianism and so on. So rather than looking for a clear homosexual presence in visual culture, as many gay and lesbian scholars had done, queer theorists look for the homosexual in the heterosexual and vice versa. They seek the points where out categories break down and stop making sense.

We saw earlier that anti-essentialist feminists argued against a celebration of woman's apparent feminine qualities rooted in the female body, since they saw this as merely consolidating patriarchal ideas. In the same

way, queer theorists see the same problem in hanging on to categories like gay and straight; simply to use 'gay' as a positive and valued notion keeps in place the same notions of norm and deviance. This is why many of these scholars identify themselves as queer. It is a fluid and unspecific term that can mean anything, registering only the wish to be other than normal, without classifying oneself in any way. (There is a question, of course, as to whether one actually lives in this way. Often, 'queer' is only used as a synonym for 'homosexual' or 'lesbian', thus undermining the more radical claim signalled by the term. Moreover, one might ask: given the profound mistrust of any binary categorisation, what of the classification normal/ queer?) In this refusal of categories, queer theorists have adopted a yet more radical anti-essentialist position, arguing that not only is gender a social construct, and not only is sexuality a construct, but sex itself is socially constructed. To think of male and female as natural kinds uninflected by socially produced ideas and values is mistaken; there is, they argue, no foundational truth to the body to which we can appeal. This is not to say that bodies are not materially different, and the argument is not that dis-course and society *causes* the difference between male and female. Queer theory does argue, however, that bodies and sex can never be extricated from our norms and values. We can never know an objectively sexed body. For instance, to point to a figure in a painting and to say, 'This is a woman' is not a straightforward factual description. It is already bound up with a socially conventional way of seeing the world, not least in the fact that we think of the binary division between male and female as objective, rather than laden with assumptions.

An example of how this can be brought to bear on the visual image is to be found in an essay on gender by **Whitney Davis** (2003). Davis treats his subject from a queer theoretical point of view. In many respects this is an unorthodox contribution to the debate, but it is undoubtedly a highly innovative one. It also makes very clear the way in which queer theory chal-lenges the focus of feminist and lesbian and gay scholarship, seeking to overturn such explanatory categories as masculine and feminine, or hetero-sexual and homosexual.

The refusal of these taxonomies, however, creates a certain difficulty, since it means that the term gender becomes very elastic. No longer can one think of sex, gender and sexuality as different things; they are all sub-sumed by the term 'gender', in that they are all taken to be socially con-structed. Thus 'male' is a gender, 'masculine' is a gender, 'homoeroticised masculinization' is a gender, as well as the notion of many different genders which are unspoken or undefined. While this certainly prevents any simpli-fication or reductive definition of gender, it raises the question of what

gender might actually mean when the term becomes so attenuated and deliberately imprecise. Davis begins by asserting that gender is not a question of difference, as Parker and Pollock maintained in *Old Mistresses*, but rather of agreement. What Davis seems to mean is this: while there are particular images that offer differential definitions of male and female, definitions where the two elements are given a significance in terms of their relationship (such as active and passive, strong and weak, desiring and desired, etc.), what is more important is how the categories of male and female are made to cohere, how their stability is maintained. What is the mechanism by which masculinity is always assumed to be active rather than passive, when there is no empirical or theoretical reason for supposing such a thing?

The suggestion is that we need to attend not only to what an image shows, but also to the ways in which gender is, to use Davis's own term, part of our visual 'grammar', the broader conceptual frame in which we assess the world and its representation. So, while differences are defined in visual culture, and while images offer us bodies which seem to be naturally divided into various sorts such as male and female, Davis argues that more fundamental is the system of thought which requires us to see the world in terms of these divisions. In essence, this is the queer theoretical idea that to talk of male and female is to talk of gender regulation and social norms. If Parker and Pollock identified difference as the ideological structure of sexism, Davis seeks to go one step further and find the deeper habits of binary thought that structure that ideology of difference.

To exemplify this, Davis looks at Degas's *Young Spartans Exercising* (Figure 18). On the face of it, this seems to depict a clear sexual distinction between boys and girls. It also seems a straightforward visual account of their gendering, the roles they are going to take up in later life; for the girls this is childbearing, represented by the matrons behind them in the distance, and for the boys it is lawmaking and public life, represented by the men behind them. However, these divisions are not as stable as they might at first appear. First, there is another binary distinction at work in the image: youth versus maturity. The girls with their short hair and half-naked bodies are much closer in appearance to the boys than to the mature women in the background. Similarly, the boys are more like the girls than they are like the mature men, given their often indistinct bodily and genital morphology. Moreover, the youths are part of a Spartan *syssita*, which is a homosexually organised communal bond. In other words, the assumption of heterosexual desire which structures the scene of the mature figures in the background (fathers, mothers, and their children in the foreground) is disrupted by showing alternative affective and sexual relationships between the boys, for

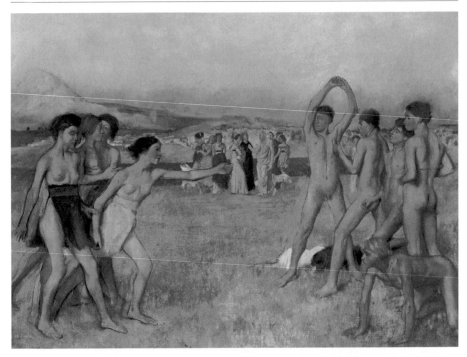

18 Hilaire-Germain-Edgar Degas, *Young Spartans Exercising*, *c*.1860, oil on canvas, 109 ×
154 cm, National Gallery, London

instance. This disruption goes further. This 'homoeroticised masculinisa-
tion' is transferred to the girls, which in turn has the effect of partially
feminising the boys. Thus, in this reading, the straightforward narrative of
patriarchal authority is at odds with the unstable and muddled genders and
desires that emerge from a close visual analysis.

What is striking is the fact that the groups of male and female are
distinct in spite of these complications. This is where the notion of gender
as 'grammar' emerges. One might suppose Degas's image to be gendered
male. Its clear distinction of public, powerful men, and private, maternal
women seems to suggest that this represents a male view, a male position
in the world, a male form of representation (regardless of the body of the
artist himself). Another kind of feminist might make this point by saying
that it represents a patriarchal image. But for Davis such a reading is not a
solution, but part of the question to be answered: the question of agree-
ment. Male and female are imposed on the picture simply by virtue of
convention, by the way the composition is structured around a binary divi-
sion. What Davis is doing here is taking the queer theoretical notion that
bodies and sex are not natural, but are always caught up in a system of

gendering. In saying of these figures, 'It's a girl' or 'It's a boy' we are not describing them objectively, but revealing the ways in which we assume they should be viewed and understood, removing other possibilities from what these bodies might be. Reading the image against the grain in this manner can reveal the orthodoxies that underpin other readings, including those of artists and original audiences. It is not that this is what the picture really means, but rather what system is in place and how the 'supergendering' – that is, the apparently natural binary structure of male and female – can be made to cohere with the 'subgendering' – the disruptions that cast doubt on that binary structure.

Critical appraisal

Reactions to early feminist art history – as to feminism in general – were often extremely hostile. Opponents declared such work to be politically motivated polemic rather than history, the misuse of the academy for propagandistic purposes rather than scholarly endeavour. Such arguments, grounded in the belief that history was somehow beyond personal and political considerations, were, of course, exactly what feminism was challenging, exposing sexist assumptions that passed for fact. Another line of attack was that feminist art history was all very well in its way, but in turning to women artists, the questions of crafts and so on, it dealt with second-rate work and was thus a minor, if interesting, subset of the discipline. As we have seen, it was the assumptions underpinning such a point of view that feminism explicitly challenged, deconstructing notions of greatness, of the canon, and of art history's wilful blindness to questions of sex and gender. While anti-feminist arguments like these are still to be found, they no longer have any real force. We hope it is not naive or over-optimistic to say that art history as a discipline now recognises not only that feminism is a legitimate approach, but that it is essential to any fully adequate understanding of art and its history.

As we have seen, feminism faces considerable difficulties when it incorporates within itself a radical epistemology (a philosophical view of the nature of knowledge). Because feminists emphasise the importance of the differences in individuals' viewpoints in forming attitudes, beliefs and views of the world, feminism is often tempted towards taking up relativist positions. But this, as we have argued, is a dangerous course to take, because it can lead to undermining the force of some of the claims that feminists want to make most strongly, above all, the claim that it is a matter of fact, not opinion, that there is no reason to privilege the heterosexual male vantage point.

The remarkable ascendancy of feminist art history in the academy, and to a lesser extent in other areas of culture, has produced a steady stream of books, articles, journals, conferences, and exhibitions dealing with gender. Indeed, more recent critical accounts of feminism have, in fact, argued the opposite of these early critics: that feminist art history, rather than being too politicised, has lost touch with its radical roots. The success of feminism in the academy has been seen by some as double-edged, a process whereby the representation of gender has been taken up but the broader political project of feminism has been ignored.

Feminism has also been criticised on the grounds that it is overly predictable; that whatever image or object it deals with, it always comes to the same conclusion that the work is sexist, or that it resists sexism. This is an impoverished view of feminism, and does not account for the concerns for specificity that we saw in Parker and Pollock. They clearly argue that simply identifying sexism is insufficient. One needs to understand the specific forms it takes, and the ways in which it is defined and inflected by questions of class, age, race, ethnicity and so on. 'Sexism' is another category that must be addressed as a series of different social and political forms rather than a general and trans-historical category. Moreover, this claim of predictability is also countered by the way in which feminist art history has continually used other methods to support its historical analysis.

While clearly identifying the problems of patriarchy and sexism, and exposing how these are evident in the production and consumption of art, feminism has to turn to other theories in order to explain why this is the case and how it persists, as we have witnessed in the various case studies examined above. Importantly, this mixing of a feminist approach with other theories has introduced questions of sex and gender into models which might have hitherto ignored women, or actually exhibited sexist thinking themselves. Feminists using psychoanalysis have pointed out those places where Freud exhibits sexism, and Marxist feminists have long demonstrated the ways in which much Marxist thought replicated patriarchal prejudices. This is a two-way street, where feminism has both used and enriched other methods. The difficulty that this symbiosis raises is that of priority. Marxist feminism, for example, claims that both gender and social class are crucial. Parker and Pollock's account of Anguissola and Nead's analyses of the image of the respectable Victorian woman clearly see class as inseparable from sex and gender. The question is: which is the more fundamental? The implication is that there is no primary historical cause, no single mechanism that is foundational to historical change. As a consequence, all a historian can do is to offer a discontinuous account of the complex interactions between them, the 'non-unified' history that Parker and Pollock called for.

Feminist art history has also been dogged by accusations that it fails to appreciate art and its pleasures, as if beauty is somehow destroyed by politics. At one level, this kind of accusation is simply a sexist defence mechanism, and fails to comprehend the difference between judgements of taste – whether someone thinks a work is beautiful or not – and an historical account of a work – why it was made, and what its meanings might have been to a contemporary audience. Here, the question of the historian's own pleasure is irrelevant. If Michael is studying the meanings that Dürer's *Melancolia I* had for its contemporary audience or the symbolic functions of the Sphinx, his own reaction to these works lies outside his study. The historical questions are unrelated to whether he finds pleasure in these objects or not.

More interestingly, though, there is an historical question about visual pleasure to be addressed. If an artwork is specific to its cultural and historical moment, then its reception must be similarly specific. In other words, Michael's pleasure or displeasure in Dürer may not be relevant, but that of the original audience may well be an issue. Feminism has certainly not ducked this question. Why something is seen to be beautiful, or has provided pleasure, has been a major concern as evident in questions like: Why is a man's work deemed to be beautiful while a woman's is merely pretty? Why is a passive, unconscious female nude deemed more beautiful than an active and muscular one? There is a third question, too, which continues this line of argument. This concerns what one might call the ethics of pleasure, and here feminists have sometimes been very wary of unbridled visual delight. Laura Mulvey's pioneering article 'Visual Pleasure and Narrative Cinema' (which is discussed in Chapter 9) asked why it is that women can both recognise an image as sexist and find pleasure in it at the same time. Similarly, Parker's and Pollock's critique of Linda Nochlin remarks that the latter does not really question the notion of 'greatness' in art and the way in which it is constructed and maintained. This is not to be confused with a stony-faced or sour Puritanism. These issues are raised because scholars recognise the pleasures of canonical artworks, however problematic that may be in political terms. Moreover, much feminist work, like Mulvey's, opens up the possibility of alternative sources of visual pleasure. The key point is that for a feminist approach, visual pleasure is not a given but something that must also be explained by art history.

There is no disputing that feminism has transformed the discipline of art history, and it has done so by importing a feminist political agenda which both challenges the boundaries of art history and demands a critique of its theoretical precepts. Feminist art history is not to be understood as a simplistic rejection of, say, Panofsky or Riegl on the grounds that they are sexist and therefore unreliable. It is, rather, an understanding that if one

is fully to account of the complex and specific history of an artist or an image, including matters of sex, sexuality and gender, then one cannot retain a belief in the progressive unfolding of history, of steady universal human development. Instead, one must look for difference and discontinuity, and the explanation of the specific historical moment. The gains made are clear, but so too is the price paid. No longer can we find a single mechanism that explains historical change, but for feminism this refutation of mono-causal history is a necessary step if a non-sexist art history is to be written.

Bibliography

Broude, Norma and Garrard, Mary D. (eds), *Feminism and Art History: Questioning the Litany* (New York: Harper & Row, 1982); Norma Broude and Mary D. Garrard (eds), *The Expanding Discourse: Feminism and Art History* (New York: Harper & Row, 1992). Two useful anthologies of articles which show how wide-ranging feminist art history has been both in terms of its subject matter and its theoretical commitments.

Callen, Anthea, *The Angel in the Studio: Women in the Arts and Crafts Movement, 1870–1914* (London: Astragal, 1979). A study which shows how a feminist approach can unsettle scholarly orthodoxies. Callen's rewriting of the history of the Arts and Crafts movement explores the implication of sexual and class inequalities at all levels: theorising about craft, different forms of production, and circulation.

Camille, Michael, 'For Our Devotion and Pleasure': The Sexual Objects of Jean, Duc de Berry', *Art History*, vol. 26, no. 2 (2001) pp. 7–32. An attempt to deal with male–male desire in medieval art, but while he insists on a rigorous historical specificity to the concepts it uses, Camille also cites psychoanalysis, thus questioning some of his own claims.

Davis, Whitney, 'Gender', in Robert Nelson and Richard Schiff (eds), *Critical Terms for Art History*, 2nd edition (Chicago and London: University of Chicago, 2003) pp. 220–33. A suggestive but difficult text, written in a style that is not always clear. This is a contemporary account of gender and provides an approach quite unlike those of previous major scholars.

Duncan, Carol, 'Virility and Domination in Early Twentieth-Century Vanguard Painting', in Norma Broude and Mary D. Garrard (eds), *Feminism and Art History: Questioning the Litany* (New York: Harper & Row, 1982) pp. 293–313. A pioneering article from 1973 that begins to construct some of the arguments in *Old Mistresses* from a Marxist standpoint.

Dyer, Richard, 'Don't Look Now', in *Only Entertainment* (London and New York: Routledge, 1992 [1982]) pp. 103–20. One of the earliest gay interventions in the representation of the male nude. Witty, insightful and, most of all, lucid.

Nead, Lynda, *Myths of Sexuality: Representations of Women in Victorian Britain* (Oxford: Blackwell, 1988). An influential use of Foucault, although never dogmatic about its theoretical sources.

Nochlin, Linda, 'Why Have There Been No Great Women Artists?', in Thomas B. Hess and Elizabeth C. Barker (eds), *Art and Sexual Politics* (New York: Macmillan, 1973) pp. 1–39. In spite of subsequent criticisms, such as that of Parker and Pollock, this is one of the most important articles yet published in feminist art history, and still raises important questions.

Parker, Rozsika and Pollock, Griselda, *Old Mistresses: Women, Art and Ideology* (London: Routledge & Kegan Paul, 1981). A hugely influential book that set an agenda for feminist art history still being followed in one way or another.

Parker, Rozsika and Pollock, Griselda, *Framing Feminism: Art and the Women's Movement, 1970–85* (London: Pandora, 1987). A useful anthology of articles and reviews from the early days of the Women's Art Movement with an excellent introduction.

Pollock, Griselda, *Vision and Difference: Femininity, Feminism and the Histories of Art* (London: Routledge, 1988). An important collection of articles, including 'Vision, Voice and Power' which is a key text for understanding the relationship between Marxism and feminism in art history.

Tickner, Lisa, *The Spectacle of Women: Imagery of the Suffrage Campaign, 1907–1914* (London: Chatto & Windus, 1987). A brilliant account of the visual culture associated with the suffragettes and their opponents. This is exemplary in the way that contemporary feminist politics and historical concerns can be combined.

WHILE THIS BOOK offers a chronological account of art history and its development, we noted in the introduction that there are points at which the distinction between 'historical' and 'contemporary' accounts collapses. Psychoanalysis has been one of the most widely used methods in recent years, but it would be quite mistaken to think of it as a new development since it has provided a stimulating and powerful cultural theory since its inception at the end of the nineteenth century. It hardly needs saying that psychoanalysis did not begin as an art historical method; but, like Marxism, it has proved to be an extraordinarily adaptable toolkit that scholars in many disciplines have used for the analysis of culture. Indeed, so influential has psychoanalysis been, it is probably the best known of all the theories in this book. Many people will know the name Freud, and terms like 'Freudian slip' or 'phallic symbol' will not have people scratching their heads in puzzlement as might 'Geist' or 'mode of production'.

It was **Sigmund Freud (1856–1939)**, a Viennese doctor, who invented psychoanalysis and his writing is still the most important and the most frequently quoted. While Freud created psychoanalysis as a medical therapy for the treatment of certain mental disturbances such as neurosis, the technique has perhaps been even more influential as an interpretative tool in non-medical fields, particularly in recent years where the vogue for psychoanalytic studies in the humanities has increased in inverse proportion to the displacing of analysis by other neurological and psychological theories in science. The reason that psychoanalysis has had this other career is that, in creating a therapeutic medium, Freud also constructed a model of the human mind, and from this he extrapolated a theory of culture, which he used to support his clinical practice. From the outset, it was clear to Freud and his followers that the new 'talking cure' would have a usefulness and impact beyond the walls of the doctor's consulting room. Freud and his acolytes wrote extensively on the significance of the theory for culture, history, social science and so on; and art history was by no means excluded. Freud himself was a great collector of art; he took an active and scholarly interest in the subject and we examine his essay on the Renaissance artist Leonardo da Vinci. We have already seen that art history has sometimes derived its procedures from psychological theories (in Chapters 5 and 6, for

example) and in this sense Freudian work could be viewed alongside that of, say, Warburg in its concern for identifying the psychic context of art production and consumption. Though Warburg himself was hostile to psychoanalysis, he and Freud share a concern for the relationship between internal mental structures and cultural products.

In order to grasp how principles of psychoanalysis are pertinent to our own field of art history, we need first to lay out some basic ideas. This may seem a relatively long excursus, but it is necessary if we are to understand the specific principles of psychoanalysis. Although Freud's ideas changed through his career, and although the field has split into many competing schools, each with their own perspective, there are some underpinning notions that are common to all. Two ideas are fundamental to all psychoanalytic theories. First, psychoanalysis declares that our mental life is not the same as our conscious life. As well as our consciousness, with its faculties of reason and imagination, thinking and wondering, our minds have an **unconscious**; this is the most important keyword in this chapter. Freud did not invent or discover the idea of the unconscious, but he did come up with a radical and novel account of it. He maintained that our unconscious was formed from repressed mental events in childhood: infantile desires, traumatic memories, unacceptable erotic longings. These events are banished from consciousness and create an unconscious, to which we have no direct access, where they are retained. The nature of the repressed material alerts us to the second key principle: that sexual impulses are central to the human psyche and, hence, human behaviour. While many of Freud's contemporaries would have tried to dismiss sexual desire as an animal appetite to be controlled (or enjoyed), a reminder of a baser instinct that man was capable of overcoming, Freud insisted that it was the very essence of human life. Moreover, he defined sexuality not as something that simply emerges at puberty but is always present from infancy. As we shall see, this has important implications for the psychoanalytic study of culture.

In his own practice in Vienna, Freud had many patients who exhibited hysterical symptoms, coughs or tics or compulsive behaviours which seemed to have no physical cause. Freud worked on the basis that these ailments were psychosomatic, that the cause was not physiological but psychic and that in order to cure them he needed to attend to his patients' mental life rather than their bodies. What was required was a theory of mind to explain the causes of neurosis and the ways in which physical ailments and symptoms were caused. What kind of psychic concerns and troubles were being expressed by these coughs, tics and stammers? Freud believed these symptoms were instances of the unconscious making itself heard, the emergence

of repressed desires and fantasies from the inaccessible depths of the mind into waking life. The unconscious is not simply a mental dustbin where unacceptable psychic material is dumped and forgotten, but is active, forever seeking to make its contents known to consciousness. Since this is true of the human mind as such, and not just of neurotics, the same process is witnessed in everyday life, in what appear to be trivial events. Slips of the tongue – those instances where one means to say one thing but says another – are a prime example. These are no mere accident, says Freud, but the surfacing of a repressed wish, a sign of the internal conflict between the conscious and the unconscious. Again, we can identify two radical ideas that this entails: first, there is no qualitative difference between the neurotic mind and the 'normal' mind; and, second, we are all radically divided mentally. However much we may think of ourselves as an 'I', a neatly unified and whole person, there is always another, inaccessible part of ourselves. This sounds odd but is clearly illustrated by another key Freudian interest: dreaming. When we dream, the dream comes from inside; it is the product of our own mind. Yet, curiously, we are surprised by our dreams, we fail to understand them, they are beyond our control. So though I may be dreaming, it is as if there is another being in my head projecting the dream; and this other being is also me. This is a particularly vivid experience of the split between conscious and unconscious.

So far, we have seen that psychoanalysis is concerned with our unconscious, from where repressed sexual desires resurface in oblique ways. How is this useful or applicable to art history? Freud's model of the mind is one where instinct and social rules, fantasy and reality, are permanently in conflict. This is also the structure of his model of culture. In his *Introductory Lectures on Psychoanalysis*, Freud writes:

> We believe that civilization has been created under the pressure of the exigencies of life at the cost of satisfaction of the instincts; and we believe that civilization is to a large extent being constantly created anew, since each individual who makes a fresh entry into human society repeats this sacrifice of instinctual satisfaction for the benefit of the whole community. (Freud, 1953–74, vol. 14, p. 22–3)

In other words, civilization is the result of the tension between the most basic desires on the part of individuals and a requirement to contain or police those desires in the interests of the social order. The repression of instincts and sexuality is at the heart of culture. So what is true of individual and trivial human life – slips of the tongue, dreams – is also true of more elevated experiences, such as art. Art is no exception to the rule that conscious human expression always bears the marks and strains of the

the processes of reason, unconscious material becomes more noticeable, and can be revealed more readily. Of course, the art historian does not have the artist on the couch to do this, but may have writings, diaries, letters, and other documents as a source; and from these one can spin out connections, links and allusions. Turning now to Freud's essay on Leonardo we can see exactly how this is done.

Freud on Leonardo

Freud's essay, 'Leonardo da Vinci and a Memory of His Childhood' (1910), is a pyscho-biographical account; it deals with the mental or psychic life of the artist, particularly his early years, and the ways in which this determined the art he made in later life. There are many biographies of artists which tie pictures to the artist's life, of course, arguing that events like bereavement or marriage explain why and how a painting was made, but Freud is less interested in external events and places a greater emphasis on Leonardo's sexual development and unconscious. Two key methodological principles are apparent in this approach: first, Freud is concerned with how the past, Leonardo's infancy, emerged in his adult life; second, Freud's analysis is concerned with Leonardo's sexuality, exploring how this was shaped during his earliest years and how this, in turn, shaped his painting practice.

The argument of the essay is complex and subtle and is not easy to summarise, but a less nuanced précis may allow key perceptions to be made more clearly. The pivot of the essay is Leonardo's earliest memory. The artist recalled lying in his cradle as an infant, when a vulture swooped down and opened the baby's mouth with its tail, shaking the tail against his lips. This is hardly the most obvious starting point for a discussion of Renaissance art, but this very fact demonstrates a key principle of psychoanalysis: namely, that the seemingly trivial is often the most important (again, one is reminded of Freud's enthusiasm for Morelli). Something that may seem to be of no consequence may in fact be the crucial piece of evidence, the tiny fissure through which the unconscious might be glimpsed. This memory, however, is not really a memory at all. It is, in fact, a fantasy. Ideas in later life may feel like straightforward memories, but are not reliable; here again we see the active unconscious at work. Memories are not just stored in a huge databank for later retrieval, but are constantly being reworked and embroidered by the unconscious.

Freud then interprets Leonardo's fantasy of the vulture. The root memory is of suckling, but the mother's breast is turned into the vulture's tail. The tail is a phallic symbol – Freud points out that the Italian word

for tail, 'coda', is also slang for penis – and so the fantasy turns the mother into a figure with a penis. Why is this? Freud identifies both biographical and cultural sources for the memory. Biographically, he points out that Leonardo lived alone with his mother until the age of five, and, in the absence of a husband, the mother and son's erotic bond was not challenged by the Oedipal process; hence, there was an highly invested sexual aspect to their relationship. Culturally, he speculates how some of Leonardo's adult knowledge may have been worked into the memory by his unconscious; and, in particular, ideas about the ancient Egyptian identification of the vulture with motherhood and, more tellingly still, virgin birth. This information reinforces the idea that the memory expresses a sexualised infantile desire for the mother.

More importantly, though, there is a general piece of Freudian theory used to justify this interpretation. This is Freud's theory about **castration anxiety**. All little boys, said Freud, believe that everyone has a penis, male and female. Because they have a penis themselves, they assume that this is a characteristic of all humans, including their mother. At some point they discover this is not the case, and Freud describes the acquisition of this knowledge as traumatic for the little boy. Seeing that his mother has no penis, he believes that it has been removed; in effect, the boy thinks his mother has been castrated, and this provokes the fear that he, too, may suffer the same fate. He learns, of course, that male and female bodies are different, and that women do not have penises. But in spite of his conscious and rational knowledge of this, in his unconscious he retains the idea of a phallic mother, the happy notion of a time when he was ignorant of sexual difference and there was no fear of being castrated. There are different possible outcomes to this key moment in the boy's development. One is fetishism, which we discuss later. Another is homosexuality; for Freud, at least when he is writing about Leonardo, the refusal to accept that male and female bodies are different, the disavowal of sexual difference, creates homosexual desire. In other words, the boy grows up in a psychic world where everyone, including sexual objects, have a penis.

So Freud analyses the vulture fantasy to conclude that Leonardo had an overly sexualised attachment to his mother and that this was, in part, a cause of his homosexual orientation. He proceeds to some of Leonardo's images to show how this unconscious desire for an erotic bond with the mother is repeated in the paintings. First, there are the famous smiles of Leonardo's women, exemplified by the Mona Lisa. This, says Freud, is his mother's smile that he compulsively depicts; it is a smile that is seductive and sexualised, and yet also distant. This ambivalence is the mark of a desire for erotic union and a disavowal of that desire. In painting, the artist

becomes an infant again, reliving the eroticised experience of the mother's face, but simultaneously pacifies this desire by representing the woman as detached, uninvolved in any kind of sexualised intimacy. Thus, the smile reveals the heterosexual desire of the infant affirming a sexual desire for the mother and the homosexual identity of the adult, which for Freud is a defence mechanism warding off that desire. Second, Freud discusses two other works, the *Virgin and Child with St Anne* (1508–10) and the cartoon of a similar subject, *Virgin and Child with St Anne and St John the Baptist* (1499–1500) in the National Gallery, London (Figure 19). These pictures contain, according to Freud, the synthesis of the history of Leonardo's childhood. The images both represent the Virgin Mary with her mother and the infant Christ. Curiously, Freud points out, both women seem to be of a similar age, while St Anne should be somewhat older. Moreover, they are hard to disentangle, as if the two bodies are fused into one.

The reason for this is, again, to be found in the details of Leonardo's psychic biography. At the age of five he moves to live with his father and stepmother. This image, for Freud, is a fantasy of his two mothers. Rather than an image of child, mother and grandmother, he has produced an image of child, stepmother and birth mother, as if the unconscious wish for his first love emerges in the image. Freud also points out how the bodies of the two women seem to overlap – indeed, in the National Gallery cartoon, it is almost as if one body sports two heads – which he sees, too, as an expression of the unconscious wish for the mother from whom Leonardo has been parted. This is the childhood Leonardo wanted; his art compensates for what went wrong in life. In his art Leonardo remains a child and retains the erotic bliss of his infantile relationship with his mother. Of course, this is completely unconscious. The subject of the picture may have been chosen consciously, but it is the unconscious which has determined its form and character. As Freud puts it: 'Kindly nature has given the artist the ability to express his most secret impulses, which are hidden even from himself, by means of the works that he creates' (Freud, 1953–74, vol. II, p. 107).

The Leonardo essay is a very good example of how the general principles we outlined at the beginning of this chapter entail a particular theory of art. The internal split between conscious and unconscious has many other correlates: our past and our present; our childhood wishes and our adult lives; our search for pleasure and our recognition of reality; our irrational instincts and our rational thinking. This is, in a sense, a rather gloomy picture of the human condition, always marked by internal strife, by a battle to come to terms with the past, by a conflict both to give in to our instincts

and to conform to social rules. But here we see how art reconciles this split, how Leonardo's unconscious desire is sublimated. A painting in Freudian terms is not an image of the world, formed as it is by the unconscious; but nor is it simply an expression of a fantasy, an escape from reality. It brings the two together.

Freudian readings are not necessarily psycho-biographical, however. Although the artist's own psyche may be an obvious concern, many scholars, as we have seen throughout this book, have been concerned to shift the focus from the individual producer to explore the social meanings and functions of the artwork. Psychoanalysis is able to provide a means of practising art history 'without names', as Wölfflin called it, and to turn its interpretative spotlight on audiences and general trends. A very good example of this is 'Fears, Fantasies and the Male Unconscious; or, You Don't Know What's Happening, Do You, Mr Jones?' a short article written by film historian **Laura Mulvey** in 1973, which was a review of work by the British Pop artist Allen Jones. Jones had just installed an exhibition titled *Women as Furniture* where chairs and stools were constructed from highly sexualised models of women, based, like so much of Jones's output, on the imagery of soft-core porn and hyper-sexualised advertising (Figure 20). Mulvey's review and critique appeared in the feminist journal *Spare Rib*. As we shall see, many feminists have been particularly drawn to Freudian and other psychoanalytic thinking.

Mulvey begins by noticing that while the works are wholly concerned with woman as a sexual object, nowhere are the female genitals to be seen. They are either hidden, or absent, or disguised. What is visible, however, are numerous phallic symbols; the women carry guns, or hold cigarettes, or brandish whips. In many cases she sees the women as having become phallic in form themselves, 'human pillars' whose shape resembles the male genitals far more than the female body. What is in evidence, says Mulvey, is fetishism. Now, fetishism is a familiar word, meaning the sexual valuing of a non-sexual object, a kind of sexual displacement, or a sexual interest in a particular thing or body part. It is possible to talk about fetishism without subscribing to psychoanalysis, but a Freudian use of the term demands a specific conception of how fetishism arises and its psychic function. Mulvey uses the term in this strictly Freudian sense. Freud maintained that fetishism was a possible outcome of the castration complex. While the boy may know consciously that his mother has no penis (and is, in his eyes, castrated) his unconscious insists that male and female bodies are not different, and finds a way of maintaining the fantasy of the maternal penis. In effect, an object of desire is chosen which unconsciously represents this maternal penis. Allen Jones's work is such a disavowal of sexual difference,

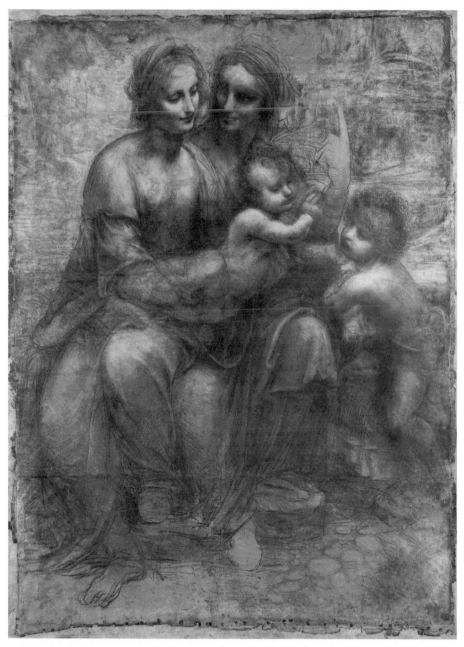

19 Leonardo da Vinci, *Virgin and Child with Saint Anne and Saint John the Baptist*, *c.*1499–1500, charcoal, black and white chalk on tinted paper, 141.5 × 104.6 cm, National Gallery, London

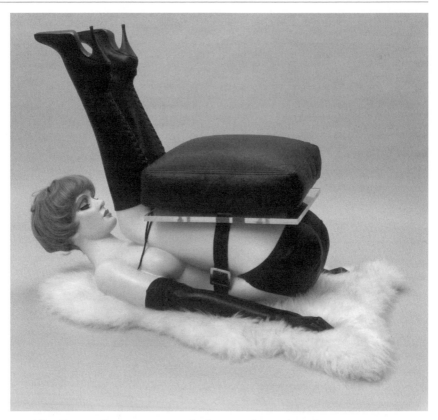

20 Allen Jones, *Chair*, 1969, painted plastic and mixed media, 77.5 × 57.1 × 99.1 cm, Tate Gallery, London

evident in the absence of the female genitals and phallic nature of the women. Each of the artworks aims to fight the fear of castration that little boys suffer, and which they carry with them unconsciously into manhood. However, this is not just a personal fantasy. Mulvey is very careful not to attempt an analysis only of the artist. This imagery, so widespread from the mass media, and from numerous popular sources, demonstrates this to be a general patriarchal fantasy. While Freud looked specifically for the unconscious life of Leonardo, Mulvey is looking for a social unconscious, a general set of psychic attitudes and fantasies which underpin social life and attitudes.

It is very important to note that simply to state that an artwork is concerned with sexual fantasy is *not* to make a psychoanalytic interpretation. There are numerous ways of writing about art in relation to sexuality which are quite distinct from psychoanalysis. Only when the hidden *unconscious* significance is sought according to Freudian principles is an interpretation psychoanalytic. What Mulvey uses from Freud is not simply an assertion

that sex is at the heart of the exhibit, but that woman is sexualised to ward off the fear of castration; that fetishism does not merely appeal to an adult sexual taste, but is specifically a mechanism where infantile fears resurface in adult life.

Looking and Lacanian analysis

One of the other reasons Freudian theory has proved so amenable to art historical investigation lies in a more general point Freud makes. In much of his work, he is concerned very specifically with looking or vision, and this emerges most forcefully in his notion of **scopophilia**, or pleasure in looking. Now, when Freud talks about scopophilia he does not mean simply an act of looking that provides pleasure in common sense or aesthetic terms. He is concerned with an unconscious, sexual pleasure. Looking, he argues, is fundamental to the child's psychosexual development; the desire to see is always underwritten by a sexual curiosity. This infantile desire to see sex is repressed. We all learn that we must not look in this way, or that we must contain our curiosity and act on it only when appropriate, but like all unconscious desires this infantile motivation is replayed in adult life. Thus, the child's curiosity to see sex is reawakened in adult visual practices like looking at art. In thinking about the consequences of this for art history, there is a shift of emphasis from production to consumption, from the artist to the spectator, as exemplified in Mulvey's critique of Allen Jones.

As one might expect, this notion of scopophilia, and concomitant concepts which trace connections between looking and sexuality, have been most productively explored in the visual disciplines of film studies and art history, and the most powerful work in this regard has emerged from feminist analyses. Feminism has long had an uneasy relationship with psychoanalysis. On the one hand, Freud's work has often been excoriated for its conventional sexism and homophobia. On the other hand, many feminists have pointed out that beneath these sexist conventions, which one should perhaps expect from someone writing at the turn of the twentieth century, there are powerful ideas which challenge orthodox thinking and provide a springboard for radical explanations of sex and sexuality. The idea that spectatorship is psychically connected to the formation of sexual identity has enabled feminists to move away from a concern with the sex of the artist to think more broadly about ways in which art consolidates sexist thinking.

The feminist turn to psychoanalysis has been indebted to the work of the French psychoanalyst **Jacques Lacan (1901–81)**. Lacanian theory first came to the fore in film studies in the 1970s, particularly through the journal

Screen. Film historians and theorists involved with *Screen* began to deploy a wide range of innovative theoretical sources including psychoanalysis, feminism, Althusserian Marxism and semiotics (see Chapter 10), and art historians soon began to follow suit, with major figures like T. J. Clark and Griselda Pollock publishing their work in the journal. We have already seen how art history has always relied on other disciplines for its theoretical and methodological bases (such as Panofsky drawing on Kantian philosophy, or Antal turning to the political philosophy of Marx) and this was a further instance of what might be seen as art history's fundamental interdisciplinarity. As with Freud, before turning to the uses of Lacan, we outline two of his concepts which have been particularly important for art history.

The first of these is what Lacan calls the **mirror stage**. As an infant, the child has no real sense of its own boundaries, where its body ends and the rest of the world begins. It knows that different parts of its body can provide sensations, pleasurable or painful, but does not understand that these different body parts form a whole. Indeed, the infant simply responds to a set of bodily fragments, both its own and others' such as the mother's breast. Then, at some stage in its development – Lacan, it must be said, is not very specific here – the child sees itself in a mirror and sees a complete image. The child recognises itself as more than a set of parts and sensations, but as a whole body, a whole being with a boundary separating it from other bodies. However, this is not as straightforward as it may appear, says Lacan, for this is in fact a *misrecognition*. The child conceives itself as a whole, as a perfect controllable being. If it wants to raise an arm, it does so, and can see in the mirror that its will is granted. But the child is not a unified whole – not least because we are all split between the conscious and the unconscious. While the child may believe that he or she is in charge of its body, the unconscious will always be there disrupting it. So the image in the mirror is only a fantasy of control and unity, a denial of the fact that we are, as humans, profoundly split.

Indeed, there is yet another split that arises from the mirror stage. Lacan argues that in seeing itself in the mirror and recognising itself, the child is alienated from itself. The child sees itself out there in the mirror, as an image and mistakes the reflection, a representation, for itself. Psychically, this moment represents the creation of the ego, the sense of self. In Lacanian theory, the ego is a form of defence, a way of denying the fact that we are all fragmentary and unstable. The consequence of this idea is that psychic life is a constant struggle to retain this sense of imaginary wholeness. This is also symptomatic of the notion that the child's identity is imposed from the outside, a script or position created by culture, for which the mirror stands in Lacan's theory. This is exemplary of Lacan's

general approach. Unlike Freud's emphasis on the ways in which sexuality shapes representation, Lacanian theory asserts that representation and language shape the person and his or her sexuality. Lacan does not offer a developmental account of infancy and childhood as Freud does. Rather than a sense of an internal progress through a series of defined stages, there is a concern for the external social and symbolic structures which determine and shape us. For Freud, our sense of self has bodily causes, whereas the Lacanian infant is a kind of *tabula rasa*, simply waiting to be scripted by language. One might say that for Freud sexuality is the root of culture, while for Lacan culture is the root of sexuality. Feminists have been drawn to Lacan for this reason; his account of infancy does not suggest a predetermined trajectory already given in the infant psyche, but sees sexuality as more malleable and socially determined.

So how might this notion of the mirror stage be useful for art historians? After all, few of us are concerned with infantile artworks, or of the very earliest years of artists' lives. The answer lies again in the idea, fundamental to psychoanalysis, that our adult lives are shadowed by the continual replaying of infantile desires and wishes; that our unconscious is always trying to make itself heard. Art might replay the moment of emerging as a subject, either in a bid to regain the unity that has been lost – that is, to reimagine the blissful world before the awareness of multiple splittings – or in a bid for reassurance that one really is whole and unified and unthreatened by bodily or psychic dissolution. The latter is suggested by Mieke Bal in an account of Rembrandt's self-portraiture. Self-portraiture as a genre, she writes, can be partly related to the mirror stage since it is a symbolic restaging of that crucial moment when one misrecognises oneself as an image elsewhere in the world. Turning to Rembrandt's etchings of himself, so often described merely as studies, she contends that these many images are more than an attempt to improve his facility as an artist. They are, rather, a means of recovering 'that primal experience of emerging selfhood by re-presenting the self as other' (Bal, *Reading Rembrandt*, 1991, p. 307). In other words, this is a way of reinforcing the sense of self that emerges in the mirror stage, a way of confirming the fiction that is the ego. Like the child in front of the mirror, the artist before the canvas creates an image which is misrecognised as the self.

An alternative use of the mirror stage suggests a manoeuvre which is not defensive, but rather attempts to compensate for the pain of separation from the mother, and the ensuing awareness of isolation as a person in the world. Griselda Pollock, whom we discussed in Chapter 8, has produced many particularly subtle and lucid analyses deploying Lacanian thinking, and her important article 'Woman as Sign: Psychoanalytical Readings'

(1988), exposes Pre-Raphaelite paintings to a number of psychoanalytical concepts. While the main thrust of her interpretation of Rossetti's pictures of women is that they are fetishes, she also sees the mirror phase at work. The mirror stage is both an entering into language as a subject and a leaving behind of bliss with the mother. The unconscious is always aware of this loss, and may forever be seeking the original object of desire, forever imagining the world before the alienating moment in front of the mirror. Pollock suggests that the curious mix of realism and fantasy in paintings like *Monna Vanna* (Figure 21) may be symptomatic of just this psychic

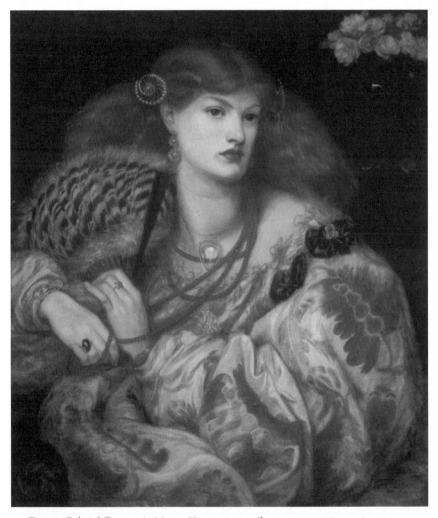

21 Dante Gabriel Rossetti, *Monna Vanna*, 1866, oil on canvas, 88.9 × 86.4 cm, Tate Gallery, London

moment. The paintings are clearly fictions or imaginary portraits of mythical women, and yet insist on the reality of the bodies in the detail, brilliant colouring and tactile presence. It is this tension that, for Pollock, represents an image that 'can satisfy the hankering after the forever lost object' (Pollock, *Vision and Difference*, 1988, p. 146). The paintings, as it were, assert the unconscious fantasy that the imagined object of desire is, in fact, real and present. Like Bal's reading of Rembrandt, this account suggests a restaging of the mirror phase, but here rather than a confirmation of the ego's formation, there is a look back to what has been lost, a memory of the maternal body left behind.

Later in his career, Lacan developed a different account of looking which, although related to the mirror stage, extended the problem of vision and image beyond the child's reflected self. As we have seen, psychoanalysis understands the unconscious as forever disturbing or disrupting the conscious, and that this is not only manifest in our thoughts and use of language, but in our visual practices too. The rational conscious look that assesses an image is haunted by the look of the sexually curious child, and however logical we feel our approach to art is, it will always bear the traces of an irrational desire to see sex, to see our infantile fantasies fulfilled in the visual field. Lacan provides a highly complex and nuanced account of this split, calling the two modes of looking **the eye and the gaze.** The eye is straightforward. This is the rational, conscious way of looking that most art historical methods assume. But something else happens when we look: we are also looked at (if not actually then potentially). Being a subject who looks in and at the world means that one is also an object that someone else scrutinises. The gaze is the term Lacan uses for this strange sense of the world looking back at us. Now, this gaze is not literally someone else looking back at us, but rather 'imagined by me in the field of the other' (Lacan, *Four Fundamental Concepts*, 1979, p. 84). It is a disturbance in the visual field, an unconscious reminder that our position is only partial and that there is always something beyond our control. Like much of Freud's thinking about the visual, Lacan's notion of the gaze is rooted in castration anxiety. Freud maintained that the child understands his mother as castrated, and that fetishism is the process whereby the maternal phallus is reimagined. For Lacan, this structure becomes the structure of desire itself, not only true in some instances but fundamental to the human psyche. Unconsciously, we always feel a sense of lack. Our desire is always a desire to recover what is missing. The gaze is a visual symptom of this feeling.

Lacan himself provides an example of this split by referring to Holbein's famous picture *The Ambassadors* of 1533 (Figure 22). This grand double portrait is most famous for a curious addition to the figures and

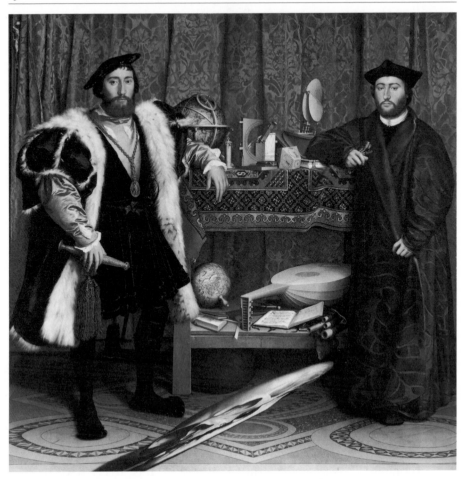

22 Holbein, *Jean de Dinteville and Georges de Selve (The Ambassadors)*, 1533, oil on oak, 207 × 299.5 cm, National Gallery, London

their attributes. At the front of the image hovers an anamorphic skull; that is, a skull painted in a strange perspective that only becomes legible from another physical position. Lacan describes the experience of viewing *The Ambassadors*. It is composed in a highly stable and geometric manner, and so makes perfect sense, but for the strange blob in the foreground. It is only on leaving the gallery and glancing back do we see that it is a skull looking back at us. This disrupts our vision in two ways. First, when we are before the painting, it unsettles our sense of visual mastery. While perspective suggests that we have control of the visual field, with everything mapped out and rationally organised, and hence comprehensible, Holbein's weird addition undermines the eye's confidence. Second, in looking back at the picture, the gaze makes *us* the object of scrutiny. We are no longer subjects but objects; to use Lacan's term we are 'annihilated', and this is a

poignant reminder of our desire never to be fulfilled. Our dream of whole-ness shatters. There are, then, always two viewers: the eye which finds logic and completeness in the image, which sees a stable relationship between the self and the world, and the gaze which disturbs vision, and reminds us that no matter what the eye may seek, there will always be something missing. So where, for example, Panofsky saw perspective as significant of a harmo-nious balance between object and subject, between mind and world, Lacan sees it as an illusory balance that is disturbed by the gaze. There is also an important difference here from Freudian notions. Freud saw art as a form of sublimation, a means of resolving, albeit temporarily, the internal split of conscious and unconscious, or the social split of instinct and civilisation. Lacan is less optimistic. For him, art may try to pacify the gaze, to provide a glimpse of a blissful world of wholeness, but it will always fail.

While many art historians have referred to Lacan's work, and par-ticularly this notion of the gaze, it has not always been used in a method-ical or rigorous manner. In particular, one will often find references to 'the gaze' which do not really fit in with Lacanian theory. While many writers in art history and other disciplines use the term 'male gaze', often with Lacan or Lacanian work cited as the source, these arguments frequently make only the non-psychoanalytic claims that to look is an assumption of power, and therefore to occupy a male or masculine social position, or that men have been allowed to look in ways that women have not. There is also work that is rigorous in its use of Lacan but which adopts a rather differ-ent conception of the gaze. The crucial article here is Laura Mulvey's seminal piece 'Visual Pleasure and Narrative Cinema' published in *Screen* in 1975. While this article introduced the idea of the gaze to many film and art historians, Mulvey does not take a rigidly Lacanian line and instead discusses the gaze as an unconscious look coming from the viewer and not as the world looking back. Mulvey conceives this gaze as created in infancy by symbolic structures, pointing out that art and other cultural phenomena do not simply express unconscious ideas but reproduce them. This answers the question of why women might find visual pleasure in, say, sexist Hollywood cinema rather than in avant-garde film. No matter how much a woman may consciously resist sexism, the gaze – that unconscious vision – seeks to reaffirm sexist ideas socially inculcated and internalised. Social structures and symbolic life position women in their unconscious to see as a man; the reproduction of patriarchal thinking at an unconscious level means that male pleasure is responded to, and the male disavowal of castra-tion inflects women's spectatorship.

However, there are art historians who have deployed the notion of the eye and the gaze in a strictly Lacanian sense. **Hal Foster** uses the eye/gaze split in his analysis of hyperrealism, art produced in the 1970s which

provided, seemingly, a simulacrum of the world. Looking at Richard Estes'
Double Self-Portrait (Figure 23), Foster wonders why this work is so disturb-
ing and absorbing if it really is no more than a direct copy of the reality
we see around us. He suggests that while the eye may see no more than
a copy of the world, the gaze alerts us to something else. It constantly
challenges the eye's apparent mastery of the world. In particular, the gaze
reminds us that we are alienated from the real world, that we have no direct
access to it and are, instead, imprisoned in the symbolic, the linguistic
structures that determine who we are. So while the scrutiny of the painting
by the eye may suggest a whole, complete world over which we have mastery,
the gaze unconsciously disrupts this feeling of power and stability. There
is something unreachable; the reality we seek or long for is a mirage. Even
in the perfectly rendered and polished surface of the hyperreal canvas, an
absence makes itself felt.

In a similar analytical move, Briony Fer draws on this eye/gaze split
to analyse Jackson Pollock's painting *Out of the Web* from 1949 (Figure 24).
This painting is a typical Pollock drip painting, but parts of the canvas
have been cut out, removed, to create two distinct kinds of surface. For
Fer, this is analogous to the doubleness of the Holbein painting Lacan
discusses. She describes the literal cuts in the painting as equivalent to

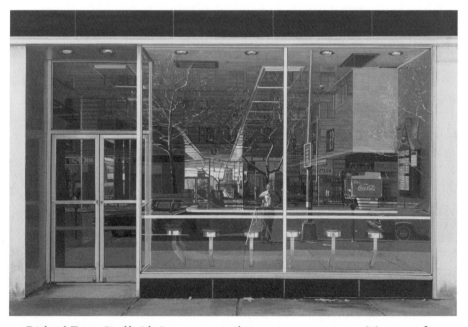

23 Richard Estes, *Double Self-Portrait*, 1976, oil on canvas, 61 × 92 cm, Museum of
Modern Art, New York

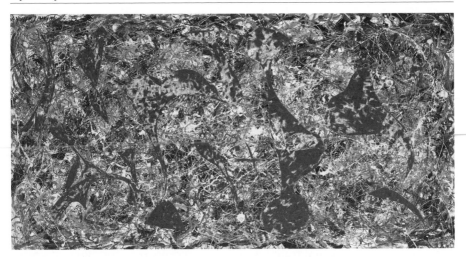

24 Jackson Pollock, *Out of the Web: Number 7, 1949*, 1949, oil on masonite on canvas, 121.5 × 244 cm, Staatsgalerie, Stuttgart

metaphorical cuts in the spectator's field of vision; that is, Pollock's composition make an ideal viewing position impossible to sustain, and so makes it clear to the viewer that he or she does not have the visual mastery often assumed in front of a painting. The viewer is asked to view two things at once, two things which cannot be resolved. Just as Lacan sees Holbein's *Ambassadors* as annihilating the self, breaking the dream of a unified ego or self, so Pollock's *Out of the Web* performs the same function. The disturbance of the visual field reveals our failure to find the wholeness we seek.

Fer makes one other point that is important. Pollock's work, she points out, has been subject to many interpretations, such as formalist readings, or social historical accounts locating his canvases in relation to the cultural battles of the Cold War. These, she says, are themselves symptoms of this visual disturbance; they are 'compensations for the damage done' (Fer, *On Abstract Art*, 1997, p. 97). In other words, she is claiming that a psychoanalytical reading takes place at a deeper level than other accounts. It is not that these other readings are wrong, but that they themselves become part of what a psychoanalytical art historian must explain.

Psychoanalytic art history rests on substantial claims about culture, and we conclude by restating three crucial ideas. First, it aims to discover the latent content of the artwork, the hidden meaning or unconscious message that plays a formative role in the creation of the work. By identifying and analysing visual symptoms, the art historian can find the presence of sexual desire in the work; not adult desire, but the unconscious repressed desires of the infant. This may be a personal desire, as we saw in Freud's

interpretation of Leonardo, or it may claim to be a broader, society-wide desire or social unconscious as Mulvey's analysis of Allen Jones claims. In either case, the fundamental principle is the same: the artwork can be analysed, like the patient on the couch, to uncover repressed desire. This leads to the second major claim that psychoanalysis makes about culture.

While Freudian approaches resemble clinical practice, there is an important difference. On the one hand, art is to some extent pathological; that is, it is motivated by and reveals psychic disturbance or trauma. Freud's analysis of Leonardo, for instance, tried to demonstrate that the artist's adult work revealed a disturbed childhood. On the other hand, art is far more than simply a neurotic symptom. Art, in Freudian theory, has a clear task to resolve these disturbances. Unlike a dream or a slip of the tongue, art is far more than a symptom. It mediates between past and present, between pleasure and reality; it not only permits the expression of sexuality and fantasy, but also contains those things. Lacan, in contrast, provides a theory which suggests that art always fails in this respect. Looking, including the viewing of art, is always a question of the unconscious seeking something missing – something that cannot be found. Thus, visual experience is characterised by loss and alienation. While art may seek to pacify us, the awareness of the gaze, of the disturbance in the visual field, works to undermine any such attempt.

Third, psychoanalysis has provided a theory of art which offers distinct vantage points, enabling the historian to exercise a concern for the artist, evident in Freud's own psycho-biographical approach; a concern for the work of art itself, in terms of its iconography; or a concern for the viewer, particularly in Lacanian developments, exploring the ways in which the viewing of art is sexually invested. Here it is not only the mind of the artist which we might discuss, but the mind of the spectator – another unconscious, another set of fantasies provoked by and catered for by the image. At the root of this is Freud's contention that looking itself is a sexual act. Artists and audiences alike are implicated in this theory. The fact that it contains a theory of visual consumption as well as production is one reason why psychoanalysis has been so important to some recent attempts to formulate the field of visual culture as a general account of visual experience and phenomena.

Critical appraisal

For all its success and its own seductive power, psychoanalysis remains extremely controversial and has often been discussed in acrimonious terms. The biggest objection is simply this: that it is not true. Freud always wanted

psychoanalysis to have a scientific status, and he understood his theory as the beginnings of a science in a strict sense. But many scholars have pointed out that it is, in fact, pseudo-science: the evidence is always anecdotal, the reasoning is circular, and there are no sufficient criteria for truth and falsity. It has been suggested that, rather than a science, psychoanalysis is more like a faith; one chooses to believe it and, if one does, it reveals what is taken to be the Truth. This critique has grown stronger as alternative models of the mind have emerged, and particularly as developments have taken place in neurology and the study of consciousness, which have displaced or disproved such central planks of the Freudian edifice as his theory of dreaming.

Even if one does not wish to dismiss psychoanalysis in such a sweeping manner, there are methodological problems internal to psychoanalysis which have to be addressed. With the technique of free association, for instance, critics have asked how the analyst knows when to stop the chain of associations. What are the criteria which might confirm that one word represents the key rather than a word spoken previously or later? The criteria are, of course, the theoretical edifice of psychoanalysis itself. In other words, the analyst has already decided what he or she is looking for and will choose evidence which confirms and justifies that decision. This is demonstrated by an infamous moment in one of Freud's best-known case studies, the *Fragment of an Analysis of a Case of Hysteria* (1905), often called 'Dora' after the name of the patient. At one point in Dora's analysis, Freud wants to know whether she is in love with her father, and so asks her. If she answers 'Yes' this is proof that she is facing up to her unconscious desire. If she answers 'No' then this is proof that she is resisting her unconscious, and, thus, also proof that Freud's hunch is correct (Freud, 1953–74, vol. 7, pp. 57–9). Whatever the evidence, it will prove what Freud wants it to prove. In the same way, psychoanalytic art history bears this problem. If one chooses to find fetishism or narcissism or evidence of the mirror stage in an artwork, any visual feature might count as evidence by its presence or by its absence. One might ask, what would be needed to disprove the analysis?

Thinkers more sympathetic to psychoanalysis have dealt with this criticism in a different way. They have argued that psychoanalysis is not to be thought of as a science – or at least not as methodologically equivalent to the natural sciences – but rather as a hermeneutic tool. This means that one should not expect the same standards of evidence as in science, and that questions of truth and falsity should not be a concern. Instead, psychoanalysis should be judged according to the plausibility and internal coherence of the stories it tells. The objection to this, however, is: if truth

is not a concern, why should one make an appeal to one theory rather than another. A narrative derived from, say, religion could be just as productive or internally coherent. So why favour Freud over Buddhism?

Psychoanalysis has also been critiqued in less sweeping ways. Historians are often suspicious of psychoanalysis because of its claims to be a universal account of psychic development, across time and geography. Freud certainly saw his ideas as fundamental to all human life, from early primitive societies around the globe to the most recent. Now, given that *Homo sapiens* is a species one might expect certain developmental characteristics to be common to all members of the species (or, strictly speaking, of the sub-species *Homo sapiens sapiens*). But psychoanalysis also lays a great emphasis on the social conditions that effect psychosexual development, such as kinship. The logic of the Oedipus complex and of castration anxiety both depend on a nuclear family. So what about societies with different family structures or different childrearing practices? Similarly, the history of sexual behaviour shows that even in Europe, attitudes and practices have changed enormously through time, and that many of Freud's assumptions are simply not true for, say, the Middle Ages.

Here we are faced with the problem that came to light at the end of chapters 7 and 8. Does psychoanalysis enable a general account of art history, or can it only produce specific accounts of certain works or moments from a particular perspective? We saw earlier that Freudian thought can offer a mono-causal account of history and, hence, an answer of sorts to the hermeneutic problem. Because we recognise the same psychic structure in the past as in the present, we can talk with authority and understanding about art from other times in terms of the fundamental structures of the mind. This is how Freud approaches Leonardo. It is the persistence of unconscious formation and desire which enables him to access an artwork produced in a different time and culture. However, what the Freudian approach cannot explain is historical change. As a solution to the hermeneutic problem it asserts stasis, an unchanging human nature, rather than historical development. Even when art historians have used a more modest version of the theory this problem persists. Both Laura Mulvey and Griselda Pollock, for instance, have concentrated on work from the later nineteenth and twentieth centuries, an era that is consonant with the sexual and kinship practices Freud describes; thus, psychoanalysis is part of the historical fabric of their studies. This specificity does not remove the problem, however. We saw that Mulvey identified fetishism as the root of Allen Jones's work. The idealisation of the female form was, unconsciously, a disavowal of the threat of castration and a replaying of the infantile fear that the mother had been castrated. However, in an

account of Dante Gabriel Rossetti's paintings of women, Griselda Pollock identifies the same dynamic. Rossetti fetishises his women from exactly the same unconscious motivation.

Now, while the work of Jones and Rossetti looks very different, and the specific visual means by which the female body is fetishised differs, psychoanalysis cannot explain why this is so. A different explanatory mechanism is required, and one which gives the contingent reasons for stylistic change over the fundamental and unchanging psychosexual determinants. While one might discuss what visual formats were available in 1860 and 1960, what styles permitted the unconscious to make itself heard – in Rossetti's case, a new style of painting that emerged in the mid-nineteenth century, and in Jones's mass-media imagery – psychoanalysis and the significance of the castration threat cannot explain how these formats came about. For a psychoanalytic art historian, this is not necessarily a problem. Indeed, it is the identification of persistent psychosexual demands which may be sought in this kind of work. But if art is specific to the culture and age that produced it, what does it mean to find the same psychic mechanisms in fourteenth-century Florence and twentieth-century Britain?

Lacanian psychoanalysis, with its emphasis on social and cultural determinants, may provide an answer with its emphasis on the social construction of sexuality. Lacan, however, sidesteps the question of history. As Hal Foster points out, Lacan's theory of the subject is not historically specific, and although 'it is not limited to one period . . . this armored and aggressive subject is not just any being across history and culture: it is the modern subject' (Foster, *Return of the Real*, 1996, p. 210). The Lacanian subject is one who is 'ghosted' by fascism, war, industry and modern life – a product of the modern era. Foster's insight raises the question of how one is to understand, say, Bal's reading of Rembrandt's self-portraiture. Can one project this modern if unspecific subject as the psychic template for seventeenth-century Europe? Is the modern ego, paranoid and aggressive, protecting itself against difference, a historically appropriate model for Rembrandt?

There are questions to be asked, also, about the specific application of Freudian thinking to art history. Is the emphasis on sexuality reductive? Is there something predictable about psychoanalytic art history's interpretations? This seems to be the price one pays. After all, Freud's theory is, at base, that sexuality is the fundamental impetus of human activity, and plays a crucial role in all our behaviour, be it manifest or latent. For feminists, of course, this is precisely the strength of psychoanalysis. Given art history's blindness to questions of gender and sexuality for so long, a theory

that finds in these issues the very kernel of social and cultural meaning is to be welcomed. From a psychoanalytic perspective, questions of sex and sexuality cannot be dismissed as historically trivial, or as a footnote to more pressing concerns. As we have seen, this is a method where sex is firmly and irrevocably at the heart of human life and history. Moreover, psychoanalysis always makes a claim to be the profoundest level of analysis. As we saw in Briony Fer's account of Jackson Pollock, other readings, while they may be true, are still subject to the analyst's insights.

One might also ask whether a psychoanalytic approach shifts the focus away from the art object itself, and simply reduces it to a symptom of something else, such as a personal psychic disturbance, or a social prejudice. It is unclear in the Leonardo essay whether Freud is using Leonardo's biography as a means to understand the paintings, or whether the paintings are merely additional evidence to support the argument about the artist's sexuality. One might argue that one need not choose between these; that psychoanalysis can provide a useful account of both work as symptom and of work as art. Nonetheless, Freud is at times somewhat hostile to the visual. His writing clearly suggests that the verbal always has priority over the visual: visual phenomena are riddles that requires verbal analysis; the truth of images can only be acquired by translating them into non-visual terms. (In Lacan this hostility takes a different form, but is even more marked.) This is in some respects a problem for art historians. Given a discipline that claims a special status for the visual, both as an experience and as a means of representation, it seems curious to then champion a method that demands the translation of the visual into the verbal – the visual as a symptom of something that can only be fully expressed by words. And, yet, one might respond, what is art history itself but the translation of images into words?

Bibliography

Bal, Mieke, *Reading Rembrandt: Beyond the Word-Image Opposition* (Cambridge: Cambridge University Press, 1991). A difficult book that combines psychoanalysis, feminism and semiotics, discussed further in Chapter 10.

Crews, Frederick (ed.), *Unauthorized Freud: Doubters Confront a Legend* (London: Viking, 1998). A collection of extracts from works that critique or refute psychoanalysis. A very good introduction to the more controversial debates in the field.

Fer, Briony, *On Abstract Art* (New Haven and London: Yale University Press, 1997). A particularly intelligent example of the use of Freud and Lacan to elucidate non-representational art.

Foster, Hal, *The Return of the Real: The Avant-Garde at the End of the Century* (Cambridge, Mass., MIT Press, 1996). Psychoanalysis is used to cast a new light on modern and contemporary art.

Freud, Sigmund, *The Standard Edition of the Complete Psychological Works of Sigmund Freud*, trans. James Strachey in collaboration with Anna Freud, 24 vols (London: Hogarth Press, 1953–74). Whatever one's opinion of psychoanalysis, this is a major document of modern thought.

Jay, Martin, *Downcast Eyes: The Denigration of Vision in Twentieth-Century French Thought* (Berkeley and London: University of California Press, 1993). Includes one of the clearest and most reliable accounts of Lacanian theory, and also offers an incisive critique.

Lacan, Jacques, 'The mirror stage as formative of the function of the I', in *Écrits*, trans. Alan Sheridan (London: Tavistock Publications, 1977) pp. 1–7. A paper delivered by Lacan in 1949, revising an earlier paper from 1936, and elaborating the idea of the mirror stage which has been often referenced by psychoanalytic art historians.

Lacan, Jacques, *The Four Fundamental Concepts of Psychoanalysis*, Jacques-Alain Miller (ed.), trans. Alan Sheridan (Harmondsworth: Penguin, 1979). Extremely opaque, but Lacan has been much used by many scholars in the humanities. His difficult and often impenetrable style is seen as playful and allusive by his supporters, wilfully obscure and incoherent by his opponents.

Mulvey, Laura, *Visual and Other Pleasures* (Basingstoke: Macmillan, 1989). Mulvey is a film historian but has played a major role in many visual disciplines, including art history. This collection includes her most famous article, 'Visual Pleasure and Narrative Cinema', and her review of Allen Jones.

Pollock, Griselda, *Vision and Difference: Femininity, Feminism and the History of Art* (London: Routledge, 1988). A collection of essays, many of which rely on psychoanalytic principles. Includes the essay 'Woman as Sign: Psychoanalytic Readings'.

Sulloway, Frank, *Freud: Biologist of the Mind*, 2nd edn (Cambridge, Mass: MIT Press, 1992). A magnificent intellectual biography.

Wollheim, Richard, *Freud* (London: Fontana, 1991). A short readable introduction by a major philosopher.

MOST ART HISTORIANS examine artworks in order to establish what they mean. We have already seen a number of methods which deploy visual, documentary and contextual evidence in order to ascertain what a work meant to its maker or audience. The scholarship on any particular work or artist grows as different interpretations are offered, and alternative or more plausible meanings found for works. Of course, few art historians would claim that their reading of a work was definitive, and, although they are likely to disagree with some previous accounts, may well see their interpretation as complementary to others. Semiotics is a method which takes a different position on this question of meaning. Rather than trying to establish what the meaning of a work might be, semioticians ask the question: how is meaning possible? What is the process whereby a few marks on canvas, or the shaping of a lump of marble enables us to come up with interpretations? How is it that we can look at an image and find a meaning in it? Semiotics is concerned less with any individual utterance or interpretation and more with the larger context which makes meaning possible. According to semiotics, the context for meaning is a system made up of **signs**. The very term 'semiotic' is derived from the Greek word for sign, *semeion*, and it is signs, and the rules which govern their use, that a semiotician addresses.

We can see at once how this differs from many other approaches. It moves the focus away from the artist or a particular spectator, and questions the system which enables individual expressions and interpretations; what the French literary critic Roland Barthes famously described as 'the death of the author' and 'the birth of the reader'. What must be understood is that although the emphasis of semiotics is on the reading of the image rather than its making, this does not mean it is concerned with the private responses of particular viewers. Semiotics, indeed, would dispute that there is a private response. Because all meaning depends on the codes and rules that govern what we can say or represent, the viewer in semiotics is simply the conduit through which that meaning flows, not a reader but a function, as Jonathan Culler puts it (Culler, *The Pursuit of Signs*, 1981, p. 38).

This search for the rules that enable interpretation makes semiotics fundamentally interdisciplinary. It is not concerned only with visual images, or with literary texts, or with other specific social and cultural phenomena,

but begins from the basis that there are rules of communication and expression that underpin all cultures (and in some versions, animal behaviour too). By seeing all phenomena as signs, semiotics aims to break down disciplinary boundaries and reveal the more general laws governing culture. Some art historians have adopted this very ambitious goal, while others have used the method more narrowly as a way of interpreting art. This interdisciplinary scope makes semiotics a broad field and numerous groups of scholars have contributed to its development, particularly in the field of linguistics. We concentrate here, however, on the two most influential models of the sign in art history. First, we look at the work of the Swiss linguist **Ferdinand de Saussure** (1857–1913), whose semiotics uses linguistics as the base discipline; that is, language is seen as the model that should be used to assess all sign systems. Second, we turn to the American philosopher **Charles Sanders Peirce** (1839–1913) who was more concerned to differentiate between different kinds of sign, and for whom semiotics was a form of philosophical logic.

Saussure

The most frequently cited text in discussions of semiotics is probably the *Course in General Linguistics* by Ferdinand de Saussure. The *Course* was published posthumously in 1916 and compiled from the notes of students at the University of Geneva, who had attended Saussure's lectures between 1907 and 1911. Although Saussure lived in the early part of the twentieth century, it was really only in the later decades that his work had an impact on scholarship. In the 1960s thinkers in a number of different disciplines looked to Saussure and the *Course in General Linguistics* as a theoretical source for their own work. So why is it that a series of fifty-year-old lectures on linguistics was taken up by anthropologists, psychoanalysts, literary critics and art historians? The answer is essentially that Saussure not only tried to identify what language was at the deepest level, but he proposed that his linguistic analysis could form the basis of a **semiology**, a 'science which would study the life of signs within society' (Saussure, 1983[1916], p. 15). The laws uncovered in linguistics would prove to be the same laws that governed all other signifying practices from rituals like eating and dressing to cultural forms like poetry and slang. What Saussure hoped, and what seemed so momentous, was that his theory of the sign would be the master discipline capable of unlocking the secrets of all others. To this end, Saussure drew a distinction between individual utterances, which he termed **parole**, and the wider system in which they were located, which he called **langue**. Rather than concerning himself with the former, Saussure sought

to understand the latter: semiology would expose the essential rules of language which enable any of us to make and understand meaningful statements. Moreover, it would do this on a scientific basis. Rather than turning to metaphysical notions, which are unverifiable, semiology would be empirical in its analysis of how humans make meaning and communicate across all social forms.

Before delving further into the possibilities Saussure opened up for cultural analysis, we must first look at his conception of what a sign is. Language was, for Saussure, a system of signs. These are not natural signs – that is, they do not simply and unproblematically refer to objects and events in the world – but they are conventions. Language is a code with rules. The elements of the code are signs which consist of a **signifier** and a **signified**. As an example, take the word 'cat'. The signifier is the sound of the word, the 'k' – 'a' – 't' noise we make when we say it, or the form of the letters on the page when we write it. The other half is the signified. This is the concept to which the sound or word refers: in this case, the concept of a small furry four-legged animal that miaows and makes a good pet.

Now, there is a crucial clarification to be made about the signified. One should not think of it as the actual object to which the word seems to refer. The signifier is not the cat itself. Instead, it is the concept that is expressed. This is a difficult point and one which is rather unclear (Saussure does not really explain the relationship between an object and a concept.) Think of it this way. If the signifier were 'cat' and the signified were Tiddles himself then the word would always mean the same thing, namely, just that furry object scampering around. But imagine that Charlotte and Michael are talking about Tiddles; one of them likes the cat, the other sees it as a nuisance who scratches furniture. Charlotte says 'I see you have a cat' – and for her the signified is a warm, cute creature. Michael replies, 'Yes, I have a cat' – for him, it is the pest who ruined his sofa. So the sound and the concept, the signifier and the signified, are the two inseparable parts of the sign, but the actual object is variable.

Central to Saussure's semiotics is the idea that the relationship between signified and signifier is arbitrary. There is no reason why we should use the word 'cat' rather than any other; we could just as easily imagine a world where we use the word 'blong'. Indeed, one only has to think of other languages where words like 'chat' and 'gatto' are used. This is merely the sound chosen to refer to that particular concept. What is important is that in each linguistic community, everyone accepts and uses that signifier. This demonstrates clearly why Saussure thought a sign was a convention. There are some signs which do not seem to have this arbitrary connection between

the two parts – for example, onomatopaeic words like 'buzz' or 'quack' clearly resemble natural sounds. Saussure calls these motivated signs, but points out that they are, nonetheless, conventions. Think, for example, of the different ways a dog barks in different languages: English dogs go 'woof' while in German they say 'wau'. Even here, then, where the relationship between signified and signifier is not wholly arbitrary, the sign is conventional.

Saussure's theory of the sign entails a very grand philosophical claim. We have seen that semiotics insists that language is not simply a question of naming. It may seem as if there is a world full of things and events and language is a means of naming these, our way of describing reality. Semiotics would disagree fundamentally with such a view. Instead, a Saussurean would argue that language actually creates our reality rather than simply describes it. In this sense it is, as Bal and Bryson point out, anti-realist (Bal and Bryson, 'Semiotics and Art History', 1991). Now the debate about philosophical realism (*not* to be confused with the art movement of the same name), is extraordinarily complex, but we can make a basic distinction here that will serve our purpose. A realist believes that there are things in the world that are a certain way, and this is true regardless of who observes them; moreover, we can make statements about these things that express this true state of affairs. An anti-realist would argue the opposite: that how the world is depends on how it is perceived. Consequently, statements we make about the world are not true because they accurately explain how things are, but because they can be justified. So why does semiotics fall into the latter of these two camps?

There are two reasons. First, the linguistic sign, a word like 'cat', say, does not simply work ostensively (that is, it does not simply point to an object in the world). Instead, as we have seen, it embodies our concept of the cat rather than Tiddles himself. The second reason for Saussure's anti-realism is related to this. A common-sense view might be that meaning is created referentially; that is, a word has a meaning because it refers to an object or event in the world. Semiotics claims this is wrong. For a semiotician, meaning is created differentially. A word means something because it is part of a system and because it differs from all the other parts of the code. So I understand the sound 'c – a – t' as meaning Tiddles because it is different from 'cut' or 'cot'; and because it is different from 'kitten' or 'puss'; and because it is different from 'dog' or 'zebra'. There are, as Saussure says, 'no positive terms', only semiotic differences (Saussure, 1983, p. 118). Many writers have challenged this, claiming that at some point language must refer to something; that to insist only on differences removes us from the world in an implausible manner.

There is one further pair of terms we must mention. Saussure's linguistic theory was explicitly developed to supersede historical philology, which had dominated linguistics in the latter part of the nineteenth century. While philologists undertook the equivalent of the archaeology of language, Saussure felt that such an approach overlooked the importance of the system (or langue) that determines every utterance. To this end, he distinguished between the **diachronic** and the **synchronic**, terms we came across in Chapter 3. For Saussure, the former refers to the evolution of language, the ways in which it changes across time; the latter to the state of the linguistic system at a particular historical moment. For Saussure, language must be approached from a synchronic point of view, since language, he asserts, can only be understood from the point of view of the user who lives at one particular time. Although, in the *Course*, he does discuss changes briefly – changes in pronunciation, or vowel shifts, for example – he really only asserts that these happen. There is no attempt to explain why or how this takes place beyond claims that social forces work upon language use or that innovations are taken up by a linguistic community. The analogous position that arises in semiotic art history is that the image or object can only be understood from the point of view of the spectator; and in the most radical versions of this method, only from the point of view of the contemporary spectator. As we shall see, this has serious consequences for any historical discipline trying to use semiotics.

Saussure's linguistics, with its theory of the sign as signifier and signified, of langue and parole, and of differentially produced meaning, was much discussed in his own discipline from the early years of the twentieth century. The real impact of Saussure on the humanities, however, happened much later in the late 1950s and, particularly, the 1960s. The centre of this was France with the explosion of what is known as structuralism. There has been much debate about the relationship between structuralism and semiotics, whether they are effectively the same method, or whether they differ in subtle ways, but it is true to say that Saussure is central to both. Structuralism is essentially Saussure's principles applied to a variety of social and cultural fields, including anthropology and psychoanalysis. It applies the idea that meaning resides in a system or code and is produced differentially, with linguistics as the model for all cultural and social analysis.

The vogue for Saussure in post-war France was more than simple modishness. It represented a dissatisfaction with and backlash against major philosophical trends. French thought was dominated at the time by interests in phenomenology – which is concerned with the immediacy of our experience of being in the world – and existentialism. This latter school of

thought emphasises the individual and his or her will; indeed, it proceeds from the notion that any philosophical inquiry should begin with the human agent and how he or she decides who they are through their voluntary actions. Moreover, existentialists asserted that no general theory could offer an adequate account of human existence. The ideas of Saussure provided a way of arguing against these modes of thought and of challenging what the structuralist anthropologist Claude Lévi-Strauss called the illusions of subjectivity. Hence, a Saussurean approach maintained that it is not humans who make culture, but culture which makes humans (an idea to which Lacanian psychoanalysis is clearly indebted). In other words, everything we do and say, from the way we organise our families to the paintings and poems we may create, are not unmediated acts and experiences but are determined by the systems within which we are located.

Structuralism, or Saussurean semiotics as it developed, was therefore deeply anti-humanist. At the same time, it dispensed with notions of intuition and will, and claimed that it could provide an objective or scientific account of human life and culture. Although some French art historians like Hubert Damisch and Jean-Louis Schefer began to apply semiotic principles to artworks, the impact of structuralism on Anglo-American art history was felt more through literary and cultural studies, in particular the writing of the polymath Roland Barthes, as well as a return to Saussure's own *Course*. The film journal *Screen* (mentioned in Chapter 9) was crucial in the UK; in the USA the journal *October* was a leading disseminator of semiotic analysis, and it is to an article published in that journal in 1981 that we now turn to see exactly how Saussurean ideas were brought to bear on images.

In her essay 'In the Name of Picasso' (1985), **Rosalind Krauss** uses Saussurean semiotics to analyse Picasso's collages. She begins by criticising some other approaches in order to highlight how semiotics can combat erroneous principles. First, there are accounts of Picasso's work which pin the meaning to his biography, analyses where the artwork is no more than a response to a personal event and where changes in style are understood as parallel to, and determined by, changes in his personal circumstances such as a new mistress or model. Second, in these and in other accounts there is an underlying belief that the picture represents something in the world, and the question many immediately ask is: what is this image of?

It is not difficult to see why a semiotic approach would take issue with these approaches. In the first case, the biographical, there is an assumption that the artist is the creator and controller of meaning in the image, and to find what the image means we have, effectively, to find the meaning

he put into it. Of course, for semiotics meaning is not something already there in the image, but rather something produced by the decoding of signs by the viewer. In the second case, there is a belief that art copies the world, and that the various signs in the image simply refer to things out in the world. But, as we have seen, a semiotic approach begins from the quite different premise that signs construct our reality; the relationship is almost reversed where what we take for the world is actually mediated by our representations. Indeed, Krauss claims that art history comes into being as a response to the inadequacy of this mimetic theory. Art history, she argues, is not about **denotation** (that is, merely identifying what an image represents) but about **connotation** (what its extended meanings are). These terms, much used in semiotics, do not actually appear in Saussure but were introduced into the debate by the linguist Hjelmslev, and taken up by Roland Barthes. Moreover, what both the biographical and mimetic approaches share is a belief that art operates according to a model where one thing unproblematically means something else – a referential theory of meaning rather than the differential theory of Saussure.

With this theoretical stance in mind, Krauss turns her attention to Picasso's collages. Having argued against any method which seeks to find a referent for every pictorial sign, she claims that collage is exactly the opposite of such an approach; it is all about 'the indeterminacy of the referent' (Krauss, *Originality of the Avant-Garde*, 1985, p. 39) Take the f-holes in *Compote Dish and Fruit, Violin and Glass* of 1912 (Figure 25): these are usually said to represent a violin. Krauss rejects such a straightforward, referential meaning. Simply to equate the f-hole with an object is to ignore the specific nature of the sign; the fact that these f-holes might be different sizes, that the two do not mirror each other as one would expect, that the quality of the line differs in each, and so on. What Picasso alerts us to here is not an object – the violin – but the signs themselves. In Krauss's reading, the f-hole is not a sign of a violin but of foreshorten-ing, the way in which the size of a mark changes according to how it is represented as oriented in space. Similarly, looking at the fragments of newspaper stuck onto the surface of the picture, Krauss refutes the idea that the meaning of these is to be found in the words that are visible. Instead, the newspaper is a sign about pictorial space. It asserts both the two-dimensionality of the picture surface, yet also evokes a sense of distance akin to aerial perspective in the way the newsprint blurs our visual field. Thus, it raises questions about figure and ground, what is empty space and what is object in the collage. It is clear from these examples that Krauss is interested in the collages as 'a metalanguage of the visual', (Krauss, 1985, p. 37) representations about representation, signs about

25 Pablo Picasso, *Bowl with Fruit, Violin and Wineglass*, 1913, charcoal, chalk, water-colour, oil on cardboard, 64 × 48.5 cm, Philadelphia Museum of Art

signs. She reads everything in the images as signs not of objects, but of pictorial self-reflection.

Krauss's other key Saussurean move is to emphasise difference. She rails against readings which produce 'the fixing and limiting of the play of meaning' (Krauss, 1985, p. 35) and argues for the instability of meaning. The

forms of Picasso's collages are **polysemic**. Any element might mean any number of things. This is a direct consequence of the idea of differential meaning. An image means one thing in one context, something else in another. Again, there is an emphasis on formal elements, and Krauss explores the way in which one sign might be significant of, say, closed *and* open form, or of planarity *and* recession. This vocabulary will be familiar: these are oppositions developed by Wölfflin in *The Principles of Art History*.

Krauss, however, has an understanding of formalism that emerges from Wölfflin's American followers, one that is insouciant of history and removes the work from its cultural context. For Krauss, to read the collages through contextual material is to pin down the meaning of Picasso's images via a theory of reference and, so, to ignore the true nature of the visual sign (its indeterminacy), and of the artwork itself (its formal nature), which reveals 'the systematic play of difference' (Krauss, 1985, p. 35). There is no doubt that Krauss's essay is a brilliant theoretical exercise, but it leaves one wondering what sense of art we are left with. If art is about the conditions of representability it makes art a curiously hermetic enterprise, and rather than expanding what we can say about it, it seems to limit the ways in which we can approach it. In spite of Saussurean theory, and Krauss's argument, many would assert that the f-hole *does* refer to a violin. The connection is not arbitrary. There seems to be a referential significance in addition to any differential ones. One wonders: is Saussure's semiotics really suited to visual inquiry?

Icon, index, symbol: Peirce

One of the difficulties that Saussurean semiotics raises for art history (and vice versa), is how one deals with visual signs using a method founded on verbal signs. For Saussure, linguistics was the foundation for semiology, since language revealed most clearly the conventional and arbitrary nature of the sign. But not all signifying phenomena are alike, and while visual signs are undoubtedly conventions, they do not always have the arbitrary nature that Saussure identified in the verbal sign. For instance, while there is clearly no necessary connection between the word 'cat' and Tiddles, this is not obviously the case if I were to draw a picture of Tiddles. While different cultures have different words for 'cat' – *chat*, *Katze*, *gatto* – one would expect to find a similarity in visual representations across cultures; Tiddles would be represented with whiskers, paws, a head and tail (probably at opposite ends of the body) and so forth.

The work of Charles Sanders Peirce provides a semiotic approach that obviates this problem. Peirce was an American philosopher whose work

ranges over a huge range of topics including mathematics, scientific method, ethics, mind and logic. His semiotics was developed as part of this much larger philosophical project. However, the use of Peirce's semiotics in art history should not be understood as symptomatic of his thought as a whole. His theory of signs has been removed from its original context and has often been combined with principles antithetical to Peirce's own. Peirce himself was a realist of sorts. He propounded the view that if scientific inquiry is carried out correctly, we can achieve a true account of what the world is like. Thus, through rational and empirical procedures we can represent the world as it is in reality. He is also a verificationist, believing that we can discover and prove truths (which is in contrast to other positions in the philosophy of science, such as Popper's famous argument that we cannot verify but can only ever falsify hypotheses, and it is by the process of falsification that science proceeds). This is, of course, quite different from Saussure's position and that of many contemporary semioticians who have aligned themselves with Peirce. What the latter have found indispensable in Peirce's work is a semiotics which explained the different forms signs could take, and the different ways meaning might be produced.

Rather than reducing all signs to one basic form, as Saussure did, Peirce offers an exhaustive taxonomy of sign types. In total, his classification designates 59,049 possibilities, but there is a more basic tripartite division that has been taken up by semioticians: **icon**, **index** and **symbol**. The icon is a sign that works by resemblance; that is, a sign that is not so much decoded as understood to refer to an object in the world. Hence, a portrait like Holbein's *The Ambassadors* (Figure 22, p. 190) is iconic, since it refers to the sitters. This does not mean that it is necessarily an accurate likeness, or even that the ambassadors themselves ever actually existed. It simply means that the sign system enables people to recognise that this stands for a certain person or persons. The index is a sign which does not resemble the object, but provides evidence of its existence or presence. For example, a hole nibbled in a geranium leaf is an indexical sign of the slug that ate it; a scar is an indexical sign, since it is a mark left by an event like a scratch or a cut. In the field of art, Pollock's drip paintings are clearly indexical – think of how *Out of the Web* (Figure 24, p. 193) reveals the movement of Pollock's body, his physical presence as he made the painting – and photography has often been described as indexical since it reveals the presence of the subject when the photograph was taken.

Finally, there is the symbol, which is closer in meaning to Saussure's generic sign. It is a mark or word or image whose meaning is conventional. Like Saussure, Peirce emphasises the role of rules or laws here: a symbol means something because all the members of a community use it in that

way. He does not, however, insist on arbitrariness. Complex works like paintings and sculptures may consist of all three of these signs; and some things may fall into more than one category. A photograph of someone, for instance, is both iconic in that it offers a resemblance of the sitter and indexical in that it is the trace of that person's being in the world. The essential point is that Peirce demonstrated that signs need to be considered in terms of the different ways they operate.

Nonetheless, there is a basic feature that applies to all signs. Icon, index and symbol all share the same basic principle of **semeiosis** or signi-fication. In Saussurean semiotics all signs share the same fundamental structure. In Peirce's semiotics signs have different structures, but all signs produce meaning through the same process of mediation which he calls Thirdness (this is a technical term in his larger philosophy and refers to the tripartite nature of signification). The three elements in this process of signification are: object, sign (or representamen), and interpretant. The object is the thing or idea or event being represented. The sign itself is the thing that stands for the object (the icon, index or symbol). The interpre-tant is not the person him- or herself, but what the sign produces in the mind of the interpreter, such as a thought, another sign or a response. Thus, the sign mediates the object and the interpretant. So rather than being concerned with the internal nature of the sign, Peirce lays a greater empha-sis on its role in connecting the mind of the viewer with the world. Indeed, Peirce's notion of semeiosis is a causal chain. The object determines the sign which, in turn, determines the effect upon the viewer. While signs do not simply describe objects, there *is* a sense of reference here; meaning is not produced differentially in the Peircean model.

It should be clear why many have seen Peirce as a more useful guide than Saussure in art history. Not only does his taxonomy of signs enable one to take account of visual signs and their non-arbitrary relation to the world, but he also offers a way of differentiating between various kinds of sign within the visual field. This has proved useful for the most basic task of categorising art objects. Rather than using style or medium or genre as ways of grouping works, it has been suggested that Peirce offers more secure and objective categories, which group works according to how they mean. Rosalind Krauss, for example, in trying to make sense of contemporary American art found that what looked like a varied array of images and objects all shared indexicality as their basic characteristic (Krauss, 'Notes on the Index, Part One', *October*, Spring 1977, pp. 68–81; 'Notes on the Index, Part Two', *October*, Fall 1977, pp. 58–67).

However, Peircean semiotics can provide far more than such a broad-brush approach. **Stephen Bann**, whose work has been important in dis-

seminating both semiotic theory and ways of using it, has deployed Peircean principles in order to address a variety of art-historical issues. He has used the method to characterise styles. For example, analysing one of Courbet's landscapes he points out that it is both iconic, in that it depicts a particular location, and indexical, in that the way it is painted emphasises 'the existential bond between the vegetable pigment and the woodland scene' (Bann, *Experimental Painting*, 1970, p. 135) and so makes the viewer aware of the physical fabric of the painting. Thus, Courbet's realism in Bann's reading is characterised by the balance between these two kinds of sign; it is a style which asserts both the material manufacture and presence of the artwork itself and the absent scene represented by the work.

Similarly, in an aside, he finds a way of using Peircean categories to define Cubism as a style. Peirce distinguishes between two kinds of icon: the image, which represents the simple qualities of an object, and the diagram, which represents the relationships between elements by means of analogy. An example of the latter might be an algebraic equation. For Bann, Cubism is understood in terms of a shift from the former to the latter; it is a style that does not seek to present the qualities of objects in the world, but their internal relationships in diagrammatic form.

Bann has also turned his attention to the titles of works. Using a very specific Peircean analysis, he declares the title to be a dicent indexical legisign. The exact meaning of this need not concern us here, except as an example of how precise Peirce tried to be in categorising the many different semiotic possibilities. Moving through art-historical examples, Bann sees a shift in titling practices, as artists use the title in different ways and to different ends. For example, Courbet's landscape *Bois de Rochemont, ou La Ronde Enfantine* (1863) has a title which directs the viewer to a minor section of the painting. The phrase *'la ronde enfantine'* – the children's ring, or game of 'ring-a-ring of roses' – prompts the spectator to seek out the children hidden away. Beyond this, Bann continues, the title invokes a circling movement, which prescribes the movement of the eye around the image. The indexical force of the title is such that we are encouraged to search the pictorial space rather than simply adopt a straightforward view down the lines of perspective to the vanishing point.

While Courbet's title tells us what is there, Manet's *Le Déjeuner* (1869) uses the indexicality of the title in a different way. The title suggests we are looking at a painting of lunch, and yet it is a painting of armour. The effect of the painting is produced largely through the interruption of the index, and leaves the viewer floundering, trying to make sense of the mismatch between title and image. Bann explains this as Manet's wish to remove certain meanings from armour. Armour is a common and popular element

in paintings of the mid-nineteenth century, associated with chivalry and the glories of the past, but Manet empties it of these meanings. Again, the suggestion is that the title does not simply tell us what is there, but suggests how we should look at it, and it is Bann's use of Peirce that enables him to pinpoint the specific strategy at work here.

There are other more complex examples in Bann's article, including an account of a change in the kind of sign a title is. What is important for us, though, is that Peircean semiotics gives Bann a precise and objective way of describing how titles work. He does not have to rely on formulations like 'The artist intends . . .' or 'The viewer may feel that . . .' – there is a specific logical explanation for the manner in which the title produces a meaning, and the way in which title and work interact. This highlights the different ways that titles produce meaning and their concomitant effects.

Semiotics in practice

While art-historical scholarship is full of references to Saussure and to Peirce, there are few analyses which adhere to their semiotic principles in a dogmatic or rigorous way (depending on which way you look at it). The problem with Saussure, as we have suggested, is that the principles of the *Course in General Linguistics* and the primacy of the verbal sign cannot always deal adequately with the visual or motivated sign. In the case of Peirce, the problem is how one uses his taxonomy of signs and his notion of semeiosis while rejecting his realist and verificationist principles. We can identify three responses to these difficulties; responses which demonstrate that semiotics can be used very productively in spite of these apparent obstacles. First, one might combine the insights of Saussure and Peirce, using the latter to counter the former's insistence on arbitrariness, while retaining the former's notion of the play of difference. Second, some art historians have developed the general principles of semiotics, rather than adhering to the letter of the originator's templates (and, of course, all methods develop in this way). Third, semiotics has often been combined with other methods, so that any shortcomings are balanced with methods that are more historical or more visual or more politicised.

The American art historian **Meyer Schapiro (1904–96)** was an early pioneer of semiotic art history, and while he rarely discusses the method in explicit terms, much of his work from the latter part of his career is indebted to both Saussurean and Peircean ideas. As we see from the example discussed briefly, Schapiro draws on Saussure's idea of differential meanings, while also using a model of semeiosis closer to Peirce's. As a scholar

also known for his contribution to Marxist art history, it is unlikely that Schapiro would accept the philosophical baggage of structuralism, but his Peircean inclinations allow him to retain a realist outlook. Unlike Krauss, Schapiro *is* prepared to name historical referents. Indeed, he insists on this. And while Krauss sees semiotics as related to an American reading (or misreading) of Wölfflin's formalism, Schapiro uses semiotics as part of an iconographic enterprise.

In *Words and Pictures* (1973) Schapiro explores the relationship between texts and images based on them. It is clear from the different ways in which a text is represented visually, that the relationship is far more complex than a naive notion of illustration would allow, and Schapiro traces the complex of factors responsible for shifts in the visualisation of a biblical narrative. He retains some of the beliefs of the iconographers, in that he sees changes in style as signalling a change in content; when the style changes, the narrative of the story changes too. He uses semiotics less for its ambitious philosophical aims, and more as an analytical tool. In the final chapter of the essay, he examines frontal and profile representations in medieval art as symbolic forms.

We came across this phrase in our discussion of Cassirer in Chapter 6; although Schapiro knew the work of both Panofsky and Cassirer, here it is used in a more familiar way. The term 'symbolic' in Schapiro's analysis has a twofold meaning. First, it is the opposite of a literal meaning. While an image can be said to represent a person or an event or an object (what it denotes) it also clearly has a more important significance, namely the connotations that are seen to be coded in the sign. Schapiro's use of the term 'symbolic' can also be related to Peirce's notion of the symbol as a type of sign that acquires its meaning through convention or usage, rather than resemblance or indexical trace. Schapiro talks about 'modes of composition' to point to the ways in which any personal style is dependent upon these conventions. These two meanings — connotation and convention — reveal a fundamental semiotic premise of the argument: that while a common-sense view might think of frontality and profile as natural images of bodily positions, they are in fact conventional forms that acquire their meanings from their relationship or difference. Schapiro underscores this point by mentioning the role of frontality and profile in actual ritual where again these bodily positions are signs; the flesh-and-blood body signifies as a sign just as much as a carved or painted one.

Schapiro compares two images of a ritual. In one there is a clear view of the event, with all the figures in profile. In the other, the figures are presented frontally and arranged down the page from top to bottom. The profile view presents the ritual as an event where everyone participates

equally. The frontal view enables the presentation of a hierarchy. So these are not simply two views of the same thing – the choice of sign (frontality and profile) gives a different meaning. Schapiro moves on to extend his analysis by mentioning the three-quarter view; the meaning of frontal and profile are also related to this. If the three-quarter view is the norm, the most frequently used sign, then the frontal figure becomes exceptional; the very fact it is *not* a three-quarter view gives it an added significance. Thus, its meaning is not necessary to the material nature of the sign – one cannot say that a frontal figure means something as such – but is derived from its difference from other signs.

Now, Schapiro makes it clear that he is not claiming that these are always the meanings of the frontal and profile figure. One cannot take this explanation and apply it to another image. Because meaning is produced differentially, one always has to assess a sign in terms of its system. What does remain the same, however, is the sense of polar ideas represented in relation to each other, so frontal and profile will always represent a difference. The question is what the possible meanings are, given the alternatives. Schapiro mentions Greek relief sculptures depicting an author and his muse. Here again there is a convention to show the author in profile and the muse frontally, representing the difference between a person and a personification. While this is quite a different symbolic language from the medieval images he discusses, there is exactly the same sense of 'profile and frontal as paired carriers of opposed meaning' (Schapiro, 1973, p. 40).

The Peircean aspect of Schapiro's practice emerges very clearly in his discussion of an image of Moses at prayer. Moses is represented standing with his arms outstretched; this, for the viewer, is a sign that Moses prefigures Christ in medieval theology – evident in the way his pose suggests the crucified body on the cross. While he does not spell this out, Schapiro is using Peirce's theory here. The object is Moses; the sign is the image of Moses at prayer; and the interpretant is the idea of Moses as prefiguring Christ. The sign is not wholly arbitrary, but a link in a causal chain of signification. Schapiro also seems to draw on Peirce's semeiosis in his emphasis on the way that the sign is addressed to the viewer. In his account of frontality and profile, too, he is concerned with the different ways in which these address the viewer and so produce different interpretants.

More recently, Mieke Bal's work has exemplified the second and third ways of developing semiotic art history we identified. She has offered an approach where, rather than sticking to the letter of either Saussurean or Peircean models, and rather than trying to combine them, she has taken up *general* principles (albeit more in a Saussurean tradition). Thus, her massive book *Reading Rembrandt* (1991) is deeply informed by semiotics but the

method is used with a certain freedom. This is a complex, difficult and fascinating work, and we can barely begin to unravel the numerous threads in it, but even a simplified account shows Bal's methodological and theoretical inventiveness. Central to her work is a refining of the definition of the sign. The sign is not a thing, for Bal, but an event. By this she means that the meaning of the sign is not fixed, but is unstable, and depends on the way it is viewed. Indeed, it has no meaning *until* it is viewed (hence the use of the term 'event'). However, this does not mean that any sign can have any meaning, and that all readings of a work of art are equally valid. While a work has more than one meaning, the possible meanings it can generate are circumscribed; the codes which govern representation produce limits.

Extrapolating from this principle, Bal also asserts that a work of art is to be understood not as a given with a meaning, but as an effect, a set of all possible readings. Again, because there are semiotic laws governing the making and reading of paintings, this does not mean that the image can be interpreted in any way whatsoever, but rather that different interpretations can be produced according to the specific visual signs, their combination and material qualities. It is clear that, as with all semioticians, she is decisively turning away from the artist and the notion that the authorial intention is the same as the meaning of the work. Instead, she is interested in the meaning produced by the reader or viewer. To this effect she mentions in her introduction that some of the works discussed are likely to be attributed to artists other than Rembrandt, particularly in the wake of the Rembrandt Research Project mentioned in Chapter 4. But for a semiotician like Bal, this is of no concern. All that matters is that the painting has been read as a painting by Rembrandt, and to this effect she refers throughout to 'Rembrandt', the quotation marks pointing to the fact that the sign-event produces a Rembrandt regardless of which historical figure actually made the painting.

This notion of the sign-event is relevant to her concern with the relationship of word and image. Bal argues in her book that there is no real boundary between visual and verbal signs; this is an artificial distinction that overlooks the codes that these different media share. As we have seen, semiotics is a method that insists on forms of signification that are true for all media (this emerged in Saussure's dream of semiology and in Peirce's *semeiosis*). Here, the notion of the sign as an event is crucial, since it allows Bal to categorise not in terms of image and text, but in terms of narrative, textuality, realism, and so on; it is ways of reading, ways of producing meaning, different *events* that structure her analysis, rather than the material forms of artworks.

An example of how these general principles are brought to bear on a
specific artwork is well illustrated by her reading of Rembrandt's *The Toilet
of Bathsheba* of 1654 (Figure 26). Bal discusses two possible modes of reading
the work, both of which are convincing, and yet are contradictory. First,
there is a realist reading where one views 'signs for the real'. In this instance
we might see the painting as representing a natural, real scene; the details,
like the curtains or a surface texture, all suggest that this is the transcription
of a real event. Second, though, there is a reading which is textual, one
where the signs are viewed as 'signs for the text'. By this, Bal means that we
become aware of this as a work of art, something constructed, artificial,
full of signs that could mean any number of different things. In reading
'signs for the text', the emphasis is on formal coherence rather than detail;

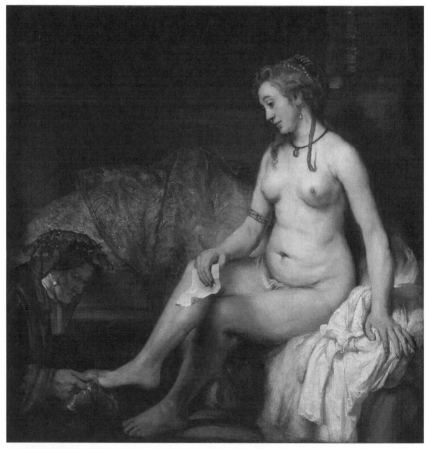

26 Rembrandt Harmensz van Rijn, *Bathsheba at Her Toilet*, 1654, oil on canvas, 142
× 142 cm, Musée du Louvre, Paris

rather than a mass of phenomena, the text presupposes a unity. The difference between the 'sign for the real' and the 'sign for the text' is not the sign itself – after all, we would be looking at exactly the same painting – but the way it is read, the way the viewer chooses to read it. Here again we see why Bal calls the sign an event (unlike Schapiro for whom the sign is a thing that has an effect). This may be about the interpretation of a particular sign. On Bathsheba's letter there is a red spot. This could be read as sealing wax. In this case, it is a sign for the real, a detail in the painting among others. But Bal points to an alternative. In the biblical story of Bathsheba, she commits adultery with David and becomes pregnant; in order to hide his guilt, David brings about the death of her husband, Uriah. In this context, the red spot might be blood, a sign of the blood to be spilt in Uriah's death. Here it becomes a sign for the text, where it is more than just a detail but a path to recognition of the entire narrative and the way in which the image produces it.

So Bal proposes plural readings, and mobile readings where meaning is shifting rather than fixed. Although these readings are myriad, they are not arbitrary, depending as they do on the detail and nature of the work. Nonetheless, meaning is produced by the viewer and his or her choices. This is a particularly bold and radical reader-oriented approach, that extends semiotic principles of anti-realism, anti-individualism, and polysemy. It takes very seriously, and at face value, Saussure's contention that language can only be understood from a user's point of view and traces this notion to a logical end-point.

Bal also demonstrates the third way in which semiotics has been adapted to avoid an overly dogmatic approach, and to enable a richer approach to the visual sign. Many art historians have combined semiotic insights with other methods such as feminism, or psychoanalysis; Bal is herself deeply committed to both of these. Combining semiotics with other methods can be problematic, since the commitments underpinning, say, certain versions of feminism or Marxism are not always consonant with the anti-realism and anti-humanism of semiotics as it is most commonly practised. For Bal, however, this is not a problem. Her feminism is such that it fits the anti-individualism of semiotics (which would not be the case for many other feminists, such as Linda Nochlin). She argues that in order for a feminist reading to emerge one needs to prove that different readings are possible and legitimate; that there is room for a feminist alternative to orthodox interpretations, and that such an alternative is plausible. To do this, one has to turn away from authorial intention and privilege the female or feminist spectator; and this, in turn, requires the notion that meaning is unstable and can be produced differently. Her psychoanalytic position is

similarly adept, and while a Freudian would find semiotics' anti-realism hard to accept, Bal is essentially a Lacanian (we have already glimpsed her work in Chapter 9) and follows Lacan's particularly idiosyncratic interpretation of Freud.

Looking a little more closely at the example of Rembrandt's self-portraits we can see exactly how semiotics and psychoanalysis can fit together. The Rembrandt images were products of the mirror stage for Bal; they relived the experience of the child looking in the mirror and misunderstanding the complete and unified ideal reflection as the self. Bal sees self-portraiture as analogous to this moment of alienation from the self, or as a replaying of this formative moment. This is also a moment of narcissism, of the child's desire for the reflection, its self-love. Bal points out that this is in fact not self-love, but loving the sign in the mirror which is taken to be the self. Like the viewer of Bathsheba, choosing between a realistic and a textual reading, so the child in the mirror phase has the same dilemma, torn between seeing this reflection as truly the self, a sign for the real, or seeing it as a sign for the text, signifying alienation and loss. In a similar way, other methods have been viewed through the lens of semiotics. Marxist semioticians have used the method to discuss ideology as a question of signs; ideas can be decoded and exposed as false consciousness, mere convention rather than truth. Other feminist scholars have discussed woman as a sign, using semiotics to explore the ways in which what might appear to be a true image of femininity is, again, no more than a convention which is anything but natural. The key point is that semiotics lends itself to combination with other methods and can yield rich results if contradictions are avoided, and basic assumptions (such as anti-realism) are adhered to. This can also overcome some of the limitations of Saussure and Peirce applied mechanically, but does not address the fundamental problem of semiotic art history.

Critical appraisal

Reviewing the art-historical literature which adopts, say, a social historical or a feminist perspective, one is struck by how many scholars use these methods, by the sheer volume of books and articles that explicitly demonstrate a commitment to historical–materialist or anti-sexist positions. Reviewing the same body of scholarship for evidence of semiotic art history one is struck by the reverse: that relatively few people in the discipline seem to be wholeheartedly committed to semiotics. One should not conclude from this fact that semiotics has been less significant or is less

interesting in terms of its theoretical and methodological questions, but rather that it has had a different impact on, and in, art history. This difference points up both the strengths and problems of the method.

To begin with the strengths, the influence of semiotics has been felt less in the number of studies it has underwritten and more in terms of general issues it has raised. In other words, many have used semiotics not as a fully-formed method to be used per se, but as a forum for debating some central methodological concerns. We want to emphasise two of these concerns, which have been discussed with real urgency in the wake of semiotics' appearance. The first key issue is the nature of representation. We have seen that semiotics asserts that all images are signs to be decoded, and that even apparently natural signs are in fact conventions. This position has two targets. First it combats what Norman Bryson has called 'perceptualism', the notion, most cogently expressed in Gombrich's *Art and Illusion*, that visual images constantly test themselves against reality and come closer and closer to an accurate depiction of what the eye perceives (the notion of art progressing by trial and error that we mentioned in Chapter 5).

But semiotics also poses a challenge to other methods which recognise the conventional nature of the visual sign. Panofsky, for example, was quite clear that changes in perspective are not simply the result of increasing accuracy but of shifting mind–world relations. He had picked up Cassirer's notion that a human is an *animale symbolicum*; what characterises people is that they make symbols. Although his argument relies on the notion of representation as a matter of the mind rather than the world, semiotics offers a view that is in many respects the opposite of this. For a semiotician, it is not humans who make symbols, but symbols that make humans. For Cassirer and Panofsky, the connection between sign and concept is necessary; in semiotics – at least its Saussurean version – it is arbitrary. So if Panofsky sees art as connecting mind and world, semiotics (again the Saussurean variety) sees signs as evidence of an unbreachable chasm between them.

Second, semiotics has also encouraged art historians to reflect on the question of meaning. Indeed, one might say that semiotics tried to liberate meaning and interpretation, freeing it from the chains of traditional criteria and offering a wider range of interpretative possibilities. Of course, scholars have long recognised that an image or object can be read in different ways, but there has been a strong tendency in art history to combat this perception and to try to identify *the* meaning of an artwork. Most often, this authentic or true meaning has been equated with authorial intention; although reception-based studies often seek to identify the meaning

perceived by the patron or original audience. Unlike such inquiries, semiotics, with its emphasis on *langue* rather than *parole*, does not seek to privilege one meaning over another. What matters is to describe the field of all possible interpretations. The question raised here is why one might want to work this way. Most art historians have convictions that they want not only to make clear, but which they want to claim as truer or more important than others.

However, semiotics remains fundamentally problematic for any historical discipline since, as Bann points out, it 'cannot by its very nature accommodate the phenomenon of change' (Bann, 'The Mythical Conception in the Name', 1985, p. 177). While it can be used to identify the codes in use in a particular culture at a particular moment, semiotics is always locked into that moment, with no way of speculating on historical process preceding or following it. This is true of both Saussurean and Peircean models. Saussure is really only interested in the synchronic. Indeed, his structural approach necessitates this. Since, for Saussure, meaning is only ever possible in terms of the specific relations at one moment, it becomes impossible to trace the relationship between a sign and a past *langue*. These cannot be combined, as Roy Harris eloquently points out, 'any more than Napoleon's France and Caesar's Rome can be structurally united under one and the same political system' (Saussure, 1983[1916], p. x). The semiotic can be understood as a series of synchronic moments rather than as an evolving mechanism. Peircean semiotics presents art historians with the same problem, although for different reasons. Peirce's own philosophy does allow for historical change. Peirce believed that humans have a natural instinct for the truth and that properly undertaken scientific inquiry enabled this instinct to flourish. Thus, our knowledge of reality progresses because of our ability to rationalise. However, Peirce's assumptions are now either outdated (such as his verificationism) or are unacceptable to contemporary semiotic commitments to anti-humanism and anti-realism, through which Peirce has often been reinterpreted.

This problem is acute in both the weaker and stronger versions of the method. (We use these terms to denote not the value or plausibility of the arguments, but the extent and force of the claims they make.) In the weaker version of semiotics, like Schapiro's and Bann's, the interpreter can only analyse the synchronic moment. Meaning derives from the structure of the code at the moment of making or perceiving. Hence, to practice history is to analyse the code or *langue* of a past moment. Semiotics offers no means of explaining how the system changes over time. While Schapiro could point to different uses of the frontal-profile pairing in ancient Greece and in medieval Europe, the semiotic method cannot explain how a code

changes. In the stronger version of the method, such as Krauss's or Bal's, the possibilities of history are even more limited.

In her reading of Picasso's collages, Krauss characterised the search for historical referents as a circumscription of what the images might mean. For her, these images are meta-representational; signs about signs. Bal takes the opposite view. Art can only ever reflect the viewer and his or her perspective. She states that there can be no pure historical knowledge. To invoke a context is only to produce more signs for the interpreter to read and analyse; another set of sign-events to take place. The consequence of this is that one can only read from a position in one's own code or *langue*; art history can only ever be about the concerns of the contemporary viewer. For both Bal and Krauss, to insist on history is to misunderstand visual signification and to ignore what actually happens when we interpret an image. For most art historians this presents something of a dead end, disabling rather than enabling inquiry; while there is no doubting the brilliance of Bal's work, it is not historical and nor could it ever be.

However, it is important to remember that this is by no means a weakness for someone committed to semiotics and its philosophical underpinnings. Indeed, if one believes in semiotics then this scepticism about history is a positive strength, removing the illusion that we can ever have access to the past, and erasing the metaphysical errors of mono-causal historical explanation (and of more recent approaches that still yearn for a solution to the hermeneutic problem). But it is not difficult to see why so many art historians, however invigorated they may be by semiotics, have found it impossible to align themselves with the method in a thoroughgoing way. Few historians believe that history really is no more than a text, and in spite of the intractability of the hermeneutic problem few believe that the past is quite so inaccessible.

Bibliography

Bal, Mieke, *Reading Rembrandt: Beyond the Word-Image Opposition* (Cambridge: Cambridge University Press, 1991). A difficult but fascinating book that reveals how much semiotics can achieve and the historical price one pays.

Bal, Mieke and Bryson, Norman, 'Semiotics and Art History', *Art Bulletin*, vol. 73, no. 2 (1991), pp. 174–208. A detailed and complex account of the possibilities semiotics offers the art historian written by two of the discipline's leading semioticians.

Bann, Stephen, 'The Mythical Conception in the Name: Titles and Names in Modern and Post-Modern Painting', *Word and Image*, vol. 1, no. 1 (1985) pp. 176–90. A very clear account of how semiotics can be used to address the extra-pictorial elements of art history.

Bann, Stephen, *Experimental Painting: Construction, Abstraction, Destruction, Reduction* (London: Studio Vista, 1970). An early foray into semiotics is contained in the closing chapter.

Culler, Jonathan, *The Pursuit of Signs: Semiotics, Literature, Deconstruction* (London: Routledge & Kegan Paul, 1981). Essays dealing with a number of semiotic and post-structuralist concerns from the perspective of literary theory. Culler is one of the clearest and most reliable guides to structuralism and semiotics, although his account of the relationship between semiotics and previous intellectual figures, such as Cassirer, is problematic.

Krauss, Rosalind, *The Originality of the Avant-Garde and Other Modernist Myths* (Cambridge, Mass: MIT Press, 1985). A collection of essays including both 'In the Name of Picasso' and 'Notes on the Index'.

Peirce, Charles Sanders, *The Philosophy of Peirce: Selected Writings*, Justus Bucher (ed.) (London: Kegan Paul, 1940). A selection of Peirce's work from many philosophical fields, including a good selection of his lucid work in semiotics.

Saussure, Ferdinand de, *Course in General Linguistics*, Charles Bally and Albert Sechehaye (eds) with the collaboration of Albert Riedlinger, trans. and annotated Roy Harris (London: Duckworth, 1983[1916]). The reconstruction of Saussure's lectures with an excellent introduction.

Schapiro, Meyer, *Words and Pictures: On the Literal and the Symbolic in the Illustration of a Text* (The Hague: Mouton, 1973). While theoretical principles are never made explicit, this is a brilliant use of semiotics and indicative of why medievalists have found it such a useful method.

W E HAVE SEEN how more recent approaches to art history have undermined the universal claims of earlier methods. Marxism has insisted that class difference must always be taken into account; similarly, feminism has asserted the importance of sex and gender differences. Rather than making general statements that are applicable to all people, these methods argue that such statements mistake an interest group – the bourgeoisie or heterosexual men, for instance – for all humanity. In a sense, postcolonialism follows this trend, but here differences of race and ethnicity are at issue. Postcolonialism maintains that universal claims are mistaken since they assume that a certain white, Western identity or position is the template for all people, and that cultural differences are ignored. Indeed, the very term 'postcolonial' suggests this, evoking as it does histories of empire, resistance and decolonisation. It should be clear from the outset that there is a powerful political agenda at work.

Postcolonial theory is perhaps best thought of in geographical terms. The model of centre and periphery is frequently invoked; a distinction between a metropolitan centre, where power is held and where decisions are made, and the periphery, the outlying areas which are administered or exploited. The British Empire is a clear example, with the imperial capital of London at the centre and the many colonies around it. This might not be a literal image of imperial geography – after all, colonial subjects from India or elsewhere may actually live in London itself – but it is at least a metaphorical one. Postcolonial theory asks this: what would history look like if it were written from the point of view of the periphery? What stories would history tell if, rather than the perspective and values of the centre, the colonised voice narrated and evaluated? What if the coloniser ceased to speak for the colonised, and the colonised spoke instead for the coloniser? Postcolonial history, then, might be described as the periphery talking back to the centre, as the viewpoints of the marginalised or the colonised. It challenges or questions the authority of some voices, and demands that others be heard.

On the one hand, this means that a different history emerges. So, for example, accounts of modernism will not simply trace developments in Picasso's Paris and the New York of Abstract Expressionism, but will insist on the ways modernism will have been used and practised in, say, Mexico

City or Delhi. But postcolonialism goes further than simply expanding the artistic canon to encompass the globe. Postcolonial theory's more important aim is to expose the preconceptions and prejudices that underpin other accounts. It is not simply seeking to correct errors, to argue about facts – although that is inevitably something that has to be done – but also seeks to demonstrate how the very philosophical and political commitments of many historians will always ignore, or misrepresent other peoples and cultures. Hence, a postcolonial analysis will not argue that, say, many modernist art historians misunderstood African artefacts, but that their very values, their fundamental background beliefs about race and culture meant they would always misrepresent it. Their point of view is always partial and imbued with colonial interests. Postcolonialism, in this way, recasts what we have called the hermeneutic problem in geographical rather then temporal terms. Given that an artwork is specific to its culture and location, how can a viewer from a different culture understand it? How can an outsider ever be so immersed, so inside that other culture, that he or she can approach the art work with any kind of authority?

Two points need to be made at the outset with regard to what postcolonialism is not. First, it is not a study of other cultures. Looking at African masks or Australian aboriginal painting is not the same as postcolonial analysis. Postcolonial theory is concerned with something rather more specific: it deals with the interaction between imperial and indigenous cultures, most notably that between Western imperial nations and their colonies (but not exclusively). So rather than exploring other cultures as such, it looks at what happens to cultures when they meet, what the material effects of colonisation are, how the process of colonisation changes the ways people think, and act, and write, and paint, and so on. Moreover, postcolonial theory is not only concerned with the effect of colonisation on other cultures, but just as much with the ways in which the colonised changed the coloniser's culture. For example, postcolonialism has not simply asked how the presence of the British changed the culture of Indians, but also how British culture was irrevocably changed by contact with India.

Second, postcolonialism is not a systematic approach like Hegelianism or Marxism; it does not have a single model of historical development, or a set of specific theoretical precepts. Indeed, postcolonial theory has relied on some of the other approaches discussed in this book in order to explain the ways in which cultures affect each other. Some have used psychoanalysis, for example, as a means of exploring the psychic effects of the colonial encounter; others turn to Marxism to offer an economic or class-based account of intercultural exchange. It is more useful to think of postcolonialism as a set of interests or a viewpoint than a theory proper.

As Robert Young points out, postcolonialism provides 'a politics rather than a coherent theoretical methodology' (Young, 'Ideologies of the Postcolonial', 1998, p. 5). This sense of politics cannot be overstated. Just as feminism cannot be understood outside the context of the women's movement and calls for equality, so postcolonial theory is inextricably related to political struggles in various parts of the world, the decolonisation of many countries after the Second World War, and the fight for racial and ethnic equality around the globe.

In art history, it has been a response to what was perceived as a particular problem in the discipline, a problem that is at once political, historical and moral. In spite of the long and complex history of intercultural exchange, most notably in the imperial projects of Britain, France, Germany and other nations, such exchanges never seemed to be acknowledged by art historians. Although Western painting often relied on artefacts from other cultures – particularly in movements like 'primitivism' – accounts tended to proceed as if these were objects that simply appeared from nowhere and were no more than formal exemplars that allowed artists to rethink style and aesthetics. The history of how those objects appeared in European cities, why ethnographic museums were established and how they presented these objects, was not addressed. It is as if history only happens in the West, and the rest of the world is merely a repository for interesting and exotic objects. It is this sense of the scope of history that postcolonialism attempts to correct. Because there is no single body of theory on which postcolonialism depends, it is a remarkably diverse field. We now address two major strands which offer divergent approaches: one which focuses on the opposition of cultures; and one which argues that cultures are hybrid – that is, they are not self-contained but are the product of continual intermixing and exchange.

Edward Said and *Orientalism*

The work which, in effect, created postcolonialism was Edward Said's *Orientalism*, first published in 1978. **Edward Said (1936–2003)** was professor of English and comparative literature at Columbia University, New York, and as a Palestinian was involved with politics in the Middle East. Of course, many other writers and thinkers had addressed the issues of cross-cultural encounters and exchanges, and had written histories of empire and colonisation. Much of this work, however, was not postcolonial in that it still proceeded from the point of view of the centre rather than the margin. In literary studies, for instance, there has long been an interest in Commonwealth literature, but, as the title suggests, this did not originally have

the radical ambitions of postcolonialism. In art history there is most notably Bernard Smith's *European Vision and the South Pacific* (1960) which examined European responses to Pacific peoples and cultures and the ways in which representations of them were shaped by European representational traditions and ideas.

The real precursors of postcolonialism, however, were figures involved with decolonisation around the globe, both culturally and politically. Key interventions include the *négritude* movement which emerged in the Franco-phone world in the late 1930s and 1940s. This was an anti-colonial tendency that offered a positive image of Africa in the wake of colonial racism and denigration, and assessed the collective experience of the black diaspora. *Négritude* was a loosely-defined term and was used in divergent ways. For the poet Aimé Césaire it signalled a concern for the social determination of black consciousness; that is, for the ways in which colonialism had shaped African identities. In contrast, for the thinker and politician Leopold Senghor, *négritude* described a fixed nature of black identity, essential char-acteristics that persisted through different historical experiences. More important still for contemporary scholars has been the work of **Frantz Fanon (1925–61)**. Born in Martinique, Fanon worked as a psychiatrist in French North Africa and was actively involved in political struggles, such as the Algerian fight for independence. His book *Black Skin, White Masks* (1986) explored the ways in which the black psyche was distorted and damaged by colonialism and this work has been very influential in the development of postcolonial approaches. While these examples, and many others, were crucial to the debate about culture and colonialism, it was the publication of Said's *Orientalism* that is often taken to mark the beginnings of postcolonialism as it is generally understood.

Said's originality is evident in the way he defines the subject of his book. Orientalism is, first, an academic specialisation: a topic studied by archaeologists, historians, theologians, and others in the West who are concerned with Middle Eastern and North African cultures. This is a straightforward definition. But Said adds two further meanings to the term. Orientalism is also something more general, something that has shaped Western thought since the Greeks, at least: namely, a way of dividing up the world between the West and the East. What appears to be a simple geographical fact is, says Said, actually an idea. The division of the world into these two parts is not a natural state of affairs, but an intellectual choice made by the West in order to define itself. The third meaning for Orientalism is more historically specific. Since the latter part of the eigh-teenth century, when European colonialism in the Middle East developed most fully, Orientalism has been a means of domination, a part of the colonial enterprise. Said argues that colonialism is not only about the

physical acts of taking land, or of subjugating people, but is also about intellectual acts. The academic study of the orient is unthinkable outside its colonial context and vice versa. So rather than just an innocent scholarly topic, Orientalism is a general way of imagining the world's divisions and a specific mechanism for furthering the colonial quest.

We mentioned earlier that postcolonialism does not have its own set of theoretical precepts, but is instead a point of view which uses other approaches for theoretical support. In Said's case, that support comes from the work of the French philosopher Michel Foucault, whom we discussed in Chapter 8. Foucault's own work is very decisively not postcolonial, but Said saw that a Foucauldian approach to history would enable him to rethink the relationship between Western and Eastern cultures. Like many feminist scholars, he draws particularly on Foucault's notion of discourse and on the philosopher's argument that knowledge is inextricable from power. How, then, does this help Said? He describes the Orient as a product of discourse; that is, not as something in the world that is discovered and analysed, but as something created by Western institutions and ideas. In keeping with his Foucauldian position, Said understands this as a question of power. The definition of the Orient is a means of regulating it; the apparent truths discovered are in fact ideas circulated and accepted as part of Western colonial activity in the Middle East. This sense of the Orient as a discursive construct, in turn, enables Said to make one of his most important and striking arguments: what the West believed it had discovered about the East tells us little about the colonised cultures, but much about the coloniser's. The texts and disciplines that comprise Orientalism – historical narratives, analyses of religion, travel writing, etc. – reveal the values and preconceptions of the West, of the way people in Paris or London wanted to see themselves, their fears and ambitions and prejudices. In particular, the image created of the East is used as a means of producing one's own identity. This picture of the East functions as a distorting mirror image, enabling the West to say that whatever they are, we are not. This is one of Said's most influential insights. It demonstrates, too, how postcolonialism is concerned with the effects of colonialism on the coloniser's own culture.

Said's book does not actually address visual art, and it was Linda Nochlin who first brought his theoretical perspective to painting in an article called 'The Imaginary Orient' (1983). We have already encountered Nochlin as a pioneer of feminist art history in Chapter 8. In this article, Nochlin initiates a postcolonial analysis, discussing Orientalist painting – a genre that was popular and widespread in the nineteenth century. In particular, Nochlin looks at Parisian Salon paintings that purported to depict the Orient and its mores. Nochlin's account reiterates the fundamental

notions that structure Said's argument. These paintings, with their painstaking and meticulous descriptions of Middle Eastern markets and mosques, harems and temples, tell us nothing about the cultures they purport to represent, but viewed from a critical postcolonial position reveal much about the French culture that produced and consumed them. However much they may appear to be true representations, topographically and anecdotally, they in fact only illustrate the background beliefs and ideological needs of Europeans.

First and foremost these are not the accurate depictions of Oriental life they pretend to be, but are fantasies as Nochlin's title suggest (which is a phrase she borrows from Said's book). The work of Gérôme and Delacroix should be understood as an imaginative invention. The subject matter is a compendium of stereotypical qualities: types who are lustful, violent and lazy, for example. Gérôme's *The Snake Charmer* (Figure 27) shows a young boy performing for an audience of men, and Nochlin identifies in the beautiful youthful flesh and, particularly, in the buttocks which are the fulcrum of the composition, more than a hint of sexual deviance. Similarly, the stock scenes of life in the harem, of barbaric customs, of religious

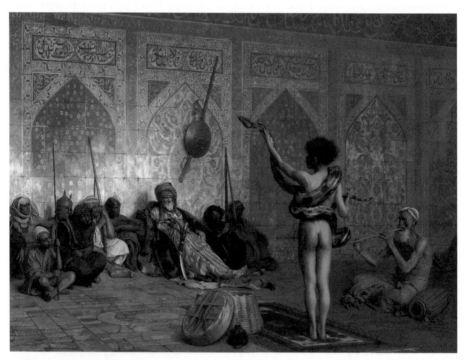

27 Jean-Léon Gérôme, *The Snake Charmer*, c.1870, oil on canvas, 83.8 × 122.1 cm, The Sterling and Francine Clark Art Institute, Williamstown, Massachusetts

fanaticism and so on all represent a culture which is mired in the past and overly devoted to sensual and sexual pleasures. But while this purports to illustrate the East's moral depravity, it actually satisfies Western sexual appetites and so, rather than presenting an image of Oriental morals, it in fact illuminates the sexual attitudes and hypocrisy of colonial Paris.

Nochlin also points to what is absent in the paintings, and argues that this image of a decadent civilisation is constituted by what is not there. There are no Europeans in the images, no signs of the West, of tourists or visitors or administrators. It is as if the West never intervened in the Middle East and its society has been untouched. Together, these things provide a very clear image of an Other, a people – or, rather, a group of cultures and peoples – who would be seen by contemporaries as the very opposite of their civilised and moral French selves. The depiction of a pure Orient, betraying no sign of intercultural contact, emphasises the way in which a pairing, often referred to as a dyad, is set up: West and East, us and them.

Nochlin's visual analysis also has one other crucial component. As well as what is depicted and what is omitted, she discusses the style and technique of the paintings. Looking at an artist like Gérôme, one of the most successful of the French Orientalist painters, she notes that the surface betrays no sign of the artist's hand. The astounding attention to detail, the smoothness of the surface, and the ultra-naturalistic finish all have a role in the construction of this Oriental Other. For what one sees in looking at a Gérôme reinforces the idea that this is a true depiction, and not an invention from an artist's imagination, or a politically loaded account derived from social and political sources.

Nochlin's analysis, then, relies on the fundamental notions Said puts forward in *Orientalism*. The paintings are inventions, examples of the West fantasising a place called the Orient and having the power for this to count as a true image. But these are not purely imaginative fantasies; they also have a purpose, and that purpose is to construct an Other, create a dyad of the West and the Other, and so consolidate a notion of the world divided into two quite distinct parts, geographically, morally and culturally. The images work to remind the viewer that it is the West, apparently, that is the locus of morality. Hence, these images have a political purpose in that they help to justify Western intervention in the East; they represent a culture which needs either moralising, or rescuing from its own inexorable decline.

While its importance has never been in question, Said's work – and other scholarship based on his method – has been the subject of much debate and criticism (as one might expect of a work that inaugurated a new

method). Two particular problems stand out. First, there is an internal theoretical contradiction in *Orientalism*, and this relates to the distinction we saw earlier between Orientalism as a long-standing feature of Western culture's way of dividing the world and Orientalism as a modern mechanism of colonialism. In the latter case, Said deploys a Foucauldian method, based on the notion of discourse: that the Other – in this case, the Orient – is always a construct. This entails the impossibility of mutual understanding, since one cannot step outside discourse and find the truth about another culture. On the other hand, though, Said ends the book with a humanist wish. Orientalism failed, he says, because it 'failed to identify with human experience' and did not recognise the 'common enterprise of promoting human community' (Said, 1978, p. 328). In opposition to the work of the Orientalists who populate his book, Said champions a scholarship that defends 'human freedom and knowledge' (Said, 1978, p. 327).

These are inspiring words and sentiments which are very appealing. But if Foucault is correct, then knowledge is always an effect of power, and freedom is an illusion. So how are these grand claims possible? This is, perhaps, the central problem of postcolonialism, and one related to our central concern of the hermeneutic problem. We discuss this further at the end of this chapter.

Second, there is a less abstract problem. Said's account is about the West, detailing as it does the way the West 'orientalises' the cultures of the Middle East in order to produce a sense of Western identity. This has been criticised for offering too homogenous a picture of the West itself, too homogenous a picture of cultural relations. The model of us and them overlooks the many dynamics within and between cultures. Moreover, critics have noted, this concentration on the internal coherence of Western discourse fails to address the question of the actual effects of colonialism on culture – its material effects. What about resistance? What about the encounters between people outside the texts Said dissects? A second model of postcolonialism has developed which is better equipped to deal with these questions, and we now turn to that.

Hybridity

While Said, and Nochlin after him, emphasise the division of West and East, this other powerful strand of postcolonial theory takes a rather different approach to relations between cultures. Instead of concentrating on the separation of cultures, on the dyadic split between 'us' and 'them', other thinkers and scholars have emphasised the idea of **hybridity**. The term hybrid, of course, is derived from the biological sciences. It refers to the offspring produced by two different species. This has been used as a

metaphor by some postcolonialists for the description of cultures, to emphasise that cultures are not single, pure formations, but are mixtures of different ethnic or cultural components and traditions. Cultures interact and shape each other through exchange. In talking about hybridity and cultural exchange it is important, again, to emphasise what this is not.

Art history has long recognised that European and American artists have used forms and visual ideas from colonial cultures. So-called 'primitivism' is the best example; the use by European painters of such artefacts as African masks or Oceanic carving as a visual source, to extend their stylistic vocabulary. Such a move is often attached to a simultaneous idealising of other cultures as, say, sexually liberated or closer to nature or any number of other stereotypical notions. Hybridity is not about this absorption and the stylistic borrowings so well documented in the discipline. The difference is illustrated by a controversy that arose in 1984 when the Museum of Modern Art in New York staged an exhibition called *'Primitivism' in Modern Art: Affinities of the Tribal and the Modern*.

The show was based around a set of comparisons, placing modern artworks alongside tribal objects to show where inspiration had come from and to demonstrate a general 'affinity' between makers of culture in different parts of the world. The anthropologist **James Clifford** wrote a long and critical review of the exhibition which revealed very clearly the ways in which the more traditional art-historical approach to cultural difference actually hid an important history. Clifford took issue with the notion of 'affinity', the idea that different peoples share something that transcends culture and history. Moreover, the emphasis on a purely visual affinity overlooked the ways in which objects had moved from one part of the world to another, how colonial cultures had acquired these objects, and the ways in which they were redefined as 'art' regardless of their use in the locations where they had been made. In effect, the exhibition effaced the history of the tribal artefacts, and while it purported to show the influence of the tribal on Western modernism, it failed to address both how this influence was implicated in colonialism, and the ways in which colonial culture had transformed the world of the colonised. Clifford argued that the notion of a transcendental 'affinity' connecting peoples both disavowed material and historical processes and ignored the fact that colonialism is a two-way process. An approach that deals adequately with the question of cultural encounters would need to be more historically specific, and more attentive to the political and ethical issues that underpin these encounters. It is not enough simply to celebrate non-Western art – this is, in itself, often central to colonial endeavours. A postcolonial theory founded on the idea of hybridity is far more thoroughgoing as an historical method and in terms of pinpointing the politics of cultural exchange.

A good example of this is **David Craven**'s account of Abstract Expressionism from a postcolonial viewpoint. It might be surprising to explore the work of Jackson Pollock in this way; after all, it is hard to see how his all-over drip painting could be discussed in relation to the interests of postcolonialism. This, in part, is Craven's point. Abstract Expressionism has long been seen as the epitome of modernism, the end point of a teleological process whereby painting becomes less and less representational and more to do with the materiality of paint on canvas. Historians have seen the ascendancy of Abstract Expressionism as the triumph of American painting, a moment when New York becomes the locus of the most important avant-garde practice. More recently, politically-minded historians have examined the way in which Abstract Expressionism was used by the CIA to signal American freedom during the Cold War, and its use in travelling exhibitions as a means of exporting the ideology of the ruling American elite and its global ambitions. Craven begins by pointing to two paradoxes that trouble this orthodoxy. Abstract Expressionism is viewed as a sign of American cultural imperialism, and yet a majority of Americans are indifferent or hostile to it. Second, there has been a great receptivity to Abstract Expressionism in Latin America at a time when American intervention was increasing and provoking resistance. If Abstract Expressionism really is no more than a conduit for imperialism, then why the hostility at home and the enthusiasm amongst anti-Americans abroad?

Craven's article is wide-ranging in the material it covers, but here we examine his account of Jackson Pollock as exemplary of his general approach. By trying to view and analyse Pollock's work from the margin rather than the centre, he seeks to show that this is neither the pure Western art modernists would have us believe, nor is it only implicated in the global politics of the developed world. Craven discusses Pollock's long-standing interest in Native American cultures, and argues that Pollock's famous 'drip' paintings are modelled on Navajo sand paintings. Pollock does not, however, simply absorb Navajo art as a visual novelty; unlike some modernist painters he does not view the Navajo as an exotic 'other', as happens in Orientalism. Instead, he identifies with the Navajo. Rather than emphasising the cultural distance between him and the Navajo, he seeks out commonality.

What is crucial to Craven's argument is another historical detail. Pollock immersed himself in Navajo art at a time when Native Americans' traditional cultural forms were being discouraged and the state was actively creating an acceptable Indian idiom. Art schools for Native Americans, for example, were teaching different techniques and forms of representation that were more acceptable to the state and which suggested assimilation rather than difference. Craven sees Pollock's use of Navajo culture as a

challenge to this racism. Pollock is not simply copying visual motifs; he is absorbing Navajo values and representing them in his canvases. This is politically motivated. He sees his own left-wing values as consonant with Navajo values, as if both he and they presented a challenge to the increasingly repressive cultural agenda of the USA which reached its apogee with McCarthyism in the early 1950s.

Craven sees beyond the dyad of native and white American cultures, and finds a political group that cuts across this pairing. In addition to this, Craven points out that Pollock also developed his radical techniques working in the New York workshop of the Mexican Communist painter Siqueiros – a workshop characterised by a mix of white and Hispanic American artists. Again, there is a blending here of cultures around shared left-wing political beliefs. Abstract Expressionism is not simply a continuation of European schools and influences. While there certainly are influences from Europe, such as Surrealism (itself already participating in anti-colonial politics and non-Western art practices), the style is also shaped by Navajo and Mexican work. This is underwritten by a sense of political affinity, and is not simply the appropriation of visual forms.

It is this alternative history of Abstract Expressionism, Craven concludes, that radical artists in Latin America understand and hence explains their enthusiasm for Abstract Expressionism as a form of subversive art. Craven's history of Abstract Expression is one that unfolds temporally and geographically in contrast to orthodox accounts which either celebrate a heroic moment in New York when the avant-garde becomes American, or explore the ways this pure US style is exploited by the state and politicised as a weapon in the Cold War. In effect, a post-colonial approach reveals Abstract Expressionism to be not American-type painting but an art of the Americas, globally dispersed in origin, and moving between cultures, a pan-American radical style. Again it is worth pointing out that, given the absence of a specific theory in postcolonialism, Craven finds his commitments elsewhere. Just as Said turns to Foucault, so Craven uses Marxist ideas. His analysis takes account of economic and political developments as partially determining artworks; indeed, his very premise is that Abstract Expressionism is not a 'pure' and apolitical practice, but is the product of global politics. What enables the linkage between white Americans like Pollock, and Native Americans, and Latin American artists, is not simply some generic humanity, but specifically a shared position in relation to the USA and its economic organisation.

A different approach to hybridity can be found in **Annie Coombes**'s essay 'Inventing the Post-Colonial' (1992) published in the cultural studies journal *New Formations*. Coombes's essay does not deal with artworks or

artefacts as such, but with curating and display. She offers a critique of a number of exhibitions in order to address the question of the postcolonial and the often rather naive enthusiasm it produces. Again, this is not a new methodological departure; what is important about Coombes's approach to postcolonialism is analogous to what we saw in the development of feminist theories of art history. Rather than simply finding a means of addressing the object, Coombes asserts that we need to think more broadly about the cultural, social and political structures in which art is displayed and consumed. We need to attend not only to objects but, more importantly, the institutional contexts in which they are located. The effects of transcultural encounters are to be found in the use of objects and artefacts rather than imminently in the object itself. There is also an analogy to be made with feminism in terms of art history as a discipline. In a move similar to Griselda Pollock's critique of early feminism, Coombes argues that it is not enough simply to add another set of items to the museum or syllabus. Expanding the canon to include non-Western or colonial work is insufficient; one needs to consider the fundamental principles of the museum or syllabus itself.

The exhibitions Coombes discusses were all self-consciously aiming to challenge the dyadic structure of West and Other, the 'us and them' model that underpinned the approach of scholars like Said and Nochlin. Instead, the curators wanted to show objects which were hybrid; that is, which were the result of cultural contact and interaction. At the same time, there was an attempt to show the objects as *different* from Western art and craft, as signs of non-Western identity. This sounds thoroughly postcolonial, but Coombes asks whether this really challenges Eurocentrism, or whether a celebration of postcolonial cultures updates the vogue for the primitive. The central problem, in Coombes's critique, was that attention to the object, and to the celebration of the object, displaced any sense of history: of the object's location, its journey from one part of the globe to another, its display, and of its continuing history. The desire to celebrate difference and diversity, to display other cultures in an unrelentingly positive manner, meant that the problems of history vanished to leave only what Coombes wittily terms 'a scopic feast' — a plethora of visual pleasure which allows the spectator to ignore global issues. In part this is a critique of **multiculturalism**, the idea of different peoples living side by side as in a major city like London or New York. A modern city is not simply a patchwork quilt of self-contained ethnic groups but a process of continual change, and artworks and objects are markers of those changes. Hybridity suggests a greater porousness but, as Coombes makes clear, merely replacing one term with another is not enough. Hybridity is too often presented

as a happy ending, embodied in the celebratory display of objects and artworks, rather than as an ongoing problem.

In the exhibition *Hidden Peoples of the Amazon* in the Museum of Mankind, London, Amazonian Indians were shown to have a rich culture which was both the result of interaction with Western or non-indigenous cultures and yet still embodied their particular identities. However, what the exhibition did not show was the struggle between the Indians and the Brazilian government and the continued resistance of indigenous peoples. In other words, the postcolonial grail of hybridity was seen as a straightforward fact rather than as an ongoing political problem.

A similar problem emerged in *Les Magiciens de la Terre* at Paris's Centre Pompidou. This was also an explicit attempt to present hybridity, and to refute the notion of an essential and unchanging native culture. However, while cultural artefacts were presented as hybrid and mobile, the exhibition ignored the question of **diaspora**; that is, of the scattering of a people and its culture around the world. While objects were seen to appear in different parts of the globe, the voluntary or forced migration of people was not addressed. Thus, the exhibition presented a world where cultures interact at a distance, while bodies remain geographically static and any move to another culture is followed by a return home; to invoke the theoretical notion of hybridity does not explain why it is that there is a large North African community in Paris. Moreover, the notion of hybridity was seen to apply everywhere, as if it were a monolithic state of all cultures, with no real regard for the balance of power or who benefits from any particular hybrid form. What Coombes is alerting us to is that hybridity can be as problematic a model as any other. Her position is closer to that of the anthropologist Nicholas Thomas. Thomas uses the term 'entanglement' to describe how different cultures are interwoven in such a way that the threads of each cannot be separated even though they may be visible. The traffic in ideas and objects does not mean that a culture blends into a perfect, smooth whole, but that it comprises many relations, visible and invisible.

Coombes's article is not simply a review of some exhibitions or of curatorial practices. She uses these case studies to identify some key problems with postcolonialism itself. Among these is a central conundrum we have traced in this book. Art history rests on the assumption that an artwork is specific to its culture which may not be our own. It requires a different set of criteria from our own for evaluation and comprehension. Nonetheless, we go to museums and view these works with pleasure and interest, recognising them as valuable. In postcolonial theory, this familiar historical problem is transformed into a geographical one. Rather than the issue of cultures reading each other through time, here we are confronted

with the problem of space; of how a culture on one side of the globe can find value in the work of a culture from the other side. What is the mechanism that enables us to do this, to bridge the huge cultural chasm between a Londoner and an Amazon Indian? Coombes's answer seems to be that there may be no mechanism; it is an illusion. The museum ascribes an aesthetic value and offers a meaning for the work, but this rests on the belief that we are simply all sharing in the wonders of human creation. Such a happy engagement with other cultures is, in effect, a denial of the history that allowed these objects to be viewed. What Coombes sees in these displays is similar to the internal inconsistency of Said's *Orientalism*: a desire both to insist on difference and on similarity at the same time. While not claiming that we can never communicate with or understand the products of another culture, Coombes implicitly suggests that the art-historical assumption of legibility and cross-cultural or transhistorical understanding may be a mistaken notion that hides unpleasant histories.

Critical appraisal

The importance of postcolonialism is plain to see. The insistence that other voices be heard and the demand that culture be understood as a global issue are both powerful reminders of what is excluded by universalising accounts of history. Postcolonialism, at a theoretical level, takes us as far from the beginnings of art history as can be. We saw that art history as a systematic discipline rested on two perceptions: that art is historically specific to the culture that produces it, and that we can formalise explanations for historical change. Hegel's concept of Absolute Idea worked to unite the local and the universal, to allow a history which is culturally specific but enables subsequent generations to understand the art of the past. In postcolonialism this unity is blown apart. Cultural specificity may be pursued to a point where an outsider is disallowed from speaking, either through insufficient knowledge, or because of the ethical problems incurred when one person decides to speak on behalf of someone else. Of course, this is also the central difficulty that postcolonialism faces: how do we bridge the gap between cultures?

There are two aspects to this problem. The first of these is a theoretical issue and is well expressed by Nicholas Thomas: 'While an account may aspire to offer a global theory . . . any text on colonialism will be deeply shaped both by the positions from which we speak and by the particular kinds of texts and histories we feel compelled to address' (Thomas, *Colonialism's Culture*, 1994, p. 27) In response to this, some scholars have simply opted for a relativist position, arguing that there can be no true, or

definitive, or authoritative account. Rather, any history merely shows a partial viewpoint with no greater claim than any other. This, needless to say, is self-undermining and a dead end for a method which has a political point to make. Others have suggested that peoples must speak for themselves; that only those inside a culture can narrate its history. The danger here is, first, a kind of self-censorship and, second, of ascribing an authenticity to other voices that one denies in one's own. This can become a version of primitivism in a sense, in that the native voice is overvalued, given an oracular knowledge or unmediated access to truth that would not be assumed of an outsider's voice. It also ignores the hybridity of cultures, by assuming there is an authentic voice unsullied by cultural contact. So how can one speak of and for another culture?

The most common response has been to rely on other theoretical methods, as we have seen Said draw on Foucault, Nochlin on feminism, and Craven on Marxism. Postcolonial sympathies are thus combined with other political or philosophical commitments. This reliance on other theoretical models and approaches may enable the work of postcolonialism but is nonetheless problematic, since one could see this move as exacerbating the hermeneutic problem rather than resolving it. While postcolonial studies assert the need to speak from the margins, the theories used are often very central in terms of their cultural provenance and implicit authority. It has been suggested that this merely reasserts the privilege of the coloniser's culture. The problem is a very profound one. If one uses Marxism or psychoanalysis or Foucauldian discourse theory, one presumably believes these to be true accounts of human history or the human psyche and appropriate to peoples in Africa or South America or the Middle East. At the same time, postcolonial theory generally argues against any such unifying notion of human nature, insisting on the local and on difference. These theoretical tools might also be seen in a more positive light. For those who claim with confidence that their own theoretical model – Western though it may be – is indeed true, much can be achieved. Feminists, for example, may be able to use a Western feminist theory to reveal the profoundly patriarchal structures not only of colonial regimes but of the indigenous cultures themselves. There are points, in other words, where scholars may recognise a Eurocentric viewpoint, but override objections with a desire to uphold certain liberal, democratic or radical values (for example, a commitment to anti-sexism or anti-racism).

The second aspect to the problem of postcolonial theory is that there is often a conflict between the wish to provide a global theory and the ways in which historical specificity undermines this aim. Scholars have tried to produce models of 'colonial discourse' or of inter-cultural relations that might characterise all colonial encounters. Nicholas Thomas has again

provided a particularly forceful critique of this tendency, exposing how the wish for an overarching theory requires a reductive approach to historical materials.

First, there is a danger of historical reductiveness. Thomas points out that the very term colonialism is often used in a rather vague manner, as if it is self-evident. Yet its forms are myriad; think, for example, of the political and cultural differences between Columbus's arrival in the Americas, the formation of the Mughal empire in India in the early sixteenth century, and the more recent Chinese invasion of Tibet. Second, there is a danger of a political reductiveness. While Thomas by no means defends colonialism, he points out that colonialism cannot be characterised as always and only ever bad, since it has also been enabling or progressive for some peoples. Moreover, a colonising culture is not a homogenous formation. In any colonial power, there are internal debates and struggles about the ethics and practice of imperialism. Third, there is also a danger of a conceptual reductiveness. Thomas's example here is the way in which colonialism is frequently muddled with racism, as if the two are not only always partners but are, effectively, the same thing. While colonialism is often underpinned by racist preconceptions this is not always the case, and may be founded, for instance, on religious beliefs instead. Thomas also reminds us that racism comes in many different varieties, and is yet another term that demands differentiation. In effect, the issue that underpins these three points is the same: there can be a tendency to homogenise and to create a mismatch between a specific historical analysis and a general theoretical position which are at odds with each other. This is, in effect, the issue that underpinned the critique of Said and the criticism Coombes makes of the way in which 'hybridity' has been used generically.

This kind of critique does not, of course, argue against postcolonialism as a method, but rather for a refinement of and a greater reflection on its theoretical basis. It is not surprising that each of the issues Thomas identifies is, in effect, a symptom of the hermeneutic problem with which this book has been so concerned. In order to produce increasingly complex and historically specific accounts of a particular artwork or moment, one has to give up any possibility of a general historical account from a postcolonial perspective, since this can only lead to reductive claims about 'colonial discourse' or racism. One might even argue that postcolonialism's greater concern for its political status than its theoretical coherence is an explicit recognition of this. Ending with postcolonialism in our survey of approaches, we see exactly how far art history has come since its beginnings. Postcolonialism demonstrates very clearly exactly how much is gained when one jettisons attempts to universalise history; the decline of the mono-

causal model enables a way of viewing and discussing culture that is sensitive to issues of difference. Yet postcolonialism also demonstrates what has been lost. The political and ethical tangles are sometimes so dense, it seems as if we are unable to pronounce except in such a partial and interested manner that our words carry no force. The best postcolonial scholarship (such as we have discussed here) has addressed these issues or attempted to negotiate them with considerable power – but the problem persists and it is unlikely to go away.

Bibliography

Clifford, James, *The Predicament of Culture: Twentieth-Century Ethnography, Literature and Art* (Cambridge, Mass: Harvard University Press, 1988). An important collection of essays that includes 'Histories of the Tribal and the Modern', Clifford's critique of the Museum of Modern Art's *'Primitivism'* exhibition.

Coombes, Annie, *Reinventing Africa: Museums, Material Culture and Popular Imagination in late Victorian and Edwardian England* (New Haven and London: Yale University Press, 1994). 'Inventing the Post-Colonial' (see below) offers a nuanced critique of the term, detailing the problems of postcolonial theory. Her influential book *Reinventing Africa* puts this into historical practice, demonstrating how a critical use of the method can cast new light on visual culture and its history.

Coombes, Annie, 'Inventing the Post-Colonial: Hybridity and Constituency in Contemporary Curating', *New Formations*, Winter (1992), pp. 39–52. See above.

Craven, David, 'Abstract Expressionism and Third World Art: A Post-Colonial Approach to "American" Art', *Oxford Art Journal*, vol. 14, no. 1 (1991) pp. 44–66. A clear demonstration of how postcolonialism can be combined with a Marxist approach.

Fanon, Frantz, *Black Skin, White Masks*, trans. Charles Lam Markmann (London: Pluto Press, 1986). An important and controversial work using psychoanalysis and existentialism to explore the effects of colonisation and racism.

Nochlin, Linda, 'The Imaginary Orient', *Art in America*, May–June (1983) pp. 46–59. An application of Said's method to visual culture.

Said, Edward, *Orientalism* (London: Routledge & Kegan Paul, 1978). One of the founding texts – possibly *the* founding text – of postcolonial studies.

Smith, Bernard, *European Vision and the South Pacific, 1965–1850* (Oxford: Clarendon Press, 1960). An early and important analysis of cross-cultural encounters and their effect on visual culture.

Thomas, Nicholas, *Colonialism's Culture: Anthropology, Travel, and Government* (Cambridge: Polity Press, 1994). Thomas is an anthropologist, but has written extensively on art and visual culture. His work is outstanding in its clarity and critical force.

Young, Robert, 'Ideologies of the Postcolonial', *Interventions*, vol. 1, no. 1 (1998). A concise introduction to some theoretical debates in the field.

THIS BOOK HAS BEEN ABOUT ART HISTORY, yet much of our discussion has referred to such fields as philosophy, politics and psychology. While art historians have their own specific objects of study – from paintings and sculptures to advertisements and hair styles – the ways in which they explain those objects have always been informed by intellectual debates elsewhere. Take a Marxist historian, for example: he or she may be studying Courbet but their interpretation of Courbet's work would be impossible without conclusions taken from political philosophy regarding class and class structure. Nor is this something new: art history has always been an in interdisciplinary enterprise. Although some scholars regard art history as a rather insular discipline nothing could be further from the truth. Moreover, the relationship between art history and other disciplines has been a genuine dialogue. While art history has used insights and theories from other fields, scholars outside art history have often looked to it for ideas. So for example, we saw that Riegl and Wölfflin gave a historical account of change in human perception. Art was the medium which most clearly documented these shifts, so had a certain pre-eminence for those studying the history of human thought. Other historians took up this notion and attempted to use the insights of art history to interpret other aspects of society. More recently, scholars in cultural history and the history of science have begun to focus on the role of visual representations and have turned to art history for methodological guidance.

During the writing of this book we have often discussed it with colleagues. In more than one case they have reacted with puzzlement and been unable to place themselves in our gallery of methods. It is probably true that few art historians work straightforwardly with a single method. As we suggested in our 'trailer' chapter, many scholars use insights and principles from different methods. Feminism, for example, has taken ideas from a range of theories and integrated them within its political perspective, or a historian of medieval art may adopt insights from social art history while using connoisseurial methods for the purpose of identifying and dating particular works.

This raises an important question: namely, are these different methods compatible? We have seen that every art-historical method carries with it

particular commitments. We have also seen that many of these commit-
ments are the result of principles that were developed in conscious opposi-
tion to another approach. For example, social art history represents artworks
as the result of an interplay of social forces, while connoisseurship takes
the individual to be the main agent of history. What then would this mean
for an art historian who is trying to use elements of both approaches in
his or her study of medieval art? Can one draw on two different methods
without contradiction? On one level, certainly, for it is possible to apply
the connoisseurial skills necessary for the dating of artworks without sub-
scribing to connoisseurship's underlying theory. But there are limits to how
far one can simply pick and choose. These accounts are theoretically mutu-
ally exclusive and, at this fundamental level, it is necessary to make a choice.
Most commonly, art historians are committed by their practice to one or
other of these fundamental positions, although they may not be fully aware
of it or its consequences. There is no art history without theory or method.
Although people may sometimes say they are not interested in theory, or
that their work does not require it, they are wrong: method may not be
explicit, but it is present. One of the reasons for writing this book is to
encourage art historians to be more self-reflective.

But this does not mean that there is no flexibility. Taking bits and
pieces from different theories has its dangers but it is often possible to use
parts of one approach productively while having a fundamental commit-
ment to a radically different theory. Feminism is a good example. Many
feminists have found, as we have seen, the use of psychoanalysis productive.
However, as has often been pointed out, psychoanalytic theory is founded
on sexist assumptions which are very much at odds with the feminist view-
point. Feminist scholars are well aware of this. But it has been no bar to
accepting some aspects of psychoanalysis. For example, the readings by
Laura Mulvey and Griselda Pollock that we looked at in Chapter 9, on
psychoanalysis, used the Freudian notion of fetishism without endorsing
some other aspects of Freudian theory.

To see why some kind of theory is inescapable, think of someone
compiling a catalogue raisonné. They might not be thinking about the
questions this book has raised – the way that art is linked to the society
in which it is produced, or how it changes over time. As far as they are
concerned they are merely compiling data. Yet there is a clear commitment
to the significance of the individual artist in explaining the way his or her
work looks. The unstated assumption is that a work of art is meaningful
because it is made by an individual and this individual, in turn, can only
be understood in the light of all of his or her work. Behind that conviction
lies what we earlier in this book called the 'metaphysics of individuality'.

Moreover what we have called the 'hermeneutic problem' – how is it that a contemporary observer from one historical and cultural position can claim to understand works from a different context – seems to some degree inescapable. As we have seen, the methods discussed in Part One offer some kind of overarching principle to link the two. From Hegel's 'Absolute Idea' to the Marxists' economic teleology such methods offer a mechanism that gives art its place in history yet allows us to understand it from where we are now. In Part Two, we saw that, although the hermeneutic question remains important, people have sidestepped it. The reason for this is that it has come to seem increasingly problematic to assume that history is tied together in a single process of development. Past solutions to the hermeneutic problem no longer seem believable. And this brings us to a further important point. The history of methods is a story of losses and gains. New methods developed in order to overcome the problems and blind spots of previous ones. But something is also lost which the next theory aims to put right, and so the tale continues.

There is no theory discussed in this book which is not open to objection. If you adopt an overarching principle to link the present with the past and account for historical changes, then you risk not being sufficiently attentive to difference. These theories claim that they apply to all people in all cultures at all times. They identify certain general causes behind all the diverse phenomena of art history. But what right do we have to assume that what we now see as fundamental applied to cultures that are very remote from us? We saw in Chapter 5 how Riegl and Wölfflin took up contemporary ideas from the psychology of vision and tried to apply them historically. However, this was largely a projection on their part which was not supported by compelling historical evidence. There is a danger that writing history becomes a kind of colonisation, claiming to be speaking for another culture but in fact unable to appreciate its distinctiveness. For that reason many writers have gone in the opposite direction and focused entirely on specific features of particular cultures. Rather than looking for historical continuity these scholars have emphasised disjunction and difference. Social art historians have been particularly good at giving this kind of analysis.

However, this leaves another kind of objection. If we give up the idea of a connecting principle common to different cultures, then how do we know that we are giving a valid interpretation. If something is radically different then it becomes unknowable and it is unclear how history can be written. In consequence a third position has emerged in recent years. This gives up the claim to reveal objectively what is historically specific and different. Instead those who take this view accept that there is no way we can

escape from our own perspective. All we can hope to do is to construct a compelling story, one that is inevitably motivated by contemporary concerns. The upshot however is that we seem to be reduced to our own narrow world. Historians are more like novelists than scientists. But perhaps this is too sweeping a position. Would it not be possible to see what is different about another culture – different, one may admit, from our standpoint – without thereby usurping the autonomy of that other culture? Indeed one might think that this is precisely what the practice of history is all about: identifying differences (in time, or in time and space) and using them to reflect upon what we might otherwise take for granted about our own understanding of the world.

The fact that we have concluded this book with a word about some of the deficiencies of art-historical method should not be taken to be discouraging. The apparently intractable problems, rather than reducing art historians to silence and bewilderment, have been the motivating forces behind the extraordinarily complex and vital tradition of art history. Yet, there have recently been some suggestions that art history as a discipline is exhausted. The claim has been made that art history is inward-looking, narrow in its concerns and unnecessarily protective of its borders. We find this hard to understand. The material and the examples we have assembled in this book seem to us to be enough to refute this charge. Art historians have been extraordinarily versatile in developing new approaches. While much of art history, it is true, concentrates on the fine arts, nothing in theory or in practice has prevented some practitioners from expanding the range of objects of investigation. From Riegl's attention to the buckle of a Roman belt through Panofsky's writing on film to Lynda Nead's discussion of pornography, art historians have often worked to expand the borders of their discipline. There is no reason why art history should not expand its remit even further and indeed it seems well placed to address the most striking recent phenomena in contemporary culture: the difference between analogue and digital representation and the manipulation of images and their status. While many scholars might prefer to call this the study of 'visual culture', such a study will have to address the same theoretical conundrums as traditional art history and will in all likelihood rely on the methods developed by it. It is hard to imagine art history's demise, but it is easy to envisage it coming ever more into interaction with those many other disciplines for which the study of images is increasingly important.

Index